THE PARADOXES OF ART

A Phenomenological Investigation

In this study, Alan Paskow first asks why fictional characters, such as Hamlet and Anna Karenina, matter to us and how they are able to emotionally affect us. He then applies these questions to painting, demonstrating that paintings beckon us to view their contents as real. Emblematic of the fundamental concerns of our lives, what we visualize in paintings, he argues, is not simply in our heads but in our world. Paskow also situates the phenomenological approach to the experience of painting in relation to methodological assumptions and claims in analytic aesthetics as well as in contemporary schools of thought, particularly Marxist, feminist, and deconstructionist.

Alan Paskow, who received his Ph.D from Yale University, is professor of philosophy at St. Mary's College of Maryland. The recipient of Danforth and Fulbright fellowships, he has published in a wide range of subjects, including the philosophy of art and literature, phenomenology and existentialism, philosophical psychology, and the thought of Heidegger and Kierkegaard.

The Paradoxes of Art

A PHENOMENOLOGICAL INVESTIGATION

ALAN PASKOW

St. Mary's College of Maryland

PUBLISHED BY THE PRESS SYNDICATE OF THE UNIVERSITY OF CAMBRIDGE
The Pitt Building, Trumpington Street, Cambridge, United Kingdom

CAMBRIDGE UNIVERSITY PRESS
The Edinburgh Building, Cambridge CB2 2RU, UK
40 West 20th Street, New York, NY 10011-4211, USA
477 Williamstown Road, Port Melbourne, VIC 3207, Australia
Ruiz de Alarcón 13, 28014 Madrid, Spain
Dock House, The Waterfront, Cape Town 8001, South Africa

http://www.cambridge.org

© Alan Paskow 2004

First published 2004

Printed in the United Kingdom at the University Press, Cambridge

Typeface Apollo 11/13.5 pt. *System* LATEX 2$_\varepsilon$ [TB]

A catalogue record for this book is available from the British Library.

Library of Congress Cataloging in Publication Data available

ISBN 0 521 82833 3 hardback

For Jackie and Linnea

In gratitude,
With love

"Somehow," he said, "nothing that philosophers or art historians – other writers too – have written about art quite captures what it is really about and what it means to me."

"Yes, yes," I said. "I agree. But it can be done."

– Fragment of a conversation that I had with a philosopher colleague in 1988

"'The death of Lucien de Rubempré is the great drama of my life,' Oscar Wilde is said to have remarked about one of Balzac's characters. I have always regarded this statement as being literally true. A handful of fictional characters have marked my life more profoundly than a great number of the flesh-and-blood beings I have known."

– Mario Vargas Llosa

Contents

Contents

Acknowledgments

If someone were to ask me when I began this book, I would say it was about forty-five years ago, when I stood, as a college sophomore, before Picasso's "The Tragedy" in the National Gallery of Art in Washington, D.C., and wondered what the painting "meant" and why Picasso was so admired by art lovers. The conclusion I came to then was this: just as a dreamer takes the imagery of his or her dream as reality, so, too, I should enter into the tragic scene before me and regard it as not only *about* the world, but as *totally* real. So I concluded that paintings at least purported to be mimetic. Plato was right. But since the three figures in Picasso's painting were after all not real people, how and why should I try to persuade myself that they were? My conclusion made no sense. My contradictory intuitions, nurtured and sustained over the years by my love of the visual arts, did not resolve themselves. But much later, around the beginning of 1987, with no clear outline in mind and yet with a sense that in doing research and writing on "my problem" I could develop a response that would at least partially dispel my disquietude, I undertook the writing of the book that follows.

Many people have helped me to formulate the ideas of this work. The philosopher's work that inspired me the most and that provides the epistemological and ontological underpinnings of this book is Martin Heidegger's *Being and Time*. I first read and discussed this work – in a mimeographed, unauthorized translation, for there was no English translation yet in print – with my fellow graduate students in a seminar directed by John Wild at Northwestern University. With his assistance, I was able to discover in Heidegger a voice that spoke to me more directly and searchingly than any other to which I had ever listened.

Acknowledgments

I am also grateful to Francis Parker, who first introduced me to the field of philosophy and whose many undergraduate course offerings I took at Haverford College before attending Northwestern. Neither he nor any other reader, however, would probably recognize that his spirit, clarity of mind, and very ideas have decisively shaped this book.

I wish to acknowledge my gratitude as well to students at St. Mary's College of Maryland who enrolled in my successive course offerings in the philosophy of art and literature as well as in the history of modern philosophy. Their challenges to my own intuitions about art and painting helped me to define and defend them in a form that is better than it would have been otherwise.

I also wish to express my appreciation for the generous assistance of Hans Robert Jauss and Wolfgang Iser, the founders of the Constance School of Reception Theory at the University of Constance in Germany. Professor Jauss was my mentor and sponsor at the University in 1987–8. From that period on, he read and commented extensively on everything that I wrote, until he died in 1997. He was a prompt, conscientious, perceptive reader, who demanded more justification and amplification of my claims than I had provided. At the same time he was strongly supportive of my entire philosophical project. I regret that I cannot present him with a copy of this book as a token of my gratitude. Professor Iser, in several direct conversations, helped me to thread my way through two serious impasses in the last chapter of this book. His thoughtful words proved extremely helpful to me.

I am grateful to the four anonymous readers from Cambridge University Press whose astute criticisms – and compliments – of an earlier version of this book were the stimulus for the rewriting of large sections of it. I am also happy to record my thanks to the following people, who read or responded to talks that I gave on parts of the book: Gereon Wolters and Dieter Teichart (both of the University of Constance), Peter Lamarque (editor of *The British Journal of Aesthetics*), Bob Scharff (editor of *Continental Philosophy Review*), P. J. Ivanhoe (Boston University), Richard Shusterman (Temple University), Tom McCarthy (Northwestern University), Jerome Miller (Salisbury University), and Andrea Hammer and Jeff Hammond (both of St. Mary's College of Maryland).

Acknowledgments

I should mention as well my appreciation for the guidance and encouragement of Beatrice Rehl, senior editor, Arts and Classics, at Cambridge University Press. She enabled me to continue my work despite some tough criticisms from one of the Press's anonymous readers. It has been a pleasure to work with her. I am grateful also to Eleanor Umali and Elizabeth Budd of TechBooks for the meticulous and patient editorial care they took with this work.

I owe thanks to Mary Bloomer, the departmental secretary who, in the face of this book's looming deadline, found time in the midst of other pressing responsibilities to edit all of the endnotes and to compile the bibliography. I owe thanks as well to Rob Sloan and Celia Rabinowitz, librarians at St. Mary's, for their timely bibliographic assistance.

Here I should mention that I received significant financial support for my project on several occasions. I wish first of all to record my appreciation to the Fulbright Commission for a Senior Research Fulbright grant that I received in 1987–8. It, along with sabbatical leave pay from St. Mary's College of Maryland, enabled me to live in Germany for an entire year. Without teaching obligations, I could discuss my ideas with colleagues at the University of Constance, pursue my research at its excellent library, and commence writing this book. I was later granted an additional year-long, sabbatical leave from St. Mary's to complete my research and writing at the University of Constance. I am grateful as well for several Faculty Development grants given to me by the College in support of my work. They allowed me to return to Europe during summer breaks to view directly and reflect on the significance of the paintings that I was writing about.

Finally, and on an altogether different plane, I want to say how grateful I am to both my daughter, Linnea, who as a painter actually creates the sort of thing I write about in this book, and my wife and colleague, Jacqueline. Linnea has taught me how artists talk about and understand their work and how I may view paintings more perceptively. Jacqueline read and commented extensively on every chapter of every incarnation of this book. Her demands for clarity were always justified, and her suggestions for better articulations of my thoughts were invaluable. She also insisted that I never give up on what I often felt to be a task that was simply too ambitious. Her faith became my faith.

Introduction

What is a painting? I am not posing a question of definition. Rather, I am interested in discovering what a painting means to us, why it can matter in our lives. Nor am I assuming that a particular painting has *a* meaning awaiting our discovery, for I know well that different people have different responses regarding the significance of the same painting and that people sometimes bring special agendas to an artwork, perhaps unconcerned with what "it means."[1] Still, most of us do seek some sort of meaning or significance in viewing a painting; ordinarily, we do not simply stare at its colors or shapes and ask no more of it. No, I claim that we wish to feel its presence, to discover what it has to say to us and often what it has to say to other people as well. In short, we desire to make at least some sense of it.

Now if I am right that when contemplating a painting we normally care about its meaning, why do we engage in this activity? After all, a painting is, from one point of view, simply a created image, and what is so special about that? If one is inclined to reply that some images are "well executed" or "pleasing to the eye" or "beautiful," this is certainly true, but the same can be said of many things, such as a superbly designed woodstove or an automobile fuel injector. Why is it that certain paintings fascinate millions of viewers and provoke them to return to and gaze at them again and again? The reason cannot simply be that they are "realistic" or "true to life," for these labels apply to most photographs, yet photographs do not ordinarily generate the same kind of intense worldwide interest that many thousands of paintings do. Moreover, the "realistic" label is applicable only to relatively few acknowledged masterpieces in certain

periods of the history of Western painting, not transhistorically or cross-culturally, and not, therefore, to innumerable other works – for example, to the animal depictions constructed by the ancient cave dwellers of Lascaux in what is now France or to the scroll paintings of landscapes rendered by the Chinese painter Hsü Tao-ning, who died around 1066.

Let us for a moment view and reflect on what many art lovers regard as a great painting, "Girl with a Pearl Earring," by the Dutch artist Johannes Vermeer (painted c. 1665–6; see Plate 1). This work happens to be "true to life" in certain respects, but I did not select it for that reason. I could in fact choose any work to illustrate the philosophical questions I am about to pose, but the Vermeer is beloved by millions of art lovers, and I happen to be one of them.

The young woman's face depicted in the work is "attractive," "pleasing." Her body is turned away from us at about a ninety-degree angle, but her head is turned to her left, so that she seemingly looks directly at us, her viewers (or should we say, at the person who has painted her?). Her eyes are bright; her lips are parted, the lower one moist. She is not exactly smiling; her expression seems to be of mild pleasure and thoughtfulness, although it is not readily apparent whether this is due to the person in her gaze, what she happens to be thinking or feeling at this very moment, or both. The white dots of reflected light in her eyes and the corners of her mouth give further animation to an otherwise barely scrutable expression. She is wearing an unusual headpiece, a colorful turban of sorts. On her left ear dangles an earring, referred to by art historians as made of pearl, but more apparently to me of silver. What surrounds this young woman is utter darkness, so that this being before us seems apparitionlike.

We may ask all sorts of questions about her. Who is this woman? Is she Vermeer's wife? His mistress? His model? Someone who serves as a maid in his home? Someone he fabricated out of his imagination? We do not know. Has she just turned toward the viewer? Or has she been looking at the viewer and is now about to turn away? Or are we seeing a last, lingering glance at the viewer? Why didn't Vermeer portray her head on, instead of from an unusual angle? Why are her lips parted? Is she expressing surprise and innocence? Or instead a kind of erotic longing? What is she thinking and feeling? And why

is this young European-looking woman wearing a turban that looks to be of North African origin?

We may pose an altogether different question, a philosophical one, about the figure. I referred earlier to Vermeer's depiction as a woman, but what he fabricated with oils on canvas is of course not a woman. It is merely colors and shapes that constitute a generically familiar image. As we view the reproduction, or if we have viewed the original painting, we couldn't possibly mistake its depiction for a real human being. Then again, it wouldn't be easy for us to look at the colors and shapes as merely physical features of the canvas, and not as features constituting the woman herself. (In trying to avoid seeing a woman, perhaps we would squint so as to blur our perception. It would be especially important to avoid looking at the figure's eyes, perhaps the mouth as well.) So there is apparently something about the painting that transports us, often even in spite of ourselves, to something real, or at least apparently real. Perhaps we could say, "Well, it is *about* something. It is a representation of a real person"; in that simple relational statement, it would seem that we capture both the physicality of the canvas and paint and the imagined reality of a person.

So are we implying that the depicted woman is only imagined and therefore not real? Are we transported to something in our imaginations? Is she in our heads? In our minds? Do we really know this? If we insist that we do, then what makes us so certain of this view? How do we know that it is true? When we look at the painting, are we simultaneously able to look into our minds to ascertain that we are merely imagining something? Obviously not literally, we concede. Metaphorically then? Do we introspect and assure ourselves that she is, in some sense, in our minds? But then can we clarify the phrase "in some sense"?

When I view the reproduction, I look at the figure and see her in front of me, "out there," and thus not in my mind. I simultaneously know that the painting is before me and that I am confronting a person. A *real* one? Well, I'm not only confronting mere oils and a canvas or simply a manikin, but of course I don't talk to the woman, smile at her, or assume that she will begin to do something. Nevertheless, I would say – ambiguously at this point, to be sure – that the woman,

as I dwell with her, is in a sense not simply imagined by me, but real to me. And real to you, too, as you dwell with her. What do I mean by "in a sense, real"? For me to explicate such a claim properly, I must provide an account of how the woman is to be understood in relation to the "truly real" people whom we know and with whom we have contact on a daily basis because I just conceded that I do not have the same kinds of sensory expectations about the woman with the earring that I have about a real human being – for example, my colleague, who happens to be in his office next to me at the moment.

Yet, answering the question I have posed requires me to challenge a way of thinking that Western philosophers have accepted as dogma for centuries. It will emerge in this work that the distinction between *what* a thing is and *that* a thing is, between "essence" and "existence" and, by extension, the distinction between what is "merely fictional" and what is "actually real," are not so sharp as virtually all Western philosophers have unquestioningly assumed, especially since, and in part because of, the work of Immanuel Kant. Chapter 1 of this book responds explicitly, and the subsequent three chapters respond implicitly, to the difficult philosophical question that I have posed.[2]

Here is another related question that may also be asked about the quasi-reality that I seem to be attributing to depictions: because many paintings do not represent people, but things – tables and bowls of fruit or landscapes, even geometric forms (abstractions), and so on – am I claiming that such representations, too, are taken to be in a sense real? Well, yes, I reply. Not only that, but we experience the depicted things to be – besides their appearances as, for example, bowls of fruit or trees or mountains – *peoplelike* beings, with personalities that "speak" to us. Thus, as I see it, depicted things, too, are not only "real to us" but are so in a way that is very similar to the way in which depicted people are "real to us." I attempt to justify this position, counterintuitive and strange though it may seem, in Chapter 2.

If depicted things are to be understood as having a status in being very much like that of depicted people, and if the latter in turn are best understood as "real," such a position, even if acceptable, still leaves unanswered the question of why and how the others – "real" people themselves – at the deepest level matter to us in the first place. If we can answer that fundamental and difficult question, we

[4]

will, I believe, be able to comprehend the principal reason why and how, at the deepest level, paintings have the effect of mattering to us in the way that they often do. In short, how I am affected in my being by a "real other" will importantly explain how I am affected by others depicted in artworks. Chapter 3 responds to the expositorily necessary question of why and how "the others" matter.

The order of the book's chapters implies that several basic philosophical questions need to be addressed before we are in a proper position to achieve a comprehension of "why and how painting matters," the subject of Chapter 4. The reader may well wonder what all of my demonstration and argumentation in the first three chapters has to do with the subject of experiencing artworks, and thus my thematic deferral may seem like an unnecessary circumlocution. It is not. If the principal philosophical points of this book about "the matter" of painting itself prove on the whole to be persuasive, then this will occur because I have challenged and redefined beforehand, both systematically and at some length, many beliefs – about our relationship to things generally, to "the others," and to fictional beings – that most educated people would be inclined to presuppose "as commonsensically obvious" or "self-evident." Thus, perhaps frustrating as it may be to some readers eager to "get to the point," we must first contemplate and survey the philosophical environment that shapes our experiencing paintings, an environment consisting of forms that are typically hidden from our aesthetic vision by virtue of the fact that they inform that vision. We must then try to apprehend, freshly and right at the outset, certain features of what "to know" means and what "to be" means; we are obligated, in a word, to investigate both epistemological and ontological entities (relations). Chapter 4 attempts to show how distinctions and arguments of the preceding chapters' conclusions can be applied concretely, phenomenologically, to our reception of a painting, how we may enter into and be transformed by it – this is to say, by what I shall call the "subworld" that it depicts.

In Chapter 5, I reflect on still another difficult and vexatious issue – what I broadly call the question of interpretation. For even if by the end of Chapter 4 I have satisfactorily demonstrated that the depictions of paintings are best understood as I have characterized them – that is, as "real" – we still need to deal with the huge and

complex issue of what might be called "artistic ambiguity," with the various – indeed, multitudinous – meaning possibilities latent in our experience of the people or the things represented in paintings. It can be asked, for example, what kind of sense I should make of my initial responses to Vermeer's depicted woman with an earring. Should I simply enjoy the beauty of her face and expression, think that it is of a lovely Dutch woman of the seventeenth century, and leave my overall reaction to that? Or am I in a way obligated (to my-self, to Vermeer) to consider more critically such first impressions of her to appreciate what the painter has taken such care to represent? Indeed, some people may assert that I am ethically required to be more searching still and critically examine the very lens of "naïve" and "personal" experience through which I view the painting. Al-though there may have been epochs, such as the fifteenth century in northern Italy, when virtually any educated European viewer could easily say what a particular depiction signified overall, with no in-terpretive reassessment even capable of being entertained (e.g., what a figure of Mary cradling the body of her beloved son Jesus meant), today, however, a feminist, Marxist, or cultural critic (to mention only a few variant representative theorists of our own time) would understand the painting very differently from the way in which a person of the earlier era would or from the way in which his or her theory-minded opponents would. Precisely because throughout this book I give great weight and credit to our direct encounter with the figures of paintings and argue that they are for us "real" beings, I risk committing myself, even granting the realist thesis that I put forth, to a methodologically simplistic position that does not do jus-tice to the many and important developments in art theory that have occurred over the past forty or fifty years in Europe and North Amer-ica. Chapter 5, titled "For and Against Interpretation," concerns itself with and responds to a whole bevy of methodological challenges to my own realist stance.

HISTORICAL CONSIDERATIONS

Issues in the philosophy of art were written about at least as early as the time of Plato (c. 428–348 B.C.E.). For at least two millennia and in

the Western tradition at any rate, Beauty, including its representation in artworks, was held to be "objective," something in the world that cultivated people could see and appreciate. Because of developments in modern science, however, and the ontologically confirming philosophical tradition that accompanied them, beginning roughly in the eighteenth century, there developed a way of theorizing that regarded Beauty not as something objective, but rather as something subjective, as a matter of taste. Now one might expect that if beauty is viewed in this way (i.e., as a matter expressive of an individual's personal sensibility), then beauty would only be "in the eye of the beholder." Each individual, according to this way of thinking (so one might anticipate), would have his or her own idiosyncratic and thus ungeneralizable responses to an artwork or to a lovely natural scene. In fact, this was not how eighteenth-century Western philosophers saw the matter, for they declared that experienced, knowledgeable, and unprejudiced people with "delicacy of taste" or "sensibility"would have, by virtue of their common humanity, nearly identical pleasures in the face of beautiful objects or beautiful natural scenes. Taste was therefore regarded as existing *in* the subject, yet manifesting itself in "the same way" in countless individual experiences, thus as something felt in common, both describable and discussable. A person's taste was also viewed by many with great social and philosophical interest, for the degree to which one possessed it was the indicator par excellence of one's good judgment, sophistication, and overall cultivation, of, in short, his or her *Bildung*, the favored term of educated Germans of the period.

It was Immanuel Kant (1724–1804) who developed the most complete theory of taste in eighteenth-century Europe, although he had important Anglo-Saxon and German predecessors (e.g., in England, Anthony Ashley Cooper, the third Earl of Shaftesbury, Francis Hutcheson, David Hume, and Edmund Burke;[3] in Germany, Alexander Baumgarten and Georg Meier). In the *Critique of Judgment* (1790), Kant developed not simply a theory of taste, but a systematic position on a whole cluster of related issues constituting the problematic for the fledgling philosophical domain that had only recently come to be known as "aesthetics," a term coined by Baumgarten around 1750. Kant's work has been enormously influential, both directly and indirectly, on Western aestheticians ever since

he published the *Critique of Judgment*. "We are all philosophizing under Kant's shadow," the twentieth-century philosopher Martin Heidegger asserted frequently. It can be said with equal accuracy that all Western aestheticians – English and North American on the one hand and continental European on the other – are theorizing under Kant's shadow as well. So if such claims about Kant's influence are correct, then this book, too, must be Kantian in spirit. And it is.

But not in ways that Kant would wholly approve of, I feel certain. For although I agree with him that what one calls beautiful is based on a feeling of there being a "purpose-seeming" quality, a purposiveness (*Zweckmässigkeit*), when one is in the presence of certain natural phenomena or (derivatively for Kant) of artworks, and, further, that one cannot ever know that one's feeling truly pertains to a real cosmic purpose, I believe that he makes a profound error in asserting "through this [aesthetic] pleasure or displeasure I do not cognize anything [i.e., beauty] *in the object* of the [sensory] presentation."[4] Later Kant states: "Yet beauty is not a property of [e.g.,] the flower itself. For a judgment of taste consists precisely in this, that it calls a thing beautiful only by virtue of that characteristic in which it adapts itself *to the way we apprehend it*."[5] The object itself is thus, according to Kant, value neutral. It just is. So "beauty" is a term that we use to denominate what we may be privately undergoing (analogous to a physical pleasure) in a particular situation, nothing more (from a cognitive point of view). Yet, we do not say that "my feeling is beautiful"; we say, for example, the *flower* is beautiful. Thus, although our finding something beautiful clearly has something to do with our feelings, in our thought and speech we make reference to something that is not merely "subjective." In fact, I would go even further and assert that certain dimensions of our feelings should be understood as underlying and allowing for the possibility of our having *a world* in the first place, and thus to label feelings as simply "subjective" already profoundly disorients us philosophically. (This dark claim will be "enlightened" in several places throughout this book, especially in Chapters 2 and 3.)

Moreover, I do not agree with Kant that a genuine aesthetic judgment is *disinterested* (which for him does not mean wholly *uninterested*), that it is based on the contemplation for its own sake of a pure semblance or appearance that makes no implicit claim to being

actual or real and that it is therefore uncorrupted by any emotional involvement with the semblance on our part. As Kant says, "Interest is what we call the liking we connect with the presentation of an object's existence . . . [I]f the question is whether something is beautiful, what we want to know is not whether we or anyone cares, or so much as might care, in any way, about the thing's existence, but rather how we judge it in our mere contemplation of it."[6] He continues, "Everyone has to admit that if a judgment about beauty is mingled with the least interest then it is very partial and not a pure judgment of taste. In order to play the judge in matters of taste, we must not be in the least biased in favor of the thing's existence, but must be wholly indifferent about it."[7]

On the contrary, I would argue that precisely because we do take aesthetic objects to be more than mere appearances of our own subjectivity and thus as in some way "real," and because they often "speak to" us as individuals, to the very significance and direction of our lives, to refer to our ideal responses as "disinterested" is altogether mistaken. We are, it seems to me, highly interested in them and not simply – perhaps never – "for their own sake," although, as Kant would say (and here I agree with him), obviously not for some scientific or utilitarian feature, as we might be affected by a thoughtfully designed and well-made chair or table.[8] I also find unpersuasive Kant's assertion that an aesthetic judgment must be based solely on an object's (or natural scene's) "form," the structure of the elements of what is observed – their complexity, order, unity, or overall balance. I believe, on the contrary, that it is especially the content, as well as the form, of an artwork that affects us and, also contra Kant, that our individual histories ineluctably bear on the kinds of pleasure and meaning we derive from our viewings of artworks. For example, it is the precise details of the woman's face in the Vermeer painting (e.g., her brown eyes, her orange-red parted lips, her silver reflecting earring) and their overall structure and color balance that enable many of us to appreciate the work in the way we do. Moreover, the precise nature of our appreciations of her face is, I feel, shaped and given particularity because of the kinds of psychological and cultural experiences that we have had as individuals. Thus, not all (properly cultivated) people will aesthetically experience the form of a flower exactly as I do, nor do I expect them to, as Kant argues I must.

Kant's views on the nature of aesthetic experience and judgment had a subsequent expression in much Anglo-American analytic aesthetics of the twentieth century. In part, this expression was due to Kant's own systematic, persuasive thinking in the *Critique of Judgment* that there was such a thing as "the aesthetic experience" in the first place, that it could and should be conceptually isolated from "mere gratification" (e.g., something like the pleasure of eating something delicious) or from the positive feelings of esteem that we undergo in the face of another's exemplary moral behavior, and that its nature and mental causes could be rigorously analyzed and comprehended. In part, twentieth-century developments in the discipline of analytic aesthetics were also brought about by larger cultural movements and ways of thinking: a reaction to nineteenth-century European Romanticism (also influenced by Kant) and its quasi-deification of natural Beauty, Art, and Genius and, especially, the general and increasing inclination in the Western world's educated public to accept the methodological orientation and practices of natural science as *the* path of access to the realm of what is truly real. (Bertrand Russell early in the twentieth century stated more than once that he was extremely impressed by the progress of modern science but depressed by its lack in philosophy. It was time, he asserted, for philosophy to become methodologically rigorous, as was true of the natural sciences, so that it, too, could point to and be proud of lasting achievements.[9])

Such objectivistic thinking in twentieth-century philosophy has in many respects been unfortunate: scientific rigor has its price, especially when it comes to the most interesting issues concerning the description and significance of human experience. For it is difficult, if not impossible, to provide precise and justified accounts of our emotional responses to objects (such as artworks) both because we are dealing with qualitative, as opposed to quantitative, phenomena and because we must make more than passing reference to first-person events and statements – that is, to what I feel and say (so-called first-person avowals) from my standpoint or what you feel and say from your standpoint. So, too, is it difficult to define what it means for me "to have a world" at the outset.[10] In contrast, to be allegedly scientifically rigorous, we are obligated to investigate human emotions by attending exclusively or at least primarily to third-person

events – that is, to what he or she or they feel and say as seen from a "neutral party's" standpoint, for then one such investigator can, repeatedly and "objectively," observe, record, and generalize upon what the other individuals do and say. According to this methodological outlook, which would find even Kant insufficiently scientific, feelings, ironically, must no longer be described as they are personally felt but instead comprehended as behavioral events (including linguistic ones) of another, of "the other person." Thus, despite the subjectivistic turn in philosophical thinking in the West, beginning in the seventeenth century with Descartes (but not manifesting itself in the field of aesthetics until the eighteenth century), there has been a persistent effort by analytic aestheticians, consciously or unconsciously, to deal with the realm of "the subjective" not on its own personally reported terms, but objectivistically, "scientifically," detachedly.[11] Their methodological disposition does not require that beauty – if it exists at all – be reassigned by them to something "in the world," as it was presumed to exist prior to the eighteenth century. It is still, and only, "in the mind," but "the mind" exhibited as public activity, and only so (e.g., in another person's talking or smiling or staring concentratedly).

Still, it might seem that viewing others with respect to their overt behavior or demanding that their first-person avowals refer to that which is objectively verifiable is not the job of aestheticians, be they analytic or otherwise oriented; such work, so it would appear, should be reserved for psychologists. But then what would aestheticians attempting to understand aesthetic experience be left to do? How would they ply their trade? Or would they have no trade to ply?

Ludwig Wittgenstein (1889–1951), arguably the most important analytic philosopher of the twentieth century, believed that his task[12] and that of other aestheticians was indeed to describe the ways in which people of a particular culture involved with artworks (e.g., in viewing paintings) spoke about their experiences, how they acted while so doing, as well as to bear in mind and, when needed, provide an account of the cultural and historical settings of such activities. But his and their philosophical objectives and practices would be somewhat different from those of behaviorist psychologists. For the latter would note what people say and do when, for example, they gaze at a Fra Angelico painting, abstract and formulate hypotheses

about their data, and verify them through further observation, with the goal of reaching psychological generalizations. (One might learn, we can imagine, that a certain percentage of people under such and such conditions are disposed to, or will, say "a," "b," and "c" and are disposed to, or will, do "x," "y," and "z" when they view certain Italian Renaissance paintings.) Wittgenstein's objectivistic approach to the comprehension of aesthetic responses, and aesthetic questions generally, is different, however, primarily because he regards what people say and do as intelligible only through the complicated network of publicly sanctioned linguistic rule-usages, what he calls "language games," a view that behaviorist psychologists would, generally speaking, reject because the very concept of linguistic practice is enmeshed in such unscientifically permeable issues as "human meaning," "intentions," "culture," and so on. Yet, although Wittgenstein does assume a sociocultural stance vis-à-vis aesthetic questions, he tends to consider most of those posed by aestheticians and nonspecialists alike to be misleading, indeed illegitimate. The questions arise, he maintains, out of their own confusion, brought about by their (our) virtually inevitable disposition to misunderstand how the language of our culture at a deep level really works. As Wittgenstein asserts at the beginning of a series of lectures that he gave on aesthetics in Cambridge, England, in the summer of 1938:

> The subject (Aesthetics) is very big and entirely misunderstood. . . . The use of such a word as "beautiful" is even more apt to be misunderstood if you look [simply] at the linguistic form of sentences in which it occurs than [is likely with respect to] most other words. 'Beautiful' . . . is an adjective, so you are inclined to say: "This has a certain quality, that of being beautiful."[13]

But such a conclusion would be wrong, Wittgenstein proceeds to argue. "Beautiful" is a term of approbation and normally has little significance for aestheticians. It is precisely our disposition to be influenced by certain similar linguistic patterns (such as "this is beautiful," "this is blue") that confuses us. Unknowingly, we misidentify one pattern as just like another and then make a consequential mistake, manifested by, say, hypostatizing and then hunting for the "quality of beauty" in an artwork. So the bona fide aesthetician, Wittgenstein concludes, must be a kind of linguistic therapist, one

whose task it is to exorcize philosophical spirits generated by language itself, or, more precisely, by ourselves, because (a) we humans are credulous beings, often seeking explanations that "have a peculiar charm," and (b) it is easy both to be taken in by certain unapparent linguistic structures and practices in our (one's) culture and then to proceed to believe and make all sorts of incorrect assertions about our own "discoveries."

Although I must acknowledge a huge debt to Wittgenstein's writings on aesthetics (and language generally) – as will become evident in the course of this book – I think that his general outlook is distorted by the twentieth-century methodological prejudices to which I have been referring. Wittgenstein does not want to deny that we have aesthetic experiences, but it would be wrong, he argues, to attempt to understand them phenomenologically, to grasp their essence and describe them as "internal events," on the basis of our own first-person point of view. What is of aesthetic importance is not what happens to us, he would insist, but what we say and do in the face of artworks. What we say and do is either in or out of accordance with aesthetic "rules," cultural practices that a person has learned and assimilated through custom and training and often without self-awareness. So, for example, if you look at a door of a cathedral, you might feel some discontentment and say to your friend, "It's too large." The meaning of your statement will only misleadingly be referred back to your feeling of unease. There is no deep, personal significance to your statement, as you might guess (unless you happen to have some bizarre and idiosyncratic association with doors in houses of worship). You have expressed (or have failed to express) an aesthetic judgment typical of the culture, a judgment linked to all sorts of aesthetic rules, which in turn are related to nonaesthetic rule valuations (e.g., in the case of the cathedral door, having to do with function and with many and multifarious historical traditions about relations among apertures in Western cathedrals, about monumental architecture generally, about clerical power, etc.). Your statement is a comment on yourself as well, about what interests you, but aesthetically speaking, it is fundamentally an indicator of how well you have learned your culture's tastes and prescriptions.

Notice how Wittgenstein has shifted our attention from ourselves as individuals to cultural norms. In doing this, he is perfectly in

accordance with – in fact he is importantly responsible for – the kind of methodological stance assumed by analytic aestheticians during the past sixty years or so.[14] They, too, have been inclined to shy away from aesthetic and psychological questions of meaning, significance, and valuation in one's own experience or "in" the works to which the experience refers. Analytic aestheticians such as Arthur Danto[15] and George Dickie[16] have (separately) instead devoted much thinking to answering the question, "What *is* an artwork?" Now although this may seem to be the question that must be answered first (i.e., before we can proceed to any other philosophizing in aesthetics) in the professional context in which it is put forth, the questioners, driven (perhaps unconsciously) by a methodological paradigm of modern natural science, tacitly divorce the factual aspect of the question from its meaning and from its valuational aspect; that is, they believe that they can define an artwork without considering whether it is good, bad, or, for that matter, absolutely horrible. Roughly, their answer to their own question is that an artwork is whatever is designated to be an artwork by publicly acknowledged art collectors, curators, art critics, and others – in short, "the artworld." Thus, if officials of a museum were to place a pile of manure on a platform in the center of one of its rooms and label it, say, "Postmodern Sanctum," it would ipso facto become an "artwork," according to both Dickie and Danto, although they would insist that nothing is valuationally implied by such a designation.[17] (Perhaps they might agree that were such a thing to happen, the artwork would be "bad," but to them it would be an *artwork* nevertheless.)

What is noteworthy to me about this kind of effort to provide us with the essential (or necessary and sufficient) conditions for labeling something as an "artwork" is how it must retreat from one's own personal sense of the nature of an artwork, even retreat from "ordinary common sense." Yet, even if we for a moment imagine our being satisfied that Dickie or Danto had achieved a rigorous definition of an artwork – that all questions that we might pose about the authentic membership of "the artworld" had been answered and that there could be no disagreements within that membership – what purpose would that achievement serve? What could one *do* with this kind of stipulative definition? Clearly, the analytic aestheticians' conceptual separation of objective fact from issues of value would not lead them

or us to solutions to the harder and more important questions. We would (or should) still ask what, generally speaking, might be the experiential value of artworks. What criteria should we use to assess them? Likewise, we ought to wonder whether an institutional definition of art would subtly militate against one's reflecting on what is indeed good or great art and what is bad or terrible art. Finally and relatedly, we should be concerned about which extremely talented people might be unjustly discouraged from regarding themselves as worthy professionals because of "the artworld's" own time-bound, market-driven prejudices – about what art is in the first place, and about what "good" art is – that ipso facto preclude such people from being anointed as "artists."[18]

Other analytic aestheticians have not been quite so reluctant to discuss the "subjective" dimension of aesthetic experience. Almost a half century ago there were thinkers such as Monroe Beardsley,[19] Jerome Stolnitz,[20] and Virgil Aldrich,[21] who argued that there really is such a thing as an "aesthetic attitude," and they, and others like them, expended huge intellectual efforts to try to demonstrate the correctness of speaking about this sort of human disposition. Thus, in a well-known book, Monroe Beardsley argued that an artwork has *one* function – to produce aesthetic experience, and that this kind of experience is different from other kinds of experience, including those kinds pertaining to the real, everyday world. Stolnitz attempted to define the aesthetic attitude as a "disinterested and sympathetic attention to and contemplation of any object of awareness whatever, for its own sake alone." But not long after this definition was put forth, Aldrich, made uneasy by the subjectivistic coloration of Stolnitz's and Beardsley's views, claimed that we must, in any bona fide account of the aesthetic attitude, redirect our attention to the objective properties of the artworks themselves. Aldrich contended that we have two ways of perceiving an object – with respect to either its observable qualities (e.g., the hardness of a particular desk surface) or its "animating" features (e.g., the bearlike face in the surface's wood grain). Thus, according to Aldrich, we see things either in one aspectual mode of perception (ordinary observation) or in an entirely different, *aesthetic* mode, what he also calls, borrowing a term from Whitehead, "prehension." Just why seeing something *as something different* (e.g., seeing a snowbank as a woman's breast) necessarily

makes the perception "aesthetic," Aldrich fails to make clear. The important point for my expository purposes is that he is determined to shift our philosophical attention from our own minds, demanding instead that we concentrate on the correlative of the aesthetic attitude, on that which is both public and objective.

Besides Stolnitz and Beardsley, and even at times Aldrich himself, there have been other analytic aestheticians who have acknowledged that a predominantly objectivistic approach to aesthetic matters does not capture their significance, that however mysterious the workings of human consciousness may be, no account of aesthetic experience can possibly be complete without some reference to them. Thus, over the past twenty-five years, Kendall Walton has developed an influential, extensive theory of the imagination, contending that our ability to be affected by artworks is much like, and builds upon, our childlike capacity to use props in games of make-believe. When we view a painting by Titian, for example, we use the figures the painter has depicted to define a world of fantasy in which we momentarily dwell.[22]

But despite Walton's probings into the domain of "inwardness" (Kierkegaard's term), even occasional references to an opponent's position as not being in accord with "the phenomenological facts," Walton, and analytic aestheticians generally, have not in my judgment properly explored the significance of such facts. And why is this so? Is it a failure of nerve? I do not think so. As I see it and as I have already suggested, the problem is their captivation by an essentially objectivistic methodological paradigm; thus, they are unable to see that such phenomena as "the aesthetic attitude," "aesthetic experience," "personal meaning [as a response to an artwork]," "the imagination," or "the world of make-believe" require not simply an acknowledgment of and some grudging postulations about "our mental lives," but instead a searching, systematic, nonobjectivistic reconceptualization of the significance of various intimations we receive about ourselves from ourselves. What I am suggesting, in other words, is that the scientifically minded analysts whose orientation I have been discussing fail to respond adequately to the most interesting issues in the field of what is called "aesthetics" because they are not able to do otherwise. This barrier exists, if I am right, because they have tacitly assumed certain essentially Cartesian

methodological principles that ineluctably lead them to dubious epis-
temological and ontological suppositions about what it means to be
a human being in the first place and what it means for such a being
to be "in a world."

My reference to Descartes's epistemological and ontological out-
look, sometimes referred to by philosophers and other theoreticans
as "the subject–object dichotomy," sometimes as the "representa-
tionalist" picture of knowing and being, has been so often repeated
during the last half century that it has become a kind of disciplinary
cliché. Few philosophers today wish to identify themselves with
"outdated," thoroughly "discredited" Cartesian suppositions. Yet,
despite their abjurations to the contrary, the analytic aestheticians
to whom I have referred, and countless others, remain importantly
Cartesian. My criticism is illustrated confrontationally and at length
in Chapters 1 and 2, and, albeit less directly for the most part,
throughout the remainder of this book.[23]

My basic criticism of analytic aestheticians' entire orientation to
their field is, I think, one that is also applicable to Wittgenstein's ap-
proach, even granting that he and they differ on many points and that
he has in my judgment advanced "the conversation" about aesthetics
greatly. Wittgenstein is right that sometimes we are tempted to make
too much of what our "private experiences" seem to be telling us
and too little of our publicly sanctioned practices – including pro-
tocols for discussing an artwork. In short, we are inclined to credit,
wrongly, what we "feel" as obvious, given, and indefeasible, and thus
we fail to acknowledge that our supposed "pristine experience" has
already been mediated by what custom and training have inculcated
into our consciousness. Nevertheless, Wittgenstein's is not the whole
story. There is "in us," I believe, something that is not, in essence,
reducible to and determined entirely by the explicit or tacit rules of
our culture; we should not understand ourselves and the world we
inhabit as wholly defined by historical "conventions" or see it and
ourselves solely as intelligible through "social constructs."[24] The
postmodernist denial that there is now – perhaps that there ever was –
such a thing as a true or authentic individual, thus the supposition
of the nonexistence or "death" of the subject, is wrong, I believe. Of
course my counterassertion is not an argument. (That comes, in sev-
eral places and several forms, throughout much of the course of this

book.) For now it is worth noting that even Wittgenstein concedes there are some aesthetic experiences that cannot be understood as classifiable under ordinary, current rules and practices of a culture:

> When we talk of a Symphony of Beethoven we don't talk of correctness. Entirely different things enter. One wouldn't talk of appreciating the *tremendous* things in Art. In certain styles in Architecture a door is correct, and the thing is you appreciate it. But in the case of a Gothic Cathedral what we do is not at all to find it correct – it plays an entirely different role with us. Here there is not question of *degree*. The entire *game* is different. It is as different as to judge a human being and on the one hand to say "He behaves well" and on the other hand "He made a great impression on me."[25]

Why can a Gothic cathedral – let us say the one at Chartres – make a "great impression" on us? Is this kind of experience also to be categorized theoretically as one wholly mediated by cultural conventions? Clearly, a deeply impressed person standing before the cathedral would have to know something about buildings, and perhaps even what it might possibly mean to believe in phenomena that transcend everyday experience. Yet, is this kind of experience best thought of solely as being in accord with the rules of a game, however complex, that we have learned to play? Might not the language game itself be something that we are able to learn only because there is some more basic feature of our humanity that makes this possible, a certain kind of care for ourselves that we are born with and that becomes structured with ever greater complexity as we mature?[26]

Besides the analytic legacy of Kant, there was another kind of philosophical response to his work in the field of aesthetics, a very different sort of methodological orientation. For while Kant's reflections on all sorts of issues embraced by the word "taste" led some of his followers and disciples to concentrate their intentions on the public expressions of taste, other thinkers were ready to explore and draw conclusions from their own personal intimations – that is, from the first-person point of view. These thinkers viewed themselves as engaged in "phenomenology," a term used by the founder of the movement, Edmund Husserl (1859–1938), to name their long-term philosophical project of mapping the fundamental features of consciousness itself from the point of view of its subject.[27]

Husserl believed that the biggest mistake that previous philosophers had made was in fact close, but not identical, to the one[28] that I have been lamenting as determinative of twentieth-century Anglo-American aesthetic theorizing: that they refused, or neglected, to observe and describe precisely their own experiences from the standpoint of oneself. The *authentic* first focus of philosophy, the data of one's own consciousness, was established by Descartes in the seventeenth century, Husserl asserted. Where Descartes went wrong, according to this position, was his claim that once the self (or ego) was demonstrated to exist (as it was in the famous "cogito" argument), its subjective contents could and should be quickly transcended so that the physical world external to one's consciousness, the domain of everyday things and people, could be reintroduced. The newly posited Cartesian world was not, it turned out, the place we actually inhabit, in the robust sense of this term, for it was now to be apprehended in a manner that disregarded its qualitative features (e.g., its colors, smells, tastes, etc.) and thus comprehended, if we were to be credited with "knowledge," only quantitatively, according to the methodological stipulations of mathematical physics. As both an homage and reaction to Descartes, Husserl sought to return philosophers to the "lifeworld" (*Lebenswelt*) that we sense and feel, to the real data of experience, "to the real things and issues" themselves (*zu den Sachen selbst*). To understand this world as the "object" of an individual consciousness, however, we must, somewhat unexpectedly, temporarily detach ourselves from it – regard it differently, critically – to avoid prematurely committing ourselves to it and thus simply repeating our deepest prejudices about it. We must, Husserl insisted, therefore and for methodological purposes, examine the data of experience apart from any initial commitment to them as externally existent. What this means is that I should at first describe my sensory data and affective perceptions as though they might have no reality distinct from my particular consciousness, as though they were simply *my* virtual reality and not of the independent physical world and of which I ordinarily take them to be a part. For example, I would describe the chair that I am currently sitting on and the table that I am sitting at as sheer phenomena or mere appearances that I cognize and not as physical things that necessarily exist when I am not perceiving them. Husserl thus called for a provisional

resistance to our "natural attitude," our commonsense involvement in the lifeworld, including its independence from our consciousness of it. He named this first methodological stage of investigation, the "phenomenological reduction" or *epoché* (which in Greek means "holding back"). He believed that if in this kind of stance of faith-bracketing neutrality we carefully attended to the multitudinous and multifarious givens of our experience, and tacitly contested its title to *objective* existentiality (but not its "feel" of existentiality), we could describe it without prejudice. We would therefore be able to ascertain, with perfect clarity, its fundamental structures or principles, those ordinarily hidden features of our conscious acts themselves that enable us to experience beings (e.g., trees, individual people, etc.) in the first place and as part of a continuous flow of meaningful past and anticipated events. Husserl wondered, for example, what cognitive principles are involved in the constructive or "constituting" experience by an individual of a physical object in space and time or what, for that matter, is essentially involved in his own (and presumably every person's) structuring experience of time itself. To describe something unprejudicially, that is, without any presuppositions whatsoever, and to discern, through what he called the "eidetic intuition," fundamental forms or patterns or essences in one's phenomenal reality, was, according to Husserl, not engaging in reverie or mere unscientific introspection, but instead undertaking a new kind of epistemological investigation that was to be *science*, even a completely rigorous or apodictic science (*strenge Wissenschaft*). Indeed, because everything we apprehend in and about the world, including ourselves, is based on and filtered through the structures of human consciousness, phenomenology was to be the absolute foundation or ground of all other knowledge whatsoever, the veritable "first philosophy" that Aristotle thought he had arrived at more than 2,300 years earlier. Unlike Kant, however, who believed that the laws governing human-constituting consciousness can only be inferred on the basis of axioms about our capacity to know anything whatever about our world, Husserl asserted that we can directly, self-reflexively, investigate and describe the data pertaining to the lens of consciousness itself. In fact, we are *obligated* to investigate and describe it, if we are to correct all sorts of biased historicocultural claims and theories that have militated against human cognitive progress generally. We

must, in short, assist "the sciences" by clarifying their epistemological bases, thereby enabling them to proceed nonrefractively, that is, transparently.

Describing the fundamental features of the experience of artworks (including paintings) was not one of Husserl's primary phenomenological interests, but he did devote some philosophical effort to this matter. His phenomenological descriptions and conclusions can be found primarily in volume XXIII of his collected works. Although Husserl ultimately failed, in my judgment, to answer the questions that I posed at the beginning of this Introduction about the kind of reality or being that fictional entities actually assume for us in our "natural attitude," his accounts of his own paradoxical experiences of paintings are suggestive and, indirectly and unintentionally, indicate the kind of epistemological position that I defend. Moreover, his reflections in another of his works, on the nature of memory, seem in fact to point him even more obviously in the right direction. Yet, even there Husserl hesitates, afraid perhaps to journey to a confusing, disturbing domain, in which he might discover something that could undermine one or more of the suppositions of his entire methodological stance. Let us briefly, but with more specificity and fewer generalizations than I have put forth up until this point, retrace his philosophical excursion into the world of paintings and of memories, for by so doing the reader will be better prepared for the position that I occupy at the end of the first chapter and throughout the remainder of the book.

In volume XXIII, Husserl asserts that in experiencing a painting generally, one should distinguish between the "physical image" [das physische Bild], the "image-object" [das Bildobjekt] (e.g., the image-of-Napoleon) and, finally, the intended target of contemplation, the "image-subject" [das Bildsubjekt] (e.g., the image-of-Napoleon-himself).[29] The physical image is the material painting itself, what one can see as a flat piece of canvas with colored shapes, having a frame, hanging on the wall of a particular room, during a certain period of time, and so forth. The "image-object," "excited" by the physical image as "substrate," however, is not a mere physical object, such as a canvas with paint on it. It is a picture or, more precisely, a representation or a depiction, and the depiction itself may in turn provoke us to conjure up the real thing or person or event itself.

As Husserl says, collapsing for a moment the distinction between image-object and image-subject: "This Grecian landscape in which I immerse myself visually surely stands before me differently from the books on my desk, which in genuine perceiving I have before my eyes as actualities."[30]

Thus, there is something besides the physical-image that I relate to, but what "more" exactly is the image-object, according to Husserl? What, too, can we say more extensively about the image-subject? That is, what do we take both object and subject to be in our world, what are their respective ontological statuses? Consider for a moment just the image-object: is it a *something* or is it a *nothing*? Here Husserl hedges, for on the one hand he asserts that "The image-object truly does not exist, which means not only that it has no existence outside my consciousness but also that it has no existence [even] inside my consciousness; it has no existence at all."[31] On the other hand, undoubtedly rethinking his claim that the image-object doesn't even have a reality in his own mind (for otherwise we may ask what is Husserl talking *about*, what is he making reference to?), he qualifies, if not contradicts, his initial statement, by asserting that (a) "what appears, for example, [to be] the image person in the oil painting, is not taken as actually present; it appears *as present* [even with the force and intensity of an immediate perception of a physical object] but is not looked upon *as actual*"[32] and (b) the "image is taken by me neither as existing nor as non-existing."[33]

Then it may be asked, what do the words being "present" but "not actual," or "neither existing nor . . . non-existing" mean? The image person in the oil painting should be viewed, Husserl claims, as part of an "ideal world . . . a world by itself,"[34] an apparent or illusory world (*Scheinwelt*) utterly different from the actual world that is its setting. Indeed, when we are engaged by a painting, the physical image and the image-object vie with each other for our attention. Ordinarily, the latter gains ascendancy over the former in our consciousness, although it does not force us to forget the physical image and the world of which it is a part.

This still leaves unanswered the question of *what is* the image-object apprehended by us. How can that which is "only present but not actual" gain ascendancy, even "triumph" – Husserl's word – over, our sense of the physical reality of a painting before which we stand?

Husserl responds that the image-object is a "perceived appearance" [*ein perzeptiver Schein*], not something (like the physical-image) that is "truly perceived" or "taken as true" [*wahrgenommen*].[35] Yet, if it is falsely perceived, are we then deluded by the image-object, as we might be when taken in momentarily by a superbly crafted wax figure of a human being? No, he contends, for when we view a painting (or an ordinary sculpture) we are aware of the conflict between the image-object and the physical object and the conflict militates against our being duped. Nevertheless, I must point out, to say that we are aware of the conflict does not shed light on the meaning of the "ideal" status for us of the image-object. Moreover, when Husserl asserts that the image-object itself also and simultaneously can lead us to apprehend an image-subject, the nature of that subject, its own, mysterious "ideal" status also cries out for explanation. To cite Husserl's own example, when we are able to see in a reproduction of a painting by Raphael the small monochrome figure of the Madonna as an imposing and sublime woman, she seems to take on a life of her own. Indeed, this kind of reality is what I suggested to be true of Vermeer's depiction, but, again, in what realm does the Madonna dwell for us?

In short, what in fact is clarified by Husserl's use of the word "ideal"? Don't we take the image-object and especially the image-subject to be something other, and perhaps "more," than "ideal"? Doesn't Husserl unwittingly imply by his use of the word "triumph" that the depicted object or scene itself becomes for us in some sense "more real," if only momentarily, than the physical painting situated before us? In volume XXIII, these questions are not answered, but as John Brough argues, around 1905 Husserl began to formulate a new position, in *On the Phenomenology of the Consciousness of Internal Time* (*Zur Phänomenologie des inneren Zeitbewusstseins*),[36] on the ontological status of our memories, expectations, and fantasies, a work that has philosophical implications for understanding Husserl's concept of the "ideal world" that we enter into when viewing a painting. In this later work, he asserts that in remembering, expecting, or even fantasizing, we do not simply apprehend an image, but instead intend the past thing or object itself, or the anticipated object itself, even the fantasized object itself. According to this Husserlian view, I do not, for example, recall an image of my boyhood friend, I recall

him; I don't dwell with the image of the young woman with the earring, I dwell with *her*.

This intriguing, and I believe fundamentally correct, position immediately raises new questions, it must be conceded. For does one in fantasy, or in viewing a painting, just then believe in the physical reality of the posited or depicted object and the world in which it is placed? If so, it would seem that such a person would be mad. If not, then all of the challenges that I have been posing to Husserl reassert themselves, for what precise "reality" does the person believe in if not the physical reality? Husserl was, I believe,[37] right in his phenomenological description when he asserted that memories or anticipations or fantasies take us to the beings themselves, but he lacked the courage of his intuitions and could therefore only remain in a kind of conceptual limbo of ambiguity.

Husserl never again took up this issue concerning the nature of our relatedness to the realm of the fictional. Moreover, his claims about the scientific rigor of his phenomenological method and his belief that it would eventually reveal to us the unshakeable epistemological foundation of all human knowledge seem not only inflated, but even quaint today, given the powerful challenges to the very project of epistemological foundationalism that have been put forth by countless philosophers (of very different methodological persuasions) over the past sixty years. What I and followers of Husserl take to be extremely useful, however, is his claim that certain kinds of first-person experience can and should be described and systematically incorporated into any adequate and complete account of what it means to be a human being and what it means to have a world. What I also take to be useful are his attempts, although imprecise and undeveloped, to provisionally locate our experiences of paintings in some sort of special domain and then at a later time to discover some way to reintegrate them with our "real world."

Here a caveat is in order: one should not infer from Husserl's and my endorsement of the importance of first-person reports that third-person descriptions can be completely ignored when one engages in phenomenology. On the contrary, I take it to be evident, as Wittgenstein has persuasively argued, that what we can say from the first-person point of view – such as, "the color of this chair annoys me and makes me want to give it away" – is contingent upon and

could never have been uttered, or even in the first place *thought*, apart from my having learned a third-person discourse about colors, chairs, what it means to be annoyed, and so forth – in short, apart from a whole host of language games that reveal the world as "the others," as all of "them" in a particular culture, normally respond to it. Yet, to concede the structural and historical dependency of first-person discourse on third-person discourse is not to say that only the latter domain is revelatory of essential traits of our humanity. For if "A" is dependent for its very being on "B," it does not follow that "A" has no significant being in its own right or contains nothing worth knowing about it. (Descartes believed that each moment of our lives is contingent upon God's reestablishing our existence, but this did not deter him from correctly insisting that so long as we exist, we are something in our own right.) In sum, I believe Husserl's subjectivistic turn to have been of great philosophical significance, albeit with the qualifications just mentioned as well as with the qualification cited earlier that Husserl did not rethink with sufficient radicality the whole issue of what underlies and allows for the possibility of there being "subjective" or "objective" experiences at all.

The philosopher who I believe offers the most promising stance for dealing with the questions that I have been posing throughout this Introduction is Husserl's most distinguished pupil, Martin Heidegger (1889–1976). His greatest work, by the virtually unanimous consent of those who take his oeuvre seriously in the first place, is *Being and Time* (*Sein und Zeit*), published in 1927.[38] In this treatise, it is his methodological and ontological contributions that I find most helpful for answering questions about the meaning of experiencing the depictions of a painting. Heidegger, while following his teacher in contending that only by taking seriously the deliverances of first-person intuition can we construct an accurate picture of our humanity, makes several important phenomenological advances, among which is his implied rejection of the detached, "inner" versus "outer," consciousness-versus-the-world methodological position assumed by Husserl. Heidegger suggests, despite his teacher's appreciation of the significance of first-person experiences, that Husserl is nevertheless insufficiently rigorous when it comes to understanding the subject of consciousness, is too much of a traditional Cartesian who believes that the subject (the ego) can

apprehend the world unsullied by its own deepest interests and concerns. Thus, Husserl, and like-minded philosophers, are disposed

> to encounter entities [or beings] within-the-world purely in the *way they look* (*eidos*). . . . In this kind of "dwelling" as a holding-oneself-back from any manipulation or utilization, the perception of what is "merely there" [*des Vorhandenen*] is consummated. . . . What is thus perceived and made determinate can be expressed in propositions and can thus be retained and preserved as what has thus been asserted. [But this] . . . perceptive retention of an assertion about something is itself [only] *a way* [and not the most basic way] of [one's own] being-in-the-world.[39]

Indeed, Heidegger contends (again tacitly referring to Husserl and many other philosophers) that

> in any of the numerous varieties which this [detached, objectifying] approach may take, the question of *the kind of being which belongs to this knowing subject* is left entirely unasked, though whenever its [kind of] knowing gets handled, its way of being is already included tacitly as its theme. Of course we are sometimes assured that we are certainly not to think of the subject's "inside" [*Innen*] and its "inner sphere" as a sort of "box" or "cabinet." But when one asks for the positive signification of this "inside" of immanence in which knowing is proximally enclosed, or when one inquires how this "inside-being" [*Innenseins*] which knowing possesses has its own character of being grounded in the kind of being which belongs to the subject, then silence reigns. And no matter how this inner sphere may get interpreted, if one does no more than ask how knowing makes its way "out of" it and achieves "transcendence," it becomes evident that the knowing [act] which presents such enigmas will remain problematical unless one has previously clarified how it and what it is.[40]

One of the many consequences of Heidegger's claim that "self" and "world" are a unitary phenomenon is that whatever or whomever we as individual humans are involved with – be it the preparing of breakfast, the repairing of a flat tire, the misperceiving of a stranger as a friend, or the thinking through of a mathematical proof – we do not do it in "our heads" (inside the "skull container"), but in "our world." We may infer from this Heideggerian claim that when we are captivated by a painting – let us say Manet's depiction (in the National Gallery of Art in Washington) of "The Old Musician" (who

is surrounded by five other figures) – the old man and the others are not taken merely to be subjects "in our minds," but (as I asserted in the case of our experiencing Vermeer's representation) beings who are "out there," thus not simply in an "ideal world" that is somehow related to our world, as Husserl speculated, but, strange as it may seem, "in *our* world." As mentioned, Husserl seemed to be leaning toward Heidegger's position in his work on the consciousness of inner time, but he did not therein, or in any other work, take the decisive step of regarding our humanity as having *being-in-the-world* as one of its fundamental traits. But Heidegger, having taken that step, provides us with the epistemological and ontological resources for answering fundamental questions about what a painting is for us and therefore how it means to us.[41]

It is ironic that this book on fictionality, art, and painting has been most deeply influenced by *Being and Time*, since the word "art" (in German, *Kunst*) is never once used in it, not to even mention the word "painting" (*Gemälde*). It is perhaps doubly ironic that I do not build on Heidegger's principal treatise on artworks, *The Origin of the Work of Art* (1936) or other later works by Heidegger that deal with works of art, especially his reflections on the poetry of Friedrich Hölderlin. My decision to view the being of things through the younger Heidegger's eyes and to reject his later vision is not due to an arbitrary *esprit de contradiction* on my part. For I believe that despite some inadequacies, *Being and Time* is the most important treatise in ontology of the twentieth century and, therefore, that it has significant implications for all domains of philosophy. I also have come to conclude that *The Origin of the Work of Art*, although evocative and provocative, is in the end insufficiently precise and developed to answer the kinds of questions that this book addresses. Let me briefly try to justify my having arrived at this conclusion.[42]

Heidegger's essay on the work of art is, as I interpret it, an attempt to help us come to the conclusion that great art, such as a painting by Van Gogh of a peasant woman's shoes, reveals something about the very nature, the being, of the shoes, the woman, and the world in which she dwells. He writes the following:

From the dark opening of the worn insides of the shoes the toilsome tread of the worker stares forth. In the stiffly rugged heaviness of the

shoes there is the accumulated tenacity of her slow trudge through the far-spreading and ever-uniform furrows of the field swept by a raw wind. On the leather lie the dampness and richness of the soil. Under the soles slides the loneliness of the field-path as evening falls. In the shoes vibrates the silent call of the earth, its quiet gift of the ripening grain and its unexplained self-refusal in the fallow desolation of the wintry field. This thing of use [*Zeug*, my translation] is pervaded by uncomplaining anxiety as to the certainty of bread, the wordless joy of having once more withstood want, the trembling before the impending childbed and shivering at the surrounding menace of death. This thing of use belongs to the *earth*, and it is protected in the *world* of the peasant woman. From out of this protected belonging the thing of use itself rises to its resting-within-itself.[43]

Note how Heidegger emphasizes the words "earth" and "world." These terms become crucial for the development of his theory about the role that art can play in our lives. For in his essay, "earth" comes to signify more than "the soil of the field" or "the planet Earth," but instead that mysterious aspect of our existence, what is unknown and perhaps unknowable, what Heidegger refers to as "the self-withholding" or the "self-concealing." "World" comes to signify more than the domain of the everyday life of care of the peasant woman. It means, among other things, the global outlook, the historical and ontological disposition, the fundamental ethicoreligious and philosophical orientation, of a people [*Volk*]. Thus "world" is a cultural and temporal term, for when a people develops a whole new way of regarding its environment, it lives in, quite literally, a new and different "world." For example, when medieval Europeans became modern Europeans, having learned to respond to beings as "objects that could be controlled and seen through by calculation . . . a new and essential world arose."[44]

The work of art, according to Heidegger, "sets up" a world and "sets forth" the earth. Moreover, "[truth is an event that] establishes itself in the work. Truth is present only as the conflict between lighting and concealing in the opposition of world and earth."[45] World and earth are thus not so much things as opposing principles of things. The strife [*Streit*] to be found in the work of art may be thought of as defining two ways according to which we understand the nature of reality or being itself. But the "conflict is not a rift (*Riss*)

as a mere cleft is ripped open; rather, it is the intimacy with which opponents belong to each other."[46] "The setting-into-[the art]work of truth thrusts up the unfamiliar and extraordinary and at the same time thrusts down the ordinary and what we believe to be such. The truth that discloses itself in the work can never be proved or derived from what went before. What went before is refuted in its exclusive reality by the work."[47] Heidegger also adds the following in his epilogue to the essay: "The truth of which we have spoken does not coincide with that which is generally recognized under the name and assigned to cognition and science as a quality [of propositions or statements] in order to distinguish from it the beautiful and the good, which function as names for the values of nontheoretical activities [such as the viewing of a painting]." For Heidegger, truth is therefore not the representation of "bare fact," and "value" is not some predicate that we use to characterize our positive or negative feelings about our experience: "When truth sets itself into the work, it appears." This appearance "is beauty. Thus, the beautiful belongs to the advent of truth, truth's taking of its place."[48] Also, truth pertains to a way of approaching beings generally. Truth, in Heidegger's sense, is that which is prior to and makes possible any particular "true ideas" that we may have: "With all our correct representations we would get nowhere, we could not even presuppose that there already is manifest something to which we can conform ourselves, unless the unconcealedness [truth] of beings had already exposed to us, placed us in that lighted realm in which every being stands for us and from which it withdraws."[49]

We should be careful not to misinterpret Heidegger's terms "earth" and "world." It is not that "the earth" and its representation in a work of art offers us pure, unmediated intimations of the reality of the natural environment. Likewise, it is not just that "the world" and its re-presentation in a work of art offers us a cultural and historical perspective that provides us with an entrée into and a clarification of the stories that the mysterious "earth" is communicating to us. For the world, Heidegger informs us, "is not simply the Open that corresponds to clearing [*Lichtung*, which also means a lighting or revealing], and the earth is not simply the Closed that corresponds to concealment."[50] The strife is, therefore, not to be understood simply as a struggle between "revealing world" and "withholding earth,"

for world has its concealing qualities and earth has its revealing qualities. Indeed, each revealing (of either world or earth) involves at the same time a concealing. To be exposed to something for our understanding and appreciation is simultaneously to be closed off from some of its other features. This latter excluding and precluding of our understanding can occur either because the other features "refuse" to reveal themselves or because they "dissemble," thus look like, but in fact, are not what we think we already know. In a word, all disclosure as truth is at the same time a closing off, thus *untruth* (which is not to be identified with falsehood; nor "does it mean that truth is never itself but, viewed dialectically, is always also its opposite"[51]). In sum, the double aspect (revealing and concealing) of both earth and world entails that the battle between them is not one of truth versus "falsehood," but instead the alternative claims that are made upon us by both earth and world, their individual, competing demands of contemporaneous truth and untruth.

Concerning the painting of the peasant woman's shoes, Heidegger concludes as follows: "Truth happens in Van Gogh's painting. This does not mean that something is correctly portrayed, but rather that in the revelation of the . . . being-of-use of the shoes, that which is as a whole – world and earth in their counterplay – attains to unconcealedness."[52]

Now there is much that is suggestive in Heidegger's essay, and I could attempt to interpret its core distinctions at length, relating his concepts of truth and untruth to earlier remarks in *Being and Time* and his concepts of earth and world to later distinctions that he puts forth (e.g., the theory of "the four-fold" principle – earth, sky, gods, and mortals), and deal as well as with his reflections on works by Hölderlin, Nietzsche, Georg Trakl, Rainer Maria Rilke, and others. In the end, however, I find *The Origin of the Work of Art* more inspiring than philosophically penetrating or fructifying.[53] I do agree with Heidegger that works of art can in some way contain a kind of truth that is not reducible to everyday, factual claims about the world, and I argue for my version of this position in Chapter 4. Nonetheless, I am not able to see sufficient clarity in the terms "earth," "world," "truth," "untruth," "beauty," and so forth, and thus I cannot ascertain the precise nature of the "strife" between earth and world or the

final synthetic revelation that is reached by means of such opposition, the event of unconcealedness. Of course I can make educated guesses about what Heidegger means, as numerous commentators (both sympathetic or critical) on his later work have done, but I do not think that my defense would be any better than what anyone else has posited, or, I suspect, any worse. I see Heidegger struggling to go beyond some of the anthropocentric tendencies that may be found in *Being and Time*. In this his effort is commendable. As one can readily bear witness, he writes in this later period of his life in a somewhat different style, which is at once less tied to traditional philosophical categories and forms of argumentation and more akin to the poetic essays of Rilke. Yet, to put it bluntly, in my judgment Heidegger has not articulated a full or convincing theory of art, nor will his distinctions provide us with the ontological basis to offer decisive guidance for the understanding of artworks, including paintings (despite what he has presented to us about Van Gogh's depiction).

One final thought: as is perhaps evident from the summary of the book at the beginning of this Introduction, each chapter of this work puts forth fundamental claims about our being-in-the-world that are controversial and that would strike most educated readers at first blush as implausible – perhaps wildly so. My hope, nevertheless, is that they will see the whole as greater than the sum of the parts, that a picture will eventually manifest itself that, as a totality, will be convincing.

NOTES

1. I respond to this question once again in Chapter 4, endnote 1. I also wish to assert that we ordinarily come to a painting searching for "meaning," if not a particular meaning, and that much of this book is an attempted demonstration that we do this, why we do this, and how we do this.

2. See especially in Chapter 1, Part III.

3. See for example and especially Hume's famous essay, "Of the Standard of Taste," *Essays, Moral, Political, and Literary*, Part I (Indianapolis, Ind.: Liberty Classics, 1987). Hume's essay was originally published in 1742.

4. *Critique of Judgment*, trans. Werner S. Pluhar (Indianapolis, Ind.: Hackett, 1987), p. 29, my emphasis.

5. Ibid., p. 145, my emphasis.

6. Ibid., p. 45.

7. Ibid., p. 46.

8. Kant's views on the nature of the aesthetic experience are complex and notoriously difficult to understand. One fundamental strain of his thinking regards the peculiar pleasure of aesthetic experience as arising from the stimulation of our conceptual faculty (or power) by certain data from the imagination. These data consist of a formal feature that outstrips our ability to comprehend it but which nevertheless suggests, without truly indicating, something purposive. Here it must be pointed out that the feeling of purposiveness has its origin solely in the inter- and free play of our imaginative and conceptual faculties. (See, e.g., ibid., pp. 182–3.) As already mentioned, we are to think of this kind of experience as utterly "disinterested." Toward the end of the *Critique of Judgment*, however, Kant asserts that the real power of an aesthetic experience arises from the fact that imagination's products *symbolize moral goodness*. Thus, there is another important (and contradictory) strain of Kant's thought in which it is insisted that when aesthetically oriented, we are very much involved emotionally in our experience – "the moral good . . . carries with it the highest interest" (ibid., p. 51) – and by implication, care deeply about whether the apprehended objects, be they in nature or the creations of an artist, are about something real: "Now I maintain that the beautiful is the symbol of the morally good; and only because we refer [*Rücksicht*] the beautiful to the morally good (we all do so [*Beziehung*] naturally and require all others also to do so, as a duty) does our liking for it include a claim to everyone else's assent, while the mind is also conscious of being ennobled, by this [reference], above a mere receptivity for pleasure derived from sense impressions, and it assesses the value of other people too on the basis of [their having] a similar maxim in their power of judgment" (ibid., p. 228). A few pages later, Kant continues: "taste is basically an ability to judge the [way in which] moral ideas are made sensible ([it judges this] by means of a certain analogy in our reflection about [these ideas and their renderings in sensibility])" (ibid., p. 232). The first, formalistic, mental faculty–centered current of Kant's thinking cited earlier greatly affected English and American aestheticians in the twentieth century. The second, content-oriented, ethico-religious current of his thought had its greatest influence on such nineteenth-century European continental thinkers as Friedrich von Schiller. In my judgment, Schiller better appreciated what was deepest and most significant in Kant's aesthetic views than those English and American aestheticians of the twentieth century, who were steeped in the first current of his thought. My sympathies with, and differences from, Kant are made clearer in the subsequent chapters of this book.

9. See, for example, "On Scientific Method in Philosophy," in *Mysticism and Logic and Other Essays*, 2nd ed. (New York: Barnes and Noble, 1971).

10. See Chapter 2, Part III, for clarification of this point.

11. To see things from a third-person point of view is not thereby and automatically to see them as a scientist would, but such a viewpoint is a necessary condition for scientific investigation.

12. Among other tasks, for aesthetics was only one of Wittgenstein's many philosophical interests.

13. *Lectures and Conversations on Aesthetics, Psychology and Religious Belief* (Berkeley and Los Angeles: University of California Press, n.d.; as noted in the text, the lectures on aesthetics were given in 1938).

14. By my generalization I do not mean to imply that there are not, at another level, significant differences among analytic aestheticians, as is made clear later when I refer to the thought of Monroe Beardsley and to that of Kendall Walton. See pp. 15–17.

15. See, for example, "The Artworld," *The Journal of Philosophy* 61 (1964).

16. *Art and the Aesthetic: An Institutional Analysis* (Ithaca, N.Y.: Cornell University Press, 1974), especially pp. 19–52.

17. Cf. Chris Ofili's controversial 1996 painting, "The Holy Virgin Mary," one of several works in the 1999–2000 exhibition – titled "Sensation" – in the Brooklyn Museum of Art. Part of the painting, in fact, contained pieces of elephant dung.

18. In this book I do not attempt to provide the necessary and sufficient conditions for identifying something as an artwork. Still, it will gradually become clear that were I to undertake such a task, the personally transformative value of an artwork would have to play a role in its definition.

19. *Aesthetics: Problems in the Philosophy of Criticism*, 2nd ed. (Indianapolis, Ind.: Hackett, 1981).

20. *Aesthetics and the Philosophy of Art Criticism* (Boston: Houghton Mifflin, 1960), especially pp. 29–42.

21. See *Philosophy of Art* (Englewood Cliffs, N.J.: Prentice-Hall, 1963), especially Chapters 1 and 2. I am speculating that Aldrich would want to go on to assert that in a prehensive mode for the attitude to be truly "aesthetic," one must perceive elements of "form" and "sensory resonance," that the object must also be "unified," "balanced," "delicate," and so forth – all terms that Aldrich uses in his book, but not to qualify his initial definition of the "aesthetic attitude." I should note that I do in fact accept Aldrich's view that perception can be aspectual, but I was disappointed not to learn from him what he believes the value of such perception to be – why, for example, seeing a cloud as "treelike" is a token of a type that helps us to comprehend the significance and power of artworks generally.

22. I deal at length with Walton's theory in Chapter 1, especially as it has been articulated in his book *Mimesis a Make-Believe: On the Foundations of the Representational Arts* (Cambridge, Mass.: Harvard University Press, 1990).

23. I am leaving out of this Introduction a discussion of theories of art in the pragmatist tradition, despite their superficial similarity of the position that I will be defining and defending in this book. I find much that I agree with in John Dewey's famous work, *Art as Experience*, volume 10 of the *Late Works of John Dewey* (Carbondale: Southern Illinois University Press, 1987). Also, I have

learned much, especially about the history of analytic aesthetics, from Richard Shusterman's book, *Pragmatist Aesthetics: Living Beauty, Rethinking Art* (Oxford, United Kingdom, and Cambridge, Mass.: Blackwell Publishers, 1992), a work that attempts to resurrect and to adapt to our own time many of Dewey's insights. And I can almost agree with Richard Rorty's claim that "all anybody ever does with anything is use it." Thus, he states, "interpreting something, knowing it, penetrating to its essence and so on are all just various ways of describing some process of putting it to work." ("The Pragmatist's Progress," *Interpretation and Overinterpretation* (Cambridge: Cambridge University Press, 1992, p. 92). In the case of Dewey I believe that he is too much of a "scientist" in his fundamental philosophical outlook, a kind of biological philosopher who values artworks principally for their "life-enhancing" pleasures. Hence, I believe Dewey to be insufficiently appreciative of our human need to come to terms with the very meaning and mystery of our existence and of how artworks can, and often do, both intensify an understanding of that need and respond to it. My point is applicable, mutatis mutandis, to Shusterman and Rorty as well. For example, Rorty argues in the essay previously cited that we should distinguish between "methodical" and "inspired" readings of texts, between "knowing what you want to get out of a person or thing or text in advance and hoping that the person or thing or text will help you want something different – that he or she or it will help you change your purposes, and thus change your life." (Ibid., p. 106). An inspired reading is thus one that "destabilizes" the reader, effecting "an encounter which has rearranged her priorities and purposes." (Ibid., p. 107). Rorty's stance, consistent with the instrumentalist core of pragmatism generally, is right insofar as it suggests that we can indeed be changed by a text, but wrong, I feel, insofar as it fails to see the dangers in getting something "out of" a text (or person) and in "rearranging" one's priorities and purposes. What Rorty is implying is that life requires techniques for the *management* of problems, some of which include our transitory destabilization, and not something that asks (demands?) of us a different kind of orientation altogether. Nicholas Plants, a critic of Rorty's position, correctly notes that "once we are committed to the attitude that we need to deal with life in order to survive, we turn everything in the world into a means we can use to achieve this goal. Everything is viewed in terms of . . . whether or not it can help us [to] avoid trauma. . . . But the attempt to avoid everything and anything having the power to make us powerless is a Herculean task which only ends when we achieve pure invulnerability . . . [If we were to follow Rorty,] we [would] paradoxically use life itself to avoid its traumas." ("Therapeutic Interpretation: Rorty's Pragmatic Hopes and Fears," *Annual American Catholic Philosophical Association Proceedings*, LXXII, [1999].)

24. See also Chapter 2, pp. 114–5.

25. *Lectures and Conversations on Aesthetics, Psychology and Religious Belief*, p. 8. I have included Rush Rhees's interpolation, the sentence that makes reference to "degree."

[34]

26. I also believe that Wittgenstein's sustained attack on, and his resultant skepticism about, our ordinary belief in the reportability and describability of psychologically private events (e.g., pains or feelings of dread), although astute and penetrating, does not compel us to adopt his linguistic behaviorism vis-à-vis such events. On the contrary, I think that the proper conclusion of his famous discussion of psychological privacy in the *Philosophical Investigations* (trans. G. E. M. Anscombe, Oxford, England: Blackwell Publishers, 1958) is that in spite of the fact that we have no shareable, public criteria enabling us to identify our private experiences and thus no "hard" evidence of the aptness of our reports on and descriptions of them, as well as, and a fortiori, of the aptness of statements of others about their own private experiences, we nevertheless must in daily life assume that ordinarily we do report and describe such things correctly and, therefore, communicate something to others that they will unavoidably believe are close counterparts to their own past experiences. It thus appears to be *psychologically necessary*, in our quotidian activities, to reject the skeptical implications of Wittgenstein's claims about psychological privacy, although from a narrow, purely epistemological standpoint, they are correct. (Try telling yourself when you have a terrific toothache that you have no criteria for determining whether the tooth pain is what others call tooth pain for themselves or that others observing your behavior, and taking it to be nonfeigning, might truthfully believe or say that your experience could well be "just anything" or even "nothing at all." Or, reversing the situation, try telling yourself the next time you may see someone writhing in pain that in fact you know nothing about what he or she is truly feeling, that your sympathy correctly pertains only to the individual's pain behavior. To be sure, you don't experience that person's feeling of pain, but can you avoid thinking that you have an extremely good sense of what the other person is personally suffering?) Moreover, although Wittgenstein's criteriological arguments are philosophically challenging and logically cast doubt upon the cognitive value of our first-person avowals, should we therefore renounce such affirmations as ipso facto having null reportorial and descriptive value? Isn't our ability to learn how to use first-person language successfully (e.g., pain talk) most plausibly accounted for by assuming that in the first place we all have certain similar experiences (such as pains) as well as the capacity to recognize them for what they are? Also, and from another point of view, doesn't a crucial dimension of our ethical lives depend on our imaginative capacity to perceive and feel the world as others apparently perceive and feel it – the more so, generally speaking, the better? While our imaginative constructions may in theory be always and altogether wrong with respect to what the other is truly experiencing, shouldn't we avoid blanket skepticism about the veridicality of these constructions – which, admittedly, are a matter of faith, but at least not contrary to evidence – if our theoretical grasp of the world is not to be schizophrenically divorced from our practical understanding of it? Finally, I wish to note that the very line of argumentation that Wittgenstein so sedulously adopts (and relentlessly pursues with more

determination than any other analytic aesthetician) presupposes the sacrosanctity and fundamentality of the centerpiece of our modern scientific outlook – the principle that we can attribute epistemic significance only to statements that are verifiable according to precise, conventionally (and thus publicly) agreed upon, sensory criteria. So here, too, (that is, in Wittgenstein's very presupposition, if I am right) we see another manifestation of the kind of bias in analytic thinking that I have been attempting to delineate and that has made it in principle extraordinarily difficult, if not impossible, for Anglo-American philosophers generally to appreciate fully the most interesting and significant features in aesthetic experience.

27. The most comprehensive work outlining Husserl's phenomenological program is his *Ideas Pertaining to a Pure Phenomenology and to a Phenomenological Philosophy*. Revised edition in two parts: Part 1 translated by F. Kersten, The Hague: M. Nijhoff, 1980; Part 2 translated by Richard Rojcewicz and Andre Schuwer, Dordrecht: Kluwer, 1989. Most of my very general remarks about Husserl's philosophical outlook are based on my reading of his *Ideas*.

28. I write "close to" and not "identically" or "precisely" because, as is made clearer later in this Introduction, as well as in Chapter 2, Husserl, too, did not adequately explore and comprehend the entire problematic of subjectivity versus objectivity, did not engage in what I referred to earlier as a nonobjectivistic reconceptualization of the significance of various intimations of our own inwardness.

29. Edmund Husserl, *Phantasie, Bildbewusstsein, Errinerung [Fantasy, Depictive Consciousness, Memory] (1895–1925)*, *Husserliana* XXIII, ed. Edward Marbach (The Hague: Martinus Nijhoff, 1980). I am grateful to John Brough of Georgetown University for sharing his articles with me on this little-known (in the English-speaking world) work by Husserl, who therein also deals with related, nonaesthetic issues.

30. Husserl, volume XXIII, p. 412, and quoted in John Brough, "Depiction and Art," *American Catholic Philosophical Quarterly*, LXVI, 2 (1992): p. 243.

31. Husserl, volume XXIII, p. 22, and cited by Brough, in *ACPQ*, ibid., p. 244.

32. Husserl, volume XXIII, p. 40, and cited by Brough in "Cuts and Bonds: Husserl's Systematic Investigation of Representation," *Philosophy Today*, suppl. vol. 43 (1999): p. 118, my emphases.

33. Husserl, volume XXIII, p. 385, and cited by Brough in *ACPQ*, p. 244.

34. Husserl, volume XXIII, p. 46, and cited by Brough, ibid., p. 246.

35. Husserl, volume XXIII, p. 489, and cited by Brough, ibid., p. 248.

36. *Husserliana* X, ed. Rudolf Boehm (The Hague: Martinus Nijhoff, 1966), translated into English by John Brough (Dordrecht, The Netherlands: Kluwer Academic Publishers, 1991).

37. Some scholars in the history of art have argued that the depictions of artworks have, at least historically, been taken by their viewers to be "real." Therefore, it may seem to some in the field that in this book I am simply

reasserting a view that has already been put forth and defended by others. Such an inference would be incorrect. Consider, as an example of what I do not reiterate, the main thesis of David Freedberg's *The Power of Images: Studies in the History and Theory of Response* (Chicago and London: The University of Chicago Press, 1989). In this chronicle of the historically typical viewer's naïve aesthetic realism, Freedberg cites dozens of examples as evidence for his position. He argues that the traditional experiential distinction between a painting and what it represents, and the correlative epistemological distinction between signifier and signified, effect utterly misleading reifications: "A radical conclusion thus imposes itself," he asserts at the end his book: "It is that we reconsider the whole insistence in Western art theory . . . on the radical disjunction between the reality of the art object and reality itself. . . . It is to propose that we will only come to understand [viewer] response if we acknowledge more fully the ways in which the disjunction lapses when we stand in the presence of images. However much we may strive to do so, we can never entirely extract ourselves from our sense of the signified in the sign; and our responses are irrevocably informed by that" (ibid., p. 436). In fact, Freedberg claims, artworks throughout history have been taken to be "the real thing," even though he concedes that a sculpture of, say, Mary was not talked to as though she would respond in the manner of a live human being. (Bernard Berenson in *The Florentine Painters of the Renaissance* [New York: G. P. Putnam's Sons, 1899] makes essentially the same point.) However, in an important respect, Freedberg's book ends where my book begins (or, to be more precise, my taking up where he leaves off occurs toward the end of my Chapter 1). He does not concern himself with any of the significant philosophical issues tacitly raised by his own position. ("This [conclusion just quoted] is not to argue for a revision of the philosophical and ontological view [of our Western philosophical tradition]," [ibid.] he states.) Nevertheless, it seems to me that Freedberg should not evade at least two fundamental issues that his book tacitly raises:

1. How can a viewer simultaneously take a statue of, say, Mary to be both a statue and yet not a statue (for it is "the real thing")? Freedberg doesn't seem to see that there is a significant problem that has come to be known among aestheticians as "the paradox of fiction" and with which they have struggled for more than a quarter of a century. The answer to this paradox, if there is one, cannot be simple. I devote the whole of Chapter 1 to offering a possible solution to it.

2. What does Freedberg mean when he states that there is a need "to integrate the experience of reality into our experience of imaging in general"? Or when he declares that "the time has come to see the picture and the sculpture as more continuous with whatever we call reality"? The requested conceptual analysis is wholly appropriate, but it would necessarily have to be of a complex psychological, epistemological, and ontological order, one that Freedberg does not attempt to articulate but which I attempt to do in Chapters 2, 3, and 4 of this book.

I should also note here that the aim of this work is not to make judgments about trends in the history of art, or even to attempt to discover what artists in various periods believed they were trying to achieve, but instead to offer a way of understanding why and how artworks generally, and especially paintings, can and often do matter to us, both personally and with respect to the world we actually dwell in – whether the period is seventeenth-century Holland or twentieth-century America; whether the subject matter is humans, animals, or still lifes; or even whether more than one artistic perspective is simultaneously implied by the artistic representation, as in paintings by Cézanne or Picasso.

38. Translated by John Macquarrie and Edward Robinson (London and Southhampton: SCM Press), 1962.

39. Heidegger, pp. 88–9. In this passage, it is to my mind evident that Heidegger is critically but politely referring to his teacher Husserl, among others. It could hardly be accidental that Heidegger here uses the Greek word *eidos*, which Husserl borrowed for labeling his "eidetic reduction," a heuristic principle ingredient in his general investigative methodology. Also, Heidegger's word *Aufenthalt*, which is related to *aufhalten* ("to arrest [something]"), makes tacit reference to Husserl's concept of the epoché, the holding back prescribed by his concept of the "phenomenological reduction." I should note that I have slightly modified Macquarrie and Robinson's translations of the words *Seinende, des Vorhandenen*, and *Innenseins*, and I have not here or in the next endnote capitalized the word "being" as they have.

40. Heidegger, p. 87.

41. The concept of "being-in-the-world" is central to Heidegger's treatise *Being and Time*. Its meaning is complex, and I explicate it later. See especially Chapter 2, although I provide further clarifications of the term in Chapters 3 and 4.

42. The following excursus, a kind of addendum to my Introduction, is designed to explain to, if not mollify, those admirers of Heidegger's thought who might have trouble understanding a seemingly obvious omission in my book; that is, my refusal to utilize and build upon post-1930s developments in his writings.

43. In *Poetry, Language, Thought*, trans. Albert Hofstadter (New York: Harper and Row, 1971).

44. Ibid., p. 77.

45. Ibid., p. 62.

46. Ibid., p. 63.

47. Ibid., p. 75.

48. Ibid., p. 81.

49. Ibid., p. 53.

50. Ibid., p. 55.

51. Ibid.

52. Ibid., p. 56. (I have substituted in the translation "being-of-use" for "equipmental.")

53. There are several sections in Heidegger's four volumes on Nietzsche, and there are some additional writings, for the most part still untranslated, on East Asian art and twentieth-century European painting, that also shed light on his theory of art. For a recent, sympathetic defense of Heidegger's post–*Being and Time* reflections on this subject, see Julian Young, Heidegger's *Philosophy of Art* (Cambridge: Cambridge University Press, 2001).

ONE

The Reality of Fictional Beings

Let us begin again. I wish to re-pose certain questions about the nature of our most basic relationship to the depictions in artworks.

Who, then, or what are the fictional beings of artistic representation? Are they merely make-believe creatures who exist only in the minds of artists and the appreciators of artworks? If this is so, if we know them to be simply fantasies without any objective claim on us as real beings, then how can we possibly care about them in any way whatsoever? After all, we know that King Lear did not really act precipitously when he decided to divide up his kingdom; in fact, he did not act (in the real world) at all; furthermore, he and most of the personages in Shakespeare's play never existed and never will exist. So why do we grieve over Cordelia's death (or if not hers, then that of any other fictional character who has meant something to us)?

How we are to understand properly beings who ostensibly do not exist – the question of the ontological status of fictional beings of all types (e.g., Zeus, the lost continent of Atlantis) – is an old problem in Western philosophy, one already identified in Plato's work. So are the related, subordinate problems of the proper ontological location of fictional beings of artistic representation as well as the correct explanation of the nature of our involvement with them, mysteries that Plato poses in Book X of the *Republic*. Not only are these issues ancient ones; I believe that they have never been satisfactorily answered.

In the Anglo-American (or, more broadly, the analytic) tradition of recent and contemporary philosophy, one version of the peculiar conundrum that I am citing concerning artistic representations has come to be known as "the paradox of fiction." It was first discussed in its present form over a quarter century ago when Colin Radford and

Michael Weston participated in a symposium titled "How Can We Be Moved by the Fate of Anna Karenina?"[1] Since that time there have been many, many books and innumerable articles in the analytic tradition addressing the paradox. All of the philosophers roughly agree on how to characterize the paradox of fiction. They assert, and I do not disagree, that it is identifiable by three propositions, any two of which may be true (whereas the third proposition, whichever it happens to be, must be false, by virtue of its logical incompatibility with the other two). Here is the paradox:[2]

1. Most (perhaps all, noninfantile) people at times have emotional responses to objects, characters, or events that they identify as merely fictitious.
2. On the other hand, to have an emotional response to objects, characters, or events is to believe that they truly exist and truly have those features one apprehends.
3. But no person who takes beings or events to be fictional at the same time believes that they are not fictional (i.e., that they are real).

Thus, if Points 1 and 2 are held to be true, then it would seem that we have landed either in a flat contradiction or else that Point 3 must be false. Yet, if we take 1 and 3 to be true, then 2 must be false. Finally, to assume the truth of 2 and 3 requires us to accept the falsity of 1. The three sets of possibilities would seem, logically, to jointly exhaust the range of possible solutions to the paradox.

As the reader might imagine, each dyadic proposal (involving the affirmation of two propositions and the denial of the third) has been defended, with variations, by one or more analytic philosophers. Thus, there are those who deny 1: I call them simulation theorists, and they in turn may be subdivided into two groups. There are those who assert (a) that we do not really have full-fledged or genuine emotions with respect to beings or events we think to be fictional; this position is best represented by Kendall Walton, whose work I'll be discussing shortly. Other simulationists maintain (b) that our emotions, though genuine, are not really about fictions, but instead (by a kind of unconscious displacement) are about real beings (people and events with whom we are or have been involved). This position is

represented by such aestheticians as Jerrold Levinson, Barrie Pask-
ins, Michael Weston, and Peter McCormick.[3] Then there are those
philosophers who deny (2) and who thus maintain that to be affected
emotionally does not necessarily entail our belief in the real existence
of the objects correlated to our emotions. It is becoming customary to
identify this second group of would-be paradox-solvers as thought
theorists. They maintain that it is perfectly possible to have all sorts
of images in our minds (either self-generated or provoked by art-
works) in which we simply do not believe; the very conjuring up of
them is sufficient to induce emotional states without any existential
commitments on our part. Peter Lamarque[4] is a thought theorist; so
is Robert J. Yanal, whose recent book I discuss later in the chapter.
Finally, there are those philosophers who deny (3) and who claim,
like Colin Radford,[5] that when we engage with fictional beings, we in
fact take them to be both fictional and real. I call these philosophers
(with no desire to covertly persuade) realists.

The paradox of fiction may also be restated, slightly simplified,
and expressed as a dilemma: if the beings of artistic representation
are creatures whom we regard as merely and solely in our minds,
do we, like children, simply pretend or "make believe" our very in-
volvement with them? So we really don't care about Cordelia after
all? Yet, we *say* we do. Are we speaking metaphorically, hyperboli-
cally, irrationally, or simply lying to one another when we speak in
this way? The other horn of the dilemma is this: if artistic representa-
tions are in an important sense real, then we seem to be committed to
the strange view that our everyday world is literally populated with
fictional beings, an apparently absurd position. We certainly don't
behave as if one fine day we actually expect to meet King Lear (and if
we did assert such an expectation, others would doubt our sincerity
or our sanity even if we ourselves expressed no such scruples). And
when we view Hamlet in a performance or read about Raskolnikov in
Crime and Punishment, we don't in our involvements advise either of
them, warn them, or take any measures to modify their anticipated
fates, as we would for close friends or relatives. Thus, our disposition
toward them or our very actions don't seem to imply that we take
Hamlet or Raskolnikov to be real.

I believe that the right approach to the problem happens to be what
is on the face of things the most implausible one. I identify myself

as a realist and boldly assert that (a) we do take fictional characters to be at the same time real. My position is at least superficially like that of Samuel Taylor Coleridge, who famously said that our proper engagement with fictions involves a "willing suspension of disbelief" in their reality.[6] And although at least one analytic philosopher makes assertions that seem to merit the realist label, the trajectory of his thinking leads him ultimately to a place that is quite different from the position that I will define.[7] In fact, no analytic aesthetician I know of robustly supports my point of view.[8] My second bold claim and the ground of my entire position concerning the reality of fictional representations is that (b) none of the proposed solutions to the paradox of fiction that analytic aestheticians proffer does justice to the logic of the issues *and* the phenomenological facts of our experience – at least those proposals presented to date. Each proposal, I maintain, fails to explain the peculiar hold that fictional beings occasionally have on us, and therefore each begs the crucial question of how this hold can obtain, given their simultaneously acknowledged fictionality. Why, in my judgment, does none of these proposals succeed in reaching its intended paradox-disentangling goal? I believe that ultimately the explanation for the multiple failures is not some technical conceptual inadequacy on the part of would-be problem-solvers, but, as I suggested in the Introduction, something deep and pervasive, an ontological orientation presupposed in the very formulation of the dilemma that I cited at the beginning of the previous paragraph. Thus, my last bold claim is that (c) beneath the various analytic solutions to the paradox of fiction lies a mistaken, neo-Cartesian, subject-object (or representationalist) epistemology and ontology that presupposes reality or "the world" (in its widest sense) to consist in a vast collection of physical beings (including human beings) existing in space and time. Ingredient in this ontological stance as well is the assumption that (1) we humans exist in a kind of epistemological and axiological separation and opposition to these other beings, and (2) that from the "cabinet" of consciousness (Heidegger's apt metaphor, the reader will recall from the Introduction) we have the capacity through sense experience to retrieve data about "the other beings" and, through the appropriate rules of inference provided by reason, to devise propositions that correlate to them and therefore constitute knowledge of them. Finally, according

[43]

to this position, it is supposed that (3) all sensorially and publicly unverifiable phenomena – all values, imaginings, artistic creations, and all errors of judgment – are to be understood subjectivistically. Thus, neo-Cartesians assume, that which is posited to be true but which is *undemonstrably* isomorphic with the physically knowable world is best regarded as only and merely in individuals' minds, hence not really in the world at all.

I acknowledge that my last bold claim (c) would take much more than this chapter (and probably more than a book) to demonstrate. In any case, it is overstated, for I feel confident that some analytic would-be solvers of the paradox of fiction, despite their fundamentally neo-Cartesian, subject-object stance, are not so narrowly empiricistic as I have just indicated: there will be those who admit to, perhaps insist on, a rich and varied ontological panoply of beings. Yet, none of the writers whom I've surveyed seems to be willing to take the truly significant and radical philosophical steps that I, following Heidegger, believe to be required if some of the unfortunate implications of subject-object epistemological and ontological thinking – inferable in analytic theorizing about the paradox of fiction – are to be adequately addressed. I am, of course, mindful of the difficulty of truly challenging a fundamental presupposition of a whole way of theorizing, indeed, of a whole "commonsensical" outlook. What I can hope for from the reader is at least an acknowledgment that none of the standard, analytic responses to the paradox of fiction is truly a solution to it. If this much is granted, then perhaps the reader would be willing to countenance the possibility that the line between fictionality and factuality (so-called) is much finer than is ordinarily acknowledged and that Heidegger's ontology, developed at length in *Being and Time*,[9] can provide us with the correct basis for devising a solution to the paradox. At any rate, in this chapter I pose several challenges to various analytic aestheticians who deal with the paradox of fiction and then argue for my own, neo-Heideggerian response to it.[10]

I'll begin – and give the lion's share of my critique of the orientation I oppose – by examining the work of a type-a simulation theorist, Kendall Walton, perhaps the best-known analytic aesthetician who has sustainedly dealt with the paradox of fiction and who insists on the utter fictionality (nonexistence) of artistic representations.

I analyze parts of his *Mimesis as Make-Believe*,[11] a large, much-praised, and influential book published in 1990 that draws upon, and develops claims in, his prior essays. Walton's work has in fact, over a twenty-year period, redefined current analytic aesthetic theory. As Peter Lamarque, editor of *The British Journal of Aesthetics*, has written, "he [Walton] has quietly revolutionized the way that [analytic] philosophers think about fiction and representation. Single-handedly he has brought make-believe from the periphery to the heart of aesthetics."[12] So let me initiate this meditation on the paradox of fiction by examining Walton's contention that the beings of artworks are nothing more than creatures in our minds. After that, in Part II of this chapter, I refer to other – in my judgment, also inadequate – responses by analytic aestheticians to the paradox of fiction, and finally I articulate my own position in Part III.

SIMULATION THEORY: KENDALL WALTON

". . . to be fictional is, at bottom, to possess the function of serving as a prop in games of make-believe,"[13] Walton contends. In this sentence, he is really summarizing his entire position that the fictional beings we contact in artistic representations have a purely subjective location. The sentence, therefore, demands amplification.

We all know how children often use tree stumps, dolls, teddy bears, or whatever (examples of what Walton calls "props") as instruments for play and fantasy. They may, for example, decide to regard the stumps as "bears," imagining all sorts of things about "them" (and about themselves, since they become heroes and villains in their games of make-believe). Similarly, according to Walton, we adults use props (representations), but of a more sophisticated variety. The work of art (e.g., a play, a painting, a novel) is of this kind, he asserts, and so it, too, should be regarded as a prop for the exercise of our imaginations. Here, in our make-believe, we often include ourselves in the fantasy, although as adults, how we respond is significantly determined by authorizing social customs, by what Walton labels, following Wittgenstein, "games." In experiencing an artwork, we are thus involved in a particular game of pretense obligating us to think and imagine certain things and not others. It is authorized for

[45]

a person to look at a Rembrandt portrait of a man and draw all sorts of conclusions about this fictional being – that he is old, wealthy, intelligent, anxious, and so on, and perhaps (again, in pretense) a person one would enjoy meeting. It is not authorized (but nevertheless possible) for a person to look at the Rembrandt and say that he or she sees it as a depiction of an animal or an inanimate object.

At this stage of exposition, Walton's theory may seem to be true, perhaps even relatively uncontroversial. An important question has already been elided, however: who or what are the so-called fictional beings with which we engage ourselves? The props that are necessary for their imaginative fabrication are certainly "out there," in the world, and not just in our heads. But if the props are there, aren't the creatures of fiction there too? The actor who plays Hamlet is certainly in the world before us, but is *Hamlet* (the man created by Shakespeare) there as well? Here Walton is ambiguous. At first he asserts that fictional "worlds, like reality, *are* 'out there' to be investigated and explored if we choose. . . . To dismiss them as 'figments of people's imaginations' would be to insult and underestimate them."[14] But what does Walton mean by saying that fictional worlds are "out there"? Are fictional worlds somehow and literally a part of "the real world"? If I claim that the actor played his role (of Hamlet) brilliantly, my assertion presupposes that I have some intuition of "the real" Hamlet. Yet, what is the nature of this signified "reality" in the realm of being? And *where* is he? To be consistent with his own basic position, Walton must say the "real Hamlet" exists merely as an historically and collectively agreed upon pretense based on the text of Shakespeare's play.[15] So despite Walton's insistence that we should view fictional beings as something more substantial than imaginary figments, in the end his position is this: the character, Hamlet, whose distinguishing features are intersubjectively agreed upon, exists only in individual minds. This is made clear when Walton informs us that as far as fictional entities are concerned, *"there aren't any* [in *rerum natura*; they don't really exist; we simply pretend that they exist]. And since there is no Gregor Samsa," he elaborates, "there is no such thing that he became an insect."[16]

But if there is no Gregor Samsa, whom do I pity as I read Kafka's story? Simply a creature of publicly authorized pretense? Still, if it is just that, and I know it to be just that, why do I feel something

for Gregor, even feel sorry for him? And why am I affected by, why do I even temporarily grieve over, Anna Karenina's fate? How, to repeat the question posed earlier, can I be emotionally affected by something that I know to be unreal?

Walton cannot wholly deny the existence of these emotions that we all sometimes feel when engaged with fictional artworks without simultaneously implying that we who care about certain fictional beings are pretenders about our feelings as well. Yet, since we do in fact feel something, he must provide a theory of how this kind of experience is to be philosophically interpreted. He does this by inviting us to consider an imaginary Charles, who watches a horror movie about a terrible green slime that is slowly absorbing to liquidation every living thing it encounters. At one point Charles shrieks in terror, for the slime is seemingly heading straight toward the viewer, about to devour him. Charles says afterward that he was "terrified" by the slime.

Was he truly terrified? No, asserts Walton. Although he doesn't deny that Charles experienced certain bodily sensations that look like the manifestations of fear (such as tensed muscles, a quicker pulse, etc.), he refuses to characterize them as genuine fear. He says instead that we should "call this physiological-psychological state [merely] *quasi-fear*."[17]

Walton tries to justify this conclusion by repeatedly giving great weight to the fact that Charles does not take action to avoid the menacing slime. Because he doesn't so act, it is inferable, Walton argues, that there was no prior deliberation; without such deliberation, we cannot really attribute belief to Charles. To be truly fearful, though, is to believe that one is really being threatened. It follows that if one does not believe there is a true threat, then one does not truly fear. In sum Walton concludes as follows: fear "emasculated by subtracting its distinctive motivational force is not fear at all."[18] Still, what shall we say about Charles' physical reactions – his sweating, his increased pulse rate, and so on – don't these responses imply his fear? No, insists Walton: we do not seek reasons or justifications for bodily responses (although we might, of course, seek explanations). Because (in this case) we don't presuppose the existence of certain beliefs, we should doubt the presence of their ordinarily correlated emotions.

Yet, since Charles shows some obvious signs of fear, might we not say that he *half believes* in the slime? Or that he *momentarily*

forgets the fictionality of the movie and takes the slime as being fully real? Again, the answer is negative, according to Walton: Charles doesn't half believe, or believe at all, in the existence of the slime, for otherwise (once again) he would take at least some measures to avoid it. Nor is he momentarily forgetful of his true situation, and for the same reason just provided, Walton continues, for it is quite possible for Charles to be (quasi-)fearful throughout the movie, without his ever having any urge to flee or call for help. So if one "grieves over" Anna Karenina while reading Tolstoy's novel, the reader doesn't necessarily do this only momentarily, as though he or she had for an instant lost a grip on reality. The (quasi-)pity for Anna can be felt by the perfectly ordinary and sane reader virtually throughout the experience of reading the novel.

Although it is not easy to respond immediately to Walton's implied criticisms of my alternative, realist position, given the apparent power of his argument, one thing seems clear: Charles is afraid of *something* – even if he takes no action – for otherwise he would not exhibit even the traces of true fear; his responses would be all pretense. Why? Because the person who fears has an object for that fear, even if it is only slight or only vague and ill defined. A critic of my view could counter that a person may be anxious and not know the target of his or her anxiety. Nevertheless, the person's difficulty in precisely identifying the fearsome object does not entail that it does not in any sense exist. In the case of anxiety (*Angst*), as both Kierkegaard and Heidegger observe, the "target" is actually not any one thing; it is, in a way, "everything," for one's whole world is threatened. Alternatively, the person may believe that his or her fear is without justification, but that, again, does not entail that one is really fearing nothing whatsoever. In any case, however, as Yanal has pointed out, even if one could make a case for the existence of some objectless emotions – states perhaps induced by drug injections – it is clear that "what fiction [per se] induces are *object-directed emotions*."[19]

Concerning this issue of the authenticity of Charles' response, Walton hedges. On the one hand, he asserts that his viewer is pretending and knows that he is pretending.[20] On the other hand, he insists that Charles "experiences quasi-fear, ... feels his heart pounding, his muscles tensed ... ; it would not be appropriate to describe him

as afraid if he were not in some such state."[21] Walton is here in a dilemma that he fails to perceive: if one pretends to be afraid and knows that he or she is pretending, then there is no fear, not even quasi-fear. On the other hand, if one in some sense does fear (even quasi-fears), then he or she is not pretending.[22] For when one pretends something, as is the case when one lies about something, the pretender or liar does not at all believe what he or she is maintaining. Thus, pretending that something is real precludes simultaneously taking it to be real.[23] Walton, in hypostatizing quasi-fear (and later quasi-grief, quasi-admiration, etc.), thus attempts to avoid the implications of a vaguely suspected but not truly acknowledged dilemma by a dangerous leap between its horns. I fear that he has been impaled on one or both of these horns.

In a 1997 essay, thus a work published after *Mimesis as Make-Believe*,[24] Walton attempts to answer critics who, like me, have been perplexed and unpersuaded by his simulation theory. He complains that they have put "undue emphasis" on his "negative claim that it is not literally true, in ordinary circumstances, that appreciators [of fiction] fear, fear for, pity, grieve for, or admire purely fictitious characters." His critics, he asserts, have failed to understand the positive contribution of his entire theory.[25] The gist of Walton's response is (a) to reaffirm that what we experience in reading fictional works, viewing movies or plays, and so on is not literally fear or pity or admiration; and (b) that recent developments in cognitive psychology and the philosophy of mind concerning "mental simulation theory" dovetail nicely with, and thus provide additional support for, his own positive aesthetic theory of make-believe. Both aspects of his modified position, however, still beg what is in my judgment the crucial question: why are we moved by the images, sounds, and so forth, of make-believe? Here are my concerns.

In the first place, Walton concedes, even insists, that we are sometimes deeply affected by fictional depictions: "It goes without saying that we *are* genuinely moved by novels and films and plays, that we respond to works of fiction with real emotion." "In fact," he continues, "our responses to works of fiction are, not uncommonly, more highly charged emotionally than our reactions to actual situations and people of the kind the work portrays."[26] Well, if we do have strong emotions, why not call them by the names that virtually

anybody but Walton would employ? Why not call them "fear," "disgust," "hatred," whatever? The burden of counterintuitive proof for this issue is surely on Walton. One reason that he gives in defense of his position is that when we are engaged imaginatively with artworks, because their depictions are not real and we know that they are not, the precise nature of our emotions with respect to them cannot be literally what we take them to be either. But, as Yanal has asserted, this conclusion seems like – I would say *is* – a non sequitur[27] and, in fact, tacitly reinstates the very questions at issue: we wish to know how our emotions are to be labeled and what they signify, and these questions should not be decided on the basis of an a priori Waltonian assumption – that the realm of the fictional is utterly, absolutely, and in all respects taken to be unreal.[28] A second reason that Walton cites for not giving his imprimatur to claims of literal fear, worry, admiration, and so on when we are engaged with fictional depictions, it will be recalled, is that we don't take action with respect to them. However, actionability is not *the criterion* (although it may be a sufficient condition) for the authenticity of our emotional responses. After all, I can see or watch video broadcasts of catastrophes (such as terrorist attacks, floods, etc.) and do nothing more than lament what I am witnessing.[29] It is simply not true that a person's actional inhibitedness in the face of artistically fictional events is a sufficient reason for doubting the authenticity of his or her self-described emotional responses.

In the second place, Walton's theory of make-believe doesn't really explain why it is that we are able to become emotionally involved with fictional beings in the first place. In his 1997 article, he exasperatedly declares that too much "ink ... has been splattered" on his theory of quasi-emotions and not enough attention has been paid to "the positive side of my account of appreciators' responses to fiction – their imaginative participation in games of make-believe – is much more important."[30] Succinctly expressed in his own words, here is his positive theory:

> [Make-believe involves mental simulation.] Appreciators simulate experiences of being attacked by monsters, of observing characters in danger and fearing for them, of learning about and grieving for good people who come to tragic ends, of marveling at and admiring the exploits of heroes. We simulate these experiences [we put ourselves

imaginatively in fictional characters' shoes].... [A]ppreciators bring much of themselves to the make-believe; their actual psychological makeup, attitudes, interests, values, prejudices, hang-ups, and so forth, come powerfully into play. And this sometimes makes their experience of the fiction a deeply moving one.[31]

All of this strikes me as quite correct – even rather obvious – but note that the overall statement does not enable us to understand why it is that our make-beliefs or simulations affect us in any way whatsoever. All that Walton suggests in response to this kind of challenge is that what we know to be true fictionally is false factually, and that we are indeed capable of being affected, "genuinely moved," by imaginary truths. Now it is the case, of course, that in Tolstoy's fictional world Anna Karenina throws herself under a train. In our imaginations we believe this truth, and we might say to another, "You are aware that in the end Anna does commit suicide, aren't you?" Nevertheless, it is one thing to be able to state a "fictional fact" (such as Anna's suicide); it is quite another thing to be moved by that which we know to be simply not true and to account for this strange phenomenon. You or I may call up an image of Ivan the Terrible in imagination, even in simulation play the role of him (by, say, putting on a sixteenth-century Russian nobleman's clothes, including his sword and dagger, and strutting about one's "chamber," etc.). Still, how should we account for this sort of activity's effecting in us a new emotional state, such as quasi-rage or quasi-longings for quasi-revenge. We "bring" much of ourselves to the simulation? Our psychological makeup "come[s] powerfully into play"? Yes, of course, but what do these metaphors of "bringing" and "coming into play" explain? How do these events happen? What enables us to take our imaginings in any way seriously? These are not irrelevant questions; nor do I think they are questions best left to psychologists (for, it seems to me, we are not in search of a causal explanation). Nor, finally, should we accept a typical Wittgensteinian response (uttered with a dismissive shrug): "Well, explanations must after all come to a halt *somewhere*!"

Third, and as has been pointed out by Noël Carroll in his review of *Mimesis as Make-Believe*,[32] Walton is unable to account for the fact that some fictions seem to affect us only minimally, if at all, and, sometimes, even despite our efforts to act in accordance with authorizing conventions. Yet, if Walton conceives of artworks as sophisticated

props that sanction and prescribe our creating certain kinds of mental fictions, why do some artworks work better for us than others? According to Walton's theory, if a tree stump can fictionally become a bear for a child, then it would seem to follow that a bad horror movie could affect us adults just as effectively as a good one. After all, like fun-loving children, we are, if the theory is to be believed, simply using artistic "props" to construct a pretended world. We don't have a child's pretend-capacity when it is a question of experiencing fictional works, however; some of them fail to move us no matter how hard we encourage them to do otherwise. Isn't this because such fictional works are "unconvincing," "not true to life," in a word, "unreal"? On the other hand, and with respect to fine artworks, don't we ordinarily experience genuine emotions and isn't this because we believe ourselves to be in contact with something truly moving? Indeed, isn't the whole complex subject of the "quality" of an artwork – fundamentally, its convincingness – left disturbingly unexplained by Walton and, I believe, unexplainable?

To condense the psychological issue at stake: Walton initially claims that those involved in artistic depictions pretend their emotions. This position, while logically solving the paradox of fiction, is psychologically false: no one ordinarily simply feigns emotions when steeped in a fictional artwork. On the other hand, Walton later concedes that we are after all genuinely moved by fictions, but he provides no elucidation of how we can be thus moved by that which we know to be "unreal."[33] In changing his position, he does draw closer to the phenomenological facts of the matter, but the paradox of fiction itself remains unsolved. So let us now turn to other analytic attempts to deal with this mystery.

As I indicated earlier, there is another camp of simulation theorists who believe that our emotions, although genuine, are not really about fictions, but instead (by a kind of unconscious displacement) about real beings (people and events with whom we are or have been involved). The simulation or pretense, therefore, is about the beings of our concern: we imagine ourselves focused on so-and-so (e.g., Hans Castorp, the principal character of Thomas Mann's *The Magic Mountain*) when in fact we are concerned about a real person (a friend, a brother, whoever) and issues that are related to, or remind us of, our own issues.[34] We read about Hans, become caught up in

his infatuation with Frau Chauchat, his irritations with Settembrini, his ambivalence vis-à-vis Dr. Behrens et al., but, according to this simulation-theoretical point of view, we can't literally be involved in the lives of such people and their problems because they simply do not exist, and we know that. That we are involved (and genuinely so), however, in *something* can't be denied, for it is impossible to care about nothing whatsoever, so there must be, so these simulation theorists argue, real referents to our concerns. Frau Chauchat, Settembrini, and Dr. Behrens must, therefore, be stand-ins for people about whom we do care, or have cared. The problems that these characters raise must be analogues of problems that we take, or have taken, seriously in our own lives.

There is a certain appeal to this position, for it does not deny that we feel something to be truly at stake in our involvements with fictional representations. The pretense is not about what we feel (Walton's position) but rather our feelings' referents (i.e., real beings, thus not imaginary constructions). Still, it does seem strange to say that when we read *The Magic Mountain*, we do not really care about Hans Castorp but about someone else, for this implies that when we are involved in artistic narratives of any sort, we are always either in a state of delusion or else we are simply lying about the true nature of our experiences. The simulation theorist who makes this kind of claim, therefore, faces a challenge similar to that which I posed to Walton: the burden of proof is on him or her to show us that what most people take to be the case is really not the case at all. Walton himself recognizes the extremity of this particular version of simulation theory: "to consider the experience commonly characterized as 'pity for Anna [Karenina]' to be merely pity for real people 'like' her (or a determination or inclination conditionally to feel pity toward people in like situations) does not do it justice. It is no accident that we speak of sympathizing with or grieving for Anna."[35] For who, it can be asked, is the true counterpart of Anna? Is it, say, an acquaintance, friend, or relative of ours? But suppose such an association never comes to mind when we are engrossed in Tolstoy's novel? Must we posit some unconscious connection about which we aver we know nothing? If some particular person does occasionally cross our imagination as we read and muse, say, "[my friend] Joyce and Anna have something in common," does this demonstrate that the true target

[53]

of our concern is Joyce and not Anna? Perhaps a simulation theorist would say that the true referent here is not a particular individual but rather some anonymous person whom we posit to be real. If this is the response, then why create another person when Anna herself can fill that ontological position in the first place? Why not say that we are involved with Anna who in some possible world could be real? Moreover, what criteria of identification would assure us that the referent of our concern is really Joyce or really some anonymous person who might exist? At least when we refer to Anna directly we have some textual reference points to which we may appeal for identificatory purposes (e.g., she is of Russian nobility, wife of Karenin, mother of a son, lover of Vronsky, etc.). But what reference points can a simulation theorist offer to us?[36]

Moreover, if Anna's struggles were simply an allegory for our struggles, we could hardly be said to care about her and her particular world at all. More generally, it would be difficult according to simulation theory to account for why literature, or most of the other arts, mean so much to so many people, except insofar as this fascination is one more alleged proof of their disposition to narcissistic indulgence. If I focus on only those concerns of Anna's that are coincidental with and translatable into my own, then to the extent that she is unlike me (and, of course, she is unlike me in all sorts of ways) I would be totally indifferent to her. This is transparently not so. The initial interest that I have for Anna begins to envelop and be enveloped by other aspects of her character and her story, giving them a meaning that at the outset they did not have. In addition, and what is perhaps most interesting in this regard about Anna, is that she, in her otherness, adds to and qualifies the implicit shape of my deepest personal concerns. In becoming engaged with Anna herself (and not with a mere mirrorlike placeholder of my specific preoccupations), I am able to literally see and feel the world differently. Thus, I am simultaneously gaining a deeper appreciation of her and, through her, of others – of new individuals, "real" and "fictional," to whom, before "meeting" Anna, I may have been indifferent or unsympathetic.

But if simulation theorists do not seem to have the conceptual resources to solve the paradox of fiction, perhaps the so-called thought theorists, the other major group of analytic aestheticians who deal

with the paradox, do. Thought theory is the denomination provided by Noël Carroll[37] (cited earlier in a different context) to those would-be solvers of the paradox of fiction who contend that (a) to have an emotional response to something does not require any beliefs about that thing's very existence, thus (b) when one imagines something and knows that one is merely imagining it, the sheer content of the experience may produce (real) emotions, such as pity, horror, affection, in the person imagining. For example, if I vividly imagine myself standing on some boards of a scaffold that hugs the Empire State Building and that provides only one narrow wooden rail for a graspable support, I can induce in myself a fear of falling, with several accompanying sensations. The very images (not beliefs about their referents) induce this state, so thought theorists maintain, despite my knowing that the imagined scene is merely a figment of my imagination. There are several variations of theorizing on this theme of fantastic cognition sans existential commitment.[38] Yanal, following and building upon Larmarque's views on the paradox, provides the latest and most careful defense of thought theory with which I am acquainted. I recapitulate his argumentation, which I take to be representative, in its crucial assumptions, of virtually all thought theorists.

THOUGHT THEORY

How can mere imaginary thoughts generate emotions? How, for example, can we be frightened by thoughts? Yanal begins his response to these questions by approvingly citing Lamarque: "The propensity of a thought to be frightening is likely to increase in relation to the level of reflection or imaginative involvement that is directed to it."[39] These levels of "reflection" and "involvement," Yanal continues, "reduce to the 'vividness' of a thought and the 'level of attention we give it.' The idea is that the more vivid a thought and the more we attend to it, the greater chance it has of bringing on an emotional state."[40] But do "vividness" of, and exquisite "attention" to, objects or events in our imagination ipso facto make us feel certain emotions? Isn't it conceivable that we could attend to some vivid image very carefully and feel virtually nothing? Despite his general

sympathy with Lamarque's position, Yanal concedes that as stated it is not yet satisfactory and precisely for the sort of reason that I just suggested. "There is a lacuna in Lamarque's theory, insofar as he fails to account for how thoughts of [say] Desdemona's suffering bring on [our] suffering given that we also believe Desdemona to be fictional."[41]

Yanal attempts to supplement this Lamarquian deficiency in his own version of thought theory. The crucial assumption of this supplementation is this: The imaginer's "disbelief in any real reference of the thoughts is rendered *relatively inactive* [my italics]. The emotion thus produced is real and typically has the character of being richly generated yet unconsummated." "Though this dimension [of belief] is largely ignored, it is the very crux of how thought theory can solve the paradox [of fiction]," he asserts. Yanal continues as follows:

> Some beliefs may be highly active; others less so; still others may be entirely inactive or nearly so. I believe that the airplane I'm traveling in is about to crash; this causes all sorts of effects in me: intense anxiety, palpitations, thoughts of loved ones, and so on. This belief is highly active. On the other end of the activity spectrum I believe that $7 + 5 = 12$. This belief causes little or no other effects in me; hence it is quite inactive. I do not mean to imply that beliefs are either active or inactive. The activity of a belief lies on a continuum ranging from beliefs I hold that have no effect on my other mental states, which would be nearly inert, to beliefs I hold that occupy my mind to the exclusion of almost everything else, beliefs that would be highly active.[42]

What is suggested by this thesis is that when I am engrossed by events in *Anna Karenina*, my beliefs about them are fairly active and thus my disbeliefs are fairly inactive. Thus, only "when I actively believe that there is no Anna Karenina who suffers ostracism and loss of love will I be in danger of falling out of pity for her."[43] This statement implies that I pity Anna to the extent that I believe that she is a real person suffering real indignities. Does Yanal mean what his statement logically entails? Apparently not. There should be, he informs us, a "low degree" of inactivity of disbelief sufficient to allow us to respond emotionally to Anna and her world, "without entrapping the spectator into believing that the fictional is real, or worse, in attempting to interact with fictions."[44] Yet, if, as Yanal

claims, we don't believe in the literal reality of Anna and her world, then what precisely is it that we believe in?[45] What is the credible remainder that is not literal?

In an effort to answer this question, Yanal distinguishes between the attributes of the objects of our awareness and their very being, between, therefore, their "essence" and their "existence." In so doing, he shifts his position significantly, for instead of elucidating his claim that we somehow suppress disbelief in real existence (and thus do believe in it), he now insists that attributes of nonexistent objects have the capacity to imaginarily captivate us and the question of their very existence becomes irrelevant:

> When we have thoughts about a fictional object, we have thoughts principally on that object's qualities. If the fiction is a character, we think that that character is quick or dull; that he inflicts injustice or has had injustice inflicted on him; . . . if the fiction is a situation, we think that that situation is dangerous or pathetic, or joyful, or annoying, and so on. We think only secondarily that it is a fiction. Existence, like assertion, is something added to the thought.[46]

If this position is right, then our involvement with Anna is not at all a matter of our semibelieving in her existence but of being taken by her qualities as an object of fantasy, of nonbeing. This implication puts us right back where Yanal began his entire investigation – with the question of how we can possibly care about beings that we know to be utterly fictional.

Yanal is clearly worried about this problem because he cites it in the form of an objection posed by Bijoy Boruah to Roger Scruton's own version of thought theory, an objection that is relevant to all thought theorists and thus to Yanal himself:

> Imagination in Scruton's theory (and thought theory generally) essentially revolves around unasserted thoughts, and these are "existentially uncommitted," that is, we [whichever persons entertain them] don't really care whether these thoughts refer [to real beings in the world]. [But] the person whose thoughts are asserted cares about what they refer to. It is this caring (Boruah calls it a "committed" frame of mind) that supplies the causal force to our emotions. Thus without commitment, we are left without any cause of emotion. Imagination, then, when lacking commitment, cannot be a source of emotion.[47]

Yanal replies to this objection by simply asserting that he disagrees with Boruah: "there is no necessary connection between 'caring' and existential commitment. In other words, Boruah lacks a reason why we can't care about what is merely present to the mind (in 'imagination' he would say), without existential commitment."[48]

We have here a profound disagreement, both psychological and philosophical, and one with important implications for the solution to the paradox of fiction, I believe. In defense of Boruah, I would propose, following but slightly modifying a suggestion of B. J. Rosebury,[49] that the reader consider three types of personal experience: (a) Recall some serious and disturbing news that a friend reported to you. What and how did you feel about the report? Allow yourself to recall your emotions. (b) Now imagine a practical joker (known by you for his "wickedness") telling you precisely the same information in the same way that the friend told you. (You assume that he is pulling your leg.) Now compare your overall response with the previous one. My guess is that your successive emotional reactions are utterly different, that in the second case you suffer no anxiety at all, that you feel virtually nothing. Now, finally, (c) conjure up some fictional character in a novel, play, film, whatever, by whom you were strongly affected at some point in your life, one who has meant something to you. (In my case, it is the questing knight in Ingmar Bergman's film, *The Seventh Seal*.) Why do you have certain definite feelings for (or against) the character? And aren't they, in their power over you, similar to your response in example (a)? Now why don't you, in example (c), have a reaction similar to that which you had in example (b)? After all, both imaginings deal with complete fictions, and their contents would seem not to be matters of concern to you. So some other explanatory factor must be at work here. What could it be? Isn't the state you are in vis-à-vis the affecting fictional character because he or she has qualities and has performed actions that you would characterize as "lifelike" or "true" or verisimultudinous (in broad senses of these words, for the character could, of course, be anyone from King Arthur to E. T.)? Thus, don't fictions matter to us because and to the degree that we link them to our world? Obversely, aren't we indifferent to our sheer fantasies because and to the degree that we are unable or unwilling to make this sort of linkage with "reality"? (Here I am agreeing with

those simulation theorists who insist on a linkage of emotions to "the real world," but I also deny their claim that the explicit fictions to which we relate are somehow transubstantiated into other beings and contents, so that the true emotional referents become something different from what we take them to be.)

It is ironic that Walton, the master simulation theorist, raises the same sort of objection to thought theorists that I do:

> What we call "fear of the slime" by ordinary appreciators [of fiction] fully aware of its fictitiousness is in general, [Lamarque] thinks, fear of the *thought* [itself, my emphasis]. I see no advantage in this suggestion. [Charles's] experience simply does not feel like fear of a thought; characterizing it as such flies in the face of its phenomenology . . . it is the *slime*, not a thought, that Charles so inevitably and unabashedly describes himself as afraid of.[50]

Where we differ, of course, concerns Walton's view that our pity for Anna is only feigned or quasi-pity and therefore mere pretense.[51] My claim, on the contrary, is that we truly pity Anna and that this is not pretense. Here I naturally risk straining the reader's credulity. If I truly pity Anna, doesn't this entail that I believe that she really exists? Have I gone mad? Do I no longer fear being mortally wounded by one horn of the dilemma that I myself posed at the beginning of this chapter? My response is a complex one and requires our reflecting further upon what we do when we are engaged with fictional beings.[52] Now I wish to offer some phenomenological reflections on what I believe we, in fact, experientially, take to be "real."

REALIST THEORY

Consider this first-person example that pertains to a so-called non-fictional being of my world. Suppose I say, "I am eager to see my overseas daughter." Here surely I do not wish for something in my head. At least, as I think of her, I do not think that she is in my head. How could I wish to see someone who I know to be already in my head? If I took her (*per impossible*, of course) to be literally in my head, I would be with her now and not wish to see her. And if I literally took her to be only an image in my head, I would not long for her;

I would simply have the image and that would be that. But, no, I miss the real person, my daughter, and insist, rightly, that she, not an image, is the object of my care.

If this point is correct, then we frequently conjure up beings who are not directly perceived, but who are nevertheless posited to be "out there," in the world. Now this kind of being whom we hypostatize as part of our world may be referred to – here I use the language of both Husserl in the Continental tradition and Elizabeth Anscombe in the analytic tradition[53] – as an "intentional object," which is an item of awareness that we regard as extramentally real but which may or may not be so. For example (following Anscombe), some ancient Greeks believed in Zeus. They did not believe that Zeus was merely in their minds; they believed that he was real (although most probably so in a manner different from the ordinary physical objects that they constantly perceived). Whether indeed Zeus was or is real is, of course, a different issue. Yet, the question remains: if the Greeks didn't believe in something in their heads, how, from their point of view, should we characterize that to which they were committed and how shall we square it with our contemporary point of view?

However we respond to this question, I would still insist that if I take my consciousness of my distant daughter to be truly *of her*, then she, as my intentional object, is posited to be in my world. But what shall we say about a fictional being? Can I say the same thing about Anna Karenina that I say about my daughter? Is she an intentional object whom I posit to be in my world? If so, is she taken to be real in the same way that I take my daughter to be real? As strange as this may sound, I think that the answer is yes, although I believe this with some caveats.

Recall for a moment a movie in which one of the characters was fascinating to you. (For me it is Tom Ripley, played by Matt Damon, in *The Talented Mister Ripley*.) When you were engrossed in the film, wasn't it true that you felt you were watching, as it were voyeuristically, a real person?[54] Again, you weren't engaged with mere images on a white screen. Didn't you take the images to be a person, just as you take certain distant images seen from a low-flying plane to be of real people? And when a character speaks, we would have a great deal of trouble simultaneously telling ourselves, "Well, that's

simply electronically reproduced sound that I translate into intelligible thought." No, we hear someone speaking. Where is this person exactly? I would say that he is in the world, in our world, not behind the movie screen, but in whatever setting the film depicts – in southern Italy on the Amalfi Coast during the 1950s, in the case of Tom Ripley. Again, we posit that a character has a mind of its own – after all, we are not responsible for the thoughts you hear expressed – and (ordinarily) that he or she sleeps, eats, ages, will eventually die, and so on. In short, we regard this being (even if it is ageless or immortal) to be logically complete and independent of us, therefore in extramental reality and thus "out there." Of course, there is one respect in which we do not regard this being as just like an everyday acquaintance, and that is in our ability to affect him or her, or, if we imagine ourselves as one of the characters in the depicted subworld, to affect him or her in a way that is different from the way it fictionally occurs.[55] This fact does not, however, contrary to what might appear, make this person ipso facto a mere figment of our imagination and thus utterly unreal. I cannot affect my overseas daughter of whom I'm now thinking, and yet I regard her as real. Ah, yes, it might be replied, but in principle I could affect her and in any case the inability referred to is merely physical, not metaphysical. I could take a plane to Florence and see her, for example. True, but note that when I think of my dead grandmother, when I conjure her up and am with her (listening to her foreign enunciations of English words, recalling her lamentations about her illnesses, etc.), I also am dealing with a being from whom I am metaphysically isolated. Yet, as is true of my absent daughter, I am dwelling with her, not simply with an image or idea in my mind. If one objects, "but your grandmother is dead, and you are in fact dwelling only in your mind," this is not really the issue, for what I am focusing on is not what another – thus from a *third-person* point of view – would say is "really taking place" in me, but how I and anyone else as a first-person experiencer ordinarily relate to absent others, be they "real" people or "fictional" beings. Indeed, our readiness to comprehend this kind of issue solely from the third-person point of view, and thus to discount the reality and significance of the first-person point of view, along with our related philosophical disposition to regard the world through Cartesian subject-object epistemological and ontological lenses, explain

why there has been so little progress made vis-à-vis the paradox of fiction, it seems to me.

So as I am responding to Tom Ripley, I regard him as a real person, someone existing independent of me, although (again, like a voyeur) I know that either I cannot affect him at all or, if I see myself as one of the participants in the story, affect him only according to the unfolding scenario depicted by the filmmaker. I also have another awareness, however, simultaneous with my involvement with Ripley, that all of this is make-believe. Thus, I do not wish to deny that when engaged with represented fiction, we are always also aware that we are so engaged. I agree with Richard Wollheim that our experience is always twofold: we are aware that there is a representation before us, and we are at the same time caught up in something that is represented. Our consciousness is indeed twofold, not onefold: (a) an awareness that the artwork is a thing that is "there" (be it something visual, auditory, and/or tactile), but not (as Danto has correctly pointed out) just as an ordinary thing, for one knows as well that it is about something other than itself; and (b) a separate awareness that is involved in the representation as something meaningful and engaging in its own right, what Wollheim calls "seeing-in." However, I claim, beyond Wollheim,[56] that when we view a painting, we posit both the essence and actual existence of a depiction as truly real, although at the same time we whisper to ourselves of its "untouchability," thus guarding ourselves against public, third-person-type, ontological extravagance and embarrassment – if, for example, we are inclined to shout our curses at Iago in a performance of Shakespeare's *Othello*.[57] But despite the monitoring and overseeing presence of one mode of cognition, the posited beings of another mode are permitted to be in our world, in a state of sheltered animation. As such, they can truly provoke, annoy, delight, or terrify – in short, they can make appeals to us to which we can hearken and which over time can resound in our world, thereby informing us of who we have become, even when we do not explicitly attend to them.

Now in qualifying my position as I have done, it may seem that I have suddenly conceded everything that Walton and other analytic aestheticians have been asserting all along, but it is not so. For whereas Walton says we pretend that Ripley exists and we pretend that we are involved in his life, I say that we do think Ripley exists

(as a real person) and we are truly involved emotionally in his life. The consciousness that says "it's all fictional" is separate from our involved (more emotional) consciousness. My view is, therefore, both similar to and different from Yanal's, for while he maintains that when we are in thrall to fictional characters, our disbelief in their fictionality is fairly inactive (which is precisely my position), he then goes on to insist that we do not truly believe in their extramental reality in any way, shape, or form, that instead we are excited by our thoughts *as thoughts* (a view that, of course, is not mine at all).

Thus I believe that when we are engaged with absent beings, be they "real" or "fictional," we have a dual vision. Does this imply a contradiction? No, although I can imagine that analytic aestheticians like Walton and Yanal would be worried about this kind of problem as well as by a view like mine that gives psychological and ontological weight to our first-person, in-the-world experiences. Such aestheticians are unwilling to countenance the possibility that at some level we truly believe in fictional beings. As far as the contradiction is concerned, however, it exists only if we assert that the self-same agent at one and the same time believes and disbelieves in fictional beings. This is not my position. It is instead that our dual vision suggests dual consciousnesses, thus two agents of awareness: one, $agent_1$, is credulous and fully engaged; the other, $agent_2$, trained as it is by "the others" to see the world as they see it, holds back, so to speak, and assesses our feelings and participations, comments on them, allows or disallows further engagements by $consciousness_1$.[58] To locate my position in a larger context, I believe this sort of dual cognition, well understood by Hegel, is something that occurs virtually all the time and, thus, not simply when we deal with absent figures ("real" or "fictional"), accounting for our being both aware and self-aware in our daily activities, in being at once utterly caught up in a particular situation and having a simultaneous, second awareness of the self-same situation that is more cautiously and suspiciously contemplative of it, expressing to itself ($agent_2$) as well as to $agent_1$ all sorts of concerns *about* what one is doing and experiencing, validating or invalidating such events according to intersubjectively sanctioned as well as personal criteria, and determining how these events are to be woven into the fabric of our past and anticipated lives.[59] We may think of dreams, as manifestations of $consciousness_1$ unbridled by

consciousness$_2$, for our belief in the extramental, existential claims that dreams make on us is normally unqualified. It is also worth remembering that young children often respond to fictions solely with consciousness$_1$, as my daughter as a five-year-old reacted, terrified and screaming, watching a film in which a house was burning down. My contention is that we never, in fact, lose consciousness$_1$, although as adults we may (wrongly) shed the belief that it is, in fact, always present.[60]

One important implication of my position is that artistic expression and the experience of it is always *about*, an attempt to "comprehend," our real world. Thus, I believe that part of what one should mean by "art," as opposed to craft, is that which "comments on," interprets, if only by reaffirmation, the way in which, in our everydayness, we view a sector of that world. (Craft will reveal things about the world too, of course, but usually it will not attempt to do this intentionally, as it were. I concede that there are intermediate cases about which it would be difficult to say whether an object was art, craft, or both.) What I mean by the phrase "our real world" is vague, to be sure. At this point I shall only assert that the referent or signified of the artwork is, according to consciousness$_1$, an independent existent thing with its own essence or nature. We, therefore, should not regard it as just a concept or image merely in a person's mind, as the thought theorists maintain, but as a being in its own right (e.g., a particular young woman wearing a silver earring, *out there*) as well as a being with a meaning or significance that one takes implicitly to pertain to one's life, to its purposes, to the sense that one makes of the fundamental direction that one feels it has, even if one is not pleased with that direction. I see the young woman (depicted by Vermeer, for example) as open, sensitive, kind, accepting, and caring; therefore, as gently seeking from me a stronger resolve to implement these virtues in my own life. (Other interpretations are entirely possible and do not contradict my point that I have identified a crucial aspect of the way in which most viewers begin to approach a represented being like the woman.) Consciousness$_2$ partially contradicts my experience and reminds me that I am only looking at a picture and that, therefore, she is "out there" only as a representation. The net effect, however, is not the sheer overruling of my first-person consciousness by my rational, third-person consciousness, for the sense or felt-meaning

[64]

that I derive from the experience of the signified being continues to reverberate in my world. She endures for me as one who might now exist, might have existed, or could in the future exist, again, in my world.[61] She is able to do this even if her possible realizations might – as they almost always would – manifest themselves in very different forms, thus with features that would no longer be recognizable as hers, as "she" could be a "he" or an animal, or even an inanimate object. For although it is the individuated cluster of features of that woman – not simply her wide open, brown, glistening eyes, or her orange-red parted lips, but these features and countless others related to each other in precisely the manner they exhibit – that has a special, affecting significance, yet some substantial part or all of what has moved or persists in moving me about her presence could be analogously, *but not identically*, reproduced in me by another, quite dissimilar, (again) individuated cluster of features in a different picture, art form (e.g., a poem in which a person or event is evoked), or even by a person with whom I have become acquainted. (Were it possible for one artwork of the same kind [e.g., a different painting of a young woman] or of a different kind [e.g., a sonnet about a young woman] to affect me *exactly* like another artwork, then I would welcome such interchangeability. But I do not do this. I want to view, for example, *Vermeer's* depiction of the young woman with the earring, not another depiction or a sonnet expressing similar sentiments.) In short, I am affected by that Vermeerian woman as a specified or particularized type and not simply as a token of an exhaustive type (in which that type would be "everything" to me and its particular token, the woman in all of her singularity, would be merely an occasion for leading me immediately to her concept, an all-encompassing and reductive, typal meaning). Moreover, she continues to exist in my world, even after the judgment of consciousness$_2$, although in a peculiar way. She is as an enduring meaning-presence who could have been at one time fully and tangibly "out there," might now be somewhere, somehow "out there," or who could exist in my future as an immanent possibility, hence a being truly able to be, although most likely in a concretion different from the one that I have just experienced. Finally, although consciousness$_2$ constantly reminds me that the woman is not "out there" (i.e., independent of me as "real people" are), she nevertheless endures in a double sense as real even

[65]

according its critical, third-person orientation, for as an important meaning-presence (as opposed to independent existent), this being is (a) not prevented from reinforcing a certain sense and direction of my whole life and, therefore, (b) affects the quality of the immediacy, even in a subtle way the very nature of the existentiality, of things in my everyday activities.[62] (Compare a situation in which you are fully and happily involved [e.g., repairing a child's bicycle] with one in which you undertake the same task suffering, for whatever reasons, considerable depression. Isn't the very being or existence of what you are working with correspondingly qualified by the nature of the disposition you assume in your respective engagements? If it is insisted that the quality of one's apprehension of a thing has nothing to do with its mode of existence, doesn't that objection once again presuppose the subject-object dualism that I have been challenging?)

Another point that may be troubling in the account that I have thus far provided of the ontological status of fictional beings is its relevance to all forms of artistic expression. Should we view and attempt to comprehend a Dürer etching in the same way that we would, say, a painting by Paul Klee? Additionally, should we even approach and try to make sense of, say, an eleventh-century painting by Hsü Tao-ning, an elegy by Rilke, a novel by Tolstoy, a ballet by Stravinsky, or a radio play by Samuel Beckett in the same way as we would the Dürer etching? In our current, postmodern academic climate, in which examples of "otherness," "difference," "borders," and "the marginalized" are constantly brought to the fore in order to "rupture" complacent thinking and "dismantle" broad, essentialist, cultural generalizations, it will probably seem anachronistic, naïve, and even quite irritating to ask the reader to embrace the proposition that all art (qua art) refers to our world and that the beings depicted by art are indeed taken by all of us at some level to be not simply *about* our world, but to be *in* and *of* it.

Such an objection, in a certain way understandable, nevertheless misses my point. Of course, I agree that all of the works just cited demand different "approaches" for their proper understanding and appreciation. But here a word like "approach" may mislead us into a merely verbal dispute because my larger philosophical point does not pertain to matters of interpretation, but to more general, onto-logical, issues – namely, to what one believes something to be in its

being, what its status in our world truly is. Thus, while a painting by Hsü Tao-ning and an elegy by Rilke respectively require for their adequate comprehension tremendous amounts and different kinds of background understanding, both historical, cultural, and aesthetic, they are both, I would maintain, *about our world* and not merely self-referential or self-contained or "about themselves." (No major thinker whom I know of, either Western or Eastern, Middle Eastern or African, ever really challenged this assumption of his or her culture about its own artworks until the eighteenth century.) Although this sort of claim about the referential or mimetic aspect of all art is controversial today, the much more controversial contention that I am putting forth is that when properly immersed in the world of an artwork, we actually take it (e.g., what is depicted in Hsü Tao-ning's painting) as we gaze at it, or the moral characterizations of Shakespeare's lover, as we read his work, to be about something or someone real, not simply in its or the person's nature or essence, but also in their very existence, to the degree that we hold in check our third-person mode of awareness, our consciousness$_2$. I have also asserted, controversially, that even after consciousness$_2$ insists on its existential judgment, we still permit ourselves to regard the depicted beings as real in the dual sense that they partially determine what we commit ourselves to as truly significant and at stake in our lives as well as shape the very "feel" or being of the other things with which we are directly involved – not just what they are, but *how* they are and thus the degree to which it can be said *that* they are.

I should add that I choose to concentrate on and to illustrate my philosophical claims about the realm of painting, as opposed to the other art forms, not because it appears to me to demand a certain kind of aesthetic preeminence, but because I have a special love for so many of its exemplifications and because I sense that the power that static images have on so many is less well understood, more puzzling than, say, the power that films or plays or even novels have on us. Additionally, although at the philosophical level on which I am writing many of my conclusions apply to each and all of the arts (and I am hoping that the reader will readily see the relevant applicability), I nevertheless need to confess that more specifically useful, differentiating, and nuanced approaches to them individually would require kinds of knowledge and understanding of them that

I simply do not possess. Of course, this work would become much longer, more complex, and even more ambitious than it currently is, if I had the requisite competence to undertake such a thing.

Now if I am right about the several respects in which artworks generally and paintings in particular should be regarded as mimetic, then our acceptance of them would seem to go a long way in explaining why fictional beings can and often do matter to us, and not just "at all," but very much. For if (a) they are real in the senses just mentioned, (b) we do truly feel and deeply believe (whatever we might at certain moments say to the contrary) that there is something of great importance at stake in the way that we choose to conduct our lives, and finally (as I argue at length in Chapter 3), (c) other people should be understood as having an ontologically special place in our world, not simply as "the others" whom I enjoy or dislike and with whom I must deal, but as beings essential to who we are (as individuals and as humans), then fictional beings do make a difference to us. In fact, at some points in our lives, they can make a difference that makes all the difference.

A second quarrel that one may have with my ontologically mimetic view of artworks is that even if we are at times drawn into and in some sense regard as real their depicted realms, or subworlds, we are, nevertheless, also often estranged from those worlds. Isn't there something right about the famous prescription of Edward Bullough, following Kant, that we should maintain an "aesthetic" or "psychical" distance on an artistic creation and that artists themselves sometimes deliberately attempt to ensure this? After all, an artwork can be framed, figuratively or literally, in such a way as to undermine our childlike disposition to be totally immersed in its subject. In Joseph Conrad's *Heart of Darkness*, for example, the narrator of the story is an unnamed man on a yawl who retells a story that he had heard from Charlie Marlow, who in turn recounts experiences that he had in an African jungle years earlier. At the beginning of Plato's *Symposium*, Apollodorus speaks to a friend about a conversation he had a few days earlier with a man named Glaucon, who in turn had recounted to him by Aristodemus an event that he had attended years earlier. Thus, we readers begin to learn about the now-famous symposium on the nature of Eros at three narrative removes from a direct participation in it, and at the remove of time

itself. Or consider how paintings generally can be made or presented. The size, scale, or framing of them, or the density of their paint, brushwork, unexpected color contrasts, or perspectival distortions often inhibit our entry into their subworlds, forcing us, it would seem, to withdraw from their "realities" to consider other aspects of the works and other issues that their creators wish, consciously or otherwise, to draw to our attention. And we cannot forget Bertolt Brecht's dramaturgical doctrine of "defamiliarization" [Verfremdung] that calls for a new kind of theater that would at once invite, but later challenge, our naïve partaking in its subworlds, in order to remind us of the allurements of fantasy and our moral and social need for a critical corrective to them.

The concern about the philosophical implications of the phenomenon of aesthetic distance is not inappropriate. Clearly, if only by virtue of our recognition of the metaphysical, transparent barrier that precludes spontaneous responses from the figures (or patterns) in an artistic subworld, we do virtually always have psychological and epistemological distance on it. Clearly, too, the artist can by various means draw our attention to and intensify our sense of that barrier. Such awareness on our part is a function of consciousness$_2$, which, as I have said, constantly qualifies the uninhibited engagements of consciousness$_1$. Yet, admitting that consciousness$_2$ plays this kind of overseeing role does not entail that the claims of consciousness$_1$ are thereby nullified. The two modes of our awareness are engaged in a dialectic with each other[63] and with their perceptual target that, at least with respect to important artworks, never appears, and perhaps never should appear, to be definitively terminated. If Conrad creates a narrator who retells a story originally told by Marlow, the reader is compelled to see the subworld of *Heart of Darkness* from more than one perspective, inevitably complicating, in contrast to more straightforwardly presented tales, his or her understanding of what took place in the African jungle and what the tale ultimately means. That subworld becomes more mysterious, invites additional questions, and requires of the reader a more astute imagination and more nuanced interpretive decisions. The realm of the "heart of darkness" does not ipso facto, however, become something separated from our real world, thus residing in a domain contemplated just by itself, depicted in a tale told solely "for its own sake." A similar consideration,

I believe, applies to Plato's *Symposium* and, mutatis mutandis, to the materials, chosen style (be it linear perspective or cubist), or formatting of paintings; to the self-deconstructing possibilities inherent in theatrical pieces; or, for that matter, to any other kind of artwork that aims at qualifying the kind of stance that one should finally assume with respect to represented objects. They are (if I am right) always apprehended as essentially and existentially real.[64] Hence, our greater epistemological sensitivity or sophistication vis-à-vis certain artworks, due to both the artist's and our own efforts, leaves intact and even supports our deepest ontological commitments.[65]

A third obvious objection that may be raised against my realist position concerns the significance of so-called abstract art. The reader may be inclined to say, even to strenuously assert, that such art is not only *not* taken by itself to be something real, but that it is not even taken to be *about* something real. Of course much has been written in the twentieth century about abstract art and its alleged non- or antimimetic properties. I simply claim at this point that this way of viewing artworks is fundamentally mistaken, appearances and countless commentaries to the contrary notwithstanding, that abstract art also is *about something* in our world, and that its referents are themselves indeed regarded by consciousness$_1$ to be real, in the senses that I outlined earlier. Obviously, I must at this point solicit patience concerning the justifications for my odd- if not perverse-seeming claims about abstract art, for they require a more searching, phenomenological investigation than I have thus far provided of what objects in the world mean to us, what people mean to us, and what and how depictions of objects and people mean to us – the subjects of Chapters 2, 3, and 4, respectively.

So let me assume that the reader is "with me" in my theorizing about fictional beings, even if still with some skepticism. If that is so, and to the extent that it is, we have taken an important step toward explaining why fictional beings are able to have the power that they do for us. Of course, there is so much more to explain about their hold on us. Even if I am right that we are at one level disposed to regard fictional characters as real beings, as long as we fail to understand *why* we care about beings in the first place – why they matter to us, make a difference to our lives – the fundamental significance of both "the fictional" and "the real" remains for us vague and abstract.

Before I attempt to give responses to this important and difficult question, we first need to look at a simpler kind of relationship, that between ourselves and *things*, for they too "speak to us" (in ways that I believe have been overlooked), and in artistic representation they too assume for us more than conceptual significance, more than mere, decodable symbolization.

NOTES

1. *Proceedings of the Aristotelian Society*, suppl. 49 (1975); pp. 67–80.

2. One recent and useful statement of the paradox may be found in Robert J. Yanal's *Paradoxes of Emotion and Fiction* (University Park, Penn.: The Pennsylvania State University Press, 1999), especially p. 11. See also Jerrold Levinson's "Emotion in Response to Art: A Survey of the Terrain," *Emotion and the Arts*, eds. Mette Hjort and Sue Laver (Oxford and New York: Oxford University Press, 1997), especially pp. 22–3.

3. Jerrold Levinson, "Making Believe," *The Pleasures of Aesthetics: Philosophical Essays* (Ithaca, N.Y.: Cornell University Press, 1996); Barrie Paskins, "On Being Moved by Anna Karenina and *Anna Karenina*," *Philosophy*, 52 (1997); Colin Radford, "The Essential Anna," *Philosophy*, 54 (1979); Michael Weston, "How Can We Be Moved by the Fate of Anna Karenina?", *Proceedings of the Aristotelian Society*, suppl. vol. 49 (1975); and Peter McCormick, "Feelings and Fictions, *Journal of Aesthetics and Art Criticism*, 43 (1985).

4. See especially "How Can We Fear and Pity Fictions?", *British Journal of Aesthetics*, 21 (1981): pp. 291–304; also *Fictional Points of View* (Ithaca, N.Y.: Cornell University Press, 1996).

5. See endnote 1.

6. *Biographia Literaria*, from *Collected Works*, volume 7, part 2, Chapter 14, p. 6 (Cambridge: Cambridge University Press, 1920), cited by Yanal, who rightly points out that, technically speaking, Coleridge is a thought theorist, since in another work he asserts that "Images and Thoughts possess a power in and of themselves, independent of the act of Judgement or Understanding by which we affirm or deny the existence of a reality correspondent to them." Letter to Daniel Stewart (May 13, 1816), ibid., note 2.

7. Radford asserts at the end of the article cited in endnote 1: "I am left with the conclusion that our being moved in certain ways by works of art, though very 'natural' to us and in that way only too intelligible, involves us in inconsistency and so incoherence" (ibid., p. 78).

8. As Yanal asserts, "[t]he most viable solutions to the paradox [of fiction] on the contemporary scene are [Kendall] Walton's theory of quasi-emotions and thought theory." By implication, the realist alternative that I put forth is, according to Yanal, barely viable or not viable at all. In any case, he does not take the trouble to discuss it.

9. *Being and Time*, trans. John Macquarrie and Edward Robinson (London and Southhampton: SCM Press, 1962).

10. Here I write "*neo*-Heideggerian" because although the ontology I refer to is definitely that of Heidegger, he has little to say about fictional beings in *Being and Time* and, as mentioned in the Introduction, nothing to say about the ontological status of artistic representations. Thus, although he does not himself in *Being and Time* develop a theory of the place of fictional artistic beings in our world, his extraordinarily original phenomenological work suggests a new way for us to understand the kind of claim that fictional or "nonexistent" beings have on us. A more substantial critique of the Cartesian subject–object epistemology and ontology than I could possibly present in this chapter may be found in *Being and Time* itself, as well as in other, later works by Heidegger. Much of his writings implicitly or explicitly challenge the absoluteness of the Cartesian ontological perspective.

11. *Mimesis as Make-Believe: On the Foundations of the Representational Arts* (Cambridge, Mass., and London: Harvard University Press, 1990). Walton thus "solves" the paradox of fiction by denying its first proposition (see p. 41), for he claims that we do not really have full-fledged or genuine emotions vis-à-vis beings or events we think fictional.

12. Another philosopher, Marshall Cohen of the University of Southern California, characterizes Walton's book on its flyleaf as "one . . . of the few genuinely distinguished contributions to aesthetic theory published in the last decade or two." Rob Hopkins, writing in *Philosophical Books* XXXIII, no. 2 (April 1992): pp. 127–8, claims that "*Mimesis as Make-Believe* is a splendid achievement, with a rigour, breadth and ambition desperately rare in the philosophy of the arts."

13. *Mimesis as Make-Believe*, p. 102.

14. Ibid., p. 42.

15. Ibid., p. 219. "Stephen [an imagined example of someone engaged in a game of make-believe] is merely pretending to refer to something and to claim it to be a ship. This frees us from the supposition that his demonstrative actually picks anything out, or even that there is anything to which he pretends to refer. He only pretends that there is something which he refers to and calls a ship. Yet his use of 'that' is easily explained. In pretending, one copies the behavior one pretends to be engaging in. In pretending to refer, one naturally uses words and gestures – demonstratives and pointings, for instance – that are ordinarily used in referring. We are freed also from the obligation to find a truth that Stephen asserts, or for that matter a falsehood, or even a proposition, true or false, that he pretends to assert. 'That is a ship' does not express a proposition; Stephen only pretends that it does." Walton's statement could be construed to mean something even more extreme than I am attributing to him, namely, that fictional beings aren't even in one's mind as images, thus that we feign even their mental existence. Yet if that is what Walton means, it can't be right, for otherwise in fictional contexts we would be engaged with nothing

whatsoever, and thus Walton would have no subject about which to pretend and no target for pretended emotions. In any case, the quotation cited next, endnote 16, indicates that his real position is not so extreme as it just appeared to be.

16. Ibid., p. 36, endnote 24. My emphasis. Later he asserts, "Imagining aims at the fictional as belief aims at the true. What is true is to be believed; what is fictional is to be imagined. There is a persistent temptation to go one step further and to think of fictionality as a species of truth. (Imagining might then be regarded as a kind of believing, one appropriate to this species of truth.) . . . I resist. What we call truth in a fictional world is not a kind of truth" (p. 41). See also his Chapter 10, "Doing without Fictitious Entities." And see endnote 33 for my explicit response to this statement.

17. Ibid., p. 196.

18. Ibid., p. 202.

19. Yanal, *Paradoxes of Emotion and Fiction*, p. 75, my emphasis. See also his more complete discussion of "objectless emotions," pp. 72–5.

20. Walton, *Mimesis as Make-Believe*, p. 393: "Charles is engaging in pretense. He makes it fictional of himself that he proclaims the imminent arrival of a slime in a spirit of desperation appropriate to the occasion." Earlier on p. 219: "Stephen [the imaginary person referred to previously (see my endnote 15)] is not trying to fool anyone, of course, when he pretends." On p. 273: "True, these worlds [of Anna Karenina and Emma Bovary and Robinson Crusoe] are merely fictional, and we are well aware that they are."

21. Ibid., p. 243.

22. Walton concedes that Charles may in some cases fear something, but it is certainly not the slime: "My claim is not that Charles experiences no genuine fear. He does not fear the slime, but the movie might induce in him fear of something else. . . . If Charles is an older moviegoer with a heart condition, he may be afraid of the movie itself or of experiencing it. Perhaps he knows that excitement could trigger a heart attack and fears that the movie will cause excitement – by depicting the slime as being especially aggressive or threatening. This is real fear. But it is fear of the depiction of the slime, not of the slime depicted" (p. 202). Yet, why would older Charles with a heart problem worry about a movie subject if he knew that his anticipated excitement would be sheer pretense? Doesn't fear of the depiction of the slime under normal circumstances presuppose a prior and more gripping fear of the slime depicted? (I say "under normal circumstances" because, as Walton argues, it is possible that I might fear something other than the slime, such as heart palpitations that could occur while viewing images of the slime. But then this qualification simply reposes the central question: what would induce Charles's heart palpitations in the first place?) Bijoy H. Boruah in *Fiction and Emotion: A Study in Aesthetics and the Philosophy of Mind* (Oxford: Clarendon Press, 1988) makes a similar mistake, I feel, when he claims the emotions of respondents to artworks to be insincere and therefore pretenses. Colin Radford (see my endnote 1) concedes that

respondents' emotions are genuine but are misdirected and, therefore, irrational. According to this last view, one should believe that Charles does fear the slime, but since the slime does not exist and he knows this, his reaction is simply logically unintelligible. My counterclaim is not diametrically opposed to Radford's, but I try to show that Charles's fear of the slime has a certain and psychologically necessary rationality to it and that comprehending that peculiar logic will lead us to the solution to the paradox of fiction.

23. This is not to say that we have no sense of pretense in our involvement with fictional beings but, again, to the extent that we pretend their existence, we don't believe in them; and to the extent that we believe in their existence, we don't pretend. Yet, both ways of relating to fictional beings are present in our experience, and always so, I maintain.

24. "Spelunking, Simulation, and Slime: On Being Moved by Fiction," *Emotion and the Arts*, chapter 2; eds. Mette Hjort and Sue Laver (Oxford and New York: Oxford University Press, 1997).

25. Ibid., p. 38.

26. Ibid.

27. Yanal, *Paradoxes of Emotion and Fiction*, p. 52. He also argues, persuasively, that a difference in cause (e.g., a real tornado versus a depicted scary extraterrestrial) for two discrete psychic events (e.g., of terror) does not imply a difference in kind (i.e., that one of the experiences is "not really" terror); see pp. 57–8.

28. I agree with Walton that in our looking at paintings – also when we are involved in other fictional contexts – there is not only a perceptual element, but also an imaginative element. It does not follow, however, as he tacitly and repeatedly infers from such facts, that the viewer sharply separates what she perceives from what she imagines, knows precisely which is which, and thus takes what she imagines to be merely imagined. Walton asserts: "The sounds produced by the flutist performing *Die Zauberflöte* seem to the listeners to be just that, while they imagine themselves to be hearing Papageno's playing." See his "Depiction, Perception, and Imagination: Responses to Richard Wollheim," *The Journal of Aesthetics and Art Criticism*, 60 (2002): p. 32. Walton's elucidation of our experience is not correct, I wish to assert. If one is steeped in the events of the performance, one first of all hears and imagines *Papageno's playing*; one doesn't simply imagine this and regard the experience as a total fantasy. It is only with a second consciousness, usually ex post facto and misleadingly, that one may come to think, "I heard the flutist in the orchestra pit, and I imagined that Papageno was playing." Now here it may seem that the disagreement I have with Walton on this issue, and thus the distinction that I am making, is insignificant, but I would reject such a response. The nature of a typical, direct involvement in an event of Mozart's opera is, in its immediacy, analogous to, say, our suddenly feeling an irritation that we might later identify as a shameful ethnic prejudice. An analogue for Walton's understanding of our archetypal viewing and listening experience would be the feeling one has about a tree stump that one points out

to a child just before proposing, "Now, Billy, let's pretend it's a bear." If my view is right, we are, usually and first of all, ontologically engaged, and, if we are so inclined, must make an effort to tell ourselves that Papageno is merely a fictional character whose role is played by an actor. If Walton is right, however, we are thoroughgoing simulators, are fully aware of our pretense in and throughout the very act of simulating, and thus must even pretend – wholly, not just partially – that we are ontologically engaged in the first place.

29. Yanal also makes similar points and at length, *Paradoxes of Emotion and Fiction*, pp. 58–61. Later in this chapter, as well as in Chapter 4, I have more to say about a person's emotional involvement in situations in which it is not possible, either physically or metaphysically, for him or her to do anything about them.

30. Walton, "Spelunking, Simulation, and Slime: On Being Moved by Fiction," p. 46.

31. Ibid.

32. *Philosophy and Phenomenological Research*, 51 (June 1991): pp. 383–7.

33. It is noteworthy that for all of the many pages that Walton devotes to characterizing the imagination in *Mimesis as Make-Believe*, he does not provide a positive theory of its nature: "What is it to imagine?", he rhetorically asks in his book on make-believe. "We have examined a number of dimensions along which imaginings can vary; shouldn't we now spell out what they have in common? Yes, if we can. *But I can't*" (p. 19, my emphasis). Why not? Because a theory of the imagination that fails to affirm the imaginer's credulity in the act of imagining cannot work, if what I have maintained throughout this chapter is correct. Thus, to imagine is in an important sense to believe. We always at some level struggle with "live [not dead] options" – to use William James's famous phrase – the very nature of which (as "live") derives from their close meaning-tie to our fundamental projects, and these in turn we take already to have roots in past, current, or anticipated *actuality*. Walton's reply to his critics ("Spelunking, Simulation, and Slime: On Being Moved by Fiction") which, as we have seen, touts a "positive theory" that links imagination to simulation theory in psychology, is unfortunately only a question-begging appeal to authority. He recommits this petitio principii fallacy when he claims that "I have identified enormous resources available to my theory for making distinctions of these kinds within the class of things serving as props in visual games of make-believe – for accounting for differences of 'realism,' in several senses among depictions, and for understanding different styles of depiction. The visual games in which pictures are props vary greatly in *richness* and *vivacity*." (See Kendall Walton, "Depiction, Perception, and Imagination: Responses to Richard Wollheim," p. 31.)

34. Perhaps it would be more accurate to identify this group of theorists as delusionists, because they believe that the person involved in the fiction doesn't realize that his or her interest in, say, Hans Castorp is not about this character at all, but about someone else (e.g., the reader's own brother) and who dwells

in a different order of being (i.e., the "real," everyday world). Yanal refers to these theorists as Factualists, but I don't believe that this term captures their intent accurately. In any case, the precise label is not of any great consequence.

35. Walton, *Mimesis as Make-Believe*, p. 204.

36. See also in Yanal's book, chapter 3, for a useful discussion of "Factualism" (one version of which I call simulation theory) and its many variations.

37. In *The Philosophy of Horror or Paradoxes of the Heart* (London: Routledge, 1990). Yanal, in *Paradoxes of Emotion and Fiction*, accepts this designation and articulates the thought-theorist position in expository terms that are correct, but which I condense. See especially p. 82 of his chapter 6, "Thought Theory from Coleridge to Lamarque."

38. Yanal lists many current subscribers to thought theory, including himself. He defends his version of this kind of theory at length in *Paradoxes of Emotion and Fiction*, especially in chapter 7.

39. Peter Lamarque, "How Can We Fear and Pity Fictions?", *British Journal of Aesthetics*, 21 (1981): pp. 291–304.

40. Yanal, *Paradoxes of Emotion and Fiction*, p. 97.

41. Ibid., p. 99.

42. Ibid., p. 104. Yanal also cautions that "the activity or inactivity of belief does not map onto another distinction that is commonly drawn, between occurrent and nonoccurrent beliefs. Occurrent beliefs are said to be beliefs a person holds that are at the moment before his mind. Nonoccurrent beliefs are beliefs a person holds that he's not, right now, thinking about. Occurrent beliefs may be relatively inactive. . . . Nonoccurrent beliefs may be fairly active. I believe I've lost my car keys, and while I succeed in not dwelling on the matter (the belief is made to stay nonoccurrent), it colors my day[,] for while nonoccurrent most of the time, it is highly active."

43. Ibid.

44. Ibid., p. 105.

45. My challenge is similar to the one that I posed to Husserl in my Introduction with respect to his assertion that in an experience of an artwork we are transported to an "ideal" world.

46. Ibid., p. 106.

47. Ibid., p. 108. The reference to Boruah is *Fiction and Emotion: A Study in Aesthetics and the Philosophy of Mind* (Oxford: Clarendon Press, 1988) pp. 92–3.

48. Ibid., p. 108.

49. "Fiction, Emotion and 'Belief,' A Reply to Eva Schaper," *British Journal of Aesthetics*, 19 (1979): pp. 120–30, and see especially pp. 123–4.

50. Cited in Yanal, *Paradoxes of Emotion and Fiction*, p. 118; from Walton, *Mimesis as Make-Believe*, p. 203.

51. Walton contends that we simply do not care about her: "Why do we care for Anna Karenina and Emma Bovary? Why do we take an interest in people and events we know to be merely fictitious? *We don't*" (p. 271, my emphasis). Soon he tries to qualify this extreme statement, but in a way that does not

diminish its bite: "But we do care – in a different way – about the experience of fictionally caring" (ibid.). This assertion logically entails that we care about an experience that itself involves no care whatsoever. Walton's psychologically strange contention is analogous to someone's saying that a group of wine lovers could find a way to cherish the taste of a particular vintage admitted by them to have in fact no taste.

52. There are numerous other examples to be found in other philosophers' works of the kind of ontological exclusivism regarding fictional beings that I am characterizing in this chapter. See, for examples, Charles Crittenden's *Unreality: The Metaphysics of Fictional Objects* (Ithaca and London: Cornell University Press, 1991) and Joseph Margolis's *Art and Philosophy* (Brighton, England: Harvester, 1980), especially pp. 252–63. Other analytic aestheticians write as though they wish to give *some* ontological status to fictional artistic beings, but being essentially positivistic in outlook, they are unwilling to go very far on their behalf. See as illustrations of my point, Terence Parsons, *Nonexistent Objects* (New Haven, Conn.: Yale University Press, 1980); David Lewis, "Truth in Fiction," reprinted in *Philosophical Papers*, volume I (New York: Oxford University Press, 1983) pp. 261–80; Peter Lamarque "Fiction and Reality," *Philosophy and Fiction: Essays in Literary Aesthetics* (Aberdeen, Scotland: Aberdeen University Press, 1983); Peter van Inwagen, "Creatures of Fiction," *American Philosophical Quarterly*, volume 4 (1977): pp. 299–308; and Nicholas Wolterstorff, *Works and Worlds of Art* (New York: Oxford University Press, 1980). A more recent instance of the sort of problem I am identifying is Eddy M. Zemach's "Emotion and Fictional Beings," *The Journal of Aesthetics and Art Criticism*, 54, no. 1 (1996), p. 43. He asserts in his essay that "An artwork . . . makes statements that are true *at* some possible worlds: . . . [But] merely possible worlds do not exist: only the real world exists; thus, the world in which Anna Karenina occurs (note: not 'exists'; only things in the real world exist, and Anna does not occur in the real world) is a nonexistent." In what sense does Anna *occur* and *yet not exist*? As a logically possible being? But how can a logically possible being be an *occurrent* being? Moreover and more important, although Zemach insists, as I do, that a sympathetic reader's concern for Anna pertains precisely to her, he does not (and I believe cannot) explain why we should care about a "nonexistent" (merely logically possible) being like Anna, especially this particular nonexistent, possible being.

53. The concept of intentionality is found in all of the major works by Husserl and is central to them. It refers to the distinguishing feature of consciousness, its characteristic of being always "of" or "about" something. For example, I am aware *of* the clouds that I just saw hovering over the lake perceivable from my cottage window. Thus, the clouds are related to and thus a part of me, but in a way quite different from the way my hand is a part of me or my observable behavior is a part of me. My awareness is *about* them, or, more precisely, *putatively* about them, since they themselves may just possibly not exist independent of my current consciousness of them, for I may right now be hallucinating.

But my cognition, veracious or false, is nevertheless and once again, referential, directed to something, *of* something other than itself, and therefore manifests "intentionality." Anscombe's famous essay is titled "The Intentionality of Sensation: A Grammatical Feature," in *The Collected Papers of G.E.M. Anscombe: Volume II, Metaphysics and the Philosophy of Mind* (Minneapolis: University of Minnesota Press, 1981), pp. 3–20. I wish to add that in my judgment, Anscombe in her example does not do full justice to her own characterization of an "intentional object," for to say that Zeus was not a mere thought or idea for the Greeks, but instead "ruler of all men and gods" is to beg the central question of the nature of the being to which the Greeks were committed. For Zeus was for them not just a description or content, sans existence, of their consciousnesses; he was, as ruler of all men and gods, a being in their *world*.

54. On this point Yanal and I agree, in opposition to Walton, that we don't *pretend* an observing persona for ourselves of the fictional world in which we're participating; we ourselves *are* the observers of it, or – here I make a bolder claim than Yanal does – are one of the characters in it, although, as I proceed to suggest, in a mode of existence that prevents us from changing the outcome of the events depicted.

55. See Chapter 4, in which I further discuss posited realities that I am unable to affect, especially pp. 169–75.

56. See *Painting as an Art* (Princeton, N.J.: Princeton University Press, 1987), Chapter 2, "What the Spectator Sees," especially pp. 46–7 and 72–5. It may seem that my own contention is simply a reiteration of Wollheim's, but he, like Husserl in his reflections on the significance of memories and anticipations, fails to carry his conclusion any further. It is one thing to say that there is a part of us that is "in the world" of the painting. It is quite another to spell out and embrace the implications of such a radical position. In the end, Wollheim's fundamental orientation, despite appearances to the contrary, is much closer to that of the thought theorist discussed earlier than to my own (i.e., that of Realism). See Chapter 4, pp. 165–8, where I return to and criticize Wollheim's position.

57. Yanal argues, consonant with Carroll's point cited earlier in endnote 32, that Walton's version of simulation theory cannot explain why some art engages us intensely and other art "leaves us cold" (*Paradoxes of Emotion and Fiction*, p. 115). Yanal asserts that the antidote to this problem is not "naturalism," but a "barrage of [mental] details" (ibid., p. 112) to whose existence or being we are indifferent. Again, why should a barrage of fine details (as opposed to something more general) make any emotional difference to us unless we take them to be real in the first place? Can't "abstract" artworks, thus creations lacking the multiplicity of details that Yanal refers to – like some of the very short, one-act plays of Samuel Beckett – sometimes be very moving?

58. Readers familiar with Plato's tripartite theory of the psyche may see a parallel between my position and his, for one can plausibly say that for Plato the "spirited" element of the psyche, *thymos*, is completely taken by and, therefore,

pursues or fears *as real* the creatures of its peculiar mode of cognition, which is both emotional and imaginative. We can see in the *Phaedrus* Plato's most graphic expression of the role that *thymos* plays in our lives. At one point in that dialogue, Socrates narrates a famous myth (246a–57b), in which the psyche is said to be like a charioteer (reason) controlling two horses, one black and ornery (our sensory appetites), the other white and often, but hardly always, noble (the part that affectively drives us to complete ourselves both individually and humanly, but that also fears its own and the entire psyche's death). From an ontological point of view, Plato sees the objects that the white horse strives for as intermediate between "the truly real" Forms or essences, apprehended by the charioteer (reason), and the changing particulars of everyday life (e.g., these tablelike things here) apprehended by the black horse (the sensory element). Thus, for Plato, the objects of cognition of the white horse are not at all real but nevertheless are regarded by it to be real, just as the black horse's sensed particulars are not real (again, according to Plato), although are taken to be so. So worried is Plato by the real-life implications of his psychological theory – believing as he does that our engagements with artworks will undermine our character and almost always will pervert our ability to know things accurately – that he condemns the arts generally and virtually banishes them from his ideal state, the Republic. I wish to say, on the contrary, that the ontological lines delineating the boundaries of the kinds of objects respectively apprehended by the three parts of the psyche – to the extent that I accept this division in the first place – should not be drawn as Plato imagines. See also endnote 16, where I suggest a parallel between Plato's theory of *thymos* and Heidegger's theory of *Seinkönnen*, that feature of our being that, Heidegger maintains, makes the deepest emotional demand on oneself. (I discuss his theory of *Seinkönnen* in the next chapter and in several places throughout the remainder of the book.) Another important difference between Plato's view of the imagination and my own is that for him our faculty simply projects possibilities of understanding that may or may not be objectively (and we could say, scientifically) true or of action that may or may not be ethically apt. He fails to notice, I believe, that the crucial poetic aspect of the imagination is not its apprehension (or failure thereof) of the true properties of things or events, but instead its apprehension of such properties as unified and animated by "persons" or what I call quasi-personalities. (This cryptic statement is clarified in the next chapter.) Finally, concerning Plato's fears about the dangers of artistic experience, cf. Chapter 5, p. 221.

59. One important piece of evidence, first put forward in our Western tradition by Plato in the *Republic* (see Book IV, 434d–41c), that we do indeed have two consciousnesses is the fact that we do not always act on what our impulses or emotions urge us to do. That we have all experienced this kind of psychic struggle entails that one part, that which seeks, wants, and wills to do something, is opposed by a second part that refuses to endorse such an inclination.

The presupposition of the entailment is that one thing (in this case, a psychic faculty) cannot act in two opposite ways at the same time and with respect to the same target. Therefore, there must be (at least) two psychic faculties. In reaching the conclusion that we virtually always have a dual consciousness, I am putting forth a claim that to contemporary philosophic minds, especially those in the analytic tradition, is controversial. Yet, it was also made and defended by such great thinkers of the past – in addition to Plato – as Aristotle, Pascal, Thomas Aquinas, Hegel, and Freud. My appeal to such authorities is, of course, not an argument, yet I believe it not to be evidentially irrelevant either. I choose not to defend my position further because doing so would take us too far afield from my primary task, which is to describe and explain why and how artworks, especially paintings, matter to us.

60. Cf. a recollection by Chuck Jones, co-creator of the cartoon character, Bugs Bunny, in an obituary for him in the *International Herald Tribune* (February 25, 2002). "'A small child once said to me: "You don't draw Bugs Bunny, you draw pictures of Bugs Bunny,"' Jones said, adding, 'That's a very profound observation because it means that he thinks the characters are alive, which, as far as I am concerned, is true.'" Cf. also, from the March 26, 2002, issue of the same newspaper, an article titled "Pride of Salinas: [John] Steinbeck at 100," by Stephen Kinzer: "'He was an animist,' [Thom] Steinbeck [the author's only surviving child] said of his father while reminiscing between public appearances. 'He would tip his hat to dogs. He'd talk to screwdrivers, start a conversation with a parking meter at the drop of a hat.'" Consider a final piece of anecdotal evidence of our credulity about things in the face of what we also believe to be otherwise. In a recent newspaper article concerning robotic pets, it was reported that their owners often become extremely attached to them: "'I get very sad when one of my dogs gets ill,' said [Harry] Brattin, 63, a motorcycle dealer from San Diego. 'When Diane's head stopped moving I felt bad. I truly felt grief.' Diane is an Aibo, a computer-controlled robot made by Sony Corp.," the reporter explained and thus "Brattin was grieving over a broken machine." "'I know it sounds really weird, he [Brattin] said.' Weird, perhaps, but not unusual," the reporter stated. "Aibos, the first mass-produced entertainment robots, have grown in popularity in the three years since their introduction, with more than 100,000 of the creatures – which cost from $850 to $1,500 – sold worldwide." See "Pets are robotic, but pride is real," Eric A. Taub, *International Herald Tribune*, May 9, 2002.

61. I have implied that consciousness$_1$ is to be wholly identified with a first-person perspective on the world and that consciousness$_2$ is to be wholly identified with a third-person perspective. Although such identifications are roughly correct, they are not precise. Consciousness$_1$ does have a limited capacity to view the world from the point of view of the other and, therefore, has, in a sense, a second-person and even a kind of third-person perspective. (This capacity explains why we can feel what another feels or play the role of another – fictional

or real – although, of course, some can do this much more convincingly than others.) Moreover, consciousness$_2$, while primarily apprehending the world from a third-person stance, does have the capacity to understand what consciousness$_1$ communicates to it and to that extent is not utterly oblivious to its other's point of view. Still, an "other-person" act by consciousness$_1$ is always from a displaced first-person stance; it is from the point of view of a particular person – for example, of what *I* imagine *him* to be feeling as I view with horror his shoulder twisting peculiarly as it hits the ground – and, therefore, is not precisely of the same epistemological kind as that of consciousness$_2$, which would be, to continue with the same example, an awareness that *one* suffers (or that *all people* suffer) pain when a shoulder is twisted in that way and that, therefore, *he* must be suffering. Thus, what consciousness$_2$ can do in its generalizable function comes at the cost of its incapacity to appreciate or suffer anything directly or immediately. See also Chapter 4, pp. 165–8 for more commentary on Wollheim's position.

62. My hope is that it is now clearer why, in the Introduction, I claimed that the traditional and virtually sacrosanct distinction between essence and existence, between what a thing and that a thing is, that many great Western philosophers have maintained – such as, and most famously, Thomas Aquinas and Immanuel Kant – needs to be rethought and qualified. I have more to say on this topic in Chapters 2, 3, and 4.

63. The dialectic or negotiation that takes place between consciousness$_1$ and consciousness$_2$ occurs, it seems to me, in every waking moment of our lives, and frequently we implicitly, and sometimes explicitly, call upon others to verify or falsify the claims of one consciousness or the other. They judge the sureness or instability of our grip on life and the world according to the degree to which what we say and do is "reasonable" or deviates from their accepted norms.

64. *Consciousness$_1$* also apprehends according to *how* a subworld is depicted (and not simply what it is and that it is). A photographically realistic painted scene, for example, would be perceived differently from a very similar scene depicted in the peculiar style of Edvard Munch. Thus, the conceptually, but not actually, separable form or mode of presentation of a work at the same time shapes the way that consciousness$_1$ experiences its content and being.

65. One may be also inclined to object that postmodern art tacitly presents a peculiar and significant challenge to my realist thesis insofar as its countless instantiations may play with various artistic styles simultaneously or parody all sorts of older forms of presentation, thereby disorienting us and nullifying any credulous inclination that we may have to regard the depictions as real. In postmodern artistic experiences, too, however – if there, indeed, are such things (for I am dubious that we live in a genuinely *post*modern age) – I claim that we still seek meaning-beings that pertain to our world, even if we are supposed to perceive its (alleged) ultimate unseriousness or surreality, its lack of any absolute values by which we might guide our lives. If we are led to take

the world as axiologically without foundation, then that apprehension is, at least for the time that we are steeped in the artist's vision of the world, "the way it is," and thus we are inclined to regard the nonabsoluteness of any particular value that seems to make a claim on us (paradoxically and irrationally) as our new, absolute, in-the-world-apprehensible reality. See also Chapter 5, where I revisit the subject of aesthetic distancing, especially as it is effected by an art appreciator's embracing of a particular theoretical model of interpretation.

Things in Our World

In the previous chapter, I argued that the fictional beings of artistic experience are much closer in significance and reality to the so-called real beings of our everyday lives than most analytic aestheticians, and perhaps even most reflective people in the West, would acknowledge. Because my claim is fairly radical and perhaps even counterintuitive, we need to return to the foundational issues that Heidegger has already investigated. Much of the remainder of this book will make sense only after I have called attention to and described the various modes or ways by which we relate to ordinary, everyday *things* – tools, furniture, fruit, apparel, and so on, as well as to people (to be discussed in Chapter 3). These things are indeed ordinary and everyday, yet, like the fictional beings with which we from time to time dwell, we rarely allow them to identify and fully reveal themselves and, consequently, to clearly announce the special kinds of gifts they present to us. Thus, I believe that we need to view "the world" (and ourselves) differently, to return to and recover the sorts of things that we have always in a way known, but that we have tended not to take seriously, regarding them instead as "unimportant," "insignificant," merely "subjective."

We have arrived at this kind of skeptical understanding of our own perceptual activity principally, I think, because of three dialectically related reasons:

1. the complexity, ambiguity, and interpersonal unverifiability of certain features of first-person experience;
2. the capacity of these features to lure us into places of unwanted disquietude; and

3. the viewing of these features through a deformative theoretical lens that has shaped the objects of perception in Western culture for several hundred years.

The first reason for skepticism about the correct articulation of our own personal experience is perhaps "obvious" enough, given the theoretical difficulties of our capacity to describe what is experientially unique to each of us from the first-person point of view.[1] The second reason for skepticism on the face of the matter may seem unconvincing. How, after all, can an ordinary dealing with, say, a piece of fruit lead me to a domain of profound unease? Yet, its place in my overall explanatory picture should become clear soon enough, in view of the phenomenological account that I provide of my experience of two ordinary objects. It is, in fact, the third reason, pertaining to the way in which we (multitudinous others, too) in the Western world[2] are inclined to view everyday things, that is the primary focus of this chapter. The issues that I examine are complex, and even their partial disentanglement requires me to resort to strategies and hypotheses that at first will appear unfamiliar and strange.

HOW WE VIEW THINGS

Let us consider this question: What is a *thing*? Consider a hammer, for example. We can say of it that it is an item in or of the world, it has a metal head, one side of which can be used for pounding nails into wood, the other for removing them; it has a handle of hickory, it weighs roughly 2 pounds, and so on. Or we might say that the hammer can be used as a weapon. Or as an item of sport. We could make up a game called "Throw-the-hammer." Or we could consider the hammer apart from the uses to which it may be put and say that "just by itself" it is a physical object weighing precisely 902 grams, consisting in part and at one end of steel molecules arranged in such a way as to have such and such tensile strength and in part of xylem, which in turn is composed of all sorts of complex carbon compounds, and so on.

These responses show two ordinary and basic ways of our understanding of things, either in terms of everyday, practical uses or in terms of scientific "objectivity," with a certain tacit priority attributed to the second way if the issue is "the reality" of the referred-to item. That is, we imply that the *true hammer* is the physical object that has all sorts of quantitatively determinable characteristics and that the other way of viewing the hammer, as a thing of various uses, presupposes merely conventional classifications of it, various kinds of conceptual and practical appropriations by members of our culture. The "priority," implied by such predicates for the hammer as "true" and "just-by-itself," is, in fact, ontological: the essence or nature of the hammer, we say, is not to be found in the ends to which it can be put, for they after all are variable – and presumably what a thing in fact *is*, its being, does not change from day to day – but instead in its stable, repeatably measurable characteristics.

According to Heidegger, the kind of response just imagined is not simply usual or typical but, in fact, historically necessary to the way in which we (Westerners at, least) tend to think about "things in the world." The explanatory sources of this disposition toward things are manifold, according to Heidegger, but for the purposes of this book I need to discuss only one crucial source – what has been called, and what I have referred to in various forms in the Introduction and Chapter 1 as the subject–object dichotomy or the representationalist picture of knowing, an epistemological and ontological split between a knowing subject and his or her world.

If someone were to ask us what "our world" consists of, one likely answer would be that it is a collection of "objects" of sorts – people, animals, mountains, oceans, vegetative life, and so on – a vast totality of entities that are *in* the world. Thus, according to this view, things (including ourselves) are in the world in a way that is not too different from the way in which furniture is *in* a room or water is *in* a glass; that is, one thing is "inside of" another thing in a purely spatial sense. From this way of regarding all things generally, it immediately follows that we think of ourselves as objects, too – very complex beings, to be sure, in multifarious relationships to things and to other people, and having intelligence, feelings, hopes, frustrations, and so on – but physical beings nevertheless, each one of which

being located in a particular place and at a particular time *in* this world.

Being physically in the world, we can also locate ourselves as individuals as "here," whereas everything else is separate from us and hence not "here," but "there." Being so, one question that immediately and naturally arises is this: how does each of us get to know the things of the world that are physically "over there"? The answer might seem to be that our minds (or brains), being contained in our skulls, and most of our sensory organs being for the most part contained there too, receive data conveyed to us by various physical processes (e.g., photons of light, waves of sound, pressures of mass) and then interpret these data according to conceptual "programs" or "systems" of experiential decipherment that have a partly neurophysiological, partly cultural basis. The mind, therefore, so it seems according to this way of thinking, is a sort of central processing unit within a box that draws in its "booty" from the outside and then sorts through it in order, among other purposes, to ascertain what is "out there" and useful to know. The mind is, according to this slightly theorized but basically commonsensical position, an extraordinarily complicated "thing" that stands in many kinds of physical relationship to all of the other "things" of the world. In Heideggerian terminology, the subject or self is taken, according to this commonsense perspective, to be a thing that is "just there"[3] in space and time, externally or contingently related to the rest of its world, which is also "just there" in space and time (of a greater magnitude).

Furthermore, if our relatedness to the world is constituted by our complex physical being acting as a receiver and classifier of data delivered to us from other physical things, then the "reality" or "being" of these latter entities would seem to consist wholly in their physical, quantifiable properties, whereas other, nonquantifiable characteristics, such as their "existential meanings" – for example, the special delight that I take in a bouquet of flowers that I have arranged – would necessarily be rusticated to the domain of "subjectivity," the place where we "add on" to our experience, but which tells us nothing about the "things themselves." After all, it will be and has been said (e.g., by Kant, as I indicated earlier, by my students in philosophy classes over the years), what's real are the physical flowers; the "meaningful pleasure" comes from me; it's obviously not in the flowers.

Nevertheless, Heidegger encourages us to recall and reflect on the way in which we actually experience things rather than continue unwittingly to place on the objects of perception a kind of theoretical overlay that distorts their meaning, inclining us to misapprehend their being as physical things "out there" in an earthly setting, hence "just there" or, to use Heidegger's terminology (merely) "present-at-hard" (*vorhanden*). So how *do* we "experience things"? Heidegger invites us to thrust aside our usual interpretive dispositions and to reconsider the manner in which we respond to and deal with a common tool, a hammer that is lying on a workbench.

If we conjure up this "thing" as an ingredient of a memory of a project in which we were engaged (e.g., putting together a broken picture frame), it is clear that the recalled hammer for us was not just a physical thing that we had initially gaped at and then indeed determined to be a hammer, and that, as a hammer, was somehow seen to be appropriate for the repair of a picture frame. No. The hammer was part of a context of tools (e.g., nails, pieces of wood, screwdrivers, saws, planes, etc.) that had an overall "place" in the workshop. The hammer had (and has) a meaning for us, made (makes) sense to us, as an item of use. It is *for* some task; it has a purpose. It is not, as we manipulate it, just an isolated thing: in our dealings with it, it is implicitly linked to nails and wood, and these "things" (which are not themselves just isolated entities either) constitute what Heidegger calls a "with-which" of involvement, and both the hammer and the related materials are in turn linked to a "toward-which" – that is, an immediate goal, such as the restored picture frame. In short, a hammer is not simply a physical object defined and limited by its surface, but is instead a relational being essentially connected to human concerns, to an "in-order-to" objective. In Heidegger's own words,

> In dealings such as this, where something is put to use, our concern subordinates itself to the "in-order-to" which is constitutive for the equipment we are employing at the time; the less we just stare at the hammer-Thing, and the more we seize hold of it and use it, the more primordial does our relationship to it become, and the more unveiledly is it encountered as that which it is – as [an item of] equipment. . . . The kind of being which equipment possesses – in which it manifests itself in its own right – we call "readiness-to-hand" [*Zuhandenheit*].[4]

[87]

Heidegger goes on to claim that this mundane illustration of how we involve ourselves with implements in our immediate domestic environment is revelatory of the place of "things" in our lives generally. Thus, our whole experienced world is populated not with "bare," self-contained physical entities that we must somehow decipher in their physicality and then to which we must give cultural or personal significance, but instead with beings that are for us already and essentially interconnected – if only tacitly – with one another, and together and ultimately, to our human concerns. Consider this statement by Heidegger about leather manufacture:

> In the work there is also a reference or assignment to "materials": the work is dependent on leather, thread, needles, and the like. Leather, moreover, is produced from hides. These are taken from animals, which someone else has raised. . . . So in the environment certain beings become accessible which are always ready-to-hand. . . . Hammer, tongs, and needle refer in themselves to steel, iron, metal, mineral, wood, in that they consist in these. In equipment that is used, "Nature" is discovered along with it by that use – the "Nature" we find in natural products. . . . Our concernful absorption in whatever work-world lies closest to us has a function of discovering; and it is essential to this function that, depending upon the way in which we are absorbed, those beings within-the-world which are brought along [*beigebrachte*] in the work and with it (that is to say, in the assignments or references which are constitutive for it) remain discoverable in varying degrees of explicitness and with a varying . . . penetration.[5]

Thus, the world of things that is revealed to us phenomenologically is one that in the first place makes sense because the very items with which we are involved, or in principle might deal with (from cabbages to kings, from microbes to galaxies), are in some way enmeshed in the web of our individual and collective purposes. What this suggests to Heidegger is that the self and the world are not two discrete things, but instead, at the deepest level, one relational being. A human being – Heidegger's term is *Dasein*,[6] an old word given a new meaning by him – is not then essentially a consciousness literally inside of a physical cabinet that somehow must process internal data and then project them outwardly in order to reconstruct "the world." We, therefore, should not think of ourselves as beings who are *in* a world that is separate from us. Nor should we think of ourselves as

by ourselves, *but possessing or having* a world. No, self and world always go together, thus not accidentally but essentially, which is to say that it makes no sense to think of a human being without a world.

Of course, this is not to say that I am (or was) literally the tree that I was gazing at a moment ago, but that the tree is what it is and how it is in part only because and to the extent that I am who I am. It is not simply "out there," awaiting my correct perception, but its essence or whatness and its very existence and thatness are a function of the ordering and integrating projects of my life. These projects, in turn, make sense only because they are part of a web of affective meaning and purpose that is not simply inside me, but, again, both "inside and outside of me," definitive of my whole "worldly" or global orientation. We can state even further that I am the total felt-framework of Significance (*Bedeutsamkeit*) that enables me to find a "place" for the particular worldly things that I ordinarily regard as in all important senses utterly separate from me. Or to put this in Heideggerian terms, I am the worldhood (or worldliness, *Weltlichkeit*) of the world.[7] Thus, although I am not the tree, the Significance structure or worldhood of my basic orientation to the whole of existence allows a particular birch to be experienced in the way that it is experienced, to count as a thing with a particular signature in my world. This is not simply to affirm the tautology that if I closed my eyes I would not see a tree. It is to assert instead that if humans for some reason became extinct, it would not be meaningful to claim that trees nevertheless would continue to exist, for trees are what they are, Heidegger maintains, insofar as we, given our interests and concerns, at once both define and apprehend them, even with respect to what it means for them "to be real" or "to exist" in the first place. Thus, to imagine the existence of trees in the future apart from human beings is either logically impossible or a kind of Orwellian "double-think" in which we project ourselves into an imaginary time period, perhaps floating in the atmosphere above the earth's surface, posit the existence of trees, and then say to ourselves, illegitimately, "well, humans are gone." If the reader insists that in "knowing trees" there must be some things that exist prior to our knowing them and that then become classified in the act of cognition "as trees," isn't this a mere speculation that is put forth ex post facto as the obvious explanation of his or her experience

of trees – an hypostatizing of that about which one does not and cannot know anything whatsoever? To express Heidegger's and my own position broadly and in slightly different terms, human beings collectively and in their essence *are the world* in its essence (although not in its totality). The same may be said, mutatis mutandis, about us individually: each of us does not merely relate to, possess, or find him- or herself in a world; each of us in his or her essence is at the same time his or her own particular or specific worldhood or Significance, which is the totality of our meaning-possibilities on the basis of which we care about and conduct our lives. Or, more simply, from an individual and collective standpoint, our nature *is* being-in-the-world, where the preposition "in" should be regarded as an existential term, signifying "inhabiting" or "dwelling-with."[8]

But quite apart from Heidegger's claims about the self's supposed being-in-the-world, does he have a warrant to assert that our ready-to-hand (*zuhanden*) experience provides us with a better access to "reality" than present-at-hand (*vorhanden*) experience? Isn't Heidegger simply characterizing *a* way in which we may "take" the world? Is it correct to infer on the basis of our phenomenological evidence that that is the way things "really are" – not in themselves, but as they must be for us humans? Does this mean that the physical world consisting of things that are present-at-hand are simply "not the real things"? So modern science, broadly conceived, does not provide us with knowledge of what is, but only with a kind of misleading abstraction from our experience and then reifies that abstraction? If my dealings with the hammer in pounding nails are "the real thing," what would the hammer be if I were to use it as, say, a weapon? Should we say that weaponhood characterizes the thing's being, too? Suppose other people from another culture or an ancient epoch dealt with it in a way that was totally foreign to me, would that equally be "the real thing"? So a thing's being, its essential nature, can vary, depending on the use to which it is put? A thing "θ" can be both "a" and "not-a," "b" and "not-b," posited states of affairs from which it can be concluded, if true, that nothing is just itself, but is whatever we at that time happen to regard it to be? So in a sense Bishop George Berkeley was right when he summarized his epistemology and ontology with the words, *esse est percipi*, to be is to be perceived?

Heidegger's position concerning the ontological priority of "readiness-to-hand" over "presence-at-hand" is clear: the former mode of cognition reveals the being of things; the latter does not:

> But this characteristic [readiness-to-hand] is not to be understood as merely a way of taking them [ordinary, everyday things], as if we were taking such "aspects" into the "beings" which we proximally encounter, or as if some world-stuff which is proximally present-at-hand were "given subjective colouring" in this way. Such an interpretation would overlook the fact that in this case these beings would have to be understood and discovered beforehand as something purely present-at-hand, and . . . [would have to] have priority and take the lead in the sequence of those dealings with the "world" in which something is discovered and made one's own. But this already runs counter to the ontological meaning of cognition. . . . To lay bare what is just present-at-hand and no more, cognition must first penetrate *beyond* [and thus be an abstraction from] what is [in the first place experienced, the] ready-to-hand in our concern. *Readiness-to-hand is the way in which beings as they are "in themselves" are defined ontologico-categorically.*[9]

Now while Heidegger's position may be clear, it does not, ipso facto, answer the objections posed a moment ago. Indeed, one could also raise more questions: granted that our lived experience of things is never of their sheer physicality, never divorced from all of their qualitative and purposive features; granted, therefore, that our lived experience is first in the order of *knowing*, it does not follow that it is also first in the order of reality or *being* (to use Aristotle's vocabulary). Except for astronauts, no one experiences the earth as round, and yet we know that it is (and we knew that it was so even before there were photographs of it from spaceships). What we feel about the earth geometrically in our daily involvement with it does not at all seem to correspond to the being of the earth. Moreover, can Heidegger prove that the hammer's "hammerness" lies in its readiness-to-hand and not in its presence-at-hand? How might he do such a thing? What would a proof look like?

The challenges just posed, like the ones expressed a moment before them, are altogether appropriate. Indeed, enormous, vexatious ontological issues are at stake here, to which Heidegger responds at length, and not simply in *Being and Time*, but in many of his later works. His reflections are often oblique, as it were: sometimes they

are phenomenological demonstrations that certain areas of our lives have been profoundly misunderstood – such as those concerning the nature of time – sometimes they are sustained logical critiques of those, like Descartes, who hold traditional, epistemological and ontological positions opposed to his own; and sometimes, especially in his later thinking, Heidegger writes in rather general, quasi-poetic terms that suggest that the philosophical underpinnings of modern scientific and technological thinking and practices cannot be adequate to their referents, given their many baleful social and environmental consequences, and assuming (on his part) that a proper ontology would have to be consonant with human, and overall planetary, well-being, and even thriving. However, and contrary to what may appear to be so, it is not necessary for me to take up the challenges that have just been put forth, interesting and important as they are, for, as I see it, it is Heidegger's picture of how we regard things generally, as either ready-to-hand or present-at-hand, that will prove most useful for my philosophical purposes vis-à-vis artistic experience, and not whether he may be correct about the ontological priority of readiness-to-hand over presence-at-hand. So I choose to venture into this forbidding ontological territory initially mapped by Heidegger only insofar as I am conceptually obligated to, that is, to the extent that viewing it properly will directly bear on the central question of this book: what, at the deepest level, does an artwork mean to us, and how does it mean?

THINGS AS MORE THAN JUST THINGS

I begin then with the Heideggerian assertion that what a thing (e.g., once again, a hammer) in its thinghood or being is, is problematic. I also accept his claim that two ways or modes of regarding a thing are readiness-to-hand and presence-at-hand. But do these two ways exhaust the modes of regarding a thing? Might there not be a third mode or even a fourth? Might not Heidegger, careful phenomenologist though he is (at least in *Being and Time*), have failed to acknowledge and describe whole dimensions of experience pertinent to his lifelong quest to answer the question of the "meaning of being" and pertinent as well to my central wish to clarify the nature of artistic

experience? Obviously the tone of my rhetorical questions signals my belief that Heidegger has committed one or more serious errors of omission. We can best approach this lacuna by first examining still another *mode* of being-in-the-world that Heidegger posits, namely, "with-being" (*Mitsein*), what I choose to translate as "co-being."

Up until this point in the chapter, my discussion has been concerned with how we deal with things. Of course, the world is also populated with other living beings, including and especially people, whom we don't deal with as just things, but altogether differently, for they are being-in-the-world with us and we deal with them as such.[10] In his discussion of how we come to know things, Heidegger also reminds us that "others" are, so to speak, always lurking in the background:

> The work produced refers not only to the "towards-which" of its usability and the "whereof" of which it consists: under simple craft conditions it also has an assignment [or reference] to the person who is to use it or wear it. The work is cut to his figure; he "is" there along with it as the work emerges.... Thus along with the work, we encounter not only beings ready-to-hand but also beings with... [a human] kind of being [*Dasein*] – beings for which, in their concern, the product becomes ready-to-hand; and together with these we encounter the world in which wearers and users live, which is at the same time ours. Any work with which one concerns oneself is ready-to-hand not only in the domestic world of the workshop but also in the *public world*.[11]

Just as things are not to be understood as individual, isolated entities, so, too, as the reader might imagine according to what I have already stated on Heidegger's behalf, other people are not to be understood as individual, self-contained beings who are simply "out there" "in the world," with the additional qualification of being "animate," "intelligent," "intending," "highly complex," "important to us," and so on, and whom we "get to know" through long experience and reflection. On the contrary and right at the outset of our *Dasein*, we regard the others as "like us" in sharing similar tasks or projects. The world of the others is thus a co-world (*Mitwelt*) enabled by our co-being. We meet them at work or in other social contexts. We have a specific kind of concern for them as special beings, a kind of relationship that is not in some way reducible to the sort of concern that

we have for the things with which and the activities in which we are engaged, for people, as I have said, are "worlds," and things are not.[12] The others are responded to, directly or indirectly, actually or potentially, at one fundamental level as beings who care about their own being and who point the way, or show us how not, to advance our own fundamental projects. Heidegger calls this kind of concern for others solicitude (*Fürsorge*; literally, "caring for").

Now the concept of solicitude refers to the primary way in which an individual person (*Dasein*)[13] manifests his or her co-being vis-à-vis "the others." We should remind ourselves that "they" (both "real" and "fictional") are not simply "out there," quite independent of us and now and then impinging on our lives, any more than things exist in this way. Our relatedness to them is much more ontologically intimate than that, and this is true even with respect to strangers. Perhaps one useful way to conceive of a basic linkage (or ontological bond) that obtains vis-à-vis others is with respect to their role-playing possibilities for us. Of course, our relations to them are enormously complex – we desire them, use them, fear them, feel affection for them, and so on. It seems to me, however (and this dimension has been rather neglected by philosophers, and even Heidegger has not made it explicit), that we also see them as "alternative selves," characters in the drama of our lives who exhibit to and for us various ways of defining the purpose of human existence as well as our own individual existence. Assume that ascertaining these purposes for our own selves is the central concern of our lives – Heidegger claims, as mentioned in Endnote 6, that what defines us as humans is the fundamental yearning to grasp what our being ultimately can mean to us, whether we wish to admit it or not – and assume as well that whatever "answer" to this concern that we arrive at is never something that we can regard as definitive and, thus, as no longer problematic. Under these assumptions, it follows that the others will always also be of concern to us with respect to the way in which they conduct their lives. Therefore, if my (neo-Heideggerian) view is correct, "they" (i.e., those who become beings of our attention) touch us not just once in a while and as figures in a passing adventure, but always, necessarily, and *essentially*. We are "co-" as regards them, to summarize, not simply in that we need their help or wish to avoid their real or imagined threats, and not simply in that we periodically

or even frequently feel sympathy for their concerns or oppose them, but also in that their basic endeavors are (as possibilities) *our* basic endeavors, that our question of who we are is ineluctably linked to our question of who they are, that, in other words, our being is defined by their being (or what we take their being to be) – and vice versa.

Yet, this is not the place to build upon Heidegger's rather sketchy discussion of co-being and its two fundamental manifestations, positive or negative solicitude. Nor is it the place to develop a theory of the ontology of role-playing, for that requires much of a whole chapter in itself (the next one, in fact). What I wish to suggest at this point is that the category of co-being is relevant to our understanding of how we relate to *"things"* (e.g., tables and chairs, rocks, clouds, etc.); in fact, that it should rightfully be regarded as another mode of our relatedness to them. I wish to assert, in short, that at an important level of awareness, we deal with things in the mode of co-being and, consequently, we apprehend them as *quasi-people*; they "speak to us" in a manner analogous to the way in which "the real others" speak to us.

Heidegger's overlooking of our co-being relatedness to things is all the more striking since one of his illustrative statements in *Being and Time* strongly suggests that co-being is indeed a form of our relatedness to things in our world and not just our basic mode of relatedness to our fellow human beings:

> As the "environment" is discovered the "Nature" thus discovered is encountered too. If its kind of being as ready-to-hand is disregarded, this "Nature" itself can be discovered and defined simply in its pure presence-at-hand. But when this happens, the Nature which *"stirs and strives,"* which *assails us and enthralls us* as landscape, remains hidden [i.e., is unnoticed].[14]

"Stirring and striving," "assailing and enthralling" are not words that appropriately characterize the domain of readiness-to-hand, for, as we have seen according to Heidegger, that is a world in which things are apprehended utilitarianly and, therefore, put to rights according to our practical projects. But the Nature that he here imagines (and of which we have all had experience) refers to something personified; it is a humanlike being whose significance is one of both

[95]

opposition and inspiration. Thus, although Heidegger has done so much to redirect attention to our living experience concerning the ready-to-hand aspect of things, to their instrumentality and felt inter-connectedness, as well as to their ultimate dependence for their weight and value on the domain of Significance by virtue of which we lead our lives, he has, I believe, failed to see that this very same world of things always and simultaneously speaks to us – although often quietly and without our acknowledgment, to be sure – in a completely different way, namely, as quasi-persons who challenge us in confirmation or denial.

I well know that here, once again, I risk straining the reader's credulity. He or she may not be fully averse to acknowledging Heidegger's intriguing claim that for us a "world" of things (e.g., an array of tools in a workshop) is not just a random distribution of isolated physical objects that we identify in a piecemeal manner, mentally collect, and then generalize upon as "a workshop"; instead, and in the first place, it is, according to Heidegger, a workshop with its own background. The separate tools are identifiable, he maintains, because a region of concern is first grasped, not just "the workshop" but a whole area of endeavor that is affectively linked with other areas of endeavor, which are in turn and finally grasped in relation to a broad, felt goal, an ultimate "for-the-sake-of-which" (*Worumwillen*), the core of the domain of Significance that gives sense to all of our concerns and aspirations. It is quite a leap, however, to go beyond this Heideggerian phenomenological description of the manner in which we apprehend things *for use* to one that regards them at the same time as enveloped – and not just once in a while (as in the example of Heidegger's personified landscape), but at some level always – by a very different kind of meaning, such that the things suddenly and seemingly inexplicably assume "personalities" that, like the people with whom we are closely involved, express to us, directly or obliquely, the existential struggles of our individual lives.

Here I am attempting to do more than merely describe another mode of awareness that we manifest vis-à-vis things; I wish also to answer this question: why do we find a thing (say, a chair) "ugly" or "beautiful" or "boring" or "provocative" or anything else (in a valuational sense)? In fact, why do we have feeling reactions, which at the most general level of abstraction may be characterized as either

adversive or aversive, to virtually any object that we encounter? It is tempting to respond, "well, since childhood certain of our feelings have become associated, in part through custom and training (to use Wittgenstein's vocabulary) with certain objects; special chairs, for example, remind of us of this person or that (delightful or painful) situation." Other explanations are, of course, also possible. But I suspect that whatever account the reader is inclined to provide, it will presuppose an ontology of an objective world of neutral things that assume certain emotional associations through a process of gradual subjective imposition. However, if my supposition about what the reader may be inclined to say is correct, it seems to me that from a phenomenological standpoint, this standard account does not properly capture our experience. It is instead simply a repetition of what we believe *must be* "the obvious explanation" of the origin of our affective associations.

Yet, if I look carefully at a green apple that rests in a bowl of fruit on the table beside my pen and paper, I do not see "just an apple" that I later discover to have certain feelings "attached" to it. The apple itself has as part of its experienced being those qualities that I am ex post facto (and wrongly, it seems to me) inclined to label "mere private events." To be sure, if asked to describe the apple, I would most likely at first give an "objective" statement, asserting that the apple is somewhat small, yellowish-green with many lighter (also yellowish-green) flecks, and sprinkled here and there with small brownish markings. If pressed for more information, I would probably continue in the same objectifying mode. If someone whom I trusted were to beg me to be less descriptively inhibited, to identify honestly all of the features that come to mind when I look at the apple, I would say things that are revealing, not only about me personally (more accurately, about my world) but, I believe, about the very nature of our everyday experience. When I look at the same apple, I find myself also thinking that the lighter flecks both tarnish it and yet make it unusual; the shininess proves that it is an apple; and the hole at the top (where the stem is missing) seems to be dirty and looks like a great, forbidding valley that one might see while flying in a spaceship over this oddly shaped "planet."

Suppose now someone were to ask me to imagine myself "to be" this apple. How would I freely describe myself? Something like the

following: "I look a bit odd to people; they have trouble 'placing' me. My lighter 'spots' (aspects) are strange; they mark me as different, but not diseased. The dark "spots" are my imperfections, thus my solidarity with other people. Inside I am tart, but ultimately sweet and satisfying (if you "take me in" properly), but I protect myself with a tough envelope; you must penetrate me – but carefully – if you are to get to know me at all. I was once a more dependent person than I am now, but my ties are gone. Now I have a navel-like hole in me; it is a badge of freedom. And yet it tells me that while I am free of that which originally nourished me, I risk unconnectedness. So long as I share a place with the other fruit in the bowl, my life makes sense. But suppose I were taken out of the bowl; where would I be then? My hole is also a great fissure in my life. It is, although I have trouble admitting this, central to who I am, it reaches down into my core, to that which is other than what I appear to be. I fear this hole; perhaps it will someday annihilate all that I have stood for. Does it contain the seeds of a new and very different kind of life?"

I provide this example to invite you, the reader, to reconsider your own experience more honestly and completely, to ask yourself if it is not true that things themselves "speak to you," not literally of course, but as objective incarnations of fundamental issues of your life. These expressive things do not utter philosophical abstractions such as, "I don't know how I will live my life in retirement," but felt, specific, systemic, complex, concretions of how we are faring (or how we take ourselves to be faring) in life. Moreover, and as I am implying, such communications are, I think, best thought of as originating from and being unified by quasi-personalities and not simply by corpselike beings in whom we are able to later dispassionately dissect their "sinews." For just as we are not (ordinarily) challenged and disturbed by mere word-sounds when we read a fine literary work, but instead by word-meanings, with presupposed intenders of them (even if consciousness$_2$ may remind us that author so-and-so is no longer alive), so too, it seems to me, things themselves stand opposed to us as intending, quasi-living beings, hence with personalitylike characteristics. The embodied issues do not appear to be just "out there" as mere markings inscribed on things, although here also consciousness$_2$ may insist that that is all they are. On the contrary, they "proclaim" themselves as kindred to us and, therefore,

[98]

they claim something from us. Perhaps only personlike beings, alter-selves, could present the issues that they do and how they do, with such unified specificity, and with such astounding pertinence to, and at least apparent insight into, our lives.

What do I mean by the terms person*like* or personality*like* or *quasi-living* beings? When we see an unfamiliar man acting in a certain way (such as gesturing in our direction, perhaps trying to communicate something) from a distance of a hundred feet away, we immediately perceive a person to be there – we do not merely infer on the basis of visual sense data that there must be a person "yonder." This person, for us, possesses "a mind," a consciousness that is the ultimate source or unifying ground of all of his actions and reactions. Now, of course, the apple that I described does not act at all as the (imagined) man did. But even if the man did "nothing" (e.g., sat motionless on a park bench), we would still apprehend his personhood directly and not regard him as "a thing." On the other hand, the apple is not only motionless, it also does not speak, and will, naturally, never robustly display the traits of a living, sensate being. Nevertheless, I wish to assert, in the mode of co-being, the apple, like the motionless man on a bench, without speech or gestures *communicates something to me as if it were a personality* (of the sort that I narrated earlier). How do I understand the nature of the source of this kind of message from the apple? As, it seems to me, something transmitted from a being that would say what I interpret it to be saying, were it able to talk. Now, although it may appear that my counterfactual formulation of the source and meaning of my experience ipso facto cancels the claim of there being any sort of personhood in the apple, such inferred skepticism is, I would say, a residue of our modern sensibility. Once again, I am appealing to what I believe to be the intimations of consciousness$_1$, for it not only takes so-called fictional beings to be real; it also, if I am right, regards inanimate beings, in its co-being disposition, as intendingly able to communicate something to us, although naturally not through direct speech or gestures. In short, the apple I contemplate is simply there as a piece of fruit. In a certain frame of mind, however, I find that it literally shares its message with me. (For very young children, it is unproblematic for kettles to dispute with frying pans. For certain primitive peoples, trees are able to tell them something of consequence. For a participant in the

psychological exercises of gestalt therapy, there is ordinarily little difficulty in imagining oneself to be an inanimate object, such as a flower or a knife or a watch, that in fantasy becomes animate, animated, and able to give voice to the object's complex and significant message to oneself, a message that the person almost always could not have anticipated and that he or she typically finds complex and enlightening.)

To be candid, I am not certain that when a thing is contemplated noninstrumentally and sensitively, it absolutely must be thought of, on the level of consciousness$_1$, as an expression of a "personality." With respect to the overall argumentation of this book, it does not much matter whether the reader takes the word "personality" to have ontological signification for consciousness$_1$ or merely metaphorical signification. (When I speak of the "quasi-personality" or the "personlike" character of things, the first prefix and the second suffix can, therefore, be interpreted to mean, "*similar in nature* to a real personality" or else, "*analogous to*, but not really the same kind of thing as, a real personality.") The point that I would more assuredly stand by is that we do have a certain kind of noninstrumental relatedness to things, and that in this kind of mode we do experience an embodiment of our own existential issues, even if they do not for us always coalesce into what may be literally called a unifying, intending consciousness.

I confess as well that my description of the apple does not prove the issue-nature of things for us, let alone the personhood that I take to lie behind, and to be in a way responsible for, it. Allow me to say that my experience of the apple is phenomenological evidence. It is a somewhat unusual way to regard our perception, although truly, if I am right, its novelty is not that at all. What I am attempting to represent is that which I believe we already know. I am thus struggling to overcome a form of cognitive suppression born of our third-person, commonsense, and modern scientific outlook, a sector of our centuries-old Western consciousness. Also accounting for the unapparentness of our co-being experience of things, and not unrelated to our misleading ontological standpoint, is our eagerness to try to navigate the world's complexity with a certain unsympathetic efficiency, just as (to use a somewhat extravagant metaphor) a farmer who sells his calves for immediate slaughter speaks of them

as a "crop" to be harvested, thus disallowing himself the full experience of being affected by the "spirit" and individuality of each of his soon-to-be-killed animals. Of course, I do not wish to affirm that those who see "just" tables and chairs are liars, but simply that they are not attending carefully enough to their full experience – etymologically, the attempt to pass through something perilous[15] – a deficiency that authors such as Proust and Virginia Woolf, among countless others, strove in their writings to rectify. What we all experience each moment of our lives is extraordinarily complex and in many ways elusive, replete with personal invitations that we either do not wish to acknowledge or else do not at that time need to acknowledge, given pressing instrumental objectives. So much of what we take to be "there" for us is, as William James insisted in *The Principles of Psychology*, a matter of our attention. We can focus on the instrumentality of the chair, or we can shift our gaze, as it were, to its quasi-personality. I believe (and now assume) that no one is totally devoid of this oscillatory capacity; nor in fact, it seems to me, is any normal person ever totally unaffected by things in their co-being aspect. Or, differently expressed, we can say that from the first-person point of view, we are all literally or metaphorically animists.[16]

Let us look more fully at co-being experience. I have just said that each thing that we encounter, if sufficiently attended to, will be felt to have a kind of personality for us. I have thus far referred to chairs and an apple, but the same point can equally well be made about parts of things. My focus could be the back of a chair, or just its shape: each of these parts then could become an attended-to whole with its own internal parts and, therefore, complex "personality." The back of the chair before me is, for example, too morally rigid or boring or straightforward. Upon closer inspection its dark wood grain proves to be uneven in both line and shadow, and therefore I experience it as "attractive," "deep," "nuanced," and "wise." Moreover, each thing (part or whole) is always experienced in turn as ingredient in a background that provides an interpretive context for that thing. The apple, besides being actually in a bowl of fruit, could be, let us imagine, either on a tree, lying on a sidewalk, or resting on a well-crafted cherry side table. We, therefore, could in such imagined contexts say that the apple is either where it "normally should reside" as a living being, an example of a careless loss of a

preoccupied shopper, or a being that is "natural and genuine." The particular target of attention, the quasi-personality who will speak to us, is therefore partially introduced, provided with a setting, and cognitively and affectively shaped by one's current, general disposition and orientation. The domain that guides our attention itself depends ultimately on the fundamental concerns and direction of our lives – in French, *sens* = both "meaning" and "direction." Our basic affective orientation is what might be metaphorically thought of as the warp of all individual experience. It provides the structure of Significance that binds together all of the apprehended beings that we are at the time engaged with and happen upon – the woof – of our lives. But just as the woof color of a woven item affects our apprehension of the color of its warp, the woof of experience also affects the character of its warp, for otherwise the fact that we can and do sometimes importantly change our stance toward the world would be unexplainable.

Each thing encountered then, I believe, mirrors some important value issue and, in a general form, all existential issues of our lives. It is apprehended as something that we seek or something we wish to avoid or, more usually, some problem or mystery of long-standing and disturbing implications. Some things will affect us more intensely than others, however, because they will have features that speak more clearly and precisely or more deeply to our concerns. A solitary willow tree on an open meadow may touch me more than an oak tree that is part of a grove in a city park. Of two couches in a furniture store, I may be more drawn to the one with the darker and more complex fabric, since both characteristics inform me of a concern and doubt that is consistent with my own nature and that promise a kind of understanding and reassurance. Moreover, the same object may speak to me in different ways on different occasions. At one period of my life, an old but intact wallet of burnished water buffalo hide may offer me an ideal of acceptance in looming old age; a broken wineglass may remind me of the pain and finality of certain personal mistakes. Experienced at a different time (and especially in a different context), the object may link with different preoccupations. I may still perceive the wallet as "gracious old age," but now identify it with the sacrificed buffalo, and therefore feel the wallet to be demanding gratitude and humility. The shattered wineglass may define a pattern

of light-refracting pieces that urge me to destroy what is unhealthy in a relationship and look for a different constellation of possibilities. And finally, the same object will speak to me in opposite ways at the same time: it will reinforce at once both the consonances and dissonances that I feel. Thus, the attractive leather of my wallet speaks to me of a satisfying old age, but the very fact that I seek this confirmation in the wallet implies that I have been anxious about that period of my life and about my death. If I inhabit the wallet experience fully, I will discover this dissonance, perhaps in the leather's creases or in the darkest areas of its brownness.

The examples that I have provided, illustrating as they apparently do "personal" concerns, may seem to imply that the co-being of the objects that we apprehend assume mere "psychological" traits. This reading would be too simple. For although the objects of our perceived world can, for my initial expository purposes, be regarded as "personalities" who objectify our own psychological preoccupations, it is all too easy from a theoretical point of view to infer then that "Reality" is still rightfully to be viewed as a neutral world of physical objects and that the "personalities" that I perceive in things are psychic impositions or projections upon them. But while the imagined preoccupations in my examples are somewhat narrowly sketched, I in fact believe that our involvements with things simultaneously reflect for us all sorts of other domains of concern in our lives (thus, e.g., the social, the political, the economic, etc.) and that all of these adjacent regions have ties to, and are instantiations of, our fundamental stance or orientation, our complex care for our whole world. The wallet of burnished leather speaks not just to a fleeting thought about how I hope to live in retirement; it is also related to an "ultimate concern" (Paul Tillich's phrase), how I may come to terms with my own death. The solitary willow tree that I perceive in the meadow affects me not only as a "lonely being," but also as something rooted in the earth, struggling to maintain its individuality and integrity, and requiring a political and economic policy that will ensure that this will be so. Indeed, the story of the felt object is still more complex than even these two examples may suggest, for the following three reasons: (a) the personality that speaks to us is always located against and, therefore, is distinctively shaped by some particular ground that is different from other possible grounds of meaning-involvement that I might

experience; (b) each thing explicitly focused upon, each "figure" or "personality," has its own distinctive parts, any one of which can be, I believe, always at least vaguely felt and which can in turn capture our attention and become a new focus of attention, a new "figure" or "personality"; and (c) in any single experience, our whole world is in a way manifested, but the target of a particular involvement, experienced in a certain time and thus governed by special preoccupations, will give our world a special feel and meaning that will likely obscure the larger pattern and conflicts of our lives. In sum, while on one level the things we deal with from moment to moment may be thought of as discrete, animated individuals who haunt our world and in some form or another always "speak to us" and deliver specific messages, at another level of apprehension these things may be viewed as offering us larger constellations of feeling-meaning, indeed, the very ground or basis of the more particular figures on which we happen to be focused. Therefore, if I am right, in each dealing with a thing we are confronted, in an extraordinarily condensed, consolidated, and peculiar form, with an entire re-presentation of our lives and (our) reality itself. The experienced thing is thus a microcosm, a sort of Leibnizian monad which – darkly, uncannily – reflects the current struggles of our being-in-the-world, and the Significance of our lives.

I mentioned above that the same thing at different times in our lives can reveal to us a different story. But even the same thing at particular moment "m" will not elicit a predetermined response, but one that could have been otherwise. Thus, I believe with Heidegger, that we preconceptually "take in" and freely endorse a context of meaning and then dis-cover (*ent-decken*) the things in that context. Normally, for example, when I walk into my garage workshop, I have a repair (ready-to-hand) purpose in mind and find the very things that I have expected lying there in their ineluctable, independent, purposive self-sameness. I could, unusually, enter the shop with a present-at-hand disposition, thinking in terms of gram weights or metal conductivities, and thus see not nails-as-fastening-instruments, but as bits of steel with such and such quantitatively measurable characteristics. Or I could, in a more contemplative mode, pick up the nails, feel at once their lightness and substantiality, and perceive not nails per se, but "nails-as," say, emblematic of the many relatively easy but

necessary tasks that I need to undertake throughout the weekend; or, absorbed even more fully in this same manner, I could lose virtually all contact with the instrumentality of the nails and dwell almost exclusively with them as co-beings. In each of these examples, I would have the capacity to do otherwise than what I eventually decide to do, for I can choose how to respond, both with respect to the mode of relatedness in which I dwell and what actions I will take within a particular mode.

Although we have a certain freedom and "response-ability" vis-à-vis the things we encounter, what we finally do has already been to an important degree shaped and determined by several complex factors that I have already alluded to and that require a few more words – but not many, for otherwise we will lose threads that run through the fabric of this entire work – about the nature of our co-being relationships to things, as well as our obligations to them, and to ourselves.

In the first place, there is what Heidegger labels our "ability-to-be," our potentiality-for-being (*Seinkönnen*) that calls us "to be," to develop ourselves with respect to our best, deepest, "most own" (*eigenst*) capacities (one aspect of which is proper and devoted solicitude for others).[17] Our *Seinkönnen* constantly makes a claim on us to "do better," to realize original, novel choices consistent with its calling, a lure of unspecified, perfect – therefore, never fully achievable – possibility. Our *Seinkönnen* accounts for, among other dispositions, why it is that we constantly strive in our lives – even if what we strive for may be misconceived and, therefore, not truly better for us, and even if we appear to be "not striving at all" – and why our most-own and novel decisions and actions seem to be in the long run the most rewarding ones. In the second place, there is an element of "necessity" in our lives, what Heidegger refers to sometimes as "facticity," other times as "thrownness" (*Geworfenheit*). While our *Seinkönnen* calls us at each moment to act in accordance with its demand, we must do this by taking into account who we have been and are and, therefore, what the "givens" of our lives allow. I am, for example, a 63-year-old, twenty-first-century, American male, not a 20-year-old, nineteenth-century, Somali female; therefore, there are certain things that I cannot do (for physical, cultural, or psychological reasons). Now one of the givens of our lives, one area

of facticity, I believe – here I am following Freud and attempting to deepen Heidegger's phenomenological account of human *Dasein*[18] – concerns our repressions, primordial unacknowledged conflicts festering within each of our worlds. Such conflicts are not totally isolated from our conscious lives, however, and they are able in a certain manner to demand responses from us, although they do this in the strange, disguised forms that Freud documented (e.g., in dreams, inexplicable irritations, slips of the tongue, obsessions, compulsions, phobias, etc.). Yet, not just in the ways that he described, I maintain, but in the very objects with which we daily involve ourselves, as I illustrated in my discussion of my co-being orientation toward the apple. For it bespoke not just my hopes, but also my fears and, I believe, were I to explore the response still more deeply, painful issues of my (repressed) life that I have not yet faced. So, as I have said, when I encounter an object in a co-being manner, I in a compressed sense face my whole life. The disturbing aspects of the thing, along with the importunings of my *Seinkönnen* (also incarnated in the object), present me with conflicts that ordinarily and at some level I would like, and have the capacity – but am afraid – to resolve, for I might discover, I suspect, that I am other and much less than the person I explicitly believe myself to be, perhaps that I am really "nothing." My deepest conflicts set the stage for, but do not fully determine, what I will *choose* to understand-and-do. (It is, I think, misleading to assume, as many Western philosophers since Plato have, that action follows choice, for it seems to me that the way in which I grasp my situation is already an action and choice; so perhaps far-reaching insight and specific action can only be achieved dialectically, that is, as mutually implicative processes.) Our most insightful and actional advances require the courage to face our own repeatedly denied otherness. And because the word "courage" suggests that we have the capacity to make genuine choices and thus that we do in fact have free will, I am implying that the specified co-being meanings of things that we arrive at are not ipso facto "foreordained" or destined by the conflicts that shape our new experiences, even though looking at some other people's lives, even at our own at times, it may sometimes appear that they (and we) are so fated. I believe, in sum, that the great dissonances of our lives shape, but do not fully determine, the nature of our co-being

relatedness to things, and thus how we respond to such dissonances is our responsibility.

Here an implication of the conclusion of Chapter 1 should be reinvestigated. One of the points that I suggested about our double vision vis-à-vis the world is that when and to the extent that we are steeped in the reality of our first-person point of view, our credulity should not simply be regarded as a naïve positing of beings that our more intelligent consciousness$_2$ patronizingly allows us to indulge in temporarily and only within certain strict parameters.[19] The important philosophical point is not that their physical existence is from one standpoint hypostatized and then from the second, more measured one denied, as I imagine most educated people would assume occurs (to the extent that they agree with my double-vision claim in the first place), but instead that the very nature of the beings we hypostatize is in a way foundational to and thus definitive of who we are and, correlatively, what our world is. The relevant issue here, it seems to me, is not, for example, the existence or nonexistence of Zeus. It is that this god was part of a world-picture, hence a relational being, not to be understood simply as "by himself," either "there" or "not there"; he was a detail of a web of Significance that was so basic to the life of an ancient Greek that it (the web) enabled him literally to experience the beings of his life – both essentially and existentially – in precisely the manner that he did. Differently expressed, if Zeus never existed (according to modern scientific standards of verification), the Greek's world was nevertheless intersubjectively informed through and through by spiritual definitions and practices, including ones providing the necessary and sufficient conditions for what it means "to exist" in the first place. For the ancient Greek, therefore, Zeus existed as plainly as, say, electrons exist for us today.

Now I wish to shift attention from my example of a more culturally shared first- and third-person outlook – since Zeus was real for a whole society of ancient Greeks during a certain epoch – to a previous example, which illustrates a more personal and individual first-person outlook. Referring once again to the apple, I can say that if my whole life and world is, in a way, contained in the experience of it, then what I apprehend in it in a co-being mode will not simply be of private, idiosyncratic, and psychological import, but of ontological import, that is, a manifestation of what I take to be the kinds of

being of all of the beings in my possible purview. Here I suggest that although Wittgenstein is correct in asserting that we would never really be able to give reports of our first-person experiences without first grasping how to express ourselves according to what "the others" have shown us, one's own individual personal standpoint and world is, nevertheless and from a different epistemological angle, the very starting point, as it were "the given," that enables us to comprehend and develop our third-person perspective. The starting point that I am referring to, the *ur-ground* of our being, in turn enables us to give voice to the as yet unarticulated world of particulars as they are experienced from our first-person perspective.[20]

But even if the ontological claim that I just made is persuasive to the reader, there is another issue, both ontological and moral, that needs to be addressed: should we regard things – when not dealing with them as ready-to-hand instruments but as presences to be contemplated – primarily as opportunities for facing and overcoming our own fundamental personal, being-in-the-world conflicts? Such a position would be too simple, I believe, for it suggests insofar as we deal with things in our world that they are apprehended instrumentally, *or* as bare physical objects, *or*, finally, as mere mirrors of our own existential issues, and that these three modes of relatedness are categorially exhaustive. What is distressing about such a view, in my judgment, is that it seems to preclude the possibility of some sort of independent otherness entering our lives. The apple described earlier that is "out there," for example, becomes, according to the co-being view that I have been explicating, my apple, and while it is layered with provocative meanings that may lead me to ever new insights about myself – however broadly conceived – they would seem to have little or nothing to do with the apple itself, with this being that is, after all, not me. Or, to consider another example, is the hawk that I see soaring in the small, green, pastured valley surrounded by towering purplish-gray, snow-crowned mountains best understood when I feel its presence to be expressing my own yearnings to be gracefully and effortlessly "whole"? Wouldn't this kind of apprehension on my part be simply a twenty-first-century reexpression of nineteenth-century European Romanticism, an example of the pathetic fallacy, thus an egocentricity, even a narcissism? But if any and all things (or events) that we experience must be fitted into

the framework of a general response to the call of our *Seinkönnen*, as Heidegger maintains in *Being and Time*, then mustn't I in some way inevitably and always personify (or "worldify") the apple or the hawk and thus not appreciate, because of my incapacity, any of its presumed otherness?[21] Or do I want to assert in fundamental opposition to him that not everything is caught within the vast net of Significance that we cast over the pool of our experiences? Do I want to insist that there must be some as yet unmentioned category of relatedness to things that would enable us to cognize them "as they are in themselves" and not as objectifications of our needs, wishes, yearnings, or fears?

It might seem expedient to appeal to such a new sort of possibility, but I do not believe that we would be justified in doing so. Thus, it seems to me that Heidegger is basically correct to claim that whatever we are aware of and know has already been ordered and integrated according to cultural categories enabled and guided by ur-requirements of "facticity" (or "thrownness") and existential possibility (our *Seinkönnen*). Trying to imagine a fourth mode of relatedness to things seems to me to be extraordinarily difficult, like trying to imagine a new primary color. For what would it mean for me to perceive the apple or the hawk "in itself"? Would I perceive either of these beings without concepts and just apprehend them sensuously and feelingly, as a preverbal infant might? Would that be to understand them at all? Wouldn't these living beings be for me, to use William James's phrase, merely a "blooming, buzzing confusion"? Or should I entertain the possibility that although I must employ concepts for any meaningful cognition after all, my personal needs and doubts need not bias them? So I would apply neutral concepts to which virtually any adult human being has access, such as "spotted green apple," "ascending hawk in flight," or their equivalents in other languages? But why would these impersonal terms, or their linguistically translated counterparts, capture the "in-itselfness" of the apple or the bird? Wouldn't I at best be simply substituting human-centeredness, anthropocentrism, for my initial egocentrism? For isn't the underlying assumption, in attempting to capture the "thing in itself," that it must somehow be possible to shed all of our personal and even human prejudices and interests, so as to be able to view the "real apple" or the "real bird" from "nowhere," that is,

as God would see it, presupposing for the moment that there is such a being and that He or She or It in some sense "sees" things? Where might we find the absolute reality standard against which to ascertain what is prejudicial in our outlook, a measure that would enable us to separate the false from the higher, divine categorization, "the Truth" of the thing, its eternal being?

We seem to be approaching two alternative conceptual culs-de-sac: either we see a thing through individual or collective human lenses, in which case we have no proof that the lenses themselves aren't weirdly distorted, or else we see a thing through "God's lenses," in which case we have somehow (i.e., through a magical act) managed to transcend all of the prejudices, interests, needs, and underlying concerns of our own individuality and humanity and apprehended the thing's Truth. Yet, I believe that there is a way to escape this dilemma of the implications of either egocentrism and anthropocentrism on the one hand or what we may call theocentrism on the other. The escape requires a rethinking of Heidegger's category of co-being.

BEYOND ANTHROPOMORPHISM

The key to an escape route lies, it seems to me, in Heidegger's concepts of *Seinkönnen* and projection[22] (both individual and human). He regards one's projective capacity as dependent upon and a structuring of the importunings of one's *Seinkönnen*. The structuring comes about because one's "facticity" or "thrownness" limits the range of what is truly imaginable or conceivable by an individual person. Projection, or what I would designate our "possibility-framework," therefore provides a kind of blueprint within which the finite ranges of choice for thought and action are defined. Our *Seinkönnen* invites us to interpret each thing that we encounter in a novel way, but our projective nature delimits the domain of what is truly possible by (more or less unconsciously) taking into account our facticity. Usually we do not accept the bold invitation of our *Seinkönnen*, which means that how we see things and are inclined to act within the field of our projected future is similar to what we "already know." For example, we see an oak as "the same tree," be it as potential lumber, an objectification of our ambitions, or so much highly compacted

xylem, and so on. Sometimes we do fully accept *Seinkönnen*'s lure, and then we regard a thing in a very different light, and not necessarily and simply as a manifestation of our usual existential conflicts. We see it as something novel (although not totally so), and we sense it to be more ordinate to the pure, mysterious, thus not wholly graspable core of our being, that is, our *Seinkönnen*. This sort of event occurs when we are most sensitive to barely placeable intimations of our own being that both surprise us in their unpredictability and give us pleasure in their suggestion of our own creative potential. Such indications (of self-in-world) occur simultaneously with our appreciation of some hitherto unnoticed feature of another being, a feature that we experience as a kind of disturbance, affecting us, as it were, by stealth. For example, when I view a particular willow oak tree another time, I no longer assimilate its nature to myself and feel it to embody my usual longings, fears, or disappointments, but instead as something quite lovely, strange, and unknown. In a stance that Gabriel Marcel refers to as *disponibilité* (roughly, "readiness," "openness," "availability"), I take the tree to be exhibiting some sort of purpose, but one that I do not as yet, and may never, understand. Now the "purpose" that I attribute to the tree must in some sense be related to the familiar sense of the word purpose in my life and the lives of others, for otherwise my application of the term to the tree would have no meaning to anyone, including myself. But this kind of "tree meaning" need not be that of *purpose* per se, but simply that of *purposiveness* – the quality of exhibiting something purposelike (in Kant's sense). So the tree may be purposive in that it immanently contains a deeper (perhaps cosmic) meaning that I seem to sense but cannot as yet articulate, and which is perhaps not in principle articulable. I experience this meaning or purposiveness as both suggested or posed and then posited or endorsed as a "real possibility" of the way in which "things are." The experience does not occur, however, via an apprehending mode of the other's otherness that somehow transcends our ready-to-hand, present-at-hand, or co-being dispositions. The only mode of *Dasein*'s being in which purposiveness can plausibly be apprehended, it seems me, is that of *co-being*, because the kind of purposiveness that I sense cannot exist at all in things as present-at-hand. Now although there is, in fact, purposiveness in things regarded

as ready-to-hand, they are defined by *my purposefulness* within a framework of my culture's conventions of understanding and acting. (I fit the pieces of wood together *in order to* make the picture frame, for example.) No, the seeming apprehended purposiveness that I feel is of something in some way shaped by or a manifestation of an intelligence, a quasi-personality, and thus a specification of the mode of co-being.

Is my intuition of the tree's deep (cosmic?) purpose *about* the "real tree," the tree "in itself"? I cannot claim to know the attribution of purposiveness to the being of the tree to be correct, for that would be to claim knowledge of the tree apart from all human interests and considerations, which would seem to be, as indicated, highly unlikely, if not utterly impossible. Still, it seems to me that there is nothing illogical in believing that my intuition might be about or nearly about a "thing in itself," something, I assume to exist independent of all human experience and that produces certain effects that are then structured by various cognitive processes (e.g., physical, cultural, idiosyncratic, etc.) and finally experienced as "that willow oak." I am thus positing an otherness whose true meaning is declarable only as a matter of belief, with no foreseeable possibility of verification or falsification. Moreover, this thing in itself that I posit is not to be understood simply as the "real," external physical thing in itself that an ordinary person would usually take to be the thing's "true reality." No. What I believe and hope for is something that has some analogical connection with my understanding of fundamental purposes in my world. In sum, I do not *know* that a (any) thing in itself exists at all, I *only believe* that it does. I do not know, a fortiori, that the willow oak that I in a special way perceive really has at its core the purposive characteristics that I attribute to it, even if things in themselves (i.e., things apart from human cognition of them, and that particular thing in itself) do in fact exist; I can only believe that it does.

My claim about the oak is thus an assertion of faith, not irrational, and not inconsistent with the claims that I have made thus far about our co-being orientation toward things. It is, of course, Kantian in spirit, but it tries to avoid Kant's basically self-contradictory position of his "knowledge of unknowables." For his theory of knowledge is strictly limited to what he labels "appearances," which are

nevertheless enabled by purported knowables, transcendent sub-stances, "things in themselves" (*Dinge an sich*). My own theory is certainly like Kant's in arguing for an epistemological duality be-tween what is apparent to us humans and what may exist in itself. In contrast to Kant, however, I do not assume or feel a need to prove that our apparent, lived existence, or the knowledge that we possess with respect to it, *must necessarily be based on* another, epistemologically inaccessible world. I do believe, however, that it is pragmatically most useful and desirable to posit the existence of things in them-selves that are the extrahuman, epistemological ground of all human experience and that exhibit a deeper, cosmic purpose analogous to but different from any human purpose.[23]

The immediate value of positing this kind of epistemological du-ality is that (a) it allows me to continue endorsing Heidegger's (what I take to be) correct view that there is no escaping our human per-spective – that what we mean by "reality" must inevitably be shaped by our human interests and needs – while at the same time pointing to a domain in which we may logically locate our deeper, perhaps cosmic, intuitions. As mentioned, my position attempts to transcend Heidegger's phenomenological methodology to allow for its episte-mological supplementation. It is necessary to do this if we are to avoid the conclusion that our co-being relatedness to things yields nothing more than an objectified expression of our own existen-tial conflicts. But it is not simply for my own expository purposes that I posit a thing-in-itself world that is phenomenologically inac-cessible, for it seems to me that (b) Heidegger himself is logically and dialectically compelled to proceed in this direction as well, despite his determined efforts to the contrary, because his basic quest in *Being and Time* concerns, in his words, "the meaning of Being," and that meaning for Heidegger is clearly some mysterious "x" that is not to be found exclusively within *Dasein*'s world or wholly defined and exhausted by *Dasein*'s needs and interests. In fact, Heidegger himself speaks of a *world that is already patterned* by Significance: "our [fundamental] investigation," he asserts, "asks about Being itself insofar as Being enters into the intelligibility of *Dasein*."[24] If something "enters into" some domain, however, it does so from some other domain. Thus, at least in this passage, Heidegger seems to be unconsciously admitting his belief in the existence of a

phenomenologically inaccessible realm of things in themselves. Moreover, (c) my (neo-Kantian) addendum to Heidegger's phenomenology is in certain relevant respects consistent with his later philosophy, a "turning" or "bending" (eine Kehre) of his thought, beginning around 1935, in relation to all of his prior essays and treatises. In his later writings, one of Heidegger's principal tasks is to overcome what he, too, perceives to be excessively limiting, anthropocentric assumptions set forth in his philosophy up until and several years beyond the publication of Being and Time. The meaning of Being is not wholly, explicitly, and exhaustibly expressible within the circumscribed ambit of human Significance (as defined in Being and Time), he concluded, but instead requires the hypostatization of a special realm that can be referred to and apprehended only through a certain kind of poetic (thus metaphorical and analogical) thinking.[25]

Finally, (d) the special realm of possible cosmic purpose that I have posited seems to me to be pragmatically necessary if we are to avoid a kind of schizophrenia that insidiously affects a good deal of contemporary theoretical thinking in the humanities, especially concerning issues involved in "interpretation" – of social behavior, of literary texts, and so on. For, on the one hand, many contemporary social commentators and literary theorists maintain (uncritically and even dogmatically) that every thought that we have about anything at all (e.g., "women" or "Italians" or hawks or apples) is only a "social construct," thus mediated by a whole battery of cultural and historical categories. From this supposition it is inferred that it is naïve, even absurd, to believe that we could ever have epistemic contact with "the real thing itself." On the other hand, I do not see how any sane human being can truly and sustainedly live his or her life believing such a thing. For every time we deliberate or take action, we presuppose that we do believe in some things, if only partially and for the nonce, and that these things are not simply figments of a culture's collective definitional imagination, but in some important sense real, independent entities. The terms we use may, of course, be altered. We needn't call an apple "apple." We could label it "pomme" or "Apfel" or "spherelike edible/throwable." But try telling yourself that the apple is merely a social construct and that you have absolutely no idea of, and that you do not care at all about, what the

thing in your hand is really – even that it's a physical object or in your hand – that you, in fact, have no idea what anything whatsoever is except that you live in a world where apparent reality merely reflects collectively (although unconsciously) determined, arbitrary, time-bound (thus, fleeting) conventions. (Why, incidentally, is the theory of social construction not itself a social construct? If the answer is yes, it *is* a social construct, then what invites us to believe that the theory itself is true because all truth, on this view, must itself be only a product of social convention? If it is not a social construct, then why should the whole theory of the social construction of reality itself be immune to its own basic claim?)[26]

If my thinking is correct here, then we are and must all be (epistemological) realists in our everyday, if not in our theoretical, lives, even when we focus on things in the mode of co-being. Yet we needn't be naïve realists, believing that we are in touch with virtually the full reality of, say, the apple. We can instead believe that certain features that we perceive to be in the apple in our hand bear some analogous relationship to the way in which "the apple itself" exists in itself, that is, as it would be apprehended by a supremely rational and supremely good intelligence.

In this chapter I have attempted to show that ordinary "things" have much more meaning and value in our lives than we might usually acknowledge, that they always reflect, usually at a preconscious level, our deepest existential concerns and that these concerns informed by a certain stance of *disponibilité* may help us to contact not just our immediate selves (our preoccupations) all over again, but also in a sense, "the things themselves." My overall position has important implications for the subject of symbolism, that notoriously dangerous domain where many an aesthetic theory has foundered. For what I have been implicitly arguing is that symbols are found not simply in artworks, but in our world; not just occasionally, but always; not just in some places, but everywhere; and, finally, not just as things-with-meaning "out there," but as worlds of significance indissoluble from ourselves. In this new way of conceiving, we may, I believe, begin to understand the power and significance that artworks have for us, because their production and presentation to us for our appreciation presuppose and build upon the everyday quasi-personalities that are ingredient in the very substance of our lives.

[115]

The Paradoxes of Art

Most aestheticians[27] tend to reserve the term "symbolism" for culturally identifiable images or icons of moral or religious significance. (Freud and the Freudians tend to reinterpret symbols primarily as libidinal, egoistic, or "thanatic" events of drive or conflict.) If I am right, all of these theoreticians mislead us, for what are we to say of the significance of that which for them must necessarily be construed to be nonsymbols, those other representative features of artworks, let alone the things of the world itself? What is their ("nonsymbolic") artistic pertinence? Are they merely "things" or representations of things of no existential significance, to be labeled in standard cultural terms as, for example, apples, wallets, or birds? Does the more ordinary view in turn imply that it is only when and because an artist uses a symbol (e.g., a raven), or when and because the artist depicts or describes a scene of obvious moral or religious significance, that the work can begin to affect us importantly? If this is so, then the mysterious hold that many great "nonsymbolic" works have on us (e.g., almost at random, Monet's *Water Lilies*) becomes if not inexplicable, then extremely difficult to account for.

Still, it may be objected that if everything is a symbol, then nothing is a symbol – the term will have lost all meaning. I am not asserting that literally everything is a symbol and only a symbol, but that every thing or event that we experience has at some level (if only we have the patience to attend) an important story to tell us – about ourselves, about our world – although it is likely that we will instead focus on, and perceive, objects in their practical aspect. Thus, (a) the chair is normally for us, of course, just a chair, something to sit on, and (b) at some other level we also always, if only minimally, feel it to be a microcosmic allegory of our lives. We logically and experientially distinguish the tangibility and usefulness of things – their readiness-to-hand – from their co-being, "personal" aspect and, therefore, we know what it means for a thing to be nonsymbolic and to be experienced in that way. So it is not logically vacuous for me to claim that the things of my world (of the reader's world too) are thoroughly and always at one level symbolic and that they are immediately felt, not self-consciously interpreted, to be such. In each experience, there may be discovered a kind of "holy story" (in German, a *Heilsgeschichte*) similar to the one told by medieval Christian thinkers, who intuited in the things and events of the world

some phase of the birth, life, and passion of Christ as well as the possibility of our redemption through him. The phenomenological account that I am providing is, I believe, "told" to us every moment of our individual lives. It, too, involves our suffering, and the longed-for goal remains the finding of "the way," our redemption and salvation. But unlike the medieval holy story, my account, if I have delineated its basic features correctly, provides no assurance, only a hope, that the goal will ever be reached.[28]

I have concentrated my attention on things and how they speak to us to prepare the ground for our understanding of artworks, whose subject matter (even in, say, expressionistic or "abstract" paintings) presupposes and builds upon our experiences of these things. I have also made reference to "the others," to people, or, rather, to the "people in," or the "personal dimension" of, things. To provide a more complete understanding of the personhood of things as well as of the people themselves as depicted in artworks, I need to confront, if only in a very general way and if only for the purpose of clarifying their function in artworks, who the others are, that is, what we take people to be as beings, and how at the deepest level they matter to us – extremely difficult issues, of course, but necessary for my exposition.

NOTES

1. Highlighted by Wittgenstein; cf. Introduction, endnote 26.

2. By "we" I mean in this context, and generally throughout the chapter, those who have grown up in Western societies as well as those (millions or billions of) others who have been greatly affected in their outlook by modern science's "subject–object" paradigm – previously mentioned, to be revisited shortly, and discussed further in Chapter 3.

3. *Vorhanden*, usually translated as "present-at-hand."

4. *Being and Time*, trans. John Macquarrie and Edward Robinson (London and Southhampton: SCM Press, 1962), p. 98. *Zuhandenheit* could also be translated as "at-handness" or "availability," but I use Macquarrie and Robinson's translation of this term, as well as their translation of *Vorhandenheit*, presence-at-hand, because they have become so widely accepted by English-speaking readers of Heidegger.

5. *Being and Time*, pp. 100–1. Here I resist translating *Seiendes* as "entity,"
Macquarrie and Robinson's translation of the German participle (*seiened*) made
into a noun, because their term, as it is used ordinarily as well as in philosophical
contexts, has too many misleading connotations. In every subsequent quotation
from Heidegger, where Macquarrie and Robinson translate *Seiendes* as "entity,"
I substitute the word "being."

6. For readers unfamiliar with Heidegger, I should note that he uses the
word *Dasein* for human being, in an effort to invite us rethink what it means to
be human in the first place. Literally, *Dasein* signifies there- (*da-*) being (*Sein*) or,
in ordinary German, "existence" (usually applied to beings with personhood),
as in *das Dasein des Gottes*, the existence of God. Heidegger wishes to suggest
that a human being is unlike all other known beings in that it is defined by
its "thereness," which is to say, in part, that its essence is not like that of an
ordinary thing that simply is what it is currently; on the contrary, a human is
what it is by virtue of its potentiality and its affective grasp of that potentiality.
Thus, Heidegger claims, a human's "essence" (insofar as we can legitimately use
this term at all) is its "to be" or "toward being" (*Zu-sein*), what it feels itself
at the deepest level able and obligated to become. In other words, according
to Heidegger, a human is the being whose very being is felt to be at issue or
at stake for it. This is the true definition of what it means to be human, he
maintains. One also projects oneself into a future that one knows will eventuate
in one's own death. Thus, one is present to – once again, but in a different sense
"there" – in the threat of one's nonbeing, as a continuous possibility. (One's
grasp of one's inevitable end is a necessary condition for the apprehension of
the at-stake dimension of one's existence.) There are still other senses in which
a human being should be thought of as always "there" (and not simply self-
contained as a thing that is merely "here"), but the two senses that I have cited
will provide for the reader the kind of thinking that provoked Heidegger to
reuse the word *Dasein* to signify our humanness.

7. " '*That wherein*' [*Worin*] *Dasein* understands itself beforehand in the mode
of assigning itself is *that for which* [*das Woraufhin*] it has let beings be encoun-
tered beforehand. *The 'wherein' of an act of understanding which assigns or refers
itself, is that for which one lets beings be encountered in the kind of Being that
belongs to involvements; and this 'wherein' is the phenomenon of the world.* And
the structure of that to which [*woraufhin*] Dasein assigns itself is what makes
up the worldhood of the world" (*Being and Time*, p. 119).

"The [ultimate] 'for-the-sake-of-which' [the basic structure of possibility to
which *Dasein* assigns itself] signifies an 'in-order-to'; this in turn, a 'towards-
this'; the latter, an 'in-which' of letting something be involved; that in turn, the
'with-which' of an involvement. These relationships are bound up with one an-
other in a primordial unity; they are what they are *as* this signifying (*Be-deuten*)
in which Dasein gives itself beforehand its being-in-the-world [see endnote 8
for an explanation of this hyphenated term] as something to be understood. The

relational totality of this signifying we call 'Significance.' This is what makes up the structure of the world – the structure of that wherein *Dasein* as such already is" (ibid., p. 120).

Note how in these two passages Heidegger implicitly equates worldhood with Significance, which is what I have explicitly done in my expository comments in the chapter text.

8. Heidegger's phrase *"in-der-Welt-sein"* is usually translated as "being-in-the-world." His formulation can too easily be misinterpreted to mean that *Dasein* is a being that happens to be in the world. Heidegger's grammatical construction is participial, however, and, therefore "being-in-the-world" should be conceived as a predicate of the term *Dasein*. This means that a human being, according to him, has the attribute of being-in-the-world and, furthermore, this attribute is essential or definitive of him or her. Thus, Dasein *is* being-in-the-world, Heidegger tacitly asserts. Here I should also remind the reader that the word "in" of the participial construction should not mislead one into believing that Heidegger views *Dasein* as in the state or condition of being physically *in* the world. I also note that beginning in Section III of this chapter, I state a new position and attempt to go beyond the fundamentally anthropocentric thinking expressed in the paragraph to which this endnote refers and which Heidegger presupposes in and throughout *Being and Time*. Finally, the reader may wonder whether there is just one collective human world or many worlds (as many as there are *Daseins*). I do not attempt to develop a response to this important question, but my simple answer is that both are true – that due to our sharing certain features with all other *Daseins,* there is one world; at the same time, because each of us has certain issues and concerns that define who we are, there are many worlds. Thus, each of us inhabits a world that is related, but not wholly reducible, to the one common world. That is why, it turns out, there can legitimately be phenomenologically different responses to artworks, an issue I discuss in Chapter 4.

9. *Being and Time*, p. 10. I choose not to capitalize "interpretation," unlike Macquarrie and Robinson.

10. *Things* do not possess being-in-the-world because, according to Heidegger, they lack a crucial ingredient, which is a concern for their own being. Thus *Dasein* has, or more precisely, is a world because of its self-reflexive nature: it cares about both its ownmost-potentiality-for being (*Seinkönnen*) and the fact that it will die. See also subsequent pages of this chapter, as well as Chapter 3, for more on this important term in *Being and Time*.

11. *Being and Time*, p. 100.

12. See endnote 10.

13. I am now using the term in an unusual way, as a noun that applies to (any) one person, just as Heidegger virtually always does in *Being and Time*.

14. *Being and Time*, p. 100, my emphasis and translating *Sein* (being) without an initial capital letter.

The Paradoxes of Art

15. I was first provoked to think about this etymology while reading Richard Shusterman's *Pragmatist Aesthetics: Living Beauty, Rethinking Art* (Oxford, England, and Cambridge, Mass.: Blackwell Publishers, 1992); see p. 32.

16. I also believe that further evidence for the cognitive orientation that I am assuming to be universal could be established through psychological experimentation.

17. Our *Seinkönnen* is a dimension of our being suggested to us in first-person experiences; thus, it is the very sort of intimation about which analytic philosophers would be skeptical. Yet, I believe with Heidegger, were we unwilling to acknowledge its significance, or even its existence, we would ipso facto preclude ourselves from making any headway in understanding why artworks can truly matter to us.

Concerning a very different issue, here it may be helpful to cite a parallel between Heidegger's theory of a person's *Seinkönnen* and Plato's theory of a person's spirited element (*thymos*, is the Greek term, it will be recalled), that which calls each one to become a psychically fully integrated and self-actualized individual and human being (cf. Chapter 1, endnote 58.) Just as in Plato's thought, the spirited element should be regarded as the primary source of artistic creativity, since that element inspires us to translate via the faculty of imagination, sheer, abstract felt-possibility for self-completion into a more specified, posited possibility of personal expression (or action), so, too, in Heidegger's thought, we should view our *Seinkönnen* as the stimulus of one's creative expression (or action). I should quickly note, however, that according to Plato the even deeper basis of the yearnings of *thymos* is to found in something that it itself cannot properly apprehend – this target of concern is cognizable, if at all, only by the faculty of reason – namely, the Good (or the Beautiful), that unchangeable, perfect, and absolute cosmic being whose apprehension is the ultimate goal of all human, indeed all creaturely, striving. On the other hand, for Heidegger, the source par excellence of creativity is one's *Seinkönnen*. It appears to be the final basis of all creativity (thus, of reason's constructions) rather than being, as Plato contends, a power to be subordinated to reason and its supreme goal, the Good. (I write "appears to be" because Heidegger leaves open the possibility that one's *Seinkönnen* may itself be directly linked to something that transcends a source solely in oneself: "The call [of one's *Seinkönnen*] comes *from* me and yet *from beyond me*." ["Der Ruf kommt *aus* mir und doch *über* mich."] *Being and Time*, p. 320.

18. In the end, I believe that Heidegger's phenomenology requires more than expansion; it needs to be supplemented with certain ontological assumptions if his whole early philosophy is not to become a stultifying anthropocentrism. My point will become clearer shortly. I also reexplore the issue of (what I take to be) the need for additional philosophical suppositions to the general position expressed in *Being and Time* again in Chapter 5.

19. See previous chapter, part III especially. I am suggesting that the ability of consciousness$_2$ to overrule the positings of consciousness$_1$ is, at the deepest level, more limited than the reader may have inferred at the end of Chapter 1.

20. Note that I am implicitly distinguishing in this section of the chapter two levels of first-personhood: (a) the particular personal events that I learn how to characterize after and because of my social and cultural training (e.g., that which is signified when I say, "I have a pain in the lower part of my back"); and (b) the ur-ground of all one's experience, the worldhood of one's world (in Heidegger's terminology), that which is basic to and allows for the very nature and being of one's self-in-a-world ab initio. It is especially level (b) that is ignored or tacitly denied by analytic philosophers (thus, analytic aestheticians) generally and (the later) Wittgenstein. For him in particular, there can be no cognitively meaningful discussion of something like a being-in-the-world matrix of any and all of one's own "subjective" and "objective" experiences. Were we to follow Wittgenstein's tack, however, we could hardly provide satisfying explanations of why some people are especially drawn to artworks in the first place and why they seem to have more than a rule-obeying appreciation of them, but instead a much deeper kind of sensitivity, one that apparently reflects the core of who they are as individuals. Doesn't such sensitivity find its soil and nourishment in something greater than simply a talent or skill (e.g., for discerning striking color contrasts) – what I regard as their unusual sensitivity to artistic works' relevance to the at-stakeness or at-issueness of their whole lives? Furthermore, why, then, do the things in the world have "the feel" that they apparently have for all of us – assuming that the kind of description that I provided of the apple is in fact phenomenologically generalizable in a rough way – if the notion of worldhood (Significance) is not taken into explanatory account or simply discounted a priori? Why does Wittgenstein occasionally become enthusiastic about a certain kind of aesthetic response, implying that when such a thing takes place, the core of one's being is affected, if all artistic experiences should be understood solely as embodiments of publicly learned rules or conventions? ("[Let us consider] someone who has not traveled but who makes certain observations which show that he 'really does appreciate' . . . [,] an appreciation which concentrates on one thing and is very deep – so that you would give your last penny for it.") *Lectures and Conversations on Aesthetics, Psychology and Religious Belief* (Berkeley and Los Angeles: University of California Press, n.d.), note by Rush Rhees, p. 9. Indeed, I would go so far as to maintain that it is precisely the issue of whether we should give ontological credit to inklings of an "ur-ground" of one's own existence, as I have characterized it, that most deeply, thus philosophically, has estranged analytic philosophers from Heidegger's thought in *Being and Time*.

21. Here I make reference to the famous "hermeneutic circle," a problem that I examine in greater detail in Chapter 5, pp. 232–9. There I suggest that within our individual worlds of concern and struggle, there exist opportunities for existential development – particularly in encountering artworks – that occur prior to the disposition of fidelity that I am about to characterize in Part III of this chapter and that I believe to be required if we are to escape the dilemma I have been discussing in Part II. Yet, although existential advancement is possible (and necessary, for our personal and overall well-being) within each of our worlds,

it seems to me that such evolution cannot psycho-ontologically be a complete substitute for our binding ourselves to a transhuman concern and purpose.

22. See Chapter 3 for further discussion of Heidegger's term "projection" (*Entwurf*, which could also be translated as "design" or "project," but which Heidegger, always sensitive to etymology, wants us to read as a "throwing away from oneself," of that which is still in a sense bound to oneself).

23. Cf. the discussion, in my Introduction, of Kant's *Critique of Judgment*, trans. Werner S. Pluhar (Indianapolis, Ind.: Hackett Publishing, 1987). There is a parallel between my position concerning the purposiveness that we feel about all sorts of – and in principle, any – physical objects, and the apparent, formal purposiveness (*Zweckmässigkeit*) we feel, according to Kant, with respect to certain special natural things (e.g., ocean tides, waterfalls, etc., cited in his third *Critique*). Also, in both Kant's view and my own, the purpose is not known, but only posited as possibly real and independent of us, thus an object of faith. My position differs significantly from Kant's, however, in claiming that the aesthetic lure of an object (natural or human-made) is not to be found solely in its formal properties, nor do I believe that such an object is devoid of moral or practical interest for us (although, as mentioned in my Introduction, Kant's position at the end of the *Critique* seems to flatly contradict what he asserts, and is primarily known for, in the earlier part of the work). On the contrary, I believe, we are attracted by a certain thing (be it, say, a flower or a depiction of a flower) because of its concrete, "personal" properties and because they, as a unit-totality of meaning, seem to address the fundamental claim that our *Seinkönnen* makes upon us. Thus, my thesis, in opposition to Kant, is that the "aesthetic object" (insofar as it makes sense to speak about such a thing at all) is never for us one of disinterest, but rather, at least on certain occasions, something of supreme interest.

24. *Being and Time*, p. 193.

25. Although Heidegger, unlike me, is not willing to call this new realm a world of unexperiencible "things in themselves."

26. Cf. Ian Hacking, *The Social Construction of What?* (Cambridge, Mass.: Harvard University Press, 1999), a thoughtful series of essays. See especially Chapters 1, 2, 3, and 8. Cf. also my Chapter 4, where I briefly discuss a parallel issue, that of perceptual givenness versus its interpretation.

27. See Chapter 4, p. for names of thinkers in this tradition and further discussion of the topic of symbols and symbolism.

28. At a more rigorous level of analysis, I should point out that what we ordinarily take to be symbols in artworks, and what I have been loosely calling symbols (e.g., the holy stories of our lives as apprehended in things), are not really such things at all, for they do not really *stand for* other things, but *are* for us those other things already – the signifier and the signified become one and the same, just as my mirror image is in the first instance taken by me to be precisely me.

Why and How Others Matter

So far in this book I have in several places implicitly or explicitly challenged two interrelated, fundamentally Cartesian propositions: (a) that knowledge of the world is exclusively gained through our cognition of all sorts of things (such as plants or animals or people) from a neutral, detached, "third-person" standpoint and, therefore, (b) whatever is revealed to us from a first-person standpoint that is not observable for others (such as my feeling of anxiety) is not of interest in helping us to understand what is most fundamental to – the essence or nature of – anything at all, including us humans. Thus, Descartes's privileging the third-person perspective[1] for gaining knowledge has serious implications for what he identifies as "the real world." His methodological assumption is not just idiosyncratic to him or his disciples and followers, it is also to a great extent *ours*, having greatly shaped what we Westerners now denominate "common sense." Continuing in the same anti-Cartesian vein that I have pursued all along and taking my inspiration from Heidegger, I now try to delineate from an ontological perspective (but only insofar as it is necessary to shed light on the nature of artistically rendered fictions) who people ("the others") are for us, not as they are supposed to be according to traditional philosophical and even everyday thinking – complicated, conscious and self-conscious, mammals by whom we are often "greatly affected" and who are nevertheless "quite separate from us" and thus "out there" beyond us – but as we respond to them from our truest and deepest selves, thus including in our account those troublesome, "merely subjective," but fundamental feelings and concerns as well as the ontological significance suggested by their existence. I now, therefore, take up the thread

of the truncated discussion of the self vis-à-vis the other begun in Chapter 2.[2]

HOW WE ARE WITH OTHERS

In the first instance, we relate to others not as alien beings whose intentions and actions we must somehow and always decipher, but on the contrary as beings fundamentally "like us," sharing similar concerns or projects.[3] We live with them in a co-world enabled by something basic to us as humans, namely, our co-being, according to Heidegger. This co-being manner of relatedness is different from that which defines our ordinary relatedness to things, for it is only in a derivative sense, as I argued in the previous chapter, that we attribute personhood (*quasi-personality*) to them and then only with the sanction of consciousness$_1$. To the extent that we allow the overlay of consciousness$_2$ to complete our primitive cognitive deliverances, things do not have for us – are not perceived as containing – worlds in themselves, whereas people, for us, do inhabit – indeed, are in an important sense – worlds in themselves. Ordinarily, we know and act on this difference and automatically take it into account in our dealings with people.[4] This is why Heidegger characterizes our involvement with them as manifesting more than a narrowly delimited or episodic disposition, but instead a great range of thought and behavior, a whole way or mode of our being. As I previously mentioned, he identifies this way or mode as solicitude [*Fürsorge*], reserving the term "concern" (*Besorgen*, note that the root form *Sorge*, which equals "care," pertains to both terms), another mode of our being, for our dealings with things such as tools or pieces of furniture or machines.

Heidegger identifies two submodes of what he labels, respectively, *inauthentic* and *authentic* solicitude characteristic of *Dasein*, (a) leaping in for another [*für ihn einspringen*], and (b) leaping ahead of another [*ihm vorausspringen*], by which terms he means to characterize on a continuum two extreme ways in which we exhibit the quality of our care for another. In (a), we are either the agents or patients vis-à-vis the other person's concerns.[5] We attempt either to control the other, believing that we know better than the other about what

is best for him or her, or we allow ourselves to be thus controlled:

> This kind of solicitude [a] takes over for the Other that with which
> he is to concern himself. The Other is thus thrown out of his own
> position; he steps back so that afterwards, when the matter has been
> attended to, he can either take it over as something finished and at his
> disposal, or disburden himself of it completely. In such solicitude, the
> Other can become one who is dominated and dependent, even if this
> domination is a tacit one and remains hidden from him.[6]

In submode (b), we have an appreciation of the other as truly an *other*;
we acknowledge the other's independence and wish to foster it, not
by taking over his or her concerns, but by helping the other to face
them in the right manner and to take action with respect to them as a
mature agent. In this form of relatedness to another, Heidegger says
that we "give it ['care'] back to him authentically as such for the first
time. This kind of solicitude pertains essentially to authentic care –
that is, to the existence of the Other, not to a *"what"* with which he
is concerned; it helps the Other to become transparent to himself *in*
his care and to become *free for* it."[7]

In this discussion of a person's authenticity or inauthenticity with
respect to the other, Heidegger is making tacit reference to the con-
cept of our potentiality-for-being (*Seinkönnen*), cited in the previous
chapter. For central to his thinking about the quality of our care
for others is the assumption that it is based on and a function of
the quality of our care for ourselves.[8] Furthermore, as already men-
tioned, the "self" that we care about is not to be thought of as a
kind of ego or mental substance or subject of consciousness (as it is
according to the philosophy of Descartes and many other thinkers
right down to the present day), but instead as a relational being with,
at this axiological level, two relata – (a) what we could and should
be, a morally and spiritually better human being, one who is more
open, caring, creative, and decisive in all important realms than we
currently are, one who, therefore, responds more transparently to
the call of his or her *Seinkönnen*, and (b) that person who we intuit to
have already become, for better or for worse, and who we seem in-
clined to continue to be, despite the importunings of our *Seinkönnen*.
Now, for the most part, Heidegger maintains, the being who we have
become, the life we are now leading, falls quite short of what is

demanded by the call of our *Seinkönnen*, leaving us in a perpetual state, usually unacknowledged, of anxiety over and guilt about ourselves. This condition of disquietude psycho-ontologically entails that the other is often a threat to us, even if the other is just someone desired (for as desiring, we tacitly manifest a deficiency in ourselves and sense the possibility that we will not obtain what we desire). The other person can be threatening, whether he or she is regarded by us as worse, the same as, or better than we. (For if we think of the other as worse or the same as ourselves, we are often inclined to see the other as "alter egos" and persecute him or her for faults that we dislike or fear in ourselves; if better, then the other shows us that we ourselves can and should after all become better than we currently are.) Being threatened, we are not disposed to deal with the other in the mode of leaping ahead of him or her, that is (to use Heidegger's term), authentically, but instead in a manner that attempts to prevent the other from seriously affecting us in any way, thus inauthenically. We do this by various forms of domination of the other. Indeed, Heidegger makes the even stronger claim that we are usually (not just often) in some measure threatened by the other. This, too, is almost always unacknowledged. As he asserts, "this kind of solicitude, which leaps in and takes away 'care,' is to a large extent determinative for being with one another."[9]

Now Heidegger's account of the fundamental nature of our involvements with others, our co-being, tends to be quite general when referring to individual others (e.g., between ourselves and a particular person) although, it is worth noting, on the social level, pertaining to how each of us is disposed to relate to the others generally (i.e., as "the collective others" or as "the one" or as "they"), his descriptions are extensive and detailed. Indeed, Heidegger has little more to say about the ontological dimension of individual relationships than what I cited earlier concerning the two extreme modes of solicitude (i.e., authenticity and inauthenticity) of which people everywhere are capable but whose latter mode is the norm. With respect to the ontology of individual relationships, I think that Heidegger has missed important opportunities to develop his theory of authenticity (for he says nothing about how we ourselves may be open to the others for our own existential development, a mode of being that I label "allowing entry" and discuss later) as well as his theory of

inauthenticity (for he says little concretely about just how enmeshed we are in the lives of others and the manner in which we are disposed to leap in for them).

Here the concept of role-playing, which I mentioned in the previous chapter in connection with our ontological bond vis-à-vis other individuals, is relevant to our understanding of the nature of our co-being.

Of course, the concept of "role" is broad. We speak of the role of mothering or of medical doctoring, and we make reference to other forms of role-playing as well (e.g., acting in a theatrical production, the disingenuousness of a "modest" colleague, the ceremonial act of a public official). Here it is necessary for me to distinguish only two major kinds of role-playing, in a certain way roughly parallel to the distinction that I formulated in the last chapter between our dealings with things instrumentally and our dealings with them as co-beings. There is, let us say, *utilitarian role-playing* on the one hand and *existential role-playing* on the other.

In utilitarian role-playing, although we always are aware of the other as an other, and thus never utterly suppress the fact that this other is indeed a co-being – even if we seek to use or injure the other in some egregious way – we are not disposed to deal with him or her as exemplifying our most pressing existential issues. We concentrate instead on our immediate or long-range practical concerns. These others play public, at least potentially helpful, roles for us. They become for us "the bank teller" or "the taxi driver" or "my cardiologist." Regarding such people as necessary for the advancement of our interests, we are not disposed toward them ordinarily and fundamentally in any especially personal way, even when we respond to them ethically, as human beings worthy of respect, care, and attention – as, to use Kant's phrase, ends in themselves and not merely as means for our purposes.

It seems to me, however, that we also see others in ways that transcend their utilitarian value to us.[10] I believe that this other, existential way in which we respond to others is always in play in our relations to them, even if registered only dimly and vaguely in our consciousness. "My cardiologist," for example, is not just a doctor for me. He is also a man with a scarred cheek and sensitive eyes who has transplanted himself from southern India to a rural community in

southern Maryland, and who has become in and for it, in addition to being a respected physician, a financial and educational benefactor to it, and who, therefore, experientially reminds me that in my hopes and ambitions I, too, may still be able to overcome seemingly impossible external odds.

It is this second dimension of role-playing that I at this point wish to emphasize for my overall expository purposes. This mode of relating to others (ingredient in our co-being) is based upon and driven by their living exemplifications of forms of global meaning and direction that we ipso facto find attractive, repugnant, or (in different respects) of *both* positive and negative worth – but never something to which we are wholly indifferent. On this plane of engagement with the individual other, he or she is for us in varying degrees (and as mentioned briefly in the previous chapter) an "alternative self," incarnating another way that we might be, that we feel that we perhaps should be, or on the other hand a way of being that we dislike, even hate, but which contains for us certain possibilities with which we have not come fully to terms – for example, a cluster of desires that we deem both contemptible and unrenounceable. (Recent media broadcasts of people living together twenty-four hours a day under the multiple watchful "eyes" of television cameras and the huge number of viewers who avail themselves of these opportunities attest, if only as one manifestation, to the basic Heideggerian implication that I am making explicit concerning our fascination with the destinies of the other.)

In sum, our own lives are felt to be ultimately meaningful and purposeful because and to the extent that we are living, or striving to live, in accordance with our *Seinkönnen*. Because of our pride, or ignorance, or both, however, there is almost always some important deviation from the "call" of our *Seinkönnen* with respect to our global orientation. As a consequence of this not-fully-being-our-own (*uneigentlich*, literally, not-[our]own-ish, although the word is ordinarily translated from the German as "inauthentic" or "ungenuine"), the others are for us not simply the ones to help us or hinder us, nor are they those merely to appreciatively contemplate and to whom we should express gratitude. They are (virtually) always, additionally, *the issue* (albeit, to use Freud's term, "displaced") for us, as living incarnations of existential roles that we might assume or reject, if

[128]

only provisionally and temporarily. Moreover, the others are for us not simply sets of bare, abstract possibilities of what or who we could be like; nor are they simply beings whose traits we detachedly observe and then decide whether we would like to have (or not to have) them, but instead they are the beings whom we feel we ourselves truly could "become."[11]

But how could I *become* another? I am myself and she is herself. If I become her, then I am no longer myself; or if she becomes me, then she, after all, is no longer herself.

THE PARADOX OF IDENTIFICATION

We have come to another paradox. We speak of identifying with another person (even a "fictional" character), and yet by the so-called law of identity, it would appear that we could not really identify with (which equals, etymologically, to make ourselves the very same as) anything at all, for, so it would seem, everything in the whole world must be itself and not another thing. A cup is a cup, a tree is a tree, a person is a person, and so on; "a" must equal "a"; any other way of looking at this issue would involve us in self-contradiction and, therefore, in logical and ontological impossibility.

Now one obvious way in which we might solve this paradox would be to argue that when we say that we identify with another, we are simply speaking loosely and, pressed for further clarification, could amend our statement to something like this: "I can imagine what he's suffering, which is to say, if I were in his shoes, I would be sick with worry about the doctor's pessimistic prognosis." By putting the statement in the subjunctive mood, I immediately imply that I am really not in his shoes, that I don't literally see myself as identifying with *him*. Thus, the paradox would seem to vanish – a case of verbal hyperbole cured. But note a peculiar feature of the subjunctive statement, "If I were in his shoes, I would be sick with worry"; the person making the claim is ordinarily, however briefly and while expressing himself, imagining the anxiety of the sick person. Yet, how could this be unless he also, if only momentarily, imagined himself *to be* the sick person him- or herself? So it would seem, on second thought, that counterfactual statements about ourselves,

[129]

at least those made from the first-person point of view, require our briefly *being* in imagination that which we subsequently posit as not really the case. If it is objected, "Well, the sympathizer doesn't really even *imagine* himself to be the sick person," that this statement itself is verbal hyperbole, I would respond that such a reply does not seem to be in accord with the phenomenological facts of the matter. For when I utter a sincere statement of sympathy for another, I feel myself – temporarily – to be in his or her plight. "No, *your* plight," it will be immediately objected. "*You* are imagining yourself being, say, stricken with cancer." Well, I don't believe so, I wish to argue. For I am able – and the objector is able, it seems to me – to conjure up a whole host of thoughts and feelings that seem idiosyncratic to what he or she might be going through, even if the person is, say, decades younger than I (or than the objector), of a nonintellectual disposition, of a very different social or religious background, of a different temperament, and so on. As I argued in the first chapter, this point applies to fictional characters, like Anna Karenina, as well, because when I relate to her, I don't merely assimilate her problems to my own and thus simply draw her into my orbit; I identify with them and with her. Isn't that true of you, the reader, as well?

To assert that the phenomenological data challenge, as it were, the logical "law" (of the self-sameness of each and every thing) is not, of course, to solve the paradox of interpersonal identifiability. It is only to suggest that there is still a problem to be reckoned with. And here it seems to me that once again a certain presupposition, both Cartesian and commonsensical, a priori prohibits our achieving a satisfying conclusion to the matter. I have in mind the assumption, previously alluded to, that the "self" is a kind of mental, self-contained substance that simply is itself and not another thing – therefore, something that could not in any sense simultaneously make itself at one with another thing – a computerlike central unit of the mind or brain whose sole function is to gather all of the data of cognition – sensuous, affective, conceptual – and then organize and make sense of, in a word "process," them. In what follows I wish to offer an alternative view of the self or, rather, since that task would be too large for the purposes of this book, a view – essentially (early) Heideggerian in spirit – of those features of the self that would explain without

self-contradiction how we are able at once to both be ourselves and to identify with another.

Let us return to the phenomenological data pertaining to selfhood. No doubt there is some truth in the Cartesian and commonsensical assumption that each of us is a kind of subject or center or agent of consciousness that perceives and thinks, remembers and anticipates, experiences physical sensations and emotions, imagines, and so on. However, this "center of consciousness," Heidegger maintains, is only one part of the self, a part that is wrongly baptized as *the self*; with such a truncated view of the self we are thus unwittingly compelled to proceed on paths that necessarily terminate in philosophical culs-de-sac.

Recall that according to Heidegger there exists for all individuals a potentiality-for-being (*Seinkönnen*) that invites us to reorient ourselves so that our whole outlook on life and the world would be different and at the deepest level more fulfilling. This call of *Seinkönnen* is not merely an interesting characteristic or feature of the Cartesian "subject or agent of consciousness and will" (as one's thoughts or feelings might be regarded) but instead (as mentioned earlier) something that relationally defines this agent, which is to say that we could no longer even speak of the self at all if the claim of one's *Seinkönnen* were to lose its effect. Recall as well from Chapter 2 that there is an element of "necessity" in our lives, what Heidegger designates sometimes as "facticity," other times as "thrownness" (*Geworfenheit*), a rubric term encompassing the "givens" of our world, those significant features of it that characterize what we ourselves and nature itself have already unnullifiably congealed in our being, by virtue of, for example, certain past events of our lives, our personal dispositions vis-à-vis these events, our living in a particular country in a particular epoch, facing mortality, and so on. While our *Seinkönnen* calls us at each moment to act in accordance with its claim upon us, its beckonings are not to any specific set of possibilities that we should or should not have, or actions that we should or should not do. Its repeated call is thus general, to a kind of perfection or completion of our being (both in our humanness and in our individuality). Yet, our facticity limits what we are able to choose to do, and thus not all things are possible. To act at all, we must unite into concreteness two modes of our existence, our facticity and the

call of our *Seinkönnen*, and this assimilative process of thought and action, in turn, can happen only because we live in, and are always attuned to, through our co-being relatedness to the others, a public world of language and all of its historically based rules, customs, practices – a domain that Heidegger refers to as "the one" or "the they" (*das Man*).[12] According to it, anything we know or do must have already found its "general place," have been categorized, and in light of that, given cognitive and actional specificity. For examples, my indefinite desire to make sense of things gets classified by me as, say, a desire for stimulating conversation, academic study, or writing; or my inability to draw well may be grasped by me as "a given," thus part of my facticity, so that I either avoid drawing altogether, visit galleries with vicarious artistic impulses, or take photographs. The one (*das Man*) is, therefore, Heidegger's generic term for the basic framework of understanding and praxis in, of, and for a culture. It consists of multifarious and multitudinous social rules (conventions) that prescribe how we are to think and how we are to act. Because such a framework exists, each (normal) member of a culture has the conceptual tools and learned behaviors for determining what she can think or do, and how she might do it. She is, therefore, able to respond to her call to possibility and consider her past facticity in her deliberations, and she is able to blend aspects of each dimension of her being into a plan for specific action.

Here I wish to emphasize for my overall expository purposes the futurative aspect of the personal-worldly synthesis that I have been characterizing, for the felt, anticipated future is the matrix of general possibility or projection (*Entwurf*), and out of this domain we carve particular possibilities, for example, my decision to finish writing this chapter this winter and not put it off till springtime, or my decision to teach my course this coming fall on Kierkegaard with such-and-such readings and not "those other ones."[13] Moreover, our basic projective orientation not only allows us to articulate in it and, therefore, define our specific hopes (and, thus, obversely, our fears); it also latently contains – and here I am adding to the structure of Heidegger's theory of human projection – a multiplicity of general, existential roles that we allow "the others" to incarnate. The roles are theirs, of course, yet they are also "for us," which is to say that

they are fundamental responses to the question of the overarching meaning of our being for us, but which we also and simultaneously regard as enacted "by them." With varying degrees of interest for me, the other – let us say, Carl – becomes not simply my friend "whom I've known for twelve years and who knows all about drive shafts and c.v. joints," but rather "who seems to find happiness in devoting himself wholeheartedly to the logistics or means of life, virtually as ends in themselves." Or Tony becomes not simply the failed doctor whose wife divorced him and who now lives alone, isolated, writing short stories, novels, and movie scripts, but the wildly talented former close friend who "let himself go" in all sorts of ways, sacrificing himself to the "voices" within seeking poetic expression. Each of the acquaintances just referred to, therefore, is not for me merely "an other out there" or "an interesting other," or even "a person whom I admire and some of whose traits I wish I had"; but more than that, "a person who embodies a potential trajectory of my life, a way of being that could be my own." According to this (my paradoxical) view, I *am* the other, for the other always in some measure re-presents a fundamental way of being that I could, even might, assume. I, therefore, see myself in him or her; he or she exhibits a mirror image of my latent self. Yet, as stated, it is also true to say that I am and take the other to be another in his or her own right, thus a person affected by his or her own *Seinkönnen*, and I am and take myself to be a person in my own right, with my own *Seinkönnen*, and hence not the other.

What I have just stated is not meant to frustrate the reader with logical absurdity, but instead to describe the phenomenological data of my experience. I wish to assert, more audaciously, that it is *our experience*, not just mine. My claim is that we all posit the other as another in his or her own independent being and that at the same time on another level the other embodies a story or narrative for us that is not only familiar, but also our own. If *Dasein's* essence is the "to be" or "could be" of one's life, and if the other is and is taken to be in part an objectification of one's own potentialities, it follows that one's own essence is *defined* by "the other."

Still, it may be asked, if each of us is defined by the other, how are we to understand our own peculiar individuality as it relates to

our simultaneous ability to assume the identity of another? Well, to the extent that I may imagine myself to be, say, Carl (as an actress may imagine herself to be Lady Macbeth), I give myself over to one role possibility of the innumerable roles that are abeyantly, quiescently, always a part of my existence. This "giving over to" is at once a provisory endorsement of his way of being (as I imagine and comprehend it) and a provisory bracketing of all of the other roles whose voices beckon me, demanding greater acknowledgment. What is not and cannot be bracketed, however, is my *Seinkönnen*. Thus, although I may adopt some of Carl's manner of thinking and doing, even suppressing some aspects of my own facticity, I am not and cannot become wholly another, for my *Seinkönnen* calls me as subject and agent of my experience and demonstrates to me that that me contains a "me-ness," an indefeasible nature that, therefore, cannot be substituted by "another," and which I feel myself to be ineluctably obligated to come to terms with – and sooner rather than later, because I will someday, perhaps this very day, die.[14] Moreover, and according to this view, although my outlook on the world is always dual (as I argued in Chapter 1), involving as it does first-person positings of absolute identification, a capacity to put myself in another's shoes and literally take myself to be her – let us disregard for the moment my claim that there is a second agent of consciousness who oversees and protects this activity from excesses and who is anchored to the "here and now" of the everyday world – there is also, and more starkly and irrefutably, the demand of my own *Seinkönnen*, which continuously calls me back to my own fundamental and lifelong task.

Here I wish to note that the overseeing agent of consciousness, what I have called consciousness$_2$, appears not simply to be a "voice of reason" that reconnects to "commonsense" and "what's (allegedly) real"; it is also, I believe (following Plato), the agent that chooses a particular role possibility lying dormant in the domain of our projection and, thus, at least partially enacts the role's agenda and concerns.[15] This agent's form of relatedness to other aspects of one's being is complex, for when and as it endorses a particular existential role for expression, it should (a) simultaneously feel and keep some attachment to what I would call one's primary commitments – those values

and tenets that mean the most to it – for otherwise it would tacitly renounce, in and through its role-playing, a core sense of selfhood and feel utterly lost in its provisory role(s) and lost in the face of its primary roles, that is, its self-definition, that which it regards as "the center" of its being; and (b) it should not, at the same time, completely sever its ties to all of the other roles that urge their own self-expression.

The final point that I wish to make concerning this sketch of the basic structures of the relational self is that although its primary commitments may seem in most normal people to be strong, quasi-permanent, and thus virtually "absolute," such is not the case, I believe. The primary roles that one plays may appear to coalesce as "the real person," and the other role possibilities may appear to disperse as mere supernumeraries whom one flirtatiously calls forth into being and, therefore, imaginarily and temporarily becomes, but whom one soon rusticates to some shadowy underworld of quasi nonbeing. Although it seems that we must assume that each normal human being commits him- or herself to relatively well-defined primary roles, for otherwise the putative self would, in fact, be a nonself and thus be virtually insane,[16] the presupposition is from another point of view misleading. If one is in a certain way committed "to oneself," one is also – however small the degrees of variation in these acts – constantly calling his or her self-definitions into question insofar as one allows oneself to identify with another (or others). Thus, for me to listen sympathetically to a friend's sad, disturbing story about himself requires that I bracket not only my own preoccupations, but also those of my assumptions about life and the world that are tacitly contradicted by what he tells me. If I am to sym-pathize (suffer with him), I must in a way become him and, therefore, veri-fy (make true) his way of seeing things and hence cast doubt upon certain features of my own general outlook, thereby – however subtly – undermining the "real me" I ordinarily take myself to be. To assert this plasticity in selfhood is not to deny or even minimize my capacity to say "no" to these role identifications at a later point and thus to reaffirm my central commitments.

But when does my openness or plasticity of being by virtue of my imaginarily becoming another result in a significant change in

me? The rough answer to this question requires a phenomenological exploration of the kinds of existential struggle that can take place between the self and his or her other. Heidegger, it will be recalled, distinguished two modes of co-being relatedness: (a) (inauthentic) leaping in for another, and (b) (authentic) leaping ahead of the other. These ways of being are the genera of, and thus should be viewed as overarching, any and all of the various roles we do play and are capable of playing. I believe Heidegger's distinction to be not incorrect, but in accordance with my wish to understand a bit more deeply how the other affects and is affected by our entire orientation with respect to life and the world, I think it is important to discriminate (1) *kinds* of leaping in for another, that is, styles of domination that are possible vis-à-vis the other, and (2) *a second mode of authenticity* (alluded to earlier) in human relations, one that should be seen as complementing the mode of leaping ahead for another, to better comprehend what it may mean to be truly affected by him or her.

When we leap in for another there are, it seems to me, three basic types of struggle that can occur: (1) the effort, out of fear, to nullify the other completely, that is, literally or – more usually and obviously – metaphorically to kill him or her; (2) the neutralization of the other through appropriation, according to which, out of keen desire, we affirm and vastly oversimplify the other's nature, attempting to incorporate the other into our own world by making him or her only an instrument of our wishes; and (3) the partial domination of the other, out of fear or desire (or both).

As for mode (b), leaping ahead of the other, there is, I believe contrary to Heidegger, a third mode (c) of solicitude (and, of course, multitudinous and diverse exemplifications of both authentic modes manifested in the roles that we or the others play). Heidegger discusses what authentic beings can *give to* the other (by leaping ahead of, and for, him or her), but he altogether avoids mentioning, for reasons that are unclear to me, what we are able to *derive from* the other (by allowing his or her entry into our lives). The lion's share of my exposition in this context concerns itself with this last mode of being, in its receptive manifestation, for it is only when we are so disposed that we are significantly changed, even sometimes transformed, by the other. Still, more needs to be said first of all about inauthentic co-being, that is, leaping in for another.

[136]

LEAPING IN FOR, LEAPING AHEAD, AND ALLOWING ENTRY

In mode a.1 of leaping in for another, the other is a threat to me and thus I struggle with him or her. What he or she represents is a view or way of life which, if true, I feel to entail the falsity of something that I hold dear. If what I hold so dear is false, then my deepest fear is that the primary roles in life that I play, that which I take myself "to be," may also, if only partially, somehow be false, that therefore I may not yet fully be my true self, not be, to use Hegel's words, a developed "independent self-conscious being," a being who truly *is*. Therefore, in such a case, I suspect that I may be as it were "nothing," so I undertake (again I cite Hegel) a "trial by death" vis-à-vis the other. I engage with him or her and fight for what appears to me to be the core significance, "the truth," of my existence, and thus regard the other as my mortal enemy. So important is this contest, this *agon*, for my well-being and sustenance that I wish to kill the other to validate what I stand for. (To simplify my exposition, I am assuming that the combat I describe is deadly serious and without degree of threat, thus supreme, but of course our encounters with the other are invariably much more attenuated and complex than that.) If I cannot, in fact, destroy him or her, then I engage in whatever measures are necessary to nullify the power of what this other means to me and, hence, make him or her into someone virtually nonexistent. (For example, I can persuade myself that the person is immoral or hypocritical or stupid, character traits that I hold in contempt, and thereby discover a way in which to undermine the apparent genuineness and "truth" of what he or she represents to me.) Thus, I "bury" the enemy, put this being to rest. Or so it seems, because it is not really so. For the other has obviously touched something in me that I need (and, therefore, at some level want), and so he or she will as it were lie in waiting for me, ghostlike, until I resurrect and incarnate him or her (or some stand-in) and repeat the struggle in a more satisfactory way.[17] The trial by death ironically leads not simply to the temporary bracketing of the other, but a partial bracketing in myself. Thus, the enemy is not really dead, but dormant (as a part of me is, too), awaiting an opportunity, usually in other guises, to return to "being." The second irony is that the subsequent occasion, fearsome though it may be, is potentially a very good thing for me, a gift, for my vitality

and spiritual development depend on my coming to terms with him or her in a different way, certainly not by murder. In short, in this case (a.1), the self does struggle with the other, even resorting to the extreme of demonstrating that the possibility of death is of no account either for oneself or for the other (from the viewpoint of oneself). Despite this intense involvement, any significant advance must await another, and different kind of, encounter.

In mode a.2 of leaping in for another, rather than attempting to negate the other, I do the apparent opposite of what is characterized in case a.1, desiring instead to possess the other as a whole, not in part, for my deepest needs.[18] Freud's reflections on the nature of the longings of the id are useful in this context.[19] He contends that in infancy the child has so thoroughly attached him- or herself to a caretaker that the other is felt to be completely "one's own," one's animated possession who will always and approvingly gaze at, comfort, and satisfy every wish of, oneself. Here the nature of the identification of self with other appears, in its totalizing aspect, strange from the adult perspective. Freud coins the term "introjection" to characterize ideas or attitudes that one has subsumed unconsciously into one's personality, and W. W. Meissner decides to use this term to distinguish the infantile unifying act with the loved one from the later, more mature act of what Meissner calls "identification."[20] In introjection – I assume here Meissner's gloss on Freud's usage – the other is in one way incorporated into one's life, but in another sense is not, for although he or she is always "there" for the infant and thus central to his or her pleasure-seeking life, the other's desired characteristics are not, when introjected, properly appropriated as one's own, as occurs when one is no longer an infant and, inspired by certain traits in another, feels quickened and gives renewed significance to analogues of these traits in oneself. The introjected other is then for the infant a being whose being exists only as perceived, whose sole function is to express total devotion to the infant's wishes, and whose characteristics (e.g., warmth, tenderness, smiles of approval, etc.) do not yet elicit from the infant the desire to become like the other, to be a caregiver like him or her. The other is simply "there," a static but compelling presence in one's primordial world and, according to Freud, something that one is never fully able to give up. The introjected other, therefore, continues to manifest itself in our lives, playing the crucial

role in our fantasies, accounting for our otherwise inexplicable strong attachments occasionally to people whom we hardly know or whom we do know would be "wrong" for us, and accounting as well for our intense interest in certain characters depicted in literary fiction. In this condition of introjection, we developmentally remain where we have always been, powerfully affected and shaped with respect to our global outlook, in thrall to the mysterious, all-giving other. Thus (in relation to one's whole orientation vis-à-vis oneself and the larger world), one doesn't learn anything from or become anything substantively more through one's engagement with the introjected other (real or "fictional"). So too, although we may now have at a very general level an explanation of the attractiveness of certain forms of literature – in whose immersion we are evanescently gratified, but at a deeper level left essentially intact – we do not as yet have an account of self-other relatedness according to which our very being is transformed.

This, however, will not be found in mode a.3 either, in which the self attempts to dominate the other not as a totality, but only partially, which is to say that one no longer views the other as an omnibenevolent, omnicompetent provider of one's pleasures, but as a person with an independent existence who, due to one's own fears or desires (or both), must be controlled and subordinated to one's own ends or purposes. As is true of the trial by death situation discussed earlier (a.1), here one has transcended his or her infantile mode of relatedness to the other. In this third mode, one sees the other as problematic by virtue of (α) his or her possessing something that one wants or, on the other hand, threatening the existence of something that one has; and (β) having the independence and freedom from oneself to realize one's own desire or fear. But trial by death in this case is "unwise," "risky," and (one may understand) will not provide, except momentarily, the deep and lasting satisfaction one craves. So one compromises one's wishes and seeks to bring the other into one's orbit through domination. One becomes, to refer to and expand upon Hegel again, the "master" or "lord," an independent consciousness existing for oneself, who deals with the desired or the threatening aspect of the other as something to be tamed. The "slave" or "bondsman," therefore, exists at this stage not for him- or herself (from the point of view of the master), but for another.

[139]

The latter does not by virtue of this relationship truly develop in his or her being, however. The master obtains what is desired or avoids what is feared. But what is desired and obtained (e.g., food, sexual gratification, respect) is viewed by oneself as a product, as something to be literally or figuratively consumed, and not as something respectfully mediated by another and, therefore, not as a means for a more complex development of one's own being, let alone the other's being. What is feared is regarded as an evil to be strenuously avoided, and thus not as something to be open to and explored, an opportunity for recovery of important, suppressed features of one's self and world.

However, in the mode of leaping ahead of the other, one cares for the other in the most responsible manner; one *may* also open oneself to him or her, allow oneself even "to become" that person, "return" to oneself once again, having perhaps achieved an enhanced, more multifaceted, more human and humane self. But my thesis actually leads us to view a new mode of authentic solicitude.

Hegel suggests in his famous discussion of "Lordship and Bondage" in *The Phenomenology of Spirit* that, ironically, the true advance in the kind of relationship that I am describing occurs in the slave, for he or she must struggle with a resistant other (typically some matter or thing, but conceivably something living, like plants, animals, or even people), whereas the master, who has only received the nourishment and enjoyment of the fruits of the slave's labor, has merely dominated the slave and has not sought, hence not attained, a sense of achievement for his or her work; nor has the master received the recognition for it that is developmentally required from an independent and free consciousness and, therefore, he or she is not certain of self, has not arrived at the "the truth" of his or her being. On the other hand, the slave having struggled with "the object," has discovered many things about what the master wants and how to obtain or provide it, and about the master him- or herself. In fact, the discoveries that the slave has fought for and won awaken in him or her new and earlier undreamed of possibilities. The slave becomes conscious of higher purposes in life than the avoidance of pain and the achievement of physical and emotional (dominating) pleasure. In working for the master, the slave, in sum, perfects his or her hitherto unknown

talents and possibilities, sees them expressed and objectified in the accomplished work, and senses within even greater capacities worth struggling for.

According to this Hegelian model, it is not through direct struggle with the other, but through one's labor vis-à-vis "an object" (which might include a particular trait of another abstracted in the mind of the slave from the master's full, individual, and human otherness) that one achieves a higher level of self-consciousness and freedom, with the dominating other playing the role for the slave only of un- appreciated and unappreciating master and mere intermediator of the slave's efforts. Now although I do not at all wish to deny Hegel's claim concerning the personal and global importance of one's direct and unmediated struggles with "things," broadly conceived, it does seem to me that in his narrative of the trial by death he fails to do full justice to the importance of a different kind of encounter, the *unmedi- ated* struggle with the other (person).[21] Indeed, I believe that this kind of interpersonal struggle, while dialectically reinforced by (and reinforcing) the kind of *thing-mediated* struggle recounted by Hegel in "Lordship and Bondage," is a precondition for basic change in a person. And since, as I have argued, we take the fictional other at one important level to be real, the phenomenological (neo-Heideggerian) account that follows will have immediate pertinence to the last part of this chapter on fictionality as well as to our understanding of the depictions of people in paintings (Chapter 4).

In both the previous chapter and this one, I have discussed what Heidegger labels our *Seinkönnen*. This feature of our being, it will be remembered, makes an indefeasible claim upon us to be different from and "better than" we currently are; it calls us to authentic and full being. The very sense that our lives are worth something at all – actually, that they are infinitely worthy – also is felt in the call, and the fact that we will die (in fact, could die at any moment) entails for us that there is something (indeed, everything) at stake in the basic choices that we make. Now in our solicitude vis-à-vis the other, it seems to me that there are times in our lives when the other seems to be presenting something to us that is both strange and yet somehow familiar and that we, therefore, find at once both disturbing and compelling. The other "speaks to me," lures me to him or her, and

simultaneously I am driven back to something in myself that I have always known, my *Seinkönnen*. The strangeness, sometimes even the uncanniness, of what I feel puts me in conflict with myself and tempts me to deal with the other in one of the three (leaping-in-for) modes characterized earlier. Still, if I am open and courageous, I may allow myself to be with this other more closely, not simply to observe, but to immerse myself in an alien and eerily familiar world, to see and feel in a different way, even to allow myself imaginarily and provisionally to become him or her. I thereby take on an unusual role, either one whose significance I did not divine before or one that I may have temporarily played and cast off for simplistic reasons based on my disturbing and thus "unacceptable" emotional responses. In sum, the other (as the target of the co-being mode that I am describing) embodies and intensifies for me issues fundamental to the way in which I comprehend the meaning of my existence. Although manifested in a form that more than usual disquiets and discomfits me, the other also and at the same time touches something in my world that intensifies the claim on me of my *Seinkönnen*. I am called to a seemingly unreachable, indefinite, but supreme, "place," so I draw closer, wishing to be with this other intimately, to feel what it is like to participate in his or her world, in order ultimately to realize, although hardly wittingly, the supreme promise of fulfillment signified by my *Seinkönnen*.

In being with this special other, even perhaps in imagining myself as this other, I temporarily hold in abeyance my commitment to the roles of "self" to which I am primarily committed, allowing myself to indulge in the way of thinking, feeling, and acting – in short, being – of the other. Certain of my basic ways of understanding now seem somehow no longer quite right, distorted, less significant, or even irrelevant. That which earlier I presupposed to be not fully possible (e.g., an ever-opening, deepening, sustained, and sustaining relationship with another) now, momentarily at least, seems possible. A tension is established within me, and thus my agent self feels a kind of dual and opposing attraction. If the new and special way of the other continues to feel more ordinate to the call of my *Seinkönnen* than aspects of my old global disposition, I may, in faith, more fully and devotedly endorse it, thus effect a synthesis of opposing dispositions in myself, although there is no inevitability that I will do this,

because I am naturally fearful and rightfully so, for what "seems" to me to be right, I know very well, may be an illusion or it may be something that in the end will wound or destroy me. Here it should be emphasized that I am able to affirm the new orientation, achieve the synthesis, not by "thought" (in explicit propositional affirmations to myself, although I may do this, too), but by the affective and imaginative entering into and subsequent sanctioning of another's dispositions and behaviors as mine also, such that I begin to see and feel the way he or she does and, based on this identifying experience, create new images, desires, and plans, and make new kinds of choices and undertake new kinds of activities. Moreover, I affirm this new way not by apprehending and dealing with the world precisely as the other does – for that would entail the suppression of an important part of myself, a permitting of the other to "leap in for me" – but similarly, and in any case consonantly with and shaped by my other basic commitments and hence past ways of seeing, imagining, and doing. The general (but not incontrovertible) indication of my successful and authentic synthesis of otherness, as opposed to the subsuming of otherness into my orbit (or the subsuming of myself into the other's orbit[22]), would be the resultant sense of openness and joy I feel, the imaginativeness I exhibit, and my wish in gratitude to give back something equally precious to the other, indeed, to many others. Thus, as Friedrich von Schiller advises, we must learn how to see others in ourselves, not ourselves in others. That is, in and by virtue of the provocativeness of certain others, manifested in their capacity to at once attract and repel us, we must learn how to discover that trait as, in fact, our own, comprehending its nature and embracing its implications for our lives. We must, in short, appreciate and cultivate the problematic, suppressed otherness in ourselves and, thereby and reciprocally, the others themselves in their significant otherness. Obversely, we must strive to overcome our disposition to confirm a trait in others as simply "like ours," such that we apprehend in them no more than a simplistic repetition of that which we either cherish or fear in ourselves.[23]

Still, it may seem from the vantage point of this phenomenological narrative of authentic co-being that the other is only an instrument

for my own development, an opportunity for me to immerse myself in and further explore my most demanding preoccupations, for the purpose of reordering and rendering them more consistent and nuanced and, in short, to feel "better about my life." In this context, I think it is true, as I've already indicated (following Heidegger),[24] that our framework of projection does not allow us to apprehend an existential possibility in another that is absolutely "other" to us. Thus, what the other person means to me must be consistent with what I am able to comprehend (at the deepest level) about the actual or possible significance of my own life. This conceded, it does not follow that I must view the other solely as a Rorschach-like opportunity for the expression of my own explicit or implicit issues. For, it seems to me, when I imaginarily become the other, he or she can awaken possibilities in me that I did not know were there, and this kind of dawning encourages not just an exploration of my own personal preoccupations, but my faithful affirmation of the ultimate mystery of my own being and its future possibilities. Furthermore, this reverent orientation vis-à-vis my own being, which itself is always at some level grasped in its ontological dependency on the other, disposes me as well and in the same degree to the ultimate mystery of the being and future possibilities of the other. The dawning event then becomes the experiential basis for a special kind of appreciation of the other, as someone I wish to draw still closer to and yet, paradoxically, not so close as to dominate, to reduce to a being whom I know in totality, for as authentically related to the other I sense that such reduction would constitute a diminution of my true understanding of him or her (and, ultimately, of myself). In this mode of relatedness that I am characterizing, which is not a leaping ahead of the other but its complementary mode, an allowing the other entry into my life and world, the other is also responded to authentically, as both the same as I and other than I. The person must be the same, for otherwise he or she would be utterly unintelligible to me, but also different, thus not someone necessarily identical or greatly similar to me in my explicit concerns, but instead a being whom I intuit to be only similar to me – analogically so – with respect to those future, existential possibilities that I sense but do not now, will not ever, fully comprehend.[25]

[144]

Why and How Others Matter

With these observations concerning our various possible modes of relatedness to the other in mind, we are now, I believe, in a better position to understand why the figures in artistic representations can mean so much to us and the respect in which this is especially so. The simple response to these issues is that because at one level we ordinarily take the figures to be real beings, we can be affected by them in virtually the same way that we can be by "real others"; that is, we can care about them tremendously, and we are able to do this in our imaginative involvement by leaping in for them (in any of the three ways described earlier) or by appropriately identifying with and thus allowing their entry into our lives. But before I attempt to clarify my claim concerning the virtual similarity and, therefore, the true differences in our respective responses to "real" others and "fictional" others, I want to give an example of how we might identify ourselves with a fictional being. I choose, almost at random, the ship's captain in Melville's *Moby-Dick*.

Here I wish to assert that this figure, Ahab, can, as I become engrossed in the story, offer me a specification of a role matrix that is already predefined by me in my projective orientation. Thus, as I read about Ahab, just as when I meet some new person, I gradually associate him with some type (i.e., role of my own) with which I am already familiar. I can be involved with him in *two* of the three modes of co-being manifested vis-à-vis the "real" others: I can leap in for him *or* I can allow him entry into my world. (I cannot leap ahead of him, for I cannot help him.) But I am also aware, in and through my overseeing, directing "consciousness$_2$," that in either of the two modes of involvement certain kinds of thinking and behavior are disallowed (which I discuss shortly). Thus, I may view and become Ahab only in a tentative unenthusiastic manner, feeling him to be a fearsome person, a serious threat to my whole orientation toward life and the world and, therefore, someone whom I must in the end keep at a distance and "control," by not lingering in his world and, through consciousness$_2$, making critical judgments about him (e.g., that he is obsessive-compulsive or megalomanical). Or I can imagine myself uninhibitedly and sustainedly being Ahab, thereby giving free rein to values and beliefs to which I am less

firmly committed or even to which I am ordinarily opposed, hence allowing myself to dwell for a while in a subworld into which I would ordinarily not be willing to venture. Let us assume, as I read the following words in Melville's story, that I enter energetically and enthusiastically into that world. I, therefore, commit myself to the assumptions and presuppositions that make that world possible, including my imagining myself to be the captain of the ship; I have the same feelings of excitement, determination, rage, and fear regarding the great whale, Moby-Dick, that Ahab has; indeed, I *am* Ahab. I am obsessed and possessed by my enemy and, as a consequence of this (for me) unusual identification (and temporary detachment from commitments to my primary roles), new feelings and thoughts, which I hardly could have anticipated and which sometimes give me great pleasure (and sometimes considerable fear) by virtue of their novelty, suffuse my whole outlook. I find myself enthusiastically exclaiming the following to my crew:

> Aye, aye! And I'll chase him round Good Hope, and round the Horn, and round the Norway Maelstrom, and round perdition's flames before I give him up. And this is what ye have shipped for men! To chase the white whale on both sides of land, and over all sides of earth, till he spouts black blood and rolls fin out.

Having provisionally become Ahab, I can eventually have effected an important change, perhaps many changes, in myself. I am now, and do not just momentarily and abstractly believe that I am, let us imagine, a different person. Because of the story's emotional and intellectual persuasiveness, because I experienced what it was like to be Ahab-in-his-world and that sustained experience could be seamlessly woven into and give new support and coloration to the world in which I already partially believed, I have a new and greater appreciation for the tremendous determination in those who passionately and single-mindedly pursue some great goal. Moreover, just as I am able to become Ahab, so, too, I can in turn become – through my identifying efforts based on and guided by the narrator's (Ishmael's) story and his style of writing, his countless descriptions, portraits, ruminations, and so on – each of the other characters as well, finding as always within my possibility-framework (projection), suppositions to which I now give atypical emphasis and valuation and which, thereby,

enable my specific role identifications to occur in the first place, because human consciousness (the psyche), as Aristotle stated, has the capacity in a way to be all things.[26]

In principle, as I read *Moby-Dick*, I can give myself over to its subworld of nineteenth-century American adventurous whaling however I wish. But given who I am, in practice I will already have projected certain fundamental conflicts that restrict the nature and degree of my participation: as I dwell in this alien world, I also from time to time retreat from it (by virtue of the interceding efforts of consciousness$_2$) observe my involvements, pleasures, anxieties, and so on; reflect on the narrative thread of the story; wonder about its meaning, its profundity as regards human nature, its explanatory power with respect to twenty-first century American cultural values. This kind of dual consciousness oscillation that I perform – from one of varying degrees of identification, to distancing, to re-identification, to distancing once again (but sometimes of a modified, assimilative sort) – is a close analogue of the kind of involvement that I have in varying degrees on a daily basis with the "real others." As with them, the subworld that fictional characters populate poses a series of challenges to assumptions of my principal world, and often one fundamental challenge emerges as especially provocative and even troublesome. The work of fiction, thus, can open up a domain of issues and values that I am inclined to overlook or repress because they do not mesh well with my primary role commitments. But because on the one hand I can always tell myself, according to consciousness$_2$, that a particularly disturbing domain is "not real" and, therefore, not to be feared, and because on the other hand I at some level want to explore it (principally because of the demands of consciousness$_1$, which indistinctly grasps that further timidity will only jeopardize my overall and long-term well-being), I frequently meet the "purely fictional" challenge. I enter into, feel, and believe in the people of this world, often with greater emotional abandon than I do with respect to the people of the "real" world. If in this subworld I am shown a new and multidimensional manner in which to exist – a way that does not too seriously threaten my usual self-definition, my primary roles, and which is felt to be in greater accord both with the way the world "really is" as well as with the requirements of my *Seinkönnen* – then I may assume new commitments, projecting myself

toward, seemingly unconsciously, different worldly goals and thus a modified being-in-the-world. I may achieve what perhaps Aristotle was referring to in the *Poetics* when he characterized the spectator of tragedy as having undergone a "catharsis."[27]

As conceded earlier, however, I also respond to fictional beings differently from the way in which I respond to so-called real beings, just as, in thinking about my absent daughter, the nature of my involvement with her is different from the way in which I react to her when she is present. Now it seems to me that when I deal with fictional beings, my mode of relatedness to them (ordinarily) differs in two important ways from my mode of relatedness to "real people" when they are present to me. In the first place, as stated in Chapter 1, my overseeing awareness, consciousness$_2$, constantly monitors my behavior and allows me only so much free rein. I can, in and via consciousness$_1$, visualize someone like Hans Castorp, I can sympathize with his consumptive state, I can imagine myself being him and presenting myself with various scenarios for what I might do as Hans. Yet, my overseeing consciousness (again, ordinarily) will not allow consciousness$_1$, while I am engaged in the reading, to attribute thoughts or statements to Hans that contradict what is textually stated or implied (or what I take to be implied) in order to dwell in a subworld unauthorized by the narrator's written words. So the events of Mann's tale contain for me a kind of inexorability that is not found in my current interactions with my spouse. For I do not know – no one knows, not even she herself – how she will respond to me, but I do know that Hans will respond in a manner prescribed by the narrator, even if I have never read the novel before.

In the second place, although I can listen to Hans speak to Naptha, be privy to his thoughts, become Hans himself (in and through my consciousness$_1$), or, finally, be personally and directly addressed by the narrator of *The Magic Mountain*, Hans will not respond to me even if I imagine myself addressing him; nor will the narrator. Either or both of these characters remain mute in the face of my interrogations, and my overseeing consciousness makes it virtually impossible to forget this.

Thus, I cannot change the events of a fictional world and, correlatively, I cannot provoke any of its characters to deal with me personally. What these states of affairs entail is that I necessarily feel the

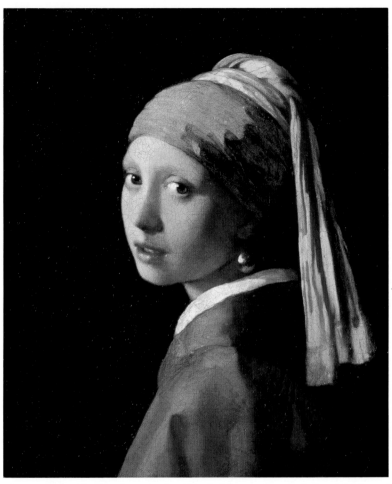

Plate 1. *Girl with a Pearl Earring* (c. 1665–6, Johannes Vermeer), Royal Cabinet of Paintings, Mauritshuis, The Hague.

Plate 2. *Woman Holding a Balance* (c. 1664, Johannes Vermeer), Photograph © 2002 Board of Trustees, National Gallery of Art, Washington.

Plate 3. "Hell," detail of *The Garden of Earthly Delights* (c. 1504, Hieronymus Bosch),

Plate 4. *Woman in Blue Reading a Letter* (c. 1663–4, Johannes Vermeer), Rijksmuseum, Amsterdam.

nature of my engagement with them to be qualified, as I would were I able voyeuristically to view someone else's intimate and troubled life without in any way being able to affect it. In fiction, the other can affect me, but, as stated, I cannot affect him or her. If nothing is asked from me regarding the other, I am not urgently *compelled* to face issues fundamental to the significance of my life, whereas when I am involved with my spouse, a friend, or a colleague, this is not so: they demand that I respond to them, or they act in such a way that I feel obligated to react, and I know that what I do can make a difference to them, as well as to myself.

Nevertheless, Shakespeare's Hamlet, as we witness his trials and sufferings, is a living presence, an active provocation for each of us to explore, in and through *his* complex otherness, unarticulated concerns and conflicts that lie at the base of *our* daily preoccupations. The play elicits, among other feelings, a sense of anxiety that our deepest commitments may be for nought, that perhaps we are all victims and victimizers, battered by and contributing to immediately personal and social forces that demonstrate life to be defined fundamentally by subjugation, greed, licentiousness, and illusion. For consciousness$_1$, the world depicted is, while we view it, totally real to us; for consciousness$_2$, it is only "imaginary" – thus, a relatively safe and secure domain in which to dwell for as long as we wish. Not endangered by any physical threats, we may allow ourselves to be exposed to whatever events the play depicts. Nor need we worry about the judging eyes of others as we sense the emergence of a troublesome conflict in our own Hamlet-defined world. At any point, we can arrest our exploration and distract ourselves with a thought such as, "Naturally this is not real" or "Hamlet [the man playing him] seems to have a cold." Seizing upon common-sensical, intersubjectively sanctioned assumptions, we retreat, reassuring ourselves that the audience is the reality and that the actors provide us with entertainment and mere pretense. Interestingly, however, we do read and view the play again and again, because at some level we know that Hamlet's story is not just pretense and that we need to participate in it (in the world, really) more fully and bravely still.[28] A work like *Hamlet* is thus both alluring and terrifying, for it presents a beautifully articulated but simplified domain that in alien guise contains for us questions and issues that we do and yet do not

wish to confront. We can explore them as much or as little as we like, knowing all the while that there is "more" for us to confront and that the work will patiently await our courageous reentry into it. "For beauty," Rilke writes in the first of his *Duino Elegies* (and here I assume "beauty" can refer to a work like *Hamlet*, as well as to natural phenomena), "is the beginning of terror we're just able to bear. And we admire it so because it serenely disdains to destroy us."[29]

Thus, when engaged with him not only do we posit Hamlet to be real – although, again, not precisely in the same manner that we take a person whom we may be living with to be real – but we are enabled by him, under appropriate circumstances, to face and explore our own existential concerns. Furthermore, because our issues are essentially linked to those of the "real," quotidian other, because the destiny of each one of us is and is felt to be intertwined with the destinies of the others – ultimately, all of them – for us to achieve a deeper appreciation of Hamlet's concerns is simultaneously to achieve a deeper appreciation of those of our fellow other(s).[30] That is why, it seems to me, we have a certain responsibility to someone like Hamlet, one similar to our responsibility to both ourselves and to the others and for a similar reason, namely, the unignorable call of our *Seinkönnen*.[31]

If my characterization of why and how others matter to us is at least roughly right, we are now, finally, in a position to investigate the significance of the depictions of paintings. My contention is that paintings are at base about others – on the face of it, fictional others, but in an important and overlooked sense, "real" others – their stories, their concerns, are, whether we acknowledge them or not, our stories, our concerns. Moreover, the painted depictions of things – such as flowers, seascapes, or buildings and even so-called abstractions, such as geometric shapes or irregular patches of color, as in the paintings of Jackson Pollock – evoke existential issues, because the "things," I maintain, are always proxies for people (or peoplelike beings) who, if we would only attend to them in the right manner, are also telling us their stories. For if we respond to physical objects, like an

old wallet or an apple, as I have described, then we also respond to colors, shapes, paint densities, brush strokes, formats, dimensions of depicted scenes, and so forth in the same basic way. Indeed, we might say that, in general, the "meaning" question concerning abstract paintings highlights my point, for when we take the trouble to understand them, we must steep ourselves in their subworlds, even become frustrated by them, and not rely on the familiar cues that suggest themselves immediately to us in viewing figurative paintings and that often encourage culturally mediating and distancing strategies of interpretation.[32]

NOTES

1. The famous "Cogito" argument, whereby Descartes demonstrates that he cannot doubt his own existence – for in the very effort to doubt that he exists he tacitly affirms that he exists – might seem to contradict my thesis that Descartes has a fundamentally third-person stance regarding the paradigmatic way to gain knowledge of things in the world. It certainly does contradict it if only the first two of Descartes's famous *Meditations on First Philosophy* or the first two sections of his *Discourse on Method* are taken into account. But if one reads beyond these parts of his works and considers the outlook that informs his whole manner of thinking – the latter parts of the *Meditations*, the *Discourse*, and much of the remainder of his entire oeuvre – then it becomes clear that it is not the intimations of subjectivity that impress him most, but on the contrary those "hard," repeatable, intersubjectively measurable data that can be garnered only through a third-person stance and that must be subjected to the methodological principles of logic and mathematical physics. Thus, ironically, at first taking seriously the claims of first-personhood, he soon tacitly denigrates their significance, putting forth instead fundamentally different epistemological and ontological positions.

2. See Chapter 2, pp. 92–110.

3. "By 'Others,'" Heidegger writes, "we do not mean everyone else but me – those over against whom the 'I' stands out. They are rather those from whom, for the most part, one does *not* distinguish oneself – those among whom one is too. This Being-there-too [*Auch-da-sein*] with them ... is something of the character of *Dasein*. ... 'With' and 'too' are to be understood *existentially*, not categorially [i.e., not as like a cluster of qualities pertaining to physical objects, but as a mode of *Dasein's* being]. By reason of this *with-like* [or "with-ish" or "inclusive," *mithaften*] Being-in-the-world, the world is always the one that I share with Others. The world of *Dasein* is a *with-world* [*Mitwelt*, a term that I have translated as *co-world*]." *Being and Time*, trans. John Macquarrie and Edward Robinson (London and Southhampton: SCM Press, 1962), pp. 154–5.

[151]

4. This is true of normal people. Some rare, brain-damaged individuals apparently can conflate these two modes of being, as is testified to in Oliver Sacks's *The Man Who Mistook His Wife for a Hat and Other Clinical Tales* (New York: Summit Books, 1985).

5. In being "patients" of the other, we allow him or her to step in for us and take over our care. I do not deal with this aspect of inauthenticity, which Heidegger should have identified and which he might have named "being leapt in by another" – important though it is for understanding human relationships – because it is not pertinent to my fundamental aim to describe our active attempts to deal with the other and to identify which of our efforts can result in our own transformation.

6. *Being and Time*, p. 158.

7. Ibid., p. 159.

8. In fact, according to Heidegger, our care for self is so basic to who we are as human beings that referring to it as I just did is a misleading redundancy (like "living life" or "unmarried male bachelorhood"), since all of an individual's kinds of care ultimately are expressions of his or her "self-care."

9. *Being and Time*, p. 158.

10. Here I am *not* reiterating Martin Buber's view that it is possible to transcend our instrumentalizing proclivities vis-à-vis another individual and thus dispose ourselves toward him or her with a certain tender respect, ethical desire, and even religious awe, so that we feel the person's presence to be not that of a mere other, a "you" with only useful or useless capabilities to serve our needs, but instead to be that of an individuated, spiritual being – in short, a "thou."

11. This conclusion is applicable to, and explains the power of, the artistically rendered fictional others as well, I believe. I develop this point later.

12. Macquarrie and Robinson translate *das Man* as "the they," which, although ungrammatical, does capture better than "the one" (the literal translation) Heidegger's meaning.

13. "Why does the understanding – whatever may be the essential dimensions of that which can be disclosed in it – always press forward into possibilities? It is because the understanding has in itself the existential structure which we call 'projection.' ... Projecting has nothing to do with comporting oneself towards a [specific] plan that has been thought out, and in according with which Dasein arranges its being. On the contrary, any *Dasein* has, as *Dasein, already projected itself* [my emphasis]; and as long as it is, it is projecting. As long as it is, *Dasein* always has understood itself and always will understand itself in terms of possibilities." *Being and Time*, pp. 184–5.

14. Heidegger makes this point by asserting that each *Dasein* intuits his or her own *Jemeinigkeit*, a term that Macquarrie and Robinson translate as "in each case mine" or "mineness." I would translate it as "ever-mineness." See, for example, ibid., pp. 67–9. Here, once again, is an essential first-person term and reference that would ordinarily be regarded with great skepticism by

philosophers committed to analytic ways of solving the sorts of philosophical issues that I am discussing in this book.

15. I should add as well that although consciousness$_2$ is the rational part of our being par excellence, there is no guarantee that it will always choose rationally. For, as Plato knew only too well, reason can – and so frequently does – fail to understand the messages and motives of other parts of its being, hence becomes confused and even corrupted by their desires and machinations or by people and events in its world.

16. For an interesting fictional example of a person who has lost his sense of self and who, therefore, suffers the psychological illness known as cosmopsis, cf. the character of Jacob Horner in John Barth's provocative early novel, *The End of the Road* in *The Floating Opera and The End of the Road* (New York: Anchor Press, 1988).

17. "They [who survive the trial by death] put an end to their consciousness in its alien setting of natural existence [death], that is to say, they put an end to [a stage of development in] themselves . . . ; and the two [antagonists] do not reciprocally give and receive one another back from each other . . . , but leave each other free only indifferently, like things. [But] . . . their act is an abstract negation [a mere obliteration of the other], not the negation coming from [a developing] consciousness, which supersedes in such a way as to preserve and maintain what is superseded, and consequently survives its own supersession." G. W. F. Hegel, *The Phenemology of Spirit*, trans. A. V. Miller (Oxford and New York: Oxford University Press, 1977), p. 114.

18. Here, i.e., in cases 1a and 1b, it is noteworthy that the other as an independent being may not even be aware of his or her own domination, since what is dominated may simply be closer to a mere "intentional object" of the dominating subject, one that has little in common with "the real person" intended. Cf. Chapter 1, pp. 60–71, in which I discuss this issue of intentionality.

19. See especially *The Ego and the Id*, trans. James Strachey (New York: Norton, 1962); *On Metapsychology*, trans. James Strachey (Harmondsworth: Penguin, 1984).

20. Freud asserts that as one ages, the id normally will, grudgingly and partially, renounce the introjected attachment, but only on the condition that the ego will take on and make its own some of the infantile other's characteristics. "It may be," he speculates, "that this identification is the sole condition under which the id can give up its objects." *The Ego and the Id*, p. 368. I have been helped in my account of introjected relatedness by Keith Oatley and Mitra Gholamain's essay "Emotions and Identifications: Connections between Readers and Fiction," *Emotion and the Arts*, eds. Mette Hjort and Sue Laver (Oxford and New York: Oxford University Press, 1997), especially pp. 278–80. Oatley and Gholamain in turn express their debt, which is mine too, to Meissner's article, "Notes on Identification," *Psychoanalytic Quarterly*, 41 (1972): 224–59 and especially p. 250. It should perhaps go without saying that in drawing on certain aspects of both Hegel's and Freud's thought, I am not committing myself to their

respective methodological and ontological assumptions concerning other issues about which they theorize.

21. My account of the unmediated encounter with the other is consistent with the general development of Hegel's thought, but I have been unable to find in *The Phenomenology of Spirit* precisely what I shall outline shortly with respect to this topic. Hegel does believe that our complete liberation and highest form of self-consciousness will be achieved in and through our identifications with others, but his statements are, to me at least, too abstract, suggesting that in the highest stages of human development a purely intellectual identification with otherness will take place, an end solely involving the *ideas* or principles of the other and not an individuated and unterminable emotional engagement with the other (that I attempt to describe). Hegel expresses the final stage of a person's development in his summary preface to *The Phenomenology* this way: "In accordance with this its essential universality [having transcended all idiosyncratic particularity], the [individual] self-consciousness is real for itself only insofar as it knows its reflection in the other (I know that others know me as themselves) – and knows itself as *essential self*, as the pure spiritual universality [thus nonparticularity] of belonging to one's family, one's homeland, etc. (This self-consciousness [of perfect understanding] is the foundation of all virtues, of love, honor, friendship, courage, all self-sacrifice, all fame, etc.)" See paragraph 39 of the 1841 German edition of *The Phenomenology*, cited in *Hegel's Phenomenology of Self-Consciousness: Text and Commentary*, ed. Leo Rauch and David Sherman (Albany: State University of New York Press, 1999). It may be that in some section of his complete works Hegel asserts exactly what I do (more amply and better) about the importance of the immediate or unmediated other as an intermediate stage in the development of self-consciousness. If so, I have been unable to bring this section to light.

22. See endnote 5.

23. The reference here is to Schiller's distinction between the man of a caring sensibility versus one of an egocentric sensibility. The latter is "Unacquainted as yet with his own human dignity, . . . far from respecting it in others; and, conscious of his own savage greed, he fears it in every creature which resembles him. He never sees others in himself but only himself in others; and communal life, far from enlarging him into a representative of the species, only confines him ever more narrowly within his own individuality." Friedrich Schiller, *On the Aesthetic Education of Man* (Oxford: Clarendon Press, 1982), p. 173. Quoted in Richard Shusterman, *Pragmatist Aesthetics: Living Beauty, Rethinking Art* (Oxford, England, and Cambridge, Mass.: Blackwell Publishers, 1992), p. 161.

24. See Chapter 2, pp. 110–17.

25. Ibid., see for a fuller discussion of this issue of analogical faith.

26. *De Anima*, Γ 8, 431 b21.

27. For a more complete discussion of my interpretation of Aristotle's concept of catharsis, see "What Is Aesthetic Catharsis?" *The Journal of Aesthetics and Art Criticism*, 42 (1983): pp. 59–68.

28. Here it is useful once again to return to Kendall Walton's book, *Mimesis as Make-Believe*. He asks: "Why play the same game [e.g., of re-reading *Hamlet*] over and over?" He responds that "the game may not be exactly the same each time, even if the readings are the same. . . . But even if the game is much the same from reading to reading, the tension and excitement of fictionally [i.e., pretendingly] not knowing how things will turn out may be present each time" (pp. 261–2). This, it seems to me, explains nothing. Our sheer pretend-denial of the known outcome of a story is hardly sufficient to account for why we sometimes eagerly reread the same work. Nor, it seems to me, is Robert Yanal's claim in *Paradoxes of Emotion and Fiction* that we misidentify the nature of our emotions when we say that once again we are "in suspense" when we see Marion (played by Janet Leigh in the film *Psycho*) stepping into the shower of her motel bathroom. We can't be "in suspense," he says, only "apprehension." Now sometimes this kind of reconsidered, subtle characterization of one's subsequent emotional response may be right, but not always, for other times we are, it seems to me, truly in suspense once again. For as we watch the movie a second or third time, we *are* Marion, and although we know in that role we will die, we do not know precisely what it will be like once more to be threatened to the core of our being and how we will existentially (as opposed to physically) respond to this horror. I am thus claiming, as an alternative to both Walton and Yanal's views, that when we reexperience the same work, we are prepared to be exposed to, all over again, and partially redefined by, an explicitly unknown but suspected aspect of ourselves, a problematic role of our own which, at the same time, is an ingredient of our being-in-the-world.

29.
. . . Denn das Schöne ist nichts
als des Schrecklichen Anfang, den wir noch grade ertragen,
und wir bewundern es so, weil es gelassen verschmät,
uns zu zerstören.

I have slightly modified Stephen Spender's English translation. Concerning a closely related issue, Rilke writes in a letter to his wife, Clara: "Works of art always spring from those who have faced the danger, gone to the very end of an experience, to the point beyond which no human being can go. The further one dares to go, the more decent, the more personal, the more unique a life becomes." Cited by Gaston Bachelard, *The Poetics of Space*, trans. Maria Jolas, (Boston: Beacon Press, 1969). Although Rilke's letter refers to the artist, to the deepest source of his or her creativity and courage, it may, I think, be equally well applied to the rightly disposed recipient of the artist's creation.

30. To appreciate someone else (or ourselves) more profoundly and sensitively does not entail that we will act toward the other or ourselves in an ethically better way. Still, to admit that such appreciation is not sufficient – and sometimes not even necessary – for our improved conduct is not thereby to deny its potential significance for our whole manner of being-in-the-world.

31. The reader may infer from my position that each of us is obligated to respond with full existential openness to anything or anyone, and everything and everyone, to be encountered, for example, that I have a profound obligation to the apple or the wallet that I described in Chapter 2 or to some stranger whom I view on a television screen, and that it is equal to the obligation that I have to my wife or daughter. Thus, it would seem theoretically that there ought to be no hierarchy of value in my or anyone's world. Now with respect to the deliverances of consciousness$_1$, such an inference would in a certain sense be theoretically proper. In fact, sometimes a simple thing (or event) can assume a peculiar significance to us and provoke a sense of obligation to it and ourselves. A long unseen camouflage-colored bowl that I endured in childhood suddenly turns up, as I work my way through the bric-a-brac of an inheritance. It transports me, by virtue of its strong "personality," to a period of my early childhood when most days were filled with deep, unnamed agitation and thus "speaks to" me powerfully and invites self-exploration. When we recall, however, that I have also asserted that we apprehend the world through the critical, assessing eye of consciousness$_2$, the inference that my general position ipso facto commits me to a world-picture without hierarchy (e.g., between things and people), is understood to be invalid because it is existentially unlivable. For although virtually anything could in principle affect me deeply as a "personality," and, when this happens, provoke a sense of obligation to it that would also help me to respond more fully to the call of my *Seinkönnen* – thus, "all roads lead to Rome" – in practice, I am differently oriented, I must live in a hierachized world, and thus cannot help feeling graded sets of obligations everywhere, to things and to people, the former subordinated to the latter, justified and maintained by consciousness$_2$ and the social world to which it is committed. Here I should also point out that even the deliverances of consciousness$_1$ show me that only some things (and only some people), in fact, have sufficient interest for me, that my deepest issues and concerns are not and cannot be obviously represented everywhere I turn my gaze, to warrant further existential exploration of them. So I should add aphoristically that "not all roads leading to Rome are equally attractive to me."

32. Here I wish to express my gratitude to Jeffrey Hammond, my friend and colleague in the English Department at St. Mary's College of Maryland, for clarifying and driving home this point. Moreover, concerning the classifiability of abstract paintings as being at the deepest level of the same ontological order as figurative paintings, the reader should, in addition to reading Chapter 4 ("Why and How Painting Matters"), recall some of the main themes of Chapter 2 ("Things in Our World"). For if I am right that at some level of awareness we always seek and in fact find, however indeterminately and however difficult it may be to express ourselves about them, personal-and-worldly meanings in the shapes and colors of specific things of all conceivable kinds – apples, old wallets, rocks, and so on – then we should expect that this mode of apprehension would be applicable to each and all of our sensuous experiences and thus to the

squiggles and colors in paintings by, say, de Kooning. The aesthetic reports from two individuals gazing at a one of his paintings will, of course, be more likely at odds than the reports from the same two individuals viewing a Vermeer, but that does not undermine my fundamental claim (following Heidegger) that we humans necessarily demand and discern some global significance even in the most abstract of artistic presentations. I am thus in agreement with the following broad statement expressed by Michael Gibson, an art critic for the *International Herald Tribune* (November 3–4, 2001), in a review titled "Serenity and Ritual: [Giorgio] Morandi's Moral World": "All of art, in fact, may be viewed as the trace of a continuous human effort to come to terms with the fact of existence – and its end." "[Art] is not so much an attempt to elicit an answer as it is one to formulate a question to which we ourselves must in time be the answer."

Why and How Painting Matters

Paintings matter to many people. But why? As I pointed out in my Introduction, they are, after all, just images. As images, it is difficult to explain their strange hold on, their apparent magical power over, many viewers. Wittgenstein rightly warns us in paragraph 524 of his *Philosophical Investigations*: "Don't take it as a matter of course, but as a remarkable fact, that pictures . . . give us pleasure, occupy our minds."

This chapter attempts to show how the images of painting may be plausibly regarded as like the fictional portrayals of literature discussed earlier. I wish to understand better, from a phenomenological standpoint, what occurs when we become fully engaged with the subject of a painting, that is, with what is represented, what it means to us, and why it is of significance. This requires me to reflect on what we take the depicted items in paintings, such as people or dream figures, landscapes, or formal patterns, to be about at the most basic level, that is, what their nature or being is and what, therefore, their relationship is to the everyday world, the so-called real world of people and objects, both natural and human-made. Here I will build on distinctions and conclusions that I have already drawn in Chapters 1, 2, and 3, devoted respectively to the being of fictions, the nature of our involvement with things, and the nature of our involvement with "the others."

First, some qualifications and warnings are in order. My goal is not to devise and advocate a new way of deciphering paintings, that is, a method according to which they are to be viewed as quasi-puzzles or challenging cultural artifacts that call for explanations or theories, as alien languages or secret codes do. Instead, I wish to indicate a way of dwelling with or inhabiting the subject matter of paintings

to allow them to speak to us more directly and clearly than they otherwise might. For I feel that our prejudices about what things are and who people are, that is, the very being of these kinds of being, undermine the intimations of our felt experience generally and, therefore, about our experience of artworks in particular. My self-chosen task is descriptive, to articulate how we to a limited degree already view a painting; but it is also prescriptive, to argue for our giving much more encouragement to our "naïve," often discredited, viewing inclinations.[1] Lest the reader believe that I am advocating a complete surrendering of the viewer to the initial demands of a painting or, on the other hand, to his or her own personal or culturally time-bound agenda, I hasten to add that my position is qualified at length in Chapter 5. I, therefore, do not wish to deny the obvious – the relevance and importance of historical investigation and its implications for the rethinking and reinterpreting of our initial experiences of a painting. Nor do I wish to deny that in the very process of viewing a work, some form of interpretation always takes place, for I do not believe that we ever "just see" an artwork (or anything else, for that matter) and therefore avoid interpreting it altogether. Also, and more important, given what I think is a contemporary epistemological dogma in the humanities, I doubt that we *always and in every respect are unable to see at all* and thus that we always and only interpret the artwork before us. If in an important sense we are able to see aspects of a painting, to experience them without an interpretive key, then perhaps it is precisely this feature of viewing a painting that calls for reinstatement and investigation. At any rate, this is be my working hypothesis.

Here, too, the following distinctions should be kept in mind. A viewer of a painting can perform this act on several levels of awareness. For my purposes, it is useful to distinguish just three of these levels or modes of viewing. In the first place, there is the unreflective visual and affective experience, the initial perception and taking in of what is in front of us – say, a woman in a dark room holding a scale. Second, I wish to distinguish the reflective effort on the part of the spectator to ascertain what the work is about, what it "means," what the artist wanted us to feel and understand (consciously or unconsciously) about the representation. We might say of the woman in the dark room just mentioned, depicted in Johannes Vermeer's

"Woman Holding a Balance" (probably painted in 1664, see Plate 2), that on this second level of awareness the work is about, among other things, a kind of religious patience, concentration, and tenderness. Finally, I want to distinguish a third level of spectatorial consciousness, the evaluative effort to place or contextualize the work according to one's viewing objectives, for example, as an image manifesting certain aesthetic qualities comparable to those of other paintings of the same period and region, or as a depiction of a cultural concern of the period (e.g., in Vermeer's "Balance" painting, seventeenth-century Dutch romanticization of domesticity and preoccupation with material wealth). In this chapter, I deal mainly with the first two levels of awareness just mentioned – the unreflective and affective visual experience as well as the reflective effort to ascertain what the work means or signifies. I have little to say here about the third level of awareness, concerning the conceptual placement of the work according to a particular purpose, because I believe that art historians and aestheticians have given insufficient attention to the most interesting features of the first two levels of awareness and because I devote most of the last chapter of this book to this third level, although admittedly there the category of investigation is the interpretive placement and not other kinds of placement, for example, the contextualizing of a work in terms of developments in painting techniques. Perhaps it is too obvious to insist that all three modes of awareness are to be found in any full experience of a viewing and that each mode partially shapes the other. Thus, ordinarily, there is no "raw" or pristine perception of a work without some reflection on its meaning or without some attempt to situate the work according to a tacit or explicit agenda of specific concerns. So in my analysis, what I separate conceptually I do for the sake of exposition only and not because I believe that they are actually distinct.

SYMBOLISM

I know of no work that deals with aesthetic responses to painting and that correctly informs us why and how a painting can exert a peculiar power over countless viewers. When the issue is raised at all, there is, typically, an immediate shift to questions concerning the

nature of *symbolism*. This approach to the issue is commonsensically understandable enough given the apparent link between symbols and what we could loosely call "meaning" and given the wide use of symbols in many Western paintings for hundreds of years during and since medieval times. It is, however, inadequate, especially, as I have suggested in several places in this book thus far, in the presupposed epistemological and ontological terms in which questions about the nature of symbolism are framed. For when this topic is discussed, symbols are ordinarily classified right at the outset according to either of two categories, those that are natural (e.g., tears, which on a human face denote sadness) and those that are artificial or conventional, for example, a dove, which denotes the Holy Ghost (in innumerable medieval and early Renaissance paintings). In this same vein, a symbol is implicitly or explicitly defined as something (conceivably *any* thing, but more often an image) that stands for or signifies something else (usually something fairly abstract, like love or chastity). What is lost sight of in such seemingly noncontroversial classification, however, is the *source* of symbolism in the world, the objects' very meaning and being-for-us-humans. For, as I have argued throughout this book thus far and especially in Chapter 2, the beings of our world (e.g., a raven or a shuttered window) are felt by us to be more than what we are inclined to say they are – for example, "just a raven" or "just a shuttered window." They are these things of course, but they are also, I have argued, "personalities" or rather "person-worlds" that speak complexly to us. If we ignore this felt dimension of things, then does it especially matter whether on a semiotic level the raven symbolizes death or whether the shuttered window symbolizes a person who has closed herself off from the world? Irrespective of historical or anthropological concerns, why is a pictorial code of any interest at all? Why not simply altogether avoid interpreting the painting and deal with texts or data that pertain more immediately to death itself or to the woman's (or some person's or persons') uncommunicativeness? In short, insofar as theoreticians of art, others too (including ourselves), fail to appreciate the true ground of symbolism, they (and we) are disposed to think about and discuss individual paintings remotely and in prosaic ways that almost never seem to be isomorphic with and explanatory of the great emotional interest exhibited by many people vis-à-vis

paintings, often, of course, by the theoreticians themselves. Thus, if our heads do not properly understand our hearts, we risk responding to paintings with either removed pedantry or uninformed rhapsody.

Many aestheticians who have written about symbolism, such as Monroe Beardsley, Richard Wollheim, Nelson Goodman, Erich Fromm, and Erwin Panofsky, have made the same basic mistake; that is, they have failed to understand the relationship between symbols and their worldly referents.[2] Here I think it instructive to revisit the whole topic of symbolism discussed earlier.[3] In particular, I wish to explicate and examine Panofsky's reflections on this subject,[4] since he exactly represents the point of view I find troublesome, offers the most complete account of pictorial symbolism to be found in the thinkers just cited, and has in the twentieth century also been influential among historians of art.

Panofsky begins his discussion of symbolism by referring to everyday experience. He imagines meeting an acquaintance on the street who expresses a greeting by tipping his hat. Panofsky then attempts to analyze the experience into its epistemological components. What has happened, he claims, is that a certain sensory configuration that he experiences (consisting of colors, lines, and volume) is immediately interpreted by him to be a man and that the changes in this data-pattern signify for him hat-lifting. Panofsky also points out that from the way in which his acquaintance performs the action, he can determine whether the man is indifferent, friendly, or hostile.

The identification of the sensed object as a man and as manifesting, let us say, hostility is, according to Panofsky, to be classified as a "primary or natural" meaning. The tipping of the hat is not "natural," however; it is a "secondary or conventional" meaning. Panofsky employs the first pair of these terms as he does because he feels that the kind of experience being referred to will be found wherever there are humans. This is clearly not so when it is a question of hat-tipping because the custom is not universal (indeed, it is almost an extinct species of politeness in Western society).

There is also, Panofsky maintains, a third level of significance to be acknowledged in the experience of the (imagined) acquaintance, what he calls its "intrinsic meaning." For besides positing a situation in which a man shows politeness by tipping his hat in a certain manner, Panofsky theorizes that a larger context of interpretation is

necessary for comprehending the personality of the acquaintance. Because of the enormous complexity and interconnected character of this context, providing as it does background information about the history of the twentieth century, the man's national, social, and educational history, his personal history, his idiosyncratic way of viewing the world, and so on, it cannot be reduced to a phrase such as "[univocal] conventional significance." Indeed, so epistemologically important is this aspect of the imagined man's behavior that Panofsky regards it as the "essential" (hence, "intrinsic") meaning of the action, whereas he characterizes the other two types of meaning (i.e., the natural and the conventional) as merely apparent or "phenomenal." (One then wonders whether and how "the natural" could be truly natural, but this is a problem that would distract us from still deeper issues.)

Just as there are three strata of epistemological meaning distinguishable in everyday life, so, too, there are, Panofsky asserts, three strata of epistemological meaning distinguishable in a painting. There is, he believes, a transferability of interpretive categories from the everyday world to the "worlds" depicted in works of art. Thus, in viewing a painting, we may distinguish in the configuration of lines and color patterns certain natural meanings (e.g., a woman kneeling), conventional meanings (e.g., the halos indicating Mary and Jesus), and an intrinsic meaning (e.g., a woman kneeling before a child evincing a religious attitude of respect for it, a kind of representation in post-fourteenth-century Western paintings that is different from that manifested in prior Western paintings). On this third level of interpretation, Panofsky states, we consider the subject of a painting as a "symptom" of an underlying cultural orientation whose understanding would be crucial for our appreciation of the painting.

Panofsky's theory of interpretation has a kind of simplicity and charm that is hard to resist. One is tempted to say "yes" to it; perhaps even to ask, "well, could it be otherwise?" But, as I have maintained, his theory profoundly misleads (as do the theories of Beardsley, Wollheim, Fromm, et al.) because of what it fails to say about its initial focus of attention, the world as we are engaged with it, the place where we dwell in everyday experience. The problem with his account, once again, is that it presupposes an opposition between

humans and their world, a subject-object dichotomy or "distantiation" that precludes their ever conceptually coming together again in the right way. Now, if my earlier characterization (in Chapter 2) of the overall co-being significance of perceived objects is roughly correct, then we should be in a better position to explain the power and mystery of paintings in our lives (and of works of art in general). For, I have said, the world of perceived objects is already and always felt on the plane of co-being to be bound up with the overall direction or Significance, the "at-stake" dimension, of our being-in-the-world and, I now wish to assert, paintings themselves proffer us image-meanings – artfully modified re-presentings of objects – of everyday co-being experiences.

Still, my account up until this point raises an important question. In Chapter 2 I recorded my co-being experience of an apple as well as of my wallet. I tried to show that when we contemplate a particular physical object, it speaks to us in ways that reflect our own current, worldly preoccupations. Now, when my concern is the meanings of depictions, it is apparent that typically in a painting the represented objects and their meanings are not thematically isolated from each other, as was the case with the apple or my wallet, for I gazed at these things apart from their contexts – by themselves, so to speak. Correlatively, the painting as a complex whole does not seem to reflect my individual, worldly preoccupations, but instead something public and perhaps at times something of even universal meaning. For, in the first place, paintings that move me appear to teach me something; I feel stirred and, broadly speaking, enlightened after dwelling with a particularly striking work. Usually, I do not feel this way after staring at an object in the physical world, although, to be sure, I will have noticed some new features in it. Second, one normally benefits from discussing a painting, even a fairly "abstract" one, with others; these discussions are useful not only with respect to our appreciation of the formal characteristics of the work, of its historical influences, or of its associations with the works of other artists of the same period, and so on, but also with respect to its basic significance established by the discussants themselves. That is, often they agree on what the painting means, and even when they disagree, not only is there nevertheless much that they already agree on, but there is usually much that they find to be possibly

appropriate or helpful in the other's opinions, one's initial claims to the contrary notwithstanding. Thus, although objects on one level contain personal co-being meanings for all of us in our everyday affairs – for they are only contingently, unessentially, related to their environment, speaking to us as "quasi-personalities" reflective of our individual, existential concerns – paintings seem to signify something of public, therefore shared, consequence, although, like physical objects experienced in the mode of co-being, and a fortiori, of existential significance.

The problem that I have posed, the tension between the personal, co-being meanings of objects to each of us individually versus the public, shared meanings of depicted objects to viewers of a painting, is a perplexing one and, as I understand it, soluble (if at all) only by our careful attention to and analysis of our "naïve," relatively uninterpreted, experience of a painting. First, we need to know how we should phenomenologically describe this pretheoretical kind of response to a painting. What takes place when we "just look at" a work and attempt to feel its power and significance?

Few historians or philosophers of art even raise the question of how one "enters into" the world of a painting and what the overall experience signifies. One exception to this generalization is Richard Wollheim, whose thought I first mentioned in Chapter 1, where I argued that we are always possessed by a dual consciousness.[5] Wollheim contends that when we stand before a painting, our awareness is almost always "two-fold, [involving] two aspects of a single experience": we know that we are viewing a picture with a flat surface, and we also and simultaneously see a depicted "world." This "world" may be abstract and, therefore, need not necessarily contain "representations," such as flowers or trees. But if, unusually, we concentrate exclusively on the canvas's markings, we then lose sight of what is being rendered; if, instead, we somehow could focus exclusively on the subject matter of the painting, as might be possible in a drug-induced state or one of insanity, then we would regard the picture's subject matter as "totally real" (i.e., continuous in its depiction with the everyday world). Corresponding to Wollheim's distinction of epistemological twofoldness is his claim that ordinarily there are two kinds of awareness in the same viewer of a painting: a spectator *of* the picture and a spectator *in* the picture.[6] The "first spectator" stands *in the gallery*;

[165]

the "second spectator" creates a "virtual reality" and participates not in the gallery, but in the rendered scene of the picture. The second spectator ("in the picture") allows him- or herself to be drawn into the depicted material; one "sees in" the marks on the canvas something familiar (e.g., the face of a boy or a tree) and thus one feels a special kind of demand being made on oneself.

Now, although it would seem the second "fold" of Wollheim's concept of twofoldness and his corresponding concept of the spectator in the rendered scene would compel him to credit our involvement with depictions as real, his position on this subject is ambiguous. On the one hand, he contends that in viewing a painting we have a genuine perceptual experience that is the basis of and that explains our emotional absorption in depictions, thus implying that we do, in fact, take them to be "out there." On the other hand, he asserts that there is a great experiential difference between seeing a figure (e.g., a boy) "in a marked surface" (such as a painting) and seeing a boy "face-to-face." The two experiences are "phenomenologically incommensurate," he insists, involving "distinct" kinds of perception. If they are truly incommensurate and thus totally different, however, then he cannot conceptually bring the perception of seeing things in a marked surface close enough to a veridical experience to account for the former's ontological claim upon us. In other words, if the depiction is not apprehended as commensurate with the reality, then I do not see how any phenomenologically explanatory basis for it is able to be provided.

Wollheim must face a second phenomenological problem. Because he uncritically adopts an epistemologically dichotomizing stance right at the outset of his theorizing, he cannot, it seems to me, really mean that the viewer of a painting literally "sees something in" it. "What a painting means," he informs us, "rests upon the experience induced in an adequately sensitive, adequately informed, spectator by [his or her] looking at the surface painting as [indicative of] the intentions of the artist led him to mark it." He continues, "The marked surface must be the conduit along which the mental state of the artist makes itself felt within the mind of the spectator if the result is to be that the spectator grasps the meanings of the picture."[7] Thus, one mind (the artist's) communicates with another mind (the viewer's) via the marks on a surface. Or does it? What exactly is "in" the

viewer's mind? Does it really find a way to go out of itself to arrive at the intentions of the artist's mind? Wollheim regards the sensory images, memories, and "the proceeds of the imagination" of the internal spectator as a total (rich and dense) text that awaits interpretation by the external spectator. Note that the internal spectator's experience is not of the world, but of a "text." Still, how is "the text" to be understood epistemologically, that is, with respect to what we can know about it and, even more pertinently – ontologically, that is – with respect to what we are inclined to say about the status of its content in the realm of being. Well, Wollheim asserts rather vaguely, according to "psychological factors and their interrelations."[8]

The die is now cast. Once he attempts to explore what is solely inside of the spectator's head – mental events, instances of, to use his phrase, "expressive perception" – Wollheim bars the way to comprehending the epistemological and ontological significance of our perceptions of paintings. For expressive perception, "that capacity we have which enables us, on looking at a painting, to see it as expressing, for instance melancholy, or turbulence, or serenity,"[9] is itself based on, he claims, projection: "expressive perception . . . rests upon an experience that is quite a bit like an experience of the first kind [in which we feel something 'not because of how the world is, but because of how we are,' i.e., as agents who project onto it]."[10] Projection and seeing are two radically different kinds of cognition, however. When I see a tree, I apprehend it, but when I project an image or a meaning, I do not see it. I cast something outside of myself and then apprehend it as though it were truly "out there," when actually I am cognizing something that originates in me. Thus, when Wollheim asserts that "expressive perception is a genuine species of seeing, and that it is for this reason that it is capable of grounding a distinctive variety of pictorial meaning," he cannot be right.[11] For how can a theory of aesthetic experience based on principles of psychological projection explain how there can be genuine epistemic contact with our world in its otherness (let alone "the mental state of the artist" and his or her painterly intentions)?

Despite my criticisms of other aspects of his thought, it should be clear that I see much of value in Wollheim's theory of twofoldness and his corresponding psychological theory of dual and simultaneous orientations. I think that it matches our experience of seeing

a painting as both an object and artifact in its own right and as a representation of a peculiar kind of reality. Failing, however, to fully appreciate the implications of his own position that we are always spectators in the painting, Wollheim does not intuit and, therefore, does not investigate the scope and significance of the reality claims that I believe are made on us in viewing paintings. (Indeed, he is inclined to understand all sorts of paintings, without unfortunately indicating their scope or domain, in Freudian terms, a position that in my judgment constitutes yet another variation on a theme of analytical reductionism.[12]) As is true of the earlier accounts of symbolism that I cited, Wollheim's aesthetic objects are seen through the wrong end of a telescope, distancing us from the phenomena that define our experience: our ultimate goal, he asserts, is to get beyond mere, confusing, internal spectatorhood and to become external spectators, arriving at "an overall *understanding* of the picture" that is synoptic and intellectual.[13] Aesthetic data, like the pieces of a complicated picture puzzle, require us to be persons of patience and astuteness, if we are later to narrate persuasive stories about the works we are analyzing. It is precisely with respect to this issue, the ontological status we attribute to fictional beings when we are fully involved with them, that Wollheim commits a significant error (as do Walton, Radford, Lamarque, and many other aestheticians to whom I referred in Chapter 1), for although picture puzzles that we solve may yield a sense of accomplishment, even delight, they do not move us or provoke us to change; they do not show us, as many paintings do, that our being-in-the-world is at stake.

INHABITING A DEPICTED SUBWORLD

So let us try to recover phenomenologically that first level of experience of a painting to which I have been alluding. How might we approach the world experienced by our internal spectator or, correlatively, the reality depicted in a painting? Because I am attempting to demonstrate many of my claims phenomenologically, it is useful to revert to "the particular," for me to investigate one exemplary case, that is, to look at a painting (or, in this case, a copy of it; see Plate 2) and to describe as well as I can my initial, undistanced, undecoded

experience of it. I have selected as my paradigmatic work the famous masterpiece referred to at the beginning of the chapter, "Woman Holding a Balance," located in the National Gallery in Washington, D.C. What I have chosen reflects not only a strong personal interest, but also a work that is less problematic to experience and understand than, say, a Cimabue, a Cézanne, a Picasso, or a Kandinsky (to mention, virtually at random, the names of some important artists in the European tradition). Doubtless, I am attempting to avoid certain complexities and perplexities of interpretation; these I confront in Chapter 5. My hope in describing my experience of the Vermeer painting is that the reader will find him- or herself confirming my fundamental approach to it and at least some of my observations, thereby acknowledging a plausible way to view paintings – not all paintings of all cultures of all times, of course, for this would involve a gross generalization and essentialization, but a majority of those within the Western cultural and artistic tradition. I should also add that my reflections will not significantly contradict some standard interpretations of "Woman Holding a Balance." My aims, again, are to show how the reader might initially dispose him- or herself to this painting, and most other Western paintings as well, to invite greater crediting to what he or she already at some level is inclined to do, and thereby to appreciate more fully the overall significance of the perceptions of painting by consciousness$_1$.

The first thing we need to do is to gaze at the illustration of "Woman Holding a Balance" as though it were a kind of photograph, for then we will be more inclined to think of the depicted woman as being or having been "real" in the ordinary sense of that word.[14]

When we gaze at a photograph with interest, for example, if it is of a special event or person or of something that occurred long ago, we see ourselves entering into a world of fact. We no longer see gray shapes on a piece of white glossy paper. We see, for example, Hitler at a massive rally. We look at his face, concentrate on his eyes or his hands to seek out telltale indications of cruelty or weakness. We contemplate the props that he and the others on stage are using, as well as the repetition of classical, white-marble columns in the background, and we also study the uniforms or hairstyles of the men in the audience, all the while asking ourselves something of this order: "What does it mean"? Thus, we viewers of the photograph are

steeped in a situation that is taking place; we are currently looking at an event that we know *was* and yet at the same time *is* before us. Of course, we know at another level that it is not occurring in the same way that the sounds of the city outside may presently be occurring. We are, with the aid of the picture before us, imaginarily involved in a real world, one that we would have directly perceived had we stood in the place of the photographer years ago. Thus, as I argued in Chapter 1, at one level we do not think of it as *just* pretense, as an image that is merely an image and nothing more. It is for us an image that is of a reality to which we are transported and that we then contemplate, just as we might, from afar, decide to participate imginarily, in a sense intimately, in the life of a cityscape viewed from the window of an airplane flying at 10,000 feet.

Where does the photographed reality (of Hitler) fit into our overall worldly orientation? Very roughly, it is placed in our felt past (either one that we actually experienced or else one that we posit to have links to our actually experienced past), a sector of our current lives containing events that really did take place and that we could have directly experienced had we been there to do so. The felt past is a central feature of our entire worldly outlook or disposition; it is a special dimension of lived experience, present and yet dormant, whose particulars we can, despite its pastness, foreground and vivify to ourselves, contemplate, and therefore *make-present*, especially with the aid of suitable reminders, such as the written recollections of others or through photographs, voice recordings, newspaper articles, and memory images. Thus, the felt past is not really experienced simply as the "no-longer," the "was" which in no sense is right now. We can and do relive our past (as a real past and, therefore, not as a fantasy in our heads), which is to say, paradoxically, that we are able to experience *now* what we take to be *in the past* (without, of course, ordinarily mistaking these events for those which are occurring "right now").[15]

The photograph of Hitler may affect each of us individually in diverse ways, naturally, but I think that some very general phenomenological statements are in order. We all know something about this man. He is, for most of us, the notorious person of the last century, the one who comes close to being our personification of evil. We ourselves struggle with evil in our own lives, both with the indifference or meanness or deceptiveness of others and, when we

are honest, with these traits in ourselves. That we stare at and try to make sense of the photograph of Hitler implies that we have not fully placed him according to a definitive interpretation. The evil that he and other Germans committed at that time becomes, when we contemplate the photograph, a presently experienced past reality that reminds us of questions (perhaps unarticulated) pertaining to our individual world, especially concerning its open and problematic future, questions that might assume the following forms: Why did World War II occur at all? Why did the Holocaust take place? Could this sort of persecution happen in the United States? Does this "event" suggest that there is no God? Are people at base and through and through egoistic? So we contemplate the world of the photograph and, consciously or otherwise, seek answers from it. As we do this, we believe that we are contacting a real past, not an imagined one. (Were my example a documentary film about Hitler that included a recording of his voice, my point would likely seem more plausible still.) Our "external spectator" (consciousness$_2$) may remind us that we are not literally perceiving a past event, but only imaginarily reconstructing what took place. Acknowledging this reminder, we must not then conclude that what we see and feel about the photograph of Hitler is merely and only a current fantasy, for our "internal spectator" (consciousness$_1$) continues to insist on the veridicality of its own experience.

Because what I am arguing may seem counterintuitive or simply false, I will here distinguish the past that took place, what I call the *concrete historical event* (e.g., that which occurred almost seventy years ago in Nuremberg and which some people alive today actually witnessed) and the past that we today posit as having occurred and which we can bring to consciousness at will, what I call the *incommercible historical event* (e.g., that which we contemplate now, but which we nevertheless relate to as of the past Nuremberg event, with the aid of memories, photographs, recordings, novels, newspaper articles, movies, etc.). I label it "incommercible" because we can have no "commerce" or intercourse with it; we cannot affect it, although it can affect us. Our orientation to it is, therefore, unidirectional and asymmetric.

Now, it may seem that I am creating an unnecessary confusion involving what did, in fact, take place and is thus is no more and what

we merely believe to have taken place and is thus "in our minds" and that this blurring of categories will entail grave philosophical problems concerning the relationship of these two "pasts." Although a legitimate question can be raised in this regard, I am not here arguing for the ontological identity of concrete historical events on the one hand with incommercible historical events on the other, or for the ontological priority of one category of events over the other. I am simply asserting that in our thinking and acting, we do tacitly distinguish between two modes or ways of responding to a past event, according to consciousness$_1$ or consciousness$_2$, and that each way is taken to be *of* something *real*. Consciousness$_2$, as overseer of both itself and consciousness$_1$, distinguishes the one mode from the other. In the case of a concrete historical event, we believe that (a) had we been there, we would have had all sorts of distinctive and mutually confirming sensory experiences of it; (b) we could have had, by certain actions that we might have taken, all sorts of distinctive, mutually confirming, roughly anticipatable sensory experiences of it; and (c) that both kinds of experience (passive and active) would have validated the label of "actuality" that we would ascribe to the event itself. Of course *now*, that concrete historical event will not change, but then it could have been otherwise, we believe. In the case of an incommercible historical event, on the other hand, we know that although the scene is being conjured up as though it were just like what we would have seen had we been there in 1938, the things that we are now aware of, for example, the Nuremberg scene of Hitler, will not change what happened just afterward no matter what actions that we may (imaginarily) take, consciousness$_2$ insists to a begrudging consciousness$_1$, although sometimes we rightly expect that we will learn from our visual experience as a result of our reflection on it. The Hitler of 1934 whom we contemplate will not hear our protests, die by our firing a bullet at him, act in any other way than how he did act. We know then, via consciousness$_2$, that "between" us and the historical event being considered, even if we imagine ourselves to be one of the rally's participants, there is a kind of metaphysical, transparent screen that prevents our interaction or commerce with its participants and objects. Nevertheless and again, we regard (via consciousness$_1$) the man whom we are thinking about (Hitler) to be a reality and not just an idle fantasy. (Ordinarily consciousness$_2$ cannot

completely suppress the ontological claims and win the endorsement of consciousness$_1$. Nor should it, since consciousness$_2$ is not always correct in its assessments for, as Pascal said, "the heart has its reasons which reason does not know." Precisely what is permitted by consciousness$_2$ to persist as "real" is both a matter of degree and a reflection of the psychological and worldly health and wisdom of the individual.)

The very language we use confirms my point about our disposition to allow photographic images to transport us to the real beings. We say, for example, "There's Hitler!" If someone else were to point out punctiliously to us that a certain shape on the paper "is not really Hitler" but only an image of him, we would reply that it is nevertheless an image *of Hitler*, that it is not of nothing, or of a friend of ours, or of Charlie Chaplin, and that regarding it as just a piece of paper suppresses the true character of our experience. I would also maintain that with the proper orientation and imagination that he (my insistent, fantasized acquaintance) could also believe (and in less positivistic moments actually does believe) that he is in contact with what I am calling an incommercible historical event, just as I do when I think of a time spent with an absent friend. If this were not so, then how could I distinguish a recollection of this time with my friend from a reverie or a sheer imagining of it? I don't simply say to myself that in the first case it did happen and in the second case it did not. I remember that such and such event happened and feel that I am dealing with it. When I do this, I do not locate the event in my head – again, how could the time spent with my friend be *in my head*?! – I regard it as having taken place in the world (a point that I argued in Chapter 1, the reader will recall). By placing it there, I give it a special status, as that which did truly happen, but also as an event with an utterly necessitated and deterministic quality and one from which I expect no new sensory experiences. It, therefore, contains less of the density and richness of the original event, as though my recollection were a kind of peculiar cross-section of it.

I wish now to build on and modify my concept of incommercible historical event to justify what I think is a fitting way to understand the deeper aspects of experiencing a painting. Let us return to Vermeer's "Woman Holding a Balance." Like the scene in the photograph of Hitler, what Vermeer depicted has, initially, the feel and look of

verisimilitude. Now we could regard Vermeer's painting as simply a recording of an historical fact, thus believing that there was, indeed, a woman in Delft on some particular day in 1665 standing in a dark room holding a scale, and that her overall appearance and surroundings were exactly and in all respects reproduced by the artist, just as he saw them and just as we would see them had we been there. Such a view would, of course, be naïve, for among other reasons, it fails to understand that art is artifice – something constructed, even if containing elements of visual actuality. (Vermeer's painting has several distortions, the most obvious being, in certain places a blurred quality, which is not congruent with our own visual experience.) But if art does not provide us with historical fact as part of its essential nature – it obviously often does provide this contingently – it is nevertheless taken to be of something in some way "out there," although, like the world of a photograph, incommercible. I think it, therefore, useful to label the world of "Woman Holding a Balance," and virtually any world that is depicted in a (Western) painting (or in other kinds of fictional medium, for that matter), incommercible as well. For although that subworld affects us, "speaks to us," we know that the woman herself does not and never will change at all. (We might fabricate a fantasy of how she came into her chamber and what she will do next, etc. In this regard, we can recall several recent works inspired by Vermeer's paintings, such as Tracy Chevalier's popular novel, *Girl with a Pearl Earring*, in which the author conjures up an entire world of seventeenth-century Delft.) At the same time, we do take that subworld to be in our world as a possible event. The depicted scene, I argued earlier,[16] is one that we believe might have existed, might now exist, or could in the future exist – if not as actually represented, then in a form conveying a meaning analogous to that contained in my viewing experience. It would be misleading to view that scene as locatable in a specific time frame, for we actually feel its being as perduring in all three of our own personal-worldly temporal modes. The woman holding the balance is, therefore, not outside of time (i.e., she is not timeless), but is instead, in a way, eternal, one who has always been, is, and will be relevant to our lives, an incommercible presence, a kind of particularized or sensualized Platonic archetype. As such she has qualities that may stimulate the recrudescence of an important concern of our lives, as well as aid us

to define and emotionally and intellectually clarify it.[17] Such a concern is real to us not only in being "out there," but in being central to who we are, to what our world is. The inhabited subworld of the painting, related to and intertwining our concern, thus becomes real to us as well, for the same reasons and to the same degree that the initial concern does. Because of this important relational and ontological feature of the subworld of a painting to our world, it seems additionally appropriate to characterize the subworld in the moment of experiencing it as an *incommercible existential* event.

Let us now shift our focus from terminological issues and contemplate the subworld of "Woman Holding a Balance," in an effort to better understand its meaning, paintings' meanings generally, and how we might optimally approach virtually any Western painting.

BEING WITH THE WOMAN HOLDING A BALANCE

We look at the picture of the woman holding a balance and rather than immediately regarding it as, say, a lovely visual object or a famous work of a Dutch Master, or an objectified male fantasy, we enter into its world, visually and quasi-corporeally, and with our imagination and uninhibited emotions, gradually allowing its content and implied issues to be blended with those of our own world, just as we might do when listening to a family member's or dear friend's complex personal problems. We feel the woman's presence, about which we have a privileged, but not altogether exact, grasp. We see that she is carefully holding a small scale in her right hand; she is weighing jewels, some of which lie on the table before her, others of which are draped over a jewelry box that sits on the table. The woman is still, quiet, relaxed, her attention wholly absorbed in her task. The light that streams through the window to the left softly and warmly illuminates her somewhat pale face and upper body and seems both to enable and bless her expression and demeanor. Much of the rest of the scene is in varying degrees of shadow. On the back wall is a somewhat obscure picture; above the woman's head and in the upper center of the wall picture is a figure with arms raised as though presiding; in the lower part of this picture, to the right and left of the woman in the foreground, naked humans are discernible.

The woman is wearing a white headdress, a deep blue jacket with white fur on its fringes, a medium brown skirt. She appears to be pregnant.[18] At the left of the scene in front of the window and opposite the woman there is a mirror. In the lower left foreground, one of the darkest areas of the picture, there is a large, obscure object covered loosely and irregularly with deep blue fabric.

We dwell in the scene, apprehending the woman as an interesting, living being. We continue to be with her, to live in her world – not, again, just with our eyes, but with our whole bodily and emotional being. The darkness to the lower left frustrates us, for although something is there, we can't quite determine its nature. What is it? We wish to know. This "obstacle," this irregular form suggesting, through its deep blueness, some sort of affinity with the jacket that surrounds the woman, is the end point of her line of vision that appears to be focused on the scale. The dark irregular form thus provides a background for what she sees and, from our point of view, seems, as our foreground, to stand in opposition to her. The form is as ill-defined, dark, and lifeless as she is well-defined, illuminated, and vital (doubly so because of the child she apparently carries). We linger over the irregular blue "obstacle"; it makes us feel somewhat uncomfortable, oppressed, anxious. But what makes us feel this way? What are we anxious about? Something about this woman's world in which we are participants. Is it because the blue irregularity is not fully accessible to us? We want to understand it more fully. She seems untroubled by it; but we are troubled. Why should we be disturbed by anything in this depicted world that at first seems to be about a calm and pleasant-looking woman, a person other than and different from us, who in her chamber is simply involved in a small and benign task? We stare at the dark-blue impenetrability. Nothing (no *thing*) comes to us. We look up above to the left and see and feel the room's source of beneficent light. We gaze once again at the woman's face and headdress, her upper body, and then her carefully poised hand. Her gaze takes us back to the dark blue formless mass. Then it occurs to us: the light and darkness are in opposition, and the woman herself is a kind of balancing point of these two embodied principles. What is light in our own lives? What is darkness? We *feel* light, for example, as truth, being, wholeness, the Way, salvation; we feel darkness as confusion, nonbeing, lostness, evil, death. The

irregular form, then, seems to be a counterforce to the light. (It does not here matter whether we intuitively know these things about light and darkness or whether they are mere learned and associated conventions that we have assimilated over the years; they are, in any case, *experienced* directly, thus unmediatedly.)

I have recorded the initial kind of experience that I believe to be a token of a type that is most useful for our properly appreciating what "Woman Holding a Balance" means to us and, if I may be so bold, how, generally speaking, Western paintings mean to us. Central to this world depicted in Vermeer's painting are three basic elements: (a) an individual person (not an indefinite number of similar human forms like those in the background picture), thus a particular woman devoted to an activity; (b) the soft lambent light that passes through the window and that gently irradiates her face; and finally (c) the dark, irregular, "menacing" object in the lower left corner. The woman is thus affected by forces of light and forces of darkness but has seemingly found a way to unite these two forces in her own life without contradiction, a theme augmented by both the whiteness and dark blueness of her jacket and the "interpenetrating" black and white triangular tile shapes of the floor on which she stands. In fact, her facial expression and demeanor imply that she has accomplished her task with modesty and grace. She could be looking at herself in the mirror (to the left) but instead is contemplating something else, perhaps the scale that she suspends, but more likely something else occasioned by her perception of it. She is, we may thus infer, not vain, and this is, therefore, not a world of *vanitas* (oft-depicted in seventeenth-century Dutch paintings; for example, Vermeer's "Woman with a Pearl Necklace"), although the woman must deal with evil and death, as we viewers must. It is a moment that is so pure and transparent that although it is in and of time, it points to that which is most real and true and, therefore, to something enduring. But if the person to whom we stand in relation is truly good, then the weighing activity must also be good. This seems to be confirmed by the pleasing quality of the jewels, linked as they are with the light that comes through the window and the light on her headdress, face, jacket fringe, and fingertips. (Note how difficult and arbitrary it would be to understand the meaning of the jewels by ignoring our feelings and intuitions about the woman and her world and by

simply applying to them some interpretive key of symbolism, à la Panofsky, in the Western tradition of art history, or à la Wollheim in the Freudian tradition.)

We remind ourselves of the woman's apparent pregnancy. I assume that she will soon give birth, to a being who will, like her, be affected by darkness (necessity) and light (possibility). When the woman becomes a mother, she will need to weigh her possible actions carefully. The right hand, which holds the scale, is precisely at the geometric center of the scene. We, therefore, perceive her hand as crucial for the weighing and possible assessment of the bright, precious jewels – perhaps intended for her own adornment, perhaps for that of another. Her left hand does not weigh but is used instead to assist in a material necessity, in this case the steadying of her whole body so as to enable the correct performance of her delicate task. From a less literal point of view, what she does with her right hand (whose activity I believe suggests right deliberation) now determines and will continue to determine the degree of goodness and ethical direction of her whole life as well as, to an important extent, that of her future child. What she decides for herself will significantly affect this being. What she decides for it will likewise significantly affect her, so it does not especially matter symbolically for whom the jewels are meant; what matters is *how* they are meant, according to what scale of value and what indication on that scale. For her child she will need to be attentive, to ascertain the measure of sympathy and discipline precisely appropriate for its well-being and proper development, and the anticipated weighing of the jewels metaphorically indicates the delicate and precise kind of deliberation that will soon be urgently demanded of her. The scene now commands our admiration of and identification with the woman. For a moment, it could even be said that we in a sense *become* that woman insofar as she expresses our own wishes – in the face of necessity, trouble, and death, as well as before transcendent, encouraging possibility – for the tender embryonic person who is in us right now, for the careful and meticulous measures that we must daily take in order to give birth to and properly nourish a child within ourselves, our own goodness.[19]

We have entered into and reflected on a Vermeerian reality. We could, of course, dwell with our experience still longer and appreciate

the scene more fully. Our immersion in this subworld is obviously not merely a simple perceiving, an unmediated gazing that is untrammeled by "reflection." Although it may have appeared otherwise, I have not meant to imply that we should somehow look at paintings with total innocence and without prejudice, as we might (wrongly) imagine this to be possible for children. Openness and availability are relative dispositions. What I am urging is that we at first view this world that Vermeer shows us as we might an accessible, gripping film. For in experiencing such a film, there is much that happens that we do not interpret but instead directly perceive. If, for example, in a mystery movie we watch one man stab another, we don't say to ourselves, "that action by Gary with that knife and the subsequent bleeding of Jake implies that a stabbing has taken place." No, we *see* the stabbing and know without interpretation that Gary intended to hurt or kill Jake. Of course, we may wonder why he has done this and thus puzzle over motives or psychological verisimilitude, but such ex post facto rumination shows all the more that some things or events such as the killing are simply responded to by us as given and, therefore, incorrectly labeled – by many contemporary philosophers and others in the social sciences and humanities who comment on this issue – as not directly apprehended, but instead as interpreted.[20] But the logic of the term "interpretation" implies that something is there to be interpreted, and that what we interpret is not itself interpreted, at least not in the very act of interpreting, for then no initial material could be thought about at all. It is a commonplace for many thinkers to say that all perception is "theory-laden," that no perception is simply epistemologically and axiologically neutral, a position that I accept. Yet, then, it is quite easy to slide into a more extreme position and assume that we can believe and live by the dogma that all of our everyday perceptions are only a manifestation of a culturally inherited set of theories, for with that move we necessarily lose sight of the meaning, complexity, and *experiential irreducibility* of certain features of our sensuous and affective lives.[21]

Thus, my recommendation in viewing "Woman Holding a Balance" is that in the first encounter we participate fully – emotionally and bodily – in the reality before us, insofar as this is possible, a reality that could be regarded as an analogue of meeting openly and with a "thou" disposition an interesting and friendly person for the first

time. Or perhaps a better comparison is the recollecting and exploring of one's own dream, which, as Freud asserted, upon initial conscious reflection almost always appears strange and of not much consequence, but which implicitly contains many levels of psychological significance. So the viewed painting is to become, I suggest, a special kind of dream, not simply Vermeer's, but one's own. Appropriately inhabited, the different features of the woman's world become our world.

Now, here the reader may be tempted to object that my approach to the viewing of painting reduces its significance to the realm of the merely "ethical" and "psychological," thus leaving out other dimensions of significance in some paintings, for example, the "social," the "political," the "economic," the "historical," or the "religious." My response is to repeat what I claimed in Chapter 2, that because we are defined by being-in-the-world and are not simply egos separated from but somehow involved with a value-neutral physical world, the basic concerns of our lives are not only ethical or psychological; they are *global* matters, thus definitive of the at-stake dimension (Significance) of our whole lives. This at-stakeness, therefore, actually encompasses all the modes of our existence including, therefore, our political, social, economic, historical, and religious beliefs. Of course, when we interpret a painting that we provisionally are able to regard as our own dreamlike construction, we are tempted to find only psychological roots. Gazing at a work by Mary Cassatt of a woman tenderly caring for her child, we might regard the depicted woman exclusively as a substitute for our own mothers, but the psychological (and the ethical) features of both an artwork and a dream will always have other important dimensions as well. The mother figure of the painting or dream will be shaped by our social beliefs, our views about nature, the religious life, and so on. Still, I believe that the existential and at-stake quality of one's life can and ought virtually always to be at the center of our viewing experience. An antiwar painting by George Grosz or Otto Dix is strongly political and social in its message, to be sure; yet, for the reception of it to make more than abstract polemical sense, the spectator must also associate it with previously experienced horrible people who, by virtue of their horribleness, have thrown into at least partial question the meaning and direction of his or her own life.

[180]

I think that my proposal that we should enter into the world of a painting as though it were a dream of our own is applicable to most paintings in the Western tradition, even "abstract" paintings of the twentieth century, although I do not deny that sometimes my "existential" approach will initially yield little, for some works are simply too foreign for us to appreciate at the outset; then we will have to consult other sources. Ordinarily, but not always, our research should take place afterward, for otherwise we risk literally forsaking a reality and substituting for it instead a kind of illusion, an interpretation of superficially felt images, one that would aim at simply demystifying and rendering unproblematic what was formerly felt to be challenging because visually difficult or enigmatic. Still, I concede – in fact, endorse – the view that to avoid serious misinterpretation and to achieve a more thoughtful and refined understanding of a work, we often *should* do postviewing research – in galleries, visual media, books, and through discussion. Moreover, after completing this kind of investigation, there is nothing to prevent our reentering the world of the painting with our newly discovered information. If we learn, for example, that a peeled lemon with its peel still attached typically signifies dissoluteness in seventeenth-century Dutch still lifes, we can as an initial exercise take some time to imagine ourselves "being" a peeled lemon with this kind of meaning.[22] After that we have the opportunity once again to dwell with and inhabit the scene in the painting with an added sense of its meaning, thereby modifying our first, less sophisticated involvement with the work.

With respect to the existential aims that I have attempted to identify in this chapter, it is important to undertake our investigation by asking questions that will help us to return once again to the existential demands of the world of the painting and not simply questions that will lead us to relatively insignificant curiosities, such as whether the woman holding the balance was Vermeer's wife or whether he made the painting with the help of the camera obscura.[23] More useful information, for example, is that scholars have identified the picture in the background of "Woman Holding a Balance" as representing the Last Judgment, the subject of countless paintings in the late Middle Ages, that in it the archangel Michael (who is directly behind and, therefore, obscured by the woman's head) is weighing on a divine scale one of the people resurrected, or rather, the soul of that

person.[24] We learn as well from another art historian that the woman is holding empty pans[25] – symbolic, I believe, of the moral openness of all the moments of her own and her child's future. While the woman must weigh precious things of this world – not simply jewels, but also metaphorically, thoughts, feelings, words of praise and criticism, physical actions, and so on – Michael carries out a different assignment following the earthly death of humans, for he weighs the lifetime ethical and religious achievements and failures of souls to ascertain who will be eternally blessed and who will be punished by being cast into hell. For now, though, the depicted focus for us is on this life, on an individual living woman, on this mother figure whose head obstructs the center of the background painting and which is at the intersection of two important axes that can be imaginarily drawn to it – from the figure of the obscure Christ (at the top, drawing the axis downward) and from the resurrected figures to be judged to the damned (drawing the horizontal axis from left to right) – all of which suggests that she is, or at least may be, the authentic flesh and blood synthesis of the dualism of matter and spirit depicted in the background work. Also, the woman is in blue (the Virgin Mary's usual dress color we learn from historians of art or may already know[26]), and the woman's calm, bowed, contemplative expression calls to mind countless earlier representations of Mary, especially in Italian painting and sculpture of the Quattrocento and Cinquecento. Additionally, like many paintings of Mary to whom an angel comes for the Annunciation, she is bathed in light that radiates from an unseen source beyond the upper left part of the scene (from our point of view, but to her right), seeming to confirm that she will bear a special child. We then associate our first experience of the painting with this new understanding and realize, viewing the depicted woman once again, that she is to be regarded historically too: she will give birth to a being who is holy and who has the possibility of spreading holiness to all people encountered. We also learn that in seventeenth-century Dutch culture, the childlike angel of earlier (medieval) painting became the angelic child, and the mother of God became the mater familias, all without any suspicion of blasphemy.[27] Thus, an important change of emphasis from other-worldliness to this-worldliness took place in the cultural milieu in which Vermeer was constructing his paintings. We may infer

in reconsidering "Woman Holding a Balance" – although, of course, other interpretations are defensible – that while the Last Judgment may still be of significance, for now we must dwell in *this* life, with the task of affirming its holiness through caring and measured deliberations that result in actions consonant with their intentions.

PERSONAL VERSUS PUBLIC MEANING

Here I think it important to return to the unresolved problem posed near the beginning of this chapter; namely, how do I self-consistently link the approach to the viewing of a painting outlined earlier with the phenomenological description that I provided in Chapter 2 concerning our co-being relationship to things? For in the narrative that I just provided of what the Vermeer means to me, the individual objects of his depicted world in "Woman Holding a Balance" do not appear to be simply uniquely experienced personalities-for-me, beings of special significance that the reader or anyone else would apprehend altogether differently. Vermeer's represented objects are ordinary things of our world, and in my discussion of the painting I identified them as such (e.g., the balance, the woman's headdress, the mirror, the blue jacket). How, in short, do I reconcile my narrative of the painting's significance, involving as it does an explicit, publicly recognizable, everyday naming of things, with the position on the co-being dimension of them that I put forth in Chapter 2, asserting that for each of us objects have quite personal, idiosyncratic meanings, reflective of our own existential preoccupations, thus meanings not shared by "the others"?

In the Vermeer, and I think in all other paintings of the Western tradition, what shapes the way in which we relate to any of the depicted objects is its overall pattern or gestalt of significance. When we first view "Woman Holding a Balance," for example, we immediately see a calm, illuminated woman standing in an undisturbed room. We don't initially see the hole in the wall or the mirror to the left. This basic perception is, roughly, the *whole* – figure and ground – with respect to which we then begin to make further visual, emotional, and interpretive discriminations, always proceeding in a manner such that the new focus (the figure; e.g., the scale) is understood in relation to

a ground. (As I indicated in Chapter 2, what is figure can become for us ground and what is ground can become for us figure.) Thus, we see the woman's headdress to be of touching softness because it is draped on the head of this pregnant woman's still, concentrating gaze while she performs with her slightly raised right hand an act of care and sensitivity. Also, in her modest and graceful stance she confirms the religious relevance of the picture behind her. But the presence of this picture itself, and the familiar shape or form of the woman's headdress, reminiscent of similar head coverings of Mary figures in earlier works by other artists, visually and historically also in turn confirm our viewing her covering as semireligious attire. The room in which she stands contains lighting that is not harsh, but gentle. The unadorned grayish wall tonally fades into the darkness of the table and fabric below, while at the same time we see (focusing on the table and looking toward the upper center) the wall's coloration softly modulating from darkness to light, thus supporting our initial view of the woman as a "religious" person. On the other hand, were the same woman with the same pose depicted as standing on a street corner with several people staring at her sadly (or maliciously), the effect on us would be completely different.[28] The pregnancy would distress us, the headdress and jacket might suggest her mental deterioration, the scale her obsession, and so on. Or were a painter to make specific modifications to her face – for example, the addition of bright red lipstick and excessive rouge and the slight alteration of her mouth and eyes (so that she would look provocatively at us) – the headdress would probably appear to be starched and rough and only superficially protective, the scale to be something too delicate for her nature and about to be crushed, the jewels to be ill-gotten, and so on.

So we perceive the scale in Vermeer's painting as an ingredient of a complex visual and emotional subworld; it is not only an illustration of something of use, a jeweler's scale; nor is it, on the other hand, simply apprehended as a kind of microcosmic personality, as happens when I gaze at my wallet, experiencing feelings that speak primarily of issues of deep concern only to me. The depicted scale *is* taken to be an instrument, but it also plays a particular role in the scene, consistent with and adding to its overall significance. Besides its instrumentality, it is apprehended as simple in construction, light, delicate, of importance (given the woman's attention and its location

in the scene), an expression of her intentions, consonant with the way that she maintains her own physical balance (in placing her left hand on the table), echoing and echoed by the weighing of souls' actions in the background picture, anticipatory of the subtle decisions that she will have to make on behalf of her future child, and so on. So in addition to being viewed as an item of use and as something containing "microcosmic personality" features that I might discover were I to stare only at it, the scale in pictorial context, unlike my wallet, is defined by (and definitive of) all of the other items of the represented subworld. In other words, the scale is for me suffused in meaning with both its practical, everyday associations as well as with its microcosmic "personality." That personality, because of its depicted relations, is itself complexly defined by the viewer's world, however; the scale will have for him or her a personality that is both individually and publicly defined, although ordinarily, it seems to me, the feel of the scale's purely utilitarian aspect will be incorporated into and thus dominated by its personality aspect. Hence, the scale is not simply transmogrified into a nonscale. It becomes for us an animated scale, one "personally" individuated by its particular characteristics, its relations to its holder, and its relations to all of the other things in the depicted subworld. The "whole" then – the "living" scale inhabiting a domain of things-cum-personalities, all informed by its principal personality, the woman herself – is enormously more complex in meaning for me (and the reader, I believe) than the part – the scale considered just by itself and as simply a scale. Given the nature of its manifold and mutually supporting relations, enabled and further reinforced by our own daily, culturally inherited practices, including conventions of artistic perception, it is difficult (although not impossible) to initially experience what is represented in a way with which most others would utterly disagree. Try to persuade yourself otherwise: tell yourself of the Vermeer that you are not viewing a tranquil woman holding a scale in a partially illuminated room. Can you succeed in doing this? (Later, of course, we may devise unusual interpretations of the work, of what it "means.")

In sum, I "take" the scale into my world as a practical item with existential meaning. Its meaning is not just in my world, but is *in* our larger perceived world; it is a publicly viewable "personality"[29] that most people in the West (responsibly educated, reasonably

sensitive) would, I believe, at some point acknowledge.[30] Were the scale in "Woman Holding a Balance" able to speak to us, it would say something like what was indicated earlier: "I am sensitive, delicate, able to weigh precious things, therefore measured, requiring a person who knows how to use me and who appreciates my worth, (fortunately) connected to just such a person, who will soon give birth, be involved in countless deliberations over her child's well-being, and who will, as long as she lives, be affected by larger forces of light (transcendence) and darkness (evil and death)." And so forth.

Again, the perceptually isolated scale is experientially relatively insignificant, but viewed in the context of its environment, it becomes an ingredient of a complex web of practical-existential, publicly shared, meaning. It obtains its meaning not only because of its own, internal characteristics as a scale and its peculiarly defined relations to everything else in its subworld, but also because of the "real-world" associations that the viewer has with scales and related items in his or her culture. To be sure, my wallet has a publicly shared meaning as well – that is, as just a wallet – but its particular constellation of existential meanings for me is principally shaped by my own peculiar associations and concerns.[31] On the other hand, the scale in the Vermeer has a being that is relationally qualified in such a way that two people in the same culture are likely to agree on much of what the common experience "means," both as an item of use and as an item of felt, world-at-stake significance (involving, e.g., fragile justice and its relatedness to "principle" or "transcendence").

They will agree on much, but not on everything. For I experience[32] the scale, allowing its full meaning to penetrate and pervade me against the background of my own fundamental concerns. For among other things, the scale reminds me of my own past and current deliberations, with all of their peculiarities. That, too, is part of its meaning, and that is why no two people are likely to agree fully on what "the painting itself" means.[33] Still, if we are willing to take the trouble to view and feel the various parts of the painting in relation to the whole as well as the whole in relation to its parts, to concentrate on and absorb the meaning of its objects, the various shapes and colors and distortions, the play of light and shadow, the harmonies and tensions and strangenesses, in short, to live for a while in this unusual, Vermeerian subworld in a focused way and with

disponibilité, as though no other reality were of much significance, then, I believe, we will properly experience the painting (although again, not with complete unicity). We will be able to talk about its overall meaning in a way that will probably prove useful and enlightening to us both, involving permutations of interpretation quite analogous to possible outcomes that we would ordinarily expect to have after sharing our impressions of the personality and character of a person whom we have just met. For the reader, having lived with the painting too, will share with me meanings that will often be either not inconsistent with mine and that will thus add to my own experience or else, if initially inconsistent with mine, be so in a manner that may eventually provoke my agreement with him or her or, if not, then perhaps his or her agreement with me. Such agreement is, obviously, not necessary, yet it is desirable. For I believe in accordance with Kant's position and despite what is popularly said about this issue, that we all seek, either explicitly or implicitly, the confirmation of the other (if only one other) with respect to the genuineness and veridicality of our perceptions, be they descriptive, prescriptive, or aesthetic. We cannot rest content with the thought that no one of similar (much less superior) sensibility would endorse our thoughts and feeling about the work.

Of course, people of the same culture do frequently disagree about what a painting means. We could think of many of reasons for this fact, but, consistent with the assumptions and aims of this chapter,[34] I wish to make explicit and briefly discuss the two most fundamental kinds of explanation for disagreement that have been tacitly assumed in this chapter: (a) different forms (and within these forms, different levels) of training in one's society, in all sorts of cultural customs and conventions generally, and in aesthetic and visual matters in particular, as well as (b) different existential preoccupations from one viewer to the next.

(a) Given the influence of Wittgenstein and many others (such as Ernst Gombrich and Clifford Geertz) on twentieth-century aesthetic thought, it is perhaps obvious enough that differences in custom and training play an enormous role in determining the disagreements of perception and judgment of two viewers of the same painting. Wittgenstein's position entails that if, and only if, two people have had similar training in many of the (often tacit) aesthetic rules of a

common culture will they have a genuine (as opposed to superficial and basically mindless) opportunity for agreement about the aesthetic meaning and value of a work.[35] Thus, Wittgenstein's view is that what we perceive, believe, even feel about a work, apart from the differences of capacities and talents among individual people, is a matter of social custom and training – essentially, therefore, of what basic rules we have learned, and of what subordinate rules of interpretation that we have learned in order to apply the more general rules. To justifiably credit someone's judgment about "Woman Holding a Balance," it is not sufficient to assume that he or she is acutely, directly, and thus innocently sensitive to "greatness"; the person must have had a good deal of experience with, and historical knowledge of, paintings generally and of the Dutch seventeenth-century period in particular. As Wittgenstein asserts, "When we make an aesthetic judgment about a thing, we do not just gape at it and say: 'Oh, how marvelous!' We distinguish between a person who knows what he is talking about and a person who doesn't. [The former] must know all sorts of things."[36] What he must know is complex and vast, although some of what he should know we take to be "obvious," for example, the features that enable us to identify a painting as a painting in the first place, what subjects are appropriate for depiction, the virtual orthodoxy of linear perspective (for works created in Europe roughly between 1350 and 1850), what clarity of detail means, and so on. Of course, the aesthetic connoisseur will not have assimilated these rules only in the classroom, studio, or art gallery; his or her protocols of painting perception must be related to and generally consistent with rules of taste and conduct within the larger theater of everyday life. For tastes in subject matter for a painting will in part depend on what members of a society find, generally speaking, valuable to view and discuss. They will also be guided by what they have learned are "appropriate" and "complementary" colors, "fitting" constellations of shapes and sizes, sacred objects and profane ones, and so on.

I agree with Wittgenstein that only if two people have had similar training in many of the often tacit aesthetic rules of a culture will they have an opportunity for significant agreement with each other about the perceptual value of the work. Custom and training (as well as individual abilities and talents), however, do not seem to explain fully why two people may be in agreement (or disagreement) in their

assessment of a painting. We can easily imagine (and perhaps even remember) a situation in which two similarly trained connoisseurs of painting perceived the same work differently and irreconcilably so. Why does this happen?

(b) The answer, I believe, is that one connoisseur has existential concerns that importantly differ from those of the other, and because of this each of these viewers sees the painting and the issues posed by it differently and, therefore, literally lives in a (somewhat) different world. Thus, if I am right, an atheistic materialist well-trained in the visual arts would not respond to the subject matter of a Vermeer painting in the same way that a similarly trained religious person of the same culture would. Further, even if two people had, say, similar religious orientations, there could be interpretive issues that would divide them. Thus, one religious person viewing "Woman Holding a Balance" might see and feel the Last Judgment in the background as not just important to the meaning of Vermeer's painting, but its core, and thus experience it differently from the way in which a more "liberal," religious person would. The first viewer might assert that while the woman is indeed focused on her life and her future child and that while we viewers are invited to do the same, the real story is in the background, one that is obscured because of the attractiveness of worldly things to her, and us, and because of her, and our, refusal to subscribe without reservation to the extraordinary demands of the "true" Christian faith and its promise of eternal bliss. Indeed, the likelihood of some disagreement would be so even if the two hypothetical people had received the same training and had grown up in the same family (as, say, twins), for necessarily there would be, besides at least slight differences in artistic training and upbringing, more important, differences of choice and commitment that would shape the way each of the two people perceived and assessed anything at all, therefore paintings as well.

If what I just proposed is correct, then it is unlikely, if not impossible, that two people will ever and in every detail completely agree on the value and significance of a particular painting. Nonetheless, consistent with what I asserted earlier, it does not follow that it is a waste of time to discuss a work, that all aesthetic responses are merely subjective, or that no significant areas of agreement are possible. On the contrary, if two people live in the same cultural world,

if their aesthetic sensitivity and "training" (broadly conceived) are similar, if their fundamental existential concerns are also similar, then the possibility of their meaningfully discussing paintings with each other and reaching substantial agreement will be great. What will divide them will be idiosyncratic (but not, therefore, "merely subjective") issues that the work will elicit, as my wallet provoked responses to it that would likely be very different from the reader's own. Yet, the worlds in which people dwell are of course not wholly different either: they will see many of the same things and may to that extent be similarly appreciative or condemning. Their conflicting perceptions, far from being occasions for philosophical skepticism or lamentation – allegedly "proving" that artistic experience is merely a matter of taste, and that *de gustibus non est disputandum* – would instead be significant opportunities for further exploration. For our existential concerns are not frozen essences that ineluctably predetermine what and how we will perceive. In viewing the world, there is a certain plasticity and freedom, depending in part on our current orientation and level of self-confidence, our intuitive sense of the possibility of making an important advance in understanding, the degree of trust that we place in the other person, and so on. Our differences in response to a painting may, therefore, be conceived not so much as barriers that separate us from each other, but instead as doors that could be opened, if responded to properly and under the right circumstances, enabling us to become closer to each other, with complete agreement being only, as I have said, an asymptotic goal.

SENSUOUS MATTERS

Let us return to and conclude the chapter with a still more perplexing issue. Assuming that when we view the Vermeer painting, we are able to enter its world, that we do contact an incommercible existential event, precisely what is the value of this sort of experience? In the case of novels, plays, or short stories, it is perhaps obvious enough, if the reader accepts my basic claims in Chapters 1 through 3 that literary works exhibit to us possible worlds in which we in an important sense *become* represented people who suffer and struggle with matters of human destiny. But a painting is a static

representation, and unlike a great novel or theatrical performance, not something of easily definable value. Its fundamental meaning – consider any "great" painting you like – is rarely unambiguous. Even if the viewer is satisfied that he or she "understands" the work, why is that understanding important? May not the great attention given by some people to paintings simply be an historico-cultural fashion? Why couldn't I substitute the interpretive account that I provided earlier (or a more elaborate one, for that matter) of "Woman Holding a Balance" for the experience derived from actually viewing the work? Perhaps we immediately want to respond to this question by asserting that the experience itself of the artwork matters tremendously, that the prose statement about it is only a feeble attempt on our part to express what is, to a great degree, ineffable. Perhaps as well our stammering efforts have at least as much to do with our reluctance to explore poorly mapped territory as they have to do with the inherent problematicness of being able to talk sense about the overall significance of our responses.

I just stated that to experience a painting appropriately, one must live in its world, to experience it as an incommercible, existential event. In giving ourselves over to the world of the painting, our feeling should roughly be (if only provisionally), "Yes, this is the way it is." For the work to achieve this end for us or, rather for us to permit ourselves to be thus affected, we must first allow and even encourage its issues and themes to overcome our own opposing feelings and beliefs. Thus, and as I argued analogously in confronting a piece of literature like *Moby-Dick*,[37] we are not at the outset totally at one with the painting's meaning. So the depicted subworld of the painting is at first, by virtue of our own stance and commitments, a kind of opponent to us. Later, we may gradually allow ourselves to submit, perhaps even surrender, to the claims of the subworld, just as we do, over a longer period of time, of course, when we meet a new person who becomes an extremely good friend. But our submitting to – if only temporarily – may require, as I have asserted, great effort from us, for many parts of the work may contradict beliefs that we hold dear. For example, we may explicitly and adamantly reject Hieronymus Bosch's depiction of the morally recalcitrant souls suffering horribly and eternally in hell, but in viewing his painting (see Plate 3, detail from "Hell," the right wing of "The

Garden of Earthly Delights"), to appreciate the work fully, we need to do more than simply suspend our disbelief; we must instead make his vision absolutely true – that is (and as I suggested in the last chapter), veri-*fy* it. We do this by (quite unconsciously) finding in our world precisely those usually suppressed feelings and dispositions expressed by Bosch's work. For at least a little while, then, we can be dominated by his way of seeing the world (in all of its details[38]) and be at one with his vision. The feeling-meanings that we experience standing before the painting may thus be something more than a transitory possession; they may be, since we are constituted by them, provisionally and partially who we at that time *are*. We assume this new identity because the painting represents a defining of Significance for our world that consciousness$_1$ regards as true and that consciousness$_2$ does not contradict but sanctions as "plausible," albeit on a less literal level than the one that Bosch apparently intended, for most of us have known the psychological hell of our own moral errors. We feel that his vision, even if not literally correct and absolute, has some important place in our whole worldly orientation, and therefore has, with our determined assistance, the power to enlarge and clarify our own vision.

When will the experience of the depicted world of a painting make an important difference to us? Its initial impact will quickly fade if we are not truly open to it, the work transcends our conventional expectations greatly, or the problematic it poses strikes us as false. Abstractly considered, virtually any painting can speak to us (from something produced by an ancient cave dweller to that of a child's stick figures). Concretely, however, and as is so with newly met people or with objects in the everyday world, certain works are much more likely to attract or provoke us because they have at least the appearance of alluding to concerns central to our lives. Our being drawn to particular works is determined by our sense of what might be called existential verisimilitude – the degree to which the artist's thematic "statement" matches and clarifies that which we previously and only vaguely and inexplicitly felt to be possibly or probably true among our conflicting and basic preoccupations – and determined as well by certain conventions of rendering that we have come to appreciate, and within such conventional frameworks, by our sense of the artist's degree of success in achieving what we take to be – but which

may not be – his or her intentions. The initial impact of the work will, therefore, sustain itself and thereafter importantly affect our way of viewing the world only if the different parts of the depicted world "fit" together properly for us that which was previously felt otherwise, as having a different emphasis or less clear meaning. In the Vermeer painting, the scale must be delicate; were it bigger or its lines darker, it would clash with the woman's considerate expression and the poised and open quality of the woman's hand. Were the fabric in the left foreground more precisely defined and a deep red, we would not apprehend it as mysterious, dark, and "evil"; on the contrary, its "vitality" would probably make the woman look bloodless and thus alienated from her own humanity. Suppose the whole scene were more sharply delineated, like a photograph. What then? We would see details – lines on the woman's face, birthmarks, scars, links between the jewels – and a kind of light that could not show the magical, preternatural quality of the fingertips of the woman's right hand or of the jewels. Indeed, were the light in the room (among other features of Vermeer's work) not softly bright, indefinite, and modulated into shadow, his vision would then devolve into something more prosaic, and I believe that nothing would be clarified for us. The worldly appearance of everything in the scene would necessarily overshadow and even opacify the spiritual possibilities immanent in the everydayness of the woman. We would perceive her as more ordinary and accessible and, therefore, we would likely see only a quite familiar and uninteresting subworld, without religious dimension.

The artist's vision affects us strongly and deeply, therefore, because we have already had a similar intimation. The artwork becomes an occasion and stimulus to better attend to, redefine, and give a different weight to certain of our feelings and existential concerns. After viewing the Vermeer painting, after initially taking in the scene as a whole, then dwelling with its parts – which both oppose and yet confirm one another, for each has a different "voice" and at the same time each contributes to the larger themes of the painting – and finally revisiting the whole once again, we allow ourselves to participate in a Vermeerian reality. We may thereby achieve a small but important advance (assuming the fundamental correctness of the artist's vision). We may henceforth, as Proust pointed out, perceive certain everyday objects, people, or scenes differently, for example, in a Vermeerian

manner. For what we open ourselves up to is not simply abstract meanings (as in the "ideas" that we might gain by reading, say, a text in psychology or ethics) but, again, *feeling*-meanings that collectively constitute more than a "story," thus a living actuality that is incorporated into our lives. Before our participation in the subworld of the Vermeer, we vaguely felt or suspected something to be the case. Perhaps we sensed, referring again to "Woman Holding a Balance" as an example, that in everyday experience there are moments in which others, or we ourselves, have done something "exactly right," in which they or we have acted in an ethically (and perhaps even bodily and aesthetically) clear and transparent way, such that the import and effect of the action will remain with us forever because the achievement serves as an unspoken image and paradigm of what our own lives ultimately mean to us and how we ourselves could always be (but rarely are). After our experience of the Vermeer, our prior, vague intuitions are, we might say, consolidated. What we took before the viewing to be a kind of hypo-thesis (something placed under and regarded as less than a thesis) now has become thesislike itself, something set down or forth as true, although here it is important to emphasize that in this metaphorical context both "hypo-thesis" and "thesis" are terms that refer to emotional dispositions, feelings that are the orientating ground of our perceptions and, therefore, do not refer to propositional attitudes, which are orientating thoughts that we are inclined to apply to our perceptions. With our own complicity, we have accepted Vermeer's vision and thus con-firmed it (made it firm with him), although we might also instead be inclined to say that we have been overtaken and had something revealed to us, as we do, analogously, when – via a whole cluster of feelings – we know, without reflection and any apparent justification, that something is simply the case – that "that person" is now being insincere. What appears to be "just right" in, or correct about, the subworld of the painting thus reaches the status of a kind of existential truth. When it has provoked us to resee what we have known and cherished or to see in a new way something that we already at some level regard as central to the way in which we understand and live our lives, then we are inclined to call it a "great" work (although here, drawing attention to and emphasizing what I think has been insufficiently understood, I am quite obviously disregarding other important and complex

factors that influence our opinion, especially the weight given by us to what respected others tell us is "great"). Yet, even a new, thesis-type or thetic (thus moving) encounter, which may occur in our viewing of "Woman Holding a Balance," is almost never mistaken by us for absolute and final truth (as it might in a drugged state). Although in the viewing of the Vermeer, our world is now seemingly distinguished by a renewed or novel sense of "reality" and "finality," its bases can appropriately or inappropriately, nevertheless, be undermined, for the stability of various aspects of our being-in-the-world is less an established achievement of unified experiences than it is an affectively provoked decisional or, better, committal reaffirmation of our felt faith, that is, of the prereflective, existential, structuring basis of individual experiences, of (in short and following Heidegger) our "fore-having" (*Vorhabe*), which is itself constituted in its basis by the ever-mineness, the at-stake-, or at-issueness, of our lives. The way in which our fore-having grounds our experiences is to an extent determined by how we choose or commit ourselves to respond to an experiential challenge, by the degree of openness and imaginativeness that we bring to a new situation. How we are generally disposed, of course, can and does change. For example, the thetic grasp that we may arrive at after viewing "Woman Holding a Balance" may itself change, if not to become once again simply hypo-thetical, then not quite as affectively certain as before. We may find ourselves, in re-viewing the Vermeer, suddenly in a state of uncertainty about the jewels the woman is weighing. We may wonder, irrespective of the question of their rightful owner (in the depicted scene), how they were obtained, and we may now feel, while still believing generally in paradigmatically good actions, that our ability to identify in particular instances what is right or wrong is marked by a still greater ambiguity than we had previously acknowledged, just as may happen when we discern our deeper and less benign motives in a prior action that we had undertaken without reservation.

Despite this openness and plasticity to novel events, or to the same kind of event experienced at a different time, no series of abstract statements could ever be a substitute for the proper experience of a great painting. The putative structures or essences signified by the abstractions in our prose statements about the painting may be accurate and astute, but the words themselves or the concepts that come to

mind are not our sensuous experiences themselves of the paintings. On the contrary, and as I have stated, these latter immersions in depicted subworlds are the living objectification and specification of modes of our very being: a currently and fully experienced Vermeer painting becomes for me an important aspect of the way I feel the world right now, and it is an important dimension of who I am right now. Thus, it is not so much "true" (in the sense of being an attribute of a statement), as it is something still more fundamental, that is, the basis of propositional truth. A series of statements may assert what I feel and am, but their communicable meanings could not be fundamentally identical to the feelings and being to which they refer, for the latter contain not just a sensuousness that is different from the propositional thoughts about them, but an associative meaningfulness and at least apparent veridicality that are not found in, but are only partially suggested by, the propositions themselves – let alone the inexhaustible complexity that cannot all at once, if ever, be encompassed by them. If I sense raindrops pattering on my head, the essence or nature of my experience at that time is, to state what is obvious enough and yet in theoretical discussions easy to overlook, something more in meaning than my statement to you that "raindrops are pattering on my head." Of course, the experience itself of the raindrops involves isolable features that I can discriminate and identify as "the [partial] meaning" of what has happened to me, for otherwise I would not know or be able to say that I was feeling "raindrops," "on my head," and so on. But the full meaning of the experience (insignificant though it may at first appear) is linked to all sorts of other concerns ultimately tied to the way in which I am oriented to existence itself. Further, referring back to the viewing of the Vermeer, the meaning of that experience is like, although (ordinarily) much more provocative and complex than, the raindrops' experience.[39]

Consider the scale in the painting once again. It is not only perceptually and affectively connected to other parts of the scene and to the whole of it, as well as to the basic concerns of our own lives; but it itself, although "a part" of the scene, is not simply a homogenous "atom," but, like the apple or the wallet that I described earlier, regarded from another point of view, "a whole" (a complex synthesis) of further discriminable parts. Each of the scale pans, for example, does not manifest the identical sort of golden reflection, the wires

connecting each pan to its upper rod are not of the same size, the black supporting, horizontal piece below the woman's right hand fades into and becomes indistinguishable from the shadow of the frame of the background painting, and so on. So the scale is not just a uniform instrument to be grasped only in relation to other parts of the scene, but is a complexly apprehended microcosm in itself (like any compound thing in the metaphysics of Anaxagoras). The apprehension of the scale, or of any constellation of parts, or of the entire scene for that matter, involves the apperceptive binding together of several felt meanings all at once, some of which oppose and seemingly (and sometimes actually) contradict one another. Now the experience of (a) an enormously intricate, yet somehow (intuited to be) correct, cognitive and emotional synthesis that we undergo while standing before a masterpiece and – assuming the correctness of my overall position – (b) the close relatedness of our aesthetic visual apprehensions generally to those of our ordinary, everyday lives, involving the sense of actuality and indefeasibility in the apprehensions, account for the power and significance that certain paintings have over us, I believe, for both kinds of involvement are based in and sustained by the felt claim that the fundamental meaning of our very lives is the core and "ever-mine" concern for each of us. Correlatively, this twofold explanation (of complexly synthesized, felt veridicality as well as its existential bearing on our entire being-in-the world) also explains why anything that we say about the meaning of the viewed event will always seem, and be, propositionally inadequate.

But more needs to be explored about what and how a painting matters. I need to discuss further the kind of "truth" gained in the experience of a painting, and I need to situate my phenomenological account in relation to a great current of contemporary thought that regards our artistic experiences as having meanings quite other and deeper than our initial felt-responses, and that views "theory" as the necessary antidote to "naïve" viewing participation. This I do in the concluding chapter, "For and Against Interpretation."

NOTES

1. Of course there are many possible and legitimate motives for viewing a painting, such as determining (a) how the various colors and shapes of the painting are formally related to one another; (b) how skillfully the artist has

rendered his or her work in linear perspective or according to any number of other criteria; (c) what school or schools the artist may be related to; (d) how the work instantiates issues of the larger culture; (e) how the work was created and who, in particular, may have influenced the painter; (f) how novel or influential the painting was in its time; (g) whether it should be regarded as a "timeless masterpiece"; (h) how monetarily valuable it is; (i) how the people of its world lived (e.g., the manner in which they decorated their holy places or whether animals were permitted in them) etc. I believe, however, that these motives should in general (not always, of course) be seen as means to the end of experiencing the painting's world, which often (again, not always) challenges us to see and feel in ways that are importantly different from our current ways of seeing and feeling.

2. Ernst Gombrich – perhaps the most famous art historian of the twentieth century – fares no better than Panofsky in comprehending the true sources of artistic experience. See, for example, his most philosophical work, *Art and Illusion: A Study in the Psychology of Pictorial Representation*, Bollingen Series 35, volume 5 (Princeton, N.J.: Princeton University Press, 1960). Like Wittgenstein, he is partly right to insist that images do not speak for themselves, that to appreciate art in a nonsuperficial way is to have already assimilated into one's consciousness and world innumerable artistic conventions. This conceded, he does not then proceed to recover and analyze the core of what I would call the full living experience obtained in viewing a painting, especially the similarity in significance between the perceptions one has of a painting's depictions and the counterpart apprehensions of "personal-world" objects of our everyday lives. Gombrich, like the others I have cited, fails to comprehend the existential ground of symbolism. Indeed, in the conclusion to *Art and Illusion*, he unexpectedly reverts to and defends instead a kind of factual, aesthetic realism that he wishes to combine with the epistemological conventionalism just mentioned. That is, he believes that although the artist does not just "see" but is fundamentally guided by historically based artistic conventions of form and basic content, within those frames of reference he or she will perceive and strive to render details of the real world accurately and that such accuracy delineates the difference between an artist's creation and a child's: "Constable's painting of Wivenhoe Park is not a mere transcript of nature but a transposition of light into paint. It still remains that it is a closer rendering of the motif than is that of a child [attempting to depict the same scene]. . . . If we accept the truth of the label that the painting represents Wivenhoe Park, we will also be confident that this interpretation will tell us a good many *facts* about that country seat in 1816 which we would have gathered if we had stood by Constable's side. Of course, both he and we would have seen much more than can be translated into the *cryptograms* of paint, but to those who can read *the code*, it would at least give no false *information*" (p. 252). Note Gombrich's use of the words "facts," "cryptograms," "code," and "information," although the emphases are my own. Note as well that Gombrich's formulation would hardly be able to

account for the significance of nonfigurative painting of the twentieth century, and in fact Gombrich was never able to make sense of this artistic evolution. Cf. also Nelson Goodman's *Languages of Art: An Approach to a Theory of Symbols*, second edition (Indianapolis, Ind.: Hackett Publishing, 1976), in which he argues that any pictorial representation should be understood as part and parcel of a denotative system, which itself is the product of "[a culture's] stipulation and habituation in varying proportions. [Moreover,] the choice among systems [of classification] is free . . . [i.e., open; not determined by factual givens]" (p. 40). His denotative theory of pictorial representation is, like Gombrich's, "intellectualistic" and subject-object dichotomizing, for it fails to probe the significance for the experiencing viewer of what Goodman labels "symbols," which I view not as conduits to something else, but "the things themselves." (By referring to them as "the things themselves," I am not asserting that they are simply "given" and, therefore, are in no way part of a system of interpretation provided by one's culture.)

3. See especially Chapter 2, pp. 115–7.

4. Erwin Panofsky, *Meaning in the Visual Arts* (Garden City, N.Y., Doubleday Anchor Books, 1955), especially chapter 1, "Iconography and Iconology: An Introduction to the Study of Renaissance Art."

5. See Chapter 1, p. 62; see also in *Painting as an Art* (Princeton, N.J.: Princeton University Press, 1987), chapter 2, "What the Spectator Sees," especially pp. 46–7 and 72–5 and chapter 3, "The Spectator in the Picture," especially pp. 182–3.

6. Wollheim has learned much from, and in this context, pays his respects to the observations of the early-twentieth-century Viennese art historian, Aloïs Riegl. Indeed, it is Riegl's fundamental distinction between the spectator of the picture and the spectator in the picture that Wollheim appropriates. See especially, ibid., pp. 102 and 176–82. He refers to Riegl's seminal work, *Das holländische Gruppenporträt* (Wien: WUV-Verlag, 1997; originally published in 1902).

7. *Painting as an Art*, p. 22.

8. Ibid., p. 306.

9. *Painting as an Art*, p. 80, and note how Wollheim circularly uses the word "expressing" to define the definiendum, "expression."

10. Ibid., p. 82.

11. Ibid., p. 80, my emphasis. He also states, "*projection* is a process in which emotions or feelings flow from us to what we perceive" (ibid.). On p. 84 he says, "Projection is fundamentally an unconscious process, and it operates, at any rate in its complex form, through phantasy."

12. Wollheim explains, "I have brought [Thomas] Jones's buildingscapes into the scope of these lectures . . . because they metaphorize the body. In doing so they exhibit very strikingly a feature that is present, to some degree or other, in all such paintings. All paintings that metaphorize the body receive some part of their authority to do so from the way they engage with primitive phantasies

about the body. Indeed, it is the submerged presence of this early material – that is, material from the early life-history of the individual – in metaphorical paintings that lends support to my claim that, in the profound cases of pictorial metaphor, what is metaphorized is the body" (ibid., pp. 244–5). Which, we are left to wonder, are in fact the "profound cases" of pictorial metaphor, and which are not? Do not most "great" paintings exhibit this characteristic? If not, what interpretive key is to be applied to them, if not the Freudian one to which Wollheim often adverts? Unfortunately, Wollheim does not address these questions. In the next chapter, I explore at some length aspects of the large topic of interpretive reductionism; see especially my remarks on Wittgenstein on Freud's explanatory strategies, pp. 227–8.

13. *Painting as an Art*, p. 183, my emphasis.

14. Cf. in my Introduction the discussion of Husserl on the reality of images and on memory in particular, pp. 21–5.

15. For a much more extensive discussion of the larger issues of human temporal experience in this same vein, see Heidegger's analysis in Division Two, *Being and Time*, especially Chapter 4, section 68.

16. Chapter 1, pp. 64–6.

17. See pp. 179–83, 184–6. for further commentary on this point.

18. A few scholars dispute the woman's pregnancy, contending that women's fashions in Vermeer's time sometimes favored a bulky appearance and that therefore, we cannot be certain that the artist sought to depict the woman as pregnant. But must we have incontrovertible proof of her pregnancy to view the painting as I am suggesting? Moreover, doesn't the light source that illuminates her belly (as well as her face and hands) give it an emphasis that would be aesthetically and thematically inappropriate were we meant simply to appreciate a bulky skirt? Isn't the red-orange vertical line of the clothing over her belly (between the parting of her jacket) suggestive of a special vitality within? Also, wouldn't viewers of Vermeer's time, when fecundity and motherhood were held to be ideals, be inclined to see this idealized woman as pregnant? Finally, isn't our own overall experience of the painting today more interestingly complex if we reject the scholarly demand for proof of pregnancy and simply endorse what most viewers would prima facie perceive to be the case? Cf. Plate 4, Chapter 5, "Woman in Blue Reading a Letter," whose subject van Gogh, in a letter written in 1888 to Emile Bernard, took to be pregnant. This point is cited in Anthony Bailey, *Vermeer: A View of Delft* (New York: Henry Holt, 2001).

19. My phenomenological description of "Woman Holding a Balance" would perhaps not be significantly different from one provided by Heidegger. (Recall his description cited in my Introduction of van Gogh's picture of a peasant woman's shoes.) But what Heidegger neglects to do in his essay, "The Origin of the Work of Art," is to offer an account of how we might approach artworks generally, how we should comprehend their ontological status systematically, including and especially the nature of their relatedness to "real beings." Had he done this, he might have arrived at an orientation to artworks that would be less

specific to him and his postanthropocentric agenda and one more concrete and pertinent to what artworks can mean to people *as individuals.* And Wollheim, I have indicated, deviates even further than Heidegger from his own fundamental intuitions about the nature of art, since he is disposed, at least in some of his specific interpretations of paintings, to translate his own "experiential proceeds" into a reductive, Freudian narrative.

20. For an excellent discussion of this whole issue of givenness versus interpretation, from which I have profited, see chapter 5, "Beneath Interpreting" in Richard Shusterman's *Pragmatist Aesthetics: Living Beauty, Rethinking Art* (Cambridge, Mass., and Oxford, England: Blackwell Publishers, 1992). Cf. also my earlier, parallel comments about social construction and its ground in Chapter 2, pp. 114–5. Finally, I should mention that although it may seem that my position fails to take account of and is contradicted by Hayden White's claim that "the very distinction between literal [factual] and figurative speech [or, simply, unstated thought] is a purely conventional(ist) distinction," this is not so. My claim is that we all do tacitly make and virtually always live by the distinction as epistemologically correct, even if later, in rare moments of abstractification, some of us may wonder whether aspects of what was apparently given as fact may have been merely a misleading construal of our experience. For a clear statement of White's position, see especially chapter 1, "Literary Theory and Historical Writing," *Figural Realism: Studies in the Mimesis Effect* (Baltimore and London: The Johns Hopkins University Press, 1999).

21. See pp. 195–7; also Chapter 5, pp. 237–9.

22. See, for example, Vermeer's "Girl with a Wineglass."

23. Naturally, in other contexts such questions would be relevant (e.g., if one were writing a biography of Vermeer or if one were attempting to understand his artistic techniques). Of course, sometimes seemingly unimportant information may prove to be artistically important after all. Finally, one's whole scholarly purpose may not be to return to the living demands of the painting, but instead to undermine them through a process of deconstruction, so that the naïve viewer is no longer under a mystifying spell. I discuss this fundamental issue at some length in the next chapter.

24. See, for example, Gregor J. M. Weber, "Vermeer's Use of the Picture-within-a-Picture: A New Approach," *Vermeer Studies*, ed. Ivan Gaskell and Michiel Jonker (Washington, D.C.: The National Gallery of Art, 1998), p. 305.

25. Nanette Salomon, "Vermeer and the Balance of Destiny," in *Essays in Northern European Art Presented to Egbert Haverkamp Begemann* (Doornspijk: Davaco Press, 1983), pp. 216–21.

26. In an earlier Vermeer work, "Christ in the House of Mary and Martha," the Christ figure is surrounded by a similar blueness, suggesting that the woman holding the balance is for Vermeer associated with Christ himself. Note, however, as I mentioned earlier, that the woman is also associated with the blue of the amorphous cloth in the left foreground, suggesting that this Mary figure is, in fact, a mortal being.

27. See Simon Schama, *The Embarrassment of Riches* (New York: Alfred A. Knopf, 1987).

28. Wittgenstein makes this point in *Lectures and Conversations on Aesthetics, Psychology and Religious Belief* (Berkeley and Los Angeles: University of California Press, n.d.), p. 35. Wittgenstein also contends that the best way to discuss the significance of artworks is to refer to the artworks themselves and not to our feelings about them: "If you ask, 'what is the peculiar effect of these words?', in a sense you make a mistake. What if they had no effect al all? Aren't they [nevertheless] *peculiar words?*" (ibid., p. 30, my emphasis). Here Wittgenstein makes an important and correct point: it is virtually always much more fruitful and interesting to discuss the works of art, not our feelings about them. But if we were to leave the issue at that, as Wittgenstein does, then we would once again and at our peril be ignoring that other level of individual and human affect that lies in the background of our artistic discriminations and that points to their "trans-rule-obeying and skill-developing" significance, our being-in-the-world.

29. It is not simply a microcosmic personality mirroring only my special issues, for I am here characterizing an abstracted being, one that contains characteristics common to both the reader and me and "the others," hence possessing only generalized microcosmic characteristics of countless viewers' existential conflicts. Thus, the scale that the woman holds will have, for most people of the Western world, felt (not simply intellectually recallable) associations of justice, but these will be individually grasped in manifold forms; or her contemplative and downward gaze will have felt associations of modesty grasped, again, in manifold forms. Still, the personal, the existential, our own being-in-the-world, lies at the base and enables us to have the "meaning-feel" in the first place of the things in the depicted subworld.

30. If a person of the Eastern world does not see it, that would not mean that it is not in the world at all, that it is "just" a construct or convention, but rather that it is not in his or her culture's world; or, perhaps that it is there, but not as it is in our (Western) world. If the reader wonders whether I believe that the physical properties of natural objects are totally a matter of cultural definition as well, I would reject such a position, maintaining that some things (e.g., the physicality of the ground we walk on) and some events (e.g., death) can be culturally constructed in counterintuitive ways only by placing the members of the whole culture at risk. There is no contradiction in maintaining that being-in-the-world has both culturally relative dimensions and transcultural, transhistorical commonalties and nonrelativities. Of course, such a view tacitly rejects the view that all truth is a "social construct" on the one hand, and that science (especially natural science) is the measure of all truth on the other hand. See also Chapter 5, endnote 20.

31. To be sure, some of these personal meanings may also be experienced in a similar way by individuals contemplating my wallet. Hence and even in the case of objects contemplated in relative isolation of their contexts, I wish to

avoid drawing a sharp line between the world of personal meanings and that of public (existential) meanings.

32. As mentioned in Chapter 2, p. 101, to attempt something perilous (with).

33. Given the interconnectedness of all of the parts of the Vermeer scene (as regards, but not limited to, its objects, formal structures, perspective, etc.) a complete description of the scale would be a never fully realizable, asymptotic goal, for ideally there would need to be references to all of the visual elements of the painting and some reference to things beyond it, both with respect to other works by Vermeer, to works by other Dutch painters of the seventeenth century, to the artistic predecessors (and successors) of the Dutch Masters, and to prior, contemporaneous, and even post-seventeenth-century cultural issues in Holland, Europe, and the rest of the world. Reference would have to made as well to the receptions of the work by viewers generally from the seventeenth century onward and, finally, to fundamental existential issues of the individual who would be viewing the work, since, I have contended, the meaning of the painting is never "in itself," never completely separable from the preoccupations of the receiving culture or the individual experiencer of the work.

34. As I have already stated, the next chapter will be devoted entirely to the complex issue(s) of interpretation via "theory" – especially those cases in which disagreements about what an artwork "means," or what its value is, are based on profound differences in standpoints.

35. See Wittgenstein, *Lectures and Conversations on Aesthetics, Psychology and Religious Belief*, especially paragraphs 15–17, 23, 25, and 26 of section 1.

36. Ibid., see paragraph 17 of section 1, p. 6. I have included a note to this sentence from James Taylor, who also attended Wittgenstein's lectures.

37. See Chapter 3, pp. 145–7.

38. But in our artistic experience, the part can become whole for us as well. Thus, it is not always necessary to surrender to the vision of the artist in all of its details. I may instead be deeply moved solely by Mary's expression in a painting by Pinturichhio or, more simply still, by her open left hand in Michelangelo's *Pietà*.

39. In Chapter 5, I introduce the term "surplus value" to indicate the kind of propositional irreducibility to which I am here referring, but the term will also have a broader meaning, which I will at that point explain. See pp. 238–43.

For and Against Interpretation

In the previous chapter especially, I sought to define a way of viewing paintings that calls for our entering into and dwelling with their depicted subworlds. In this recommended phenomenological approach, I emphasized the importance of crediting our personal experience of artworks, the sensuous and affective dimension that takes place in our first-person engagement with them. I tended to give less credit to the importance of re-viewing and rethinking the meanings of paintings, as possibly otherwise than they at first appear, or, simply put, in the light of interpretive strategies. This conceptual imbalance needs in this last chapter to be reweighted because, as is perhaps obvious enough, we do "place" artworks, attempting thereby to overcome little shocks of novelty by "pacifying" them according to some framework of interested interpretation. How, then, are we to understand our interpretive activity generally, and how might it be related to our logically and temporally prior prereflective experience of an artwork?

The tangle of issues involved in the whole enterprise of interpreting artworks is daunting. Hundreds of volumes have been written on questions concerning the nature of interpretation in the field of philosophy alone. Now consider for a moment *just a sector* of the whole "problematic of interpretation," a mere microcosm of epistemological conundrums entailed by questions that will follow shortly. Let us gaze at a mere part of a scene painted by Vermeer. (See "Woman in Blue Reading a Letter," Plate 4.)

We interpret certain brush strokes on the canvas as representing "a map," but then, on another level, how do we in general interpret maps in a seventeenth-century Dutch painting? Are they meant to convey something about Dutch politics, history, and power, even

its domination of the European map market? Were maps generally prized by their Dutch owners? Is this particular map meant to show a linkage between the depicted person and the Dutch nation? (Note the sameness of color of the skin and of the map.) Even if so, then what is this connection? And why does Vermeer depict this type of map and not another? Why does he use maps (or globes) in six other paintings? Are they represented to remind us of the great cultural achievements and geopolitical reach of Holland in the seventeenth century? Why do other Dutch genre painters of the same period generally avoid rendering maps? Perhaps this particular map depiction has, as feminists might say, a masculinist significance, since many Dutch men of the period were involved in the conquest of economic markets, peoples, and nature herself? Or should we interpret the map as having no particular significance as a map, but regard it instead as primarily a formal and tonal requirement of the overall scene?

Even here, in this relatively tiny domain of interpretive puzzlement, important and embarrassing questions can be generated seemingly ad infinitum, perhaps principally because over the past forty years in America – and earlier in continental Europe – a host of theories of interpretation of literature and the arts has sensitized us to the manifold possibilities and complexities of achieving interpretive clarity about individual artworks. We may lose our breath in this alien conceptual landscape and feel odd, overwhelmed, wondering whether any clear landmarks can ever be seen.

THE CHALLENGES OF THEORY

I think it useful to divide recent and contemporary interpretive orientations concerning artworks into seven basic schools. There are what I call (a) *traditional theories* of interpretation, for example, formalism or (its successor) "new criticism," according to which the artwork is regarded as something to be appreciated "by itself," apart from historical context and from psychological information about the artist. But, it is assumed, one's initial response to the artwork may well require some supplementary information about what some obscure aspects of it would ordinarily be thought to signify to sensitive

appreciators of it at the time of its creation, and one would be ex-
pected to reflect carefully on one's overall aesthetic experience to
arrive at a coherent, systematic interpretation of it. Here the goal
is to round out and enhance the respondent's (presumed) basically
sound, but initially unsophisticated, grasp of the artwork. There are
also (b) *psychological theories* of interpretation, for example, those
of Nietzsche and Freud, in which elements in the artwork are in-
terpreted in ways that go completely against the grain of everyday
understanding, against what Husserl calls "the natural attitude." The
mature Nietzsche, for example, regards overt artistic expressions
of Christian "virtue" as disguised manifestations of the "will-to-
power," and Freud sees symbols of libidinal, egoistic, or "thanatic"
drives and conflicts in artworks, as well as in ordinary, everyday
human events. We also find (c) *psychosocial theories* (e.g., many fem-
inist stances, in which artworks can best be interpreted as reveal-
ing explicit or disguised forms of patriarchal domination of women
in a particular culture or of their pornographic depiction). Relat-
edly, there are (d) *sociohistorical theories*, exemplified in academia
currently in three major forms: Marxism, the new historicism, and
cultural criticism.[1] According to this orientation, an artwork must
always be seen as an expression of and, at the same time, influencing,
the historically conditioned aims and practices of the larger culture
of which it is an ingredient – aims and practices that may be mis-
understood by or largely unknown to the percipient, especially if
he or she regards the artwork as though it were a discrete object to
be contemplated just "by itself." For viewing it under such isolat-
ing conditions, it may either be misleadingly ranked as "high" or
"low" art, thereby precluding the respondent's appreciation of its
important relations to other works manifesting quite different forms
of aesthetic and social discourse. Or, according to this general theo-
retical stance, the artwork may simply be experienced superficially,
thus taken at face value, as occurs when one reacts to it presuppos-
ing the prejudices and ideological assumptions of one's culture or
subculture, thus overlooking a counterintuitive significance in the
work, and thereby forgoing a more searching understanding of it, one
that might be effected by discovering other, unsystematically related
socio-historical data that could be radically rethought and formulated
as a new and more authentic "memory," what Michel Foucault calls

a "countermemory." Of course, we cannot forget (e) *subjectivist the-ories*, often expressed by some students in colleges or universities, who maintain that an artwork means whatever any respondent says it means, and that if there is a larger, publicly warranted significance to it, this state of affairs only reflects the philosophically unimportant fact that two or more individuals have perchance come to an agreement. Both David Bleich and Norman Holland can be regarded as subjectivists, but, as might be expected, their respective positions are more developed and qualified than those often put forth by beginning students in the philosophy of art.[2] Then, too, we have (f) *ethical theories* the expositors of which (such as Plato and Tolstoy) believe that all art worthy of its name should subserve the development of the good character of the respondent to it and that most art completely fails to do this and, therefore, should certainly not be entered into in a credulous, "I-thou" frame of mind that I have been recommending. Finally, we must acknowledge (g) *deconstructionism*, especially the version championed by Jacques Derrida, who, as I interpret him, is committed to the view that any particular "sign" or "signifier" of a culture's language, which would include the "language" of painting, has no immediate signified, no incontestable, experiencible denotation that anchors its meaning unambiguously and definitively. We must regard the signifier's nature instead as defined by its relation to and dependency upon other signifiers, that is, its linguistic "context," which in turn makes tacit reference to an unspecifiable number of related linguistic contexts. The larger set of contexts itself, however, contains no transparent significance to which one may consolingly resort, according to Derrida. It is syntactically permeated by what he calls *différance* (combining the notions of "difference," a definition determined by its oppositional location within an entire linguistic system, and, more importantly, "deferral" of denotative surety, of, in other words, ultimate referential redemption), and thus its boundaries are "never [fully and] absolutely determinable"[3] – even in principle. He infers from this state of affairs that each signifier in an artwork is never univocal in meaning, but indeterminate, "polysemic," precluding the possibility of a perfectly definite and final signification. Thus, Derrida concludes, it is theoretically impossible (and, therefore, in practice totally misleading) to reach a fully determinate, self-consistent, final interpretation of

any artwork whatsoever, as univocally minded philosophers, literary theorists, and ordinary respondents to artworks wish. Whatever construal a person puts forth, he further infers, there will always still lie on the horizon of interpretive possibility an indefinite number of additional, plausible, and sometimes contradictory alternatives to it.

My list of theories of interpretation could, naturally, be expanded,[4] and there are some obvious overlaps in my too-tidy categorizations. Still I think that it is important to keep something roughly like the previous list in mind if I am to be at all persuasive in my generalizations and conclusions about the whole complex of issues involved in the question concerning the proper approach that we should take in viewing paintings.

Regarding the question I have just cited, let me begin by asserting that it would be wrong simply to reject the stance of "the theorist" and affirm my own phenomenological stance *tout court*. Unless one has been oblivious to literary and artistic theories – and their application – of the past forty years, the prima facie persuasive power of the various interpretive strategies is undeniable. Consider the following three "unmasking" interpreters' views of my phenomenological response, in the previous chapter, to "Woman Holding a Balance."

Feminist

Let us look again at the painting, not viewing it through Paskow's phenomenological eyes, but as it appears to my trained feminist eyes and mind, for I have a historical consciousness of the ways in which women have been misrepresented by men.

The person holding the scale, although not strikingly beautiful according to European standards, is clearly attractive in her simplicity. She is engaged in a so-called delicate, feminine activity, the weighing of jewels, probably for a commercial purpose. Notice how the pinky of her right hand (precisely at the very center of the scene and almost at the vanishing point) is extended in the typical gesture of a well-mannered woman holding a teacup. Her jacket is bordered by soft white fur, she wears a white protective headdress and floor-length skirt, and her gaze is calm, undistracted, and cast distinctly downward, all of which compel us to perceive the woman as gentle, modest, serene. Aside from her pregnancy, she is not a

"substantial" woman. Notice, for example, her small hands and slender forearms and thin face.

Paskow is probably right that the woman is a Mary figure, given the blue color of her jacket and similarity of her gaze to those of the seemingly endless Mary paintings of the Italian Renaissance. But he implies that she is an aesthetically, morally, and above all religiously beautiful woman, someone who can provoke in us a sense of the holy and by whom we can, therefore, in a certain sense be inspired and even influenced. How fitting! – for patriarchal ends.

A wonderful example of male idealization, despite Paskow's insistence that she is the real, down-to-earth embodiment of Mary and not the abstract Mary floating somewhere in the upper reaches of the painting within the painting (thus the Mary who dwells in some nonphysical realm). Yet, Paskow's Mary, although perhaps "real" for him and representing a real fantasy of legions of males like him, is ultimately *unreal* as representative of a *real* woman. She is instead simply a man's idealized mother-wife (the two are one because of the narcissistic propensity of men to be attracted to women who represent the perfect mother). She is for a man his great appreciator and muse, an omni-benevolent presence who smiles on and approves of all of his acts, consoles him in all of his defeats, in other ways provides for him, especially with respect to food and other forms of physical and emotional sustenance, and, finally, inspires him to create great works or to enact great public deeds.

The light that illuminates her is correctly interpreted, in conformity with historical convention, as flowing from God (who, along with Christ, is traditionally "light and truth"). We must remind ourselves, however, that this Abrahamic God is also, according to the Judeo-Christian tradition, masculine. Thus, the woman's feminine goodness is enabled by a power that is greater than and, therefore, is not her own, a power that is so great (infinite, nonphysical, utterly transcendent) as to be "mystical," in fact, mystifying, for it cannot even be appreciated by reason alone, but also requires a subservient, adoring faith. Thus, while the woman has a calm and reassuring presence, it has been made possible by, and thus would completely vanish apart from, a divine masculine order and the omnipotent and supreme goodness essential to it. Moreover, while the dark blue cloth in the lower left foreground is amorphous and suggestive of death,

Paskow fails to perceive and comment on a rather large gap visible in the fabric that appears above the table, a kind of miniature cave of utter darkness. This is no ordinary, meaningless gap. Freud's psychological outlook, although infected by patriarchalism in many respects, can be usefully applied here, for the dark, diminutive cave is clearly vaginal in character. What we are viewing, in fact, is a displaced vagina, the painter's unconscious wish to divorce the woman from her own sexuality. It is not merely an aesthetic choice that the woman's jacket and the foregrounded fabric are both the same blue color. The vagina is for the painter a hellish abode of his (and, generally speaking, any man's) deepest castration fears, anticipating death itself. To complicate matters, yet rendering them self-consistent and explanatory, we should note how the golden jewels are just above and tantalizingly contiguous with the "hole" of the blue fabric. Their optical beauty suggests that for Vermeer the vagina is not simply a symbol of death, but something attractive as well. (It is not impossible for the same thing to be both attractive and repellent at the same time, for the two responses would refer to different parts of the psyche.) The displaced vagina signifies not only Vermeer's infantile wish to de-sexify his subject, but also his failure to explicitly acknowledge his own libidinal wishes and a plausible human subject for them. The upshot of the displacement is in Vermeer a fetishizing of the cloth (and, perhaps, to speak generally about other paintings by him, of the sensuous itself). Also, the snakelike vertical form under the table – floating nowhere – suggests Vermeer's own unconnected phallus, and reinforces the thesis that sexuality is both important to the painter and unplaceable. In short, while the painting has undeniably lovely qualities, especially with respect to the defining of an important moment and the complex play of light, it is ultimately one more expression of masculine sentimentalization, enabled by sexual compartmentalization and displacement.

Marxist

All objects in capitalist society contain stories that most members of that society are loath to entertain. A pair of Nike running shoes is not simply footgear for sporty people. This simple view of their nature by most people in capitalist society is a collective delusion. Yet, by

properly comprehending them in their de- or unreified incarnation, that is, in their authentic historical context, the shoes betray an allegory of social and economic struggle between wealthy owners of the instruments of production and the poorer workers who must sell their labor and do their employers' bidding (or starve, or find another employer, who will also compensate for work only according to prevailing market conditions – i.e., exploitatively). This allegory is not simply an interesting "interpretation" of the shoes; it is their essence and significance (in capitalist society). We Marxists are obligated to uncover the true story behind the mask of this capitalist product.[5] We should minimally ascertain (a) the working conditions under which it was produced; (b) the marketing means for beguiling and ensnaring customers, including the representation in advertisements of sexually provocative men and women, of prestigious items of use or exchange value, and of luxurious or exotic places for dwelling or vacationing; (c) the various forms of environmental exploitation (of oil and rubber, among other natural resources) and the adverse social and ecological consequences thereof; and (d) the small, but not insignificant, resultant corruption of all people involved in the production and consumption of the product, a corruption that takes the form of *alienation* of these people from the product itself, from one another, from the other creatures of the earth and, ultimately, from "themselves," from better (less egoistic) individual potentialities of creativity.

Vermeer, a member of an economically thriving capitalist, Dutch, mid-seventeenth-century society (one of the wealthiest nations per capita on earth at the time) produced a commodity (the painting) that has a story *in* it and one *attached to* it (the transformation of something of limited exchange value – 155 guilders – in 1696 to something today that would sell on the open market for tens, if not hundreds, of millions of dollars). Of the second story I will simply say that what is depicted in the painting ought to be supplemented by an understanding of the painting's socioeconomic history as a commodity in bourgeois society – how Vermeer's work, forgotten for nearly two centuries, was "discovered" by the French art connoisseur and authority on European painting, E. J. Théophile Thoré, who, through the influence of his enthusiastic writings geared to a certain bourgeois French audience, created a "genius" whose

"masterpieces" "had to be" owned by collecting cognoscenti. Thus, the painting's frame did not really separate the essence of the depicted scene from a world of capitalistic imperatives and concerns, of what was, and indeed still is, codified and sealed by certain highly regarded members of "society" as "great" art.

I prefer to concentrate on the first story, what we may glean from the depicted scene itself. Just as physical artifacts of everyday life are obscured allegories of class struggle, so, too, are the representations in artworks (even, it should be noted, the contents of so-called abstract paintings). One might look at the attractive face and thoughtful posture of the woman and speculate about her virtue, as Paskow does, or one might (and should) look more carefully at what she is doing, which is, of course, holding a scale for the weighing of gold and pearls. We thus need to interrupt our socially conditioned, aestheticized gaze and literally review the work, asking simple and, for some, impertinent questions. Now assuming with Paskow that Vermeer wanted us to regard the woman as in an important sense "real," where, first of all, did she get the jewels? It is relevant to note that Holland in the seventeenth century – the century of the globally admired painters later known as the Dutch Masters – had gained much of its wealth through bloody maritime conquests, having exploited peoples and natural resources in, among other places, the Dutch East Indies. Moreover, the (Dutch) West India Company was authorized by the state to engage in "honest privateering," which meant it could legally engage in acts of piracy against Spain and Portugal! We may assume that the woman herself did not directly participate in such atrocities, but her willingness (or the willingness of someone close to her) to pay for gold and pearls tacitly implies at least some responsibility for and acceptance of what took place, even if (in an imaginary dialogue with us) she were to claim ignorance of these events. For although the complexities of commodity transactions occlude stories of exploitation of people and the environment, their underlying significance is, in fact, penetrable for any uncomplacent person willing to make a minimal investigative effort. We must also ask, *why* is the woman weighing jewelry? Who will buy it and for what purpose? How much will she get for the sale? What will she use the money for? To compensate the victims of Dutch imperialism? Or, rather, to find additional ways to increase her wealth? (It's improbable that she

will simply give the jewelry away.) This woman is obviously wealthy, given her elegant, fur-fringed jacket. (And where did the fur come from? How many animals – ermine? – were trapped and skinned for their tiny pelts?) There are other things testifying to her wealth, too – the jewels of course, the painting behind her, the tiled floor, and the rich deep blue fabric in the foreground. Although the enjoyment per se of life's material aspects is not an evil – after all, the goal of Marx's communist plan is not an egalitarian society of *poor* people – the depicted scene suggests that the woman's wealth and physical beauty, if not sufficient conditions of her quiet virtue, are natural or essential features of it.

Let us consider the picture in the background (the Last Judgment), for just as artworks can be usefully interpreted as allegories of social oppression, so, too, can artworks *within* artworks. In the painting behind the woman, the resurrected, the savior, and the damned are depicted (below left, above, and below right, respectively). The saved are, of course, those who were virtuous on earth. Sometimes, however, the unvirtuous appear to be virtuous and the converse of this occurs as well, so how do we know who is morally and religiously who? Although only God and Christ truly know, there are nevertheless indications or emblems of the genuinely virtuous, which in predominantly Calvinist Holland was often signified (although, to be sure, not conclusively proven) by a person's prosperity. Thus, in the picture within a picture we see God and Christ implicitly providing a religious certificate of approval of the "benign" relationship between virtue-and-vice-weighing and jewel-weighing as well as the product of this latter kind of activity, that is, material wealth. Here it is important to note that the woman is only weighing the jewels or, more accurately, preparing to weigh them; she most probably didn't cut and refine them herself. If this speculation is correct, how did she develop her saintly virtue? For one's character, contrary to bourgeois belief, is not simply a matter of personal and private insight, resoluteness, and the resultant development and exercise of good habits, but instead and much more a mode of public being, hammered, as it were, on the anvil of economic and social necessity and shaped according to a pattern – in the case of the woman, by the specific role that she is expected to play throughout her life. Is she a wife who has been asked to do some work for her husband? Or is she

herself a "middle man" between a jeweler and customers? Whatever her role, her daily practice will necessarily and significantly inform her thinking generally and her very disposition toward other people. Will she care about others inquiringly and lovingly? Isn't her implied virtue a psychosocial falsity, a mere wish and fantasy of the artist (and of Paskow as interpreter)?

The reader should know that Vermeer married the daughter (Catharina Bolnes) of a wealthy woman (Maria Thins), whose large home the couple inhabited from the time of the marriage until Johannes's death fifteen years later. Vermeer most likely lived mainly from his mother-in-law's fortune, selling approximately only one or two of his paintings annually during his entire painting career. Thus, he had the leisure to paint pictures of idealized subjects, expressions of his own sentimentalized possibilities, cut off from the concreteness and necessities that ordinary working people, under greater compulsion to accept this world and its realities, would have to endure and come to terms with.

We should realize as well that the famous light depicted by Vermeer is not God's illumination but rather a mimesis of capitalistically created "smoke and mirrors," fantastically instantiating the society's ideological presuppositions that need to be collectively understood as a strange, diffused, vision-providing but also refracting medium, enabling people to believe that what has been robbed from others or from the natural world is (because gained "through one's own efforts," "legally," and in accordance with long-standing and fully accepted customs) "actually" and "rightfully" one's own. Finally, we should understand that Vermeer's painting, while charming in its artfulness and thereby an object of undeniable pleasure, was constructed according to specific standards of bourgeois taste of seventeenth-century Europe, standards which have, according to socioeconomic necessity, continued to be in favor right up until the present day. The work's long-term popularity is thus misunderstood to be a manifestation of some eternal principle, as participating in "the beautiful," the "pure," the "absolute" and not as the object it truly is: a well-crafted painting, the depiction of which provides confirmation and consolation to materially comfortable but unknowingly alienated middle-class aesthetes and intellectuals unwilling to turn their gaze to the world's brutalities.

Deconstructionist

Paskow, you are confident that the woman is a Mary figure, an illuminated and thus enlightened person evincing the oft-unappreciated holiness immanent in this world. She weighs with her right and righteous hand, not with the left one. She is sure, calm, balanced – "centered" (as people say), in the very center of the scene. The radiant light, containing its own intrinsic beauty and goodness, enables and manifests the beauty and goodness in this world. She reflects the light without gazing at its source and without reflecting on her reflection. *She* is saved; ergo, being like her, *we* are not damned. Ergo, we are savable. So you seem to believe.

The balance. The woman holds a scale; it is a familiar item of use, a tangible instrument of measure; its results are dependable and true, ordinarily. She contemplates the scale benignly and is pleased by its trueness. Does she really do this? Contemplating an ordinary scale with such loving consideration? Is that the true measure, the hidden truth, in the painting? Were that so, it would be a falsehood, because incommensurable with the scene's purported sanctity. No, in fact she is, as when one thinks concentratedly about a difficult problem, not seeing what she is ostensibly looking at, but something else. Something absent. The child to be born? you speculate. Perhaps. In any case, something in the future, the not-yet, the longed for, but the as-of-now nonbeing.

The various jewels' golden and silver reflections are pleasing – in themselves and for their intimations. The person who weighs them is attractive, a jewel of a woman (*een juwel van een vrow*), but they are not only for her.

"For another; yes, I understand, but for another *person*? Or beyond even that?" Are they *not for*, but instead *about* something else altogether?"

Yes, let us say they are about the ground and explanation of all beautiful objects, something beautiful all by itself, something absolute and transcendent. Thus, perfection itself.

The jewels are also strung together; they are connected, purposefully, like the great chain of being of angels, men, animals, plants, and inanimate things that God binds to Himself. The woman is embraced by the light, and the being within her, wrapped in a red-orange band,

[215]

is bound to her. But note: she uses her left hand, which touches the table before her, to steady herself. Her left, gauche, and sinister member looks for support. It seeks something provisionally stable, knowing what the right hand, arbiter of justice, does not know, does not want to know: that justice is never what it pretends to be – right, lawful, assured, ensured, and insured; that one must hold on, hold fast, surreptitiously, to a counterweight, an opposite (to that which one so "confidently" believes), for otherwise the balance will be upset (*de balans is omgesloogen*), revealing, to one's dismay, not righteousness, but hollow self-righteousness. So she uses her left hand, is barely mindful of it, and unknowingly benefits from what it knows, that its basis (the tabletop) has no clear support, for it floats on a space of darkness.

The light. The lambent irradiation is meant to suggest God's presence, you say, but the only thing that is really there is light itself – exposing the whole scene, but must we say in some sort of spiritual sense *illuminating* it? Is God truly *there*? We all at some level want to believe in his "absent presence" but, in fact, what we know is only a present absence. We seek, we wait, we think we discern signs of what is preternatural, beyond nature. The present resists adequate meaningfulness, so we rely on the future absent to render the present magical, to do the trick for us. The absent seems to accede obligingly to our primordial wishes. But although wishes *stand for* something, they support nothing; they are not *sub-stantial*. In interpreting the painting and lured by your own metaphysical fantasies, you, Paskow, are inclined nevertheless to take your stand, to in-sist that what the woman is directed toward, besides her future child, is quietly, mysteriously, and truly there. Some palpable ether of Meaning, you maintain, suffuses her world and, by implication, our whole cosmos. Are you sure? Through yearning and fantasy, spiderlike, you weave a web of hope, seeking to capture motes of "the hidden God." The result? You hold *yourself* in thrall. You are, you tell yourself, at peace and you can endure, although in fact your vision is distorted by filaments that you unknowingly extruded from your own imagination. You look for, and sometimes even believe you espy, emblems of transcendent benevolence, harbingers of perfection that will come your way and complete you, forever. That future will bring *the* event; it will be the true, the second and the final "coming," you

wish. (Was there a first coming?) No, the future will not be other than the present, it has no otherworldly significance; the Absent will always be absent; all that you know is *here*. Vermeer knows this too, tells us this, although he slyly, painstakingly, masterfully, depicts the opposite as well, in the woman's dreamy, abstracted expression, believing what, on another level, he does not believe.

The picture in the background. It attempts to provide the final Word – in the beginning and at the end there is always the Word, certified by His incontrovertible Presence . . . to some, but not to all. Not to me, not to you. The God-man exists, they say. He judges, punishes, and rewards justly and omnisciently. Vermeer conspires with his own painterly excrescences to stimulate your wish to believe, hoping that, finally, you will believe (so that he too will believe . . . that he believes). The head and shoulders of the woman holding the balance obscure the damned in the painting. This concealment is significant. What is it to be truly damned? "Suffering from fire and brimstone?" No. It is to fervently seek self-confirming, definitive meaning and value in one's life and at the same time to know that one yearns for the impossible. This is despair, the "sickness unto death," damnation here and now . . . and forever. But we must not be allowed to properly see the despairing ones. Vermeer hides them from us . . . from himself. Nor does the woman look at the amorphous, death-signifying blue cloth, as though she is determined to dwell with simple things and tasks. Her eyes may even be closed altogether.

The nail and the hole. Not in the center of the picture, but off to the top left on a featureless wall, on the margin. The measuring right hand seems to be the key to the painting, unlocking all of its secrets, but why the nail and why the irregular hole beside it? Surely, they serve some purpose. (Few masterful painters evince more care with composition than Vermeer.) For "visual balance," you surmise? With what? Who would argue that the nail and the hole are required as a visual complement? And to what? Who would say that had Vermeer not placed them in the scene, the painting would be a lesser work? Yet, he did put them there. Might they even pertain importantly to the theme of the whole painting – as a "thematic balance"? Implausible, ridiculous, you will counter. But wait. Perhaps the irregular hole on the margin of the scene and the little nail may in their own way be a whole. Per happenstance? Not at all.

We may infer that the nail at one time held a cross. Two other paintings by Vermeer exhibit crosses with a crucified Jesus; one is an early work, "St. Praxedis"; the other may be his last work, the "Allegory of Faith." Both paintings are untypical of his work and seem to represent a more traditionally religious Vermeer. In no other of his paintings do we in any sense see the suffering Jesus. Such a scene is apparently too harsh for Vermeer. While the cross traditionally signifies not only suffering, but also what is to come afterward for the faithful – the removal of the sting of death, redemption, and eternal life – when we actually look at a cross with a Jesus figure on it, what we *see* is a tortured man. Crucifixion without redemption. No payoff for him. And none, therefore, for all of our suffering. Insufferable. Vermeer removes the cross (from the "Balance" painting), but, interestingly, leaves the nail. Why does he do this? To leave a *trace*, a marker of something important. He does not wish to completely obliterate this signifier. On the other hand, we should not let the nail capture our attention, he implies. It is better instead for us to look at and to contemplate something else, nearby, a scene depicting the vicious damned to be sure, but also more prominently and thus supremely importantly, the God-Christ. We are supposed to see that He lives – that we too may live, eternally, in an absolutely and fully redeeming, blissful heaven.

"But why the hole next to the nail? Why not just the nail?" Look carefully. Contemplate its irregularity. Where does it go? "Nowhere." What does it say to us? "Well, nothing." Precisely. It speaks to us of Vermeer's hole, of "nothing," of his nothingness, of our nothingness, of the purposelessness of our lives. (In Dutch, *hol* can mean both "hole" and "hollow," as in *zijn beloften klinken hol*, i.e., "hollow promises."[6]) The painter didn't cover up this hole, for that would be to cover up the whole. Vermeer leaves it there, as a reminder, as an obscure marker, of what he cannot fully suppress, hence knows to be true, but wills at the same time not to acknowledge, not to know.

"So that's the whole of, the truth in, the painting? Vermeer wants to deny, nullify, and yet make us complicit with his own despair? The very opposite of what I thought?"

It is the whole and it is not the whole. The other whole is what you said: the woman is a Mary figure dwelling with immanent holiness in everydayness, etc., etc. Both wholes are "true," for Vermeer both despaired and believed.

[218]

"A contradiction, then?"

Yes. And so much for your synthetic and synoptic imaginings driven by faith in your own salvability and "justified" by logocentric patterns of thought. There are more (w)holes that we haven't discussed. But these for another time.

The differing theoretical responses to "Woman Holding a Balance" just cited could, of course, be expanded and rendered still more plausible. Others, in accordance with my earlier list of categories of theory, could also be added. Yet, as perhaps may be obvious, my goal was not to persuade the reader of any one of the positions – in fact, I do not fully endorse any of them – but instead to remind him or her concretely of the beguiling state of our current universe of critical discourse – of, in short, the power of "theory," how it in its various manifestations of interpretive relativism over roughly the past forty years has thrown into question the appropriateness of "natural attitude" responses to paintings (and, in fact, to artworks of all kinds and genres). In reminding the reader, I remind myself of just how difficult and distressing our philosophical and interpretive lives have become in this age of multiperspectivity and of why I am obligated to take account of this development and to further qualify my espousal of a phenomenological approach to painting.

In this same vein of complication, it is relevant to recall the sociohistorical position (d) cited earlier, perhaps most succinctly and famously expressed by Clifford Geertz in his essay "Art as a Cultural System."[7] He argues that it is a great mistake to regard works of art of different cultures as expressing some fundamental essence that we might loosely characterize as "the aesthetic." Instead, he asserts, understanding the significance of a work is "always a local matter."[8] According to him, the proper grasp of its meaning always involves understanding the preoccupations, the interpretive "equipment," and the kinds of "discriminations" (e.g., skills of hearing, seeing) that members of the culture collectively hold.

We would totally misunderstand the meaning of the activity of two poets, for example, speaking by turns in verses before an audience in a particular Moroccan village if we regarded them as simply a

counterpart to a poetry recitation at a public gathering in a Western country. In fact, Geertz informs us, what is taking place is a contest between two men, usually paid by representatives of competing groups of people, each of whom decries various lamentable states of affairs (e.g., the shadiness of merchants, the duplicity of women) and attempts to best the other poet (and the group he represents) by scathing and artfully expressed insult. Also, as another example of Geertz's worry about the dangers of cross-cultural generalizations, for us to view certain African masks as "bush Picasso" is to fail to understand their place in religious rites. Even in our own (Western) culture, we can easily misinterpret paintings of human figures by, say, Botticelli – here Geertz cites the research of art historian Michael Baxandall – if we do not know what dancing meant to Italians of the Quattrocento, for they viewed it primarily as an activity involving clusters of people in *static* poses bearing special psychosocial meanings, interrupted by bodily movements, whereas we today view dancing primarily as *movement*, perhaps of some – but not special or nuanced – psychosocial significance, and as occasionally interrupted by stasis. "In particular," continues Geertz (following Baxandall), "the *bassa danza*, a slow-paced, geometrized dance popular in Italy at the time, presented patterns of figural grouping that painters such as Botticelli, in his *Primavera* (which revolves, of course, around the dance of the Graces) or his *Birth of Venus*, employed in organizing their work."[9]

Continuing in the same relativistic vein of theoretical complication, but viewing its incarnation in "the individual" as opposed to the society, I can point out that there is no national or cosmic law requiring any one of us to understand a painting as the painter meant it or as his or her cultural contemporaries would have interpreted it. In view of this permissive situation, some defend *aesthetic subjectivism*.[10] They argue that there are as many meanings to a painting as there are interpreters of it, and there is no need and, in any case, no way to adjudicate competing claims of what the work is "about." According to this position, there is for example nothing wrong with one person's regarding certain African masks as sacred relics of religious ritual, another person's regarding them as "bush Picasso," and a third person's regarding them as "cute" articles to be placed alongside knickknacks of cats, dogs, birds, and waterfalls.

[220]

Another challenge to my phenomenological approach comes from those worried about the seductive and misleading qualities of artistic experience. For example, Plato argues that paintings (and other forms of artistic representation), although not to be understood purely subjectivistically, do tend to appeal to our emotions and appetites in ways that militate against reason's exercising its proper functions of discerning what is real (as opposed to a mere semblance) and of overseeing and controlling the emotions and appetites.[11] We all have dispositions of sentimentalism and narcissism (to use a modern word of which Plato likely would have approved), and perhaps we all can be affected by the pornographic. The viewing of certain paintings will, it is probable, strengthen these dispositions, according to him. Plato's view is at least partially right. Looking at paintings and other forms of visual representation, such as films, television programs, magazine photographs, and billboard advertisements, may at times undermine our character and, therefore, make us worse human beings. For if artworks can inspire us to become better, then they can also tempt us to morally regress, by inviting us to regard certain kinds of depicted relations as generally true when they are only partially true. Some forms of advertising, analogues of artworks in many ways, but especially insofar as they sensuously suggest verisimilitude, graphically remind us of the corrupting power of certain images, of how we can be lured into and, even if only subtly, morally eroded by skillfully devised representations of miniworlds of young, beautiful, fit, sexy, graceful, powerful, or wealthy people linked artfully to products or services for sale.

THE RESPONSE TO THEORY

By now I assume that the reader has been impressed by the challenges of "theory" generally and of at least some of the individual theories in particular. How shall I respond to this enormously complex issue, since all of the theories cited, as well as other variations on their themes, have some plausibility and would seem to require several more chapters in this book, if not a whole separate volume? I have said, in my efforts to think through the question of the most fruitful approach to artworks, that we must not divide "direct experience"

from "theory." In the remainder of this chapter my aim is not to provide a synthesis of both standpoints, but to try to justify our preserving both dialectical moments and to accept and even celebrate their oppositional tension. However, because there has been for decades, in my judgment, a grave danger among many theoretically minded people, especially academics in the humanities, of ignoring or slighting the sensuous intimations of our artistic encounters, I further argue for their importance for our psychological and "worldly" well-being.

I feel compelled to begin with a broad concession: all of the schools of theory cited do, ordinarily, have something to contribute to our understanding of a painting. Although the imagined feminist, Marxist, and deconstructionist critiques of my phenomenological response to "Woman Holding a Balance" of Chapter 4 were written as pastiches, my hope was that the reader was nevertheless persuaded that they appropriately problematize and challenge a naïve first-person, "unmediated" approach to an artwork. For who, I rhetorically ask at this our millennial beginning, can view works by men such as Courbet, Manet, or Gauguin and not think about and benefit from feminist critiques of "the male gaze?" We need to read the feminists (or the Marxists, deconstructionists, new historicists, cultural critics, et al.) to avoid being duped like credulous children into seeing the world according to our prejudices and primitive wishes. Thus, once we have been enchanted by a work, we are, I believe, obligated to step back and look more critically at its subworld, so as to determine whether our enthusiasm and delight have not been gained too dearly. In some cases, subjecting our viewing responses to critique will destroy our enchantment – and rightly so. Generally speaking, the purpose of critique, it seems to me, is to reveal likely overlooked aspects of a painting (or any artwork), its living relations to our world, and not to murderously dissect it. In many cases, our viewing will, with qualification, survive critique – and rightly so. (Even Marx in the latter part of his life reread in the original Greek Aeschylus' works once a year, and presumably not because he thought that the power and profundity of, say, *Agamemnon*, lay simply in its disguised illustration of oppressive socioeconomic relations that occurred in ancient Athens.)

I wish to make a second concession to "theory" as well, which is that in one sense the aesthetic subjectivists make a proper point too, as do the exponents of other schools of interpretation. More than

one reading of a painting is defensible. Others (historians of art, who know much more about the work than I do) have interpreted "Woman Holding a Balance" in ways that differ from my interpretation – for example, as a *vanitas* painting. I could muster some evidence suggesting that they are wrong, but I cannot gather enough evidence to prove (even in a weak sense) that they are wrong. In another sense, however, I believe the aesthetic subjectivists themselves to be wrong. For although many interpretations of the Vermeer "Balance" painting are defensible, it would be too extreme to assert that any interpretation whatsoever is defensible. "Woman Holding a Balance" is clearly not about Attila the Hun, the planet Jupiter, or Vermeer's naturalist friend, Antonie van Leeuwenhoek. Of course, it's not that God or Ivy League law would confirm my rejection of the subjectivist's position, but that anyone claiming that the painting was about Attila the Hun would simply be contravening Western conventions of communication about *what it means* to interpret a painting (unless he or she could, in fact, cite overlooked evidence for the interpretation). One might just as well claim that gargling was making music or even that walking was the same thing as flying. But to what end? What would be the positive pragmatic implications of maintaining aesthetic subjectivism beyond the reaffirmation of one's dogmatic assertions about Vermeer's painting? Moreover, I do not believe that anyone who cares substantially about paintings and who professes aesthetic subjectivism actually believes such a position in practice. Try to imagine a lover of Rembrandt's self-portraits giving equal credit to someone who knows nothing about the artist's oeuvre and who rejected it, on a quick viewing, as no better than a child's doodles. Now note that such facile crediting, if it were made, would entail that one's own view of Rembrandt's work had no authority and thus no public significance. If the person determinedly insisted that each person is an authority unto him- or herself, that there is no overarching aesthetic truth, but only the "truths" of each person's own world, then I would reply that such a position might literally be labeled "idiotic" (etymologically related to *idios*, "one's own," "private"), for it makes plain a fundamental and, what seems to me, incorrect presupposition – that we are not essentially beings-in-a-common-world, that we do not need or seek the (at least tacit, in principle) approval of some other for all of our beliefs and actions.

In sum, I believe that unqualified aesthetic subjectivism, like many other forms of extreme skepticism, can be confusedly asserted, but not practiced.

But what shall be said of Geertz's claim that all aesthetic judgment is "local," that it is wrong to seek an aesthetic essence common to all cultures, that a specific work of art (e.g., a painting by an Australian of the nineteenth century) can be understood only with reference to the peculiar customs and practices of a particular society and not at all with reference to a universal theory of "the beautiful"?[12] In this context, it is interesting to note what Geertz affirms in spite of himself: the experience of art depends on a kind of cooperation between artist and public in which the public "does not need . . . what it has already got . . . [but rather] *an object rich enough to see it[self] in; rich enough, even, to, in seeing it, deepen it[self]*" [my emphasis].[13] Surely, the words that I've italicized undermine, if not flatly contradict, Geertz's strong claims defending his anthropological, aesthetic relativism. For if there is an enriching and deepening feature in authentic art, then Geertz is here at the same time tacitly asserting what I have been arguing all along: there is, or at least may be, something that transcends the parochialness of a particular artwork of a particular society, even if we can make proper sense of it only through prior comprehension of the complex customs and practices of the culture in which it was produced. But my admitting the very real need to learn about exotic cultures or distant epochs does not undermine my basic position. We *should be* wary of mere aestheticization. The African masks that Geertz referred to are not "bush Picasso." And, as Wittgenstein says of a coronation robe of Edward II (the "Confessor"): "You appreciate it in an entirely different way; your attitude to it is entirely different to that of a person living at the time it was designed."[14] Still, isn't there some dimension to most artworks generally, whatever their cultural source, that we can (often only after much investigative effort, to be sure) grasp as "beautiful"? After all, Picasso did not produce his African-like figures by chance or sheerly from his imagination. He was greatly influenced by African sculptures first brought to England by the painter and sculptor, Frank Dobson (1898–1963).[15] Did Picasso appropriate African art in a manner that an African from the area of the work's provenance would see as a complete misunderstanding? Even if such an African was or

would be distressed by the use Picasso made of his figures, might not he or she feel this way because of a sense of violation of "place" and original purpose rather than because of Picasso's failure to appreciate what was originally beautiful in the masks? And – as a thought experiment – might not we, today, still be able to take delight in the aesthetic qualities of Edward the Confessor's coronation robe (were it available for viewing) knowing little or nothing about fourteenth-century English politics, the "divine right" of kingly rule, and so on? If not, then is all or most intercultural or historical art appreciation a tremendous illusion on the part of viewers? Why is Bellini beloved by millions after half a millennium, presumably by many who have only a shallow understanding of how fifteenth-century Italians regarded images of the Virgin Mary? Why is Vermeer, after more than three hundred years, apparently universally appreciated? Why do many non-Africans derive pleasure from viewing so-called primitive African art? Why did and does the Taj Mahal have admirers from everywhere on the planet? (The reader can supply examples of favorite works of his or her own or those of respected authorities.)

I am aware that if I give excessive emphasis to my belief in intercultural and transhistorical commonalities of aesthetic perception, I risk vaporizing the concept of "the beautiful" into abstract banality. As Geertz writes at the conclusion of his essay: "A universal sense of beauty may or may not exist, but if it does, it does not seem, in my experience, to enable people to respond to exotic arts with more than an enthusiastic sentimentalism in the absence of a knowledge of what those arts are about or an understanding of the culture out of which they come."[16] Still, if there really is something in common to the makeup of all human beings, an essence of sorts, if in fact Heidegger is basically correct (as I believe he is) that we are to be understood fundamentally as beings whose nature it is to make sense of our existence, thus whose very being demands ever-renewed meaning-deciding, global responses to the call of our ownmost-potentiality-for-being (our *Seinkönnen*), then I can assume that we all do have already a modicum of understanding of another culture – indeed, of any other human culture – and thus a kind of a priori grasp of all human beings. In that case, might we not further assume that an artwork is always the artist's attempt, insofar as she is practicing her craft – be it earnestly, comically, subversively, whatever – to "make a statement

about" the Significance of his or her being-in-the-world?[17] To be sure, we can imagine Geertz here reminding us that even if there is such a thing as a "universal aesthetic," it would do us virtually no good for the purpose of understanding a *particular* alien artwork. I could not disagree with him. But were this his reply, it would miss my point. For what I have argued in the previous chapter, and what I wish to emphasize here, is that, in general, we should not deal with alien artworks as data to be stared at dispassionately and purely contemplatively, as though we were "objective" anthropologists attempting to make sense of an undeciphered cultural custom. To do such a thing would be to renounce an opportunity to meet the work in an appropriate manner, to encourage in our engagement with it an inhabiting of *its world* as a sector of *our world*. I am, therefore, making a plea for a certain kind of stance toward artworks, something that to a degree we do already anyway, for otherwise they would make little affective sense to us at all, but which we ordinarily do timidly, almost in spite of ourselves, for the work (we are too inclined to say) is after all "not real," therefore to be appreciated as a mere ob-ject (something "out there," literally "thrown in the way") – some *thing* with, for example, "interesting tonalities" or "an impressive depiction of hands" or "harsh chiaroscuro" or "a touch of kitsch," but hardly anything more than that, hardly a quasi-living being who can be a special "other" to challenge the way in which we have determinedly spent our lives shaping our own destiny.

Let us return to the feminist, Marxist, and deconstructionist pastiches. I conceded, even insisted, that each offers an understanding that is complementary to what we learn by the alternative approach that I have been advocating throughout this book: to enter into an artwork's subworld as something that makes reality claims on us and that thus calls for an attitude of surrender. But what do we learn by adopting an opposing, *theoretical* posture? And how much do we learn? Moreover, since every theory ordinarily claims epistemological priority over every other theory, can we truly learn from all three (and still other) theoretical approaches?

Here it is useful to remind ourselves that no theoretical approach to the interpretation of artworks comes with tags attached to it certifying that it is *the* methodology, *the* way.[18] Feminists may have correctly identified oppressive patriarchal relationships in many great

artworks (including and especially literary works), but even granting that they have achieved this, it does not entitle us to conclude that one would always do well to look at all artworks (much less the world generally) exclusively through feminist lenses. Also, even if one managed to persuade oneself that a feminist methodology was "the correct one" for interpreting artworks generally, there would still be doubts about its *application* to a particular artwork; it simply might not lend itself well or at all to that work. Naturally, the same sorts of concern that I am expressing vis-à-vis feminism – actually feminisms, for there is no orthodoxy among feminists – are appropriate, mutatis mutandis, vis-à-vis Marxism, deconstructionism, and, for that matter, all other theories of interpretation. One may look for expressions of socioeconomic oppression implicit in the story of a painting or, alternatively, one may seek out "traces" of a counter story that contradicts and dismantles what most viewers would take to be the explicit theme of the work. In the end, however, these approaches are *theories*, highly speculative ways of organizing one's (enormously complex) cultural experience. They are not, after all, as clearly articulated as, and they do not have the predictive power of scientific theories, e.g., those of physics. Their application to artworks is a craft or skill, thus necessarily lacking systematic rigor and requiring the tacit assumption of numerous unproved (and often inexplicitly acknowledged) generalizations about such huge and diverse topics as "patriarchy," "culture," historical causes, essences, linguistic meaning, etc.). The artwork's interpreter carefully collects clues for his or her thesis, organizes them with great selectivity, and then artfully presents a coherent, provocative narrative – preferably with savoir faire and wit, and naturally in the au courant vocabulary of the admired connoisseurs and proponents of the particular theory. The story that is told can feel "just right," "empowering." Yet, we must remind ourselves, as Wittgenstein does in his reflections on the epistemological status of Freudian theory, that the particular interpretive narrative itself, while not necessarily false, gains strength (ironically) by the unusualness of the explanation – one is excited to be "truly in the know" and "on the cutting edge" – the highlighting of certain data at the expense of other data, the sheer repetition of the point of view, and, finally, the lovely sense of self-confirmation and even righteousness induced by "experts" or professional

colleagues' having "verified" one's own deepest suspicions, wishes, or ideological commitments.[19]

Lest my rhetoric mislead, I do not mean to imply that all "interpretive theory" yields only fables. Certainly, the three schools of interpretation that I parodied here, and other schools as well, have made important contributions over the past forty years to our understanding of artworks. For although the countless stories that their expositors have told are not definitively, or at least not strongly, verifiable, as, say, Newton's Laws are,[20] many of them have been subjected to multifarious and multitudinous internal and external critiques according to certain agreed-upon evaluative tenets and protocols common to disciplines in the humanities, and many distinguished thinkers and their followers testify to the overall explanatory power of such critiques concerning hitherto mystifying features of the artworks with which they have been preoccupied.

Nevertheless, crucial, nagging philosophical questions cannot be stilled by my casual reference to "principles and protocols" in the humanities. Thus, we may wonder, what *is* relevant evidence for particular theoretical interpretation in the first place and *how much* evidence is enough? Here I confess that no final answers can be provided, for the data an artwork presents to us can be related to virtually an infinite number of interpretive considerations. Still this conclusion that there can be "no final answers" does not mean that there can be "no answers whatsoever." Just as we ordinarily come to an explanatory conclusion – provisional though it may be – about the unusual and strange behavior of a friend or relative, so, too, do we ordinarily come to a (provisional) conclusion about what an artwork means. This occurs even though what one person finds persuasive another may well find unjustified; what one community (of, say, museumgoers, artists, art critics, art historians, et al.) finds persuasive, another community (of different museumgoers, as well as of artists, art critics, art historians, all with an agenda different from that of the first community), may well find unjustified. We can and do live with, and are not ordinarily overwhelmed by, this multiperspectivity. This is because some explanatory interpretations, although not rigorous or airtight, do strike us as better than others – clearer, more comprehensive, better supported evidentially, more consistent with what we have come to believe about the world, and so on.

Let us look at this issue of how we may cope with multiperspectivity by briefly reconsidering, critically, the claims in the three pastiches.

In the feminist critique, no evidence is provided for the assertion that the Mary figure is "simply a man's idealized mother-wife." One may know (or fantasize that one knows) many men who have yearnings of this sort, but why insist that this is Vermeer's, and all or most men's, yearning? What would demonstrate such an interpretation to be correct? What would prove it false or misleading? What would support the view that the light, symbol of the transcendent, would have to be experienced as coming from a masculine source? (In the Western tradition, the Divine is certainly not always thought of as masculine.) Moreover, the snakelike form at the bottom of the painting is not a mysterious phallic displacement, but (as one can ascertain from close scrutiny of the painting in Washington's National Gallery) at once a representation of part of the back wall and a visually necessary color demarcation between the woman's skirt and the table leg. And so forth.

In the Marxist critique, one could legitimately wonder whether the woman's association with jewelry is ipso facto a sign of her moral deficiency. Suppose it could be proved, *per impossibile*, that the woman enlisted for Vermeer's model was, in fact, a dealer in jewels who obtained her treasures through men who exploited indigenous people in the Dutch East Indies. What then? The depicted woman was, I think most viewers would agree, meant as an ideal, someone who could and ought to exist and, in any case, who was intended to remind us of our own ideality and moral and religious obligations. Are we to conclude that no ideal woman (or man) should be pictorially associated with jewelry? If not jewelry, what then? Is not absolutely everything in capitalist society, according to the logic of the Marxist essentially interconnected ("relational") view of all products and services of any and all societies, morally sullied by its defining ethos – namely, the fundamentally exploitative dimension that exists in all of its socioeconomic relations? In principle, then, *nothing* could be depicted that would be politically orthodox and aesthetically acceptable.

Concerning the deconstructionist reading of the work, it should be noted that the basic stance is skeptical apropos of any religious

dimension to our world. Why should we uncritically accept this kind of background supposition? Also, the hole in the wall should probably not be seen as pointing to an absent cross. In many other pictures of the period (e.g., those of Jan Steen), a nail on the wall supports a large key ring and one or two keys. Perhaps Vermeer resisted this kind of motif as too unsubtle, for fear that he might be blatantly suggesting that the woman's activity was "the key" to the meaning of the painting. Finally, while it is possible that Vermeer did want to suggest something negative by rendering a nail and a hole (as the pastiche states), this interpretation obviously does not commit us to a complete deconstruction of the view that I put forth in Chapter 4. (Perhaps the nail and hole were depicted as acknowledgments of the apparently meaningless and inexplicable painful events that sometimes happen to us and with which we must deal.)

Still, the problems that I am raising are more difficult than I have implied, for while we do often reach terminal points of explanation and some satisfaction in regard to the understanding of artworks, the fact of such arrivals is not self-justifying. Some people, perhaps the reader, will find grounds for legitimate disagreement with one or more of my criticisms just expressed about each of the pastiches. It is possible that a feminist may already possess other and, to her mind, sufficient evidence of male narcissism and not want or need more clear-cut, pictorial data to prove her point. The Marxist could reply that while it is true that nothing in capitalist society is morally neutral, some things (like jewels or the ermine border on the woman's jacket) are more suggestive of the evils of bourgeois society than other things (like her plain brown skirt), and that Vermeer's giving such pride of place in the scene to jewelry, as he does in other paintings, morally compels us to read the work suspiciously and critically. Finally, although the deconstructionist might agree that "Woman Holding a Balance" was explicitly meant to be an affirmation of Vermeer's faith, to believe something is by definition not to know it. Thus, the deconstructionist might continue, Vermeer at some level realized that his (and the) world might well utterly lack a religious dimension and be cosmically purposeless, that the painter himself had in his "advocated" case of the holy woman "the burden of proof" on himself. Although the deconstructionist would probably concede that the "nail and the hole" reading would be judged "tenuous" according

to a standard interpretive canon, he or she might proceed to say that the work should not be investigated via a canonical methodology, for this kind of lens, it would be contended, always refracts and distorts what is seen by virtue of its "modernist" criteria of meaning and truth, which are themselves based on dubious assumptions about humans' ability to be "objective" and to reach justified and definitive conclusions. The deconstructionist reading was designed, it would be concluded, to be disruptive (of our usual and fixed ways of viewing an artwork) and suggestive of a new, more open and "playful," thus less dogmatic construal – not "true," but not "false" either (since such dichotomous thinking presupposes the chimera of Truth) – than would likely be achieved through either an "experiential," phenomenological entering into the artwork or a doctrinaire, modernist reading of it (feminist or Marxist, for examples).[21]

The debate over the right overall approach (phenomenological or otherwise) or the right theoretical orientation (e.g., feminist, Marxist, deconstructionist, new historicist, new critical, etc.) can continue. Will it be settled? Can it be settled? By argument in particular cases, sometimes; but, as we all know, other times – often – not. The determined interpreter of an artwork can maintain his or her position, perhaps persist in marshalling more evidence for it. If we share the same frame of reference, we can point out (or have pointed out to us) ambiguities, inconsistencies, irrelevancies of thought, and so on and sometimes thereafter come to agreement. If we do not share the same approach or theoretical orientation, we can discuss assumptions and perhaps eventually come to some common understanding about them and then revert to dialogue about the artwork itself. But this sort of happy outcome, when we do not at first share the same theoretical position, is, of course, rare. Even when there is an initial, common frame of reference – assuming a certain good will and rational disposition (in some broad sense of this phrase) on the part of the interlocutors – can we, as participants or outsiders to the debate, always (usually?) pronounce with justified assurance that one interpretation is "better" and the other is "worse" (or that both are inadequate)? Can we even come to the debate unbiased, without prejudices? Can we assure ourselves that we will not judge the artwork simply according to our unacknowledged predilections and dislikes, thereby gaining little or nothing either from a phenomenological approach or from a

theoretical, interpretive approach – or from a dialectical oscillation between both sorts of approach?[22]

The objections that I have just raised may call to mind Plato's worry about the psychological dangers of artistic experience, except that now, more disturbingly, not even reason itself (contra Plato) can act as a corrective to the sensuous and sensual allure of artworks, for isn't one's own "rational faculty" ultimately not "pure reason," but instead something much more complex and adulterated, a power grounded in all sorts of implicit and explicit socially sanctioned assumptions that lack and can hardly achieve validation, since, as de facto first principles, they are by definition underived from still more basic principles and, therefore, for all practical purposes unprovable? Beyond Plato, we have, in fact, arrived at the notorious problem of the "hermeneutic circle" – an analogue of the issue encountered in Chapter 2 concerning the co-being otherness of things[23] – whereby we see and comprehend an artwork only according to our prejudging or prejudicial dispositions. Thus, our judgment about it is not, so this reasoning proceeds, anything more than "circular," a "seeing" or "understanding" or both – it matters not which – of only that which we already fundamentally believed prior to apprehending the artwork in the first place. For example, and in line with this epistemological thesis, we will apprehend nothing basically new in an encounter with "Woman Holding a Balance"; we will "discover" in it only some of our own, barely acknowledged, prior positive and negative dispositions, although because of the picture's visual novelty if it is our first encounter with it, or because in a later encounter we may notice details that earlier escaped us, we will likely delude ourselves into believing that we have experienced something "original," perhaps "important."

There is, it seems to me, no simple solution to this enigma concerning the "right" overall approach and theoretical orientation. Yet, once again, Heidegger (in *Being and Time*) can be of help to us, as can the twentieth-century tradition of theorists such as Hans-Georg Gadamer and others and those in the "Reception School" founded at the University of Constance in Germany.[24] Their basic position, which influenced the phenomenological stance that I outlined and applied in Chapter 4, can also assist us in gaining insight into the issues that I have identified in the current chapter. For reception

theory is a refinement of a phenomenological orientation. It provides both a method for comprehending the subworld of an artwork and a promising response to the hermeneutic conundrum. Thus, reception theory illuminates the complex issue of interpretive decidability and has important epistemological implications for virtually all other theoretical stances vis-à-vis the arts.

Heidegger, Gadamer, and the reception theorists (thinkers whom I will subsequently refer to as hermeneuticists) concede that it is indeed impossible to extricate oneself from the hermeneutic circle, that we never come to an artwork without biases and with a totally open mind, a sort of tabula rasa. Yet this admission does not entail that we are imprisoned within a solipsistic, "vicious circle," according to them. "In the circle is hidden," Heidegger claims, "a positive possibility of the most primordial kind of knowing."[25] His basic assumption is that although it is impossible to approach an artwork without preconceptions, it is also possible – paradoxical as this may seem – to be affected and changed in unanticipated ways by it. It is therefore not correct, according to the hermeneuticists, to say that we simply "read into" the artwork only the immediate prejudices that we have brought to it. If this were so, it would be difficult to explain why it is that we enjoy artworks and also at least sometimes believe that we have, in fact, gained something important from a particular viewing, which is not what we feel when our usual sentiments and beliefs are simply confirmed. For in the latter case, we are bored or disappointed and say or think to ourselves, "I've learned nothing from this work."

Still, how is it that we arrive at something truly new if, in fact, the hermeneuticists are right that each initial encounter with an artwork must be thoroughly prestructured by a whole battery of "existential categories" of our being-in-the-world, the most important of which Heidegger names, it will be recalled from Chapter 4, "fore-having" (*Vorhabe*)? (This structure of *Dasein* involves modes of feeling-awareness that occur prior to any definite thoughts that we may attempt to formulate.)[26] The answer to the question, implicit in the thinking of Heidegger and explicit in his followers, is that while most prestructurings will ordinarily shape our experience in roughly *the same way as before*, certain events can be apprehended by us in a personally unorthodox manner, although still consistently

with our deepest interests and concerns. This plasticity of possibility – what I previously called "response-ability," in both the literal and prescriptive senses – can occur because the existential categories by which we live are not monolithic and totally self-consistent, but polymorphous and sometimes even contradictory of one another. We can, therefore, be appealed to and affected by artworks in ways that no one (ourselves included) could have predicted or imagined. We are, in short, not unified, fully integrated beings, but in a way "multiple personalities." We say and believe that we are "this," but we are also at the same time "that."

Thus, the artwork can speak to and make a claim on some feature of our being, an aspect of ourselves that is not completely attuned to our ordinary, everyday way of thinking and feeling-perceiving. Through our availability, openness, and imaginative exertion,[27] we can temporarily establish in a different domain (of otherness that is paradoxically nevertheless and at a deeper level necessarily an ingredient of our being-in-the-world), an "horizon" of separate possibility, an "as-if" subworld that clashes with our own everyday horizon of possibility. Out of this opposition, there can eventuate, but only through our willing endorsement, a significant change within our being-in-the-world, a process that Gadamer characterizes as a "fusion of horizons" (*Horizontverschmelzung*), an experience (*Erfahrung*) which is not a simple absorption of one horizon by another, but an existential expansion of our everyday world, a true synthesis of otherness.[28]

Still, there is no warrant ensuring that the synthesis will be a "true" or "authentic" one. We may believe that we have had a "meaningful experience" of an artwork, when we have only lapsed into self-indulgence. Or we may believe that we have achieved "the valid reading," when we have only fallen into ideological self-delusion.

Indeed, here yet another concern announces itself, for if I use the pejorative words "self-indulgence" and "self-delusion," don't I thereby logically imply that I also believe in the existence of their opposites as legitimate axiological and epistemic categories, namely, "moral restraint" and "insight"? I concede this point. But then am I not at the same time really suggesting that there must be "objective truth" and with that, a method of ascertaining it? For without a method for attaining it, the very idea of truth would seem to become a meaningless abstraction. And if I accept the view that interpretive

objectivity of a sort exists, am I not contradicting myself in both insisting with the hermeneuticists that no one comes to, or leaves, an artwork totally without bias and at the same saying, against the hermeneuticists, that there is such a thing as an undistorted apprehension of an artwork?

I resist this last conclusion. My position embraces both points of view, without contradiction, I believe. I concede there are some fundamental principles that I assume to be in some sense objective and absolute – transhistorically and cross-culturally presumably, I could say – for otherwise, logically speaking, I would not be entitled to make any value judgment at all about an artwork (or about anything at all, for that matter). The very assessment of a work (e.g., "it's pure kitsch" or "it's a masterpiece") presupposes criteria that one believes to be valid, and absolutely so, if only during the time when one is making the assertion. If it is replied that perhaps the judging person merely believes his assertion, but does not claim to know that he or she is right (and thus is not tacitly committed to an axiological absolutism), nevertheless a belief itself (any belief about anything), like a piece of knowledge, presupposes the absoluteness of criteria for believing it (x rather than y), because otherwise there would be no basis whatsoever for one's belief. (If I say, to provide a simple example, "The outdoor temperature seems to be between 50 and 60 degrees," I take for granted, absolutely – if only for the nonce – my ability to interpret certain current tactile sensations in relation to my memory of past temperature conditions, the accuracy of thermometers, my ability to read them, the suitability of my speech to reflect my experience, etc.)

Yet, while I, like anyone else, must presuppose certain very basic absolutes in interpreting an artwork, this view does not entail that I must believe simultaneously that I do this without a whole battery of concerns, special interests, initial biases – in short, prejudgments – for I am, and know that I am, an historically situated man, indelibly marked by my past family ties and experiences of growing up, my current network of immediate relationships; also by American and Western cultural beliefs and practices and, more generally, by basic human needs and yearnings. But then, it may be objected, won't these complex and special lenses of my vision distort the truth of what is "there" in the artwork? Am I not, therefore, refusing to acknowledge

[235]

this necessary interpretive and evaluative bias on my part as well as the futility of trying to escape it, which, if I am a person of intellectual integrity, should result in a paralysis of any inclination to render an artistic judgment, in spite of my wish to believe the contrary? Well, yes, if we assume that our experiences are sharply and finally precut by us for our predictable consumption, and that what is "there" is something independent of our own being and well-being. But no, if I am right that there is a certain ambiguity and plasticity in our world, that we have some capacity to freely choose that to which we wish to attend and how we wish to attend to it and, as I have already stated, that we always already harbor ways of feeling and thinking that are other than and different from our explicit dispositions and which can slyly propose themselves as correctives that will be better than some of our biases, that is, be more in accord with that which is called for by our *Seinkönnen*.

Moreover, the issue of "bias" is confusing because the term has more than one meaning. One particular kind of bias that one may have about an artwork is not ipso facto cognitively distortional at all – when there is a purposeful angle from which to view it, so long as one is clear that one has a purpose and what it is. Thus, there is nothing in principle "biased" (in the sense of "a priori wrong") about, say, a feminist reading of "Woman Holding a Balance," so long as the person who does this is clear that hers may not be, and most likely is not, the only valid methodological stance, the only authentic perspective of viewing. (Cf.: "The proper approach to understanding a human being is neurophysiological." This statement may be either useful or misleading, depending on a host of suppositions.)

Finally, concerning the disconsolateness that we may still feel about our inability to ultimately escape the hermeneutic circle despite Heidegger's and Gadamer's recommendations to accept our situation by *enlarging* the circle, a discouragement that cannot be wholly mitigated within their frame of reference, by virtue of their fundamentally anthropocentric epistemological, axiological, and ontological suppositions, I think that the neo-Kantian position that I outlined in Chapters 2 and 3 is pertinent here. For just as it is possible to believe that we have the capacity to be in analogical epistemic relatedness to a "thing in itself," indeed, to its very truth or being, so, too, may we believe that our interpretations of an artwork may not simply be

For and Against Interpretation

projections of our own (even hermeneutically expanded) existential conflicts, but instead understandings that asymptotically approach "the meaning and truth" of the work itself. These lofty terms are not meant to refer to "the *eternal*, in-itself being of the artwork," for I do not think that there is such a thing when the subject is an artistic representation, but rather the ideal (best possible) "readings" of an artwork, requiring an amalgamation of both phenomenological and interpretive responses to it. Such readings would ordinarily be developed in and for that culture, but they also could be devised outside of it, either for the members of the culture being considered or for the members of the culture of the devisor. Thus, there could be many "best readings" within a culture by its own interpreters and other "best readings" by those of another culture or epoch responding to different needs and interests. All such interpretations, both intra- and intercultural, would provide the profoundest accounts of the artwork's many internal aspects in relation to the artwork as a whole. They would also and more importantly attempt to demonstrate how such readings illuminate ethical, psychosocial, or ontological issues with respect to the target culture and epoch to which the accounts were directed (and, in the case of a masterpiece, perhaps many cultures and epochs). Thus, from this methodological standpoint, even my asymptotic abstraction or, to use a Kantian phrase, "regulative ideal" (the best possible readings) would never, and could never, be *the definitive interpretations* because cultural and historical interests and boundaries would preclude such things.

Does this last concession suggest that we have landed ourselves once again in the morass of interpretive relativism? For if, according to my account, so many "best" readings of an artwork are indeed defensible and, therefore, simultaneously acceptable, then it would seem that I am attempting to evade a serious philosophical enigma. Yet, here it occurs to me that my concession of the *relativity* and acceptability of alternative interpretations of any artwork does not constitute a tacit endorsement, after all, of complete interpretive *relativism*, because the necessity of our responding personally, historically, and culturally does not ipso facto preclude the possibility of our making some correct sense of the fundamental suppositions and concerns of a culture, either one's own or another, either synchronically or diachronically. For if, following Heidegger, I am right that there

[237]

is essentially such a thing as our humanity, and if artworks are both propositionally irreducible and always speak to the particularized, but nevertheless universal, concerns of that humanity with (more or less) existential verisimilitude and forcefulness, then we may speak of a special dimension to artworks, a "surplus value"[29] or "surplus meaning" that may affect all (or most) people in all cultures and time periods, thus allowing for the possibility of our partially overcoming these boundaries.

Here, Aristotle's important thinking in the *Metaphysics* (e.g., Book B) is especially helpful as a theoretical underpinning for my claims about the possibility of there being both cross-cultural and trans-historical artistic appreciation that at the same time must assume differentiated and individuated expressions in various analogically related "best readings" of the artwork. Aristotle reminds us that "being is said [or to be understood] in many senses." We may accept the same kind of reminder as well for the words "the good," "the beautiful," or "the true," to the extent that they pertain to all living beings. The good of a dog is not the same as the good of a young woman. The good of a young woman is not the same as the good of an old man. Clearly, the use of the word "good" in each case does not involve the self-identical (univocal) meaning. But the various uses of the same term are not totally different (equivocal) either, Aristotle states, for there is something similar in the good of a young man and an old woman and even, though more remotely, between both of them and a dog. For Aristotle this similar quality is the full and highest expression of the creature's being, its actuality (*energeia*). In having a similar (but not univocal) good, all living beings are like (analogous to) one another. This theory, referred to by Thomas Aquinas and other medieval philosophers 1,500 years later as the doctrine of the analogy of being (*analogia entis*)[30] can be applied to Heidegger's concept of *Seinkönnen*. For our potentiality-to-be is, in a manner of speaking, "the good," "the beautiful," and "the true" for every human being (be he or she young or old, Salish Native American or Chinese, of this century or a remote one, etc.) – a never wholly realizable felt horizon of possibility that claims each of us individually and, in conjunction with a grasp of our mortality, pro-vokes a global stance, a coming to terms with, in one form or another, the meaning or Significance of our lives. Just as there is something

dispositionally and deeply in common to all human beings, so, too, do artistic works of all cultures and all times, attempting as they do to clarify the significance of mortal human existence, have, I believe, that very goal, broad though it be, in common. Thus, while there are, necessarily, differing artistic standards and values that are a function of and *relative* to one's time and culture, and often even differing artistic standards and values that are a function of and relative to *the individuals* of a particular culture, it would be wrong to conclude, I am arguing, that all artistic understanding is and must be "local" or, worse still, idiosyncratic and private.

Why do I bother to defend my quasi-universalistic position when, in the end, (a) it provides us with no decision-procedure enabling us to ascertain who has the "better" approach to or interpretation of an artwork; (b) it accepts the imperative of Geertz, Wittgenstein, and others that we must steep ourselves in, and learn much about, a culture's artistic norms and related customs and practices, as well as expose ourselves to countless examples of the kind of historically or culturally alien artwork we wish to appreciate to achieve a more than superficial understanding of it, a methodological directive that *seems to suggest* the positing of something like a "universal" in "aesthetic experience" is ultimately otiose and hollow; and (c) it offers no inoculation against self-indulgent and narcissistic readings of artworks? The answers to these questions are implicit in this book as a whole; in fact, they define its central motivation. Still, in closing, it may be useful to consolidate what I have put forth by answering briefly the three explicit challenges just posed. First, let me respond in one general statement to questions (a) and (b).

The core aim of this work has been to invite the reader to demonstrate for him- or herself that artistic experience is, potentially, of much greater power and significance than what many people would be inclined to express. If I have correctly identified a "surplus value" or "surplus meaning" in such experience, and bearing in mind that a change in one's world entails as well a change in the way in which one relates to others, then we should regard this kind of experience as harboring the never fully realizable capacity to intensify our sympathy with, and increase our understanding of, all human beings and the worlds to which they belong, in any and all time periods. Thus, we have permission – even a kind of obligation – to accept all sorts of

artistic invitations from other "worlds" or eras, and we should not be dismayed or intimidated by strangenesses, the seemingly ugly, the bizarre, the weird – in short, the threatening. If, on the other hand, we were to assume the opposite and thus be skeptical a priori about our capacity to sympathetically comprehend otherness, then we would be disposed to push these things away from ourselves altogether or – the equally unacceptable obverse – attempt to dominate and conquer them by adopting a stance of "dispassionate objectivity" and "scientific detachment," which Kierkegaard acerbically characterizes as "the loftiness of indifferent knowledge" and "inhuman curiosity." A third alternative in a skeptical frame of mind would be to respond superficially, to take away what strikes our fancy as, for example, "quaint," "colorful," or "lovely." Correlatively, and recalling my position on the analogicality of artistic experiences everywhere, what is implied is that although adopting this Aristotelian assumption would obviously not ipso facto help to settle particular interpretive disagreements, dialogue about such experiences and opposing responses to them would not be "pointless," but, on the contrary, an opportunity for an existentially mutually beneficial, and, perhaps, culturally contributing event. This possibility would be true, even conceding the point that the requirements of useful dialogue would vary greatly, depending on the nature and degree of presuppositional differences among the discussants. In short, the familiar proverb concerning disputes about artistic matters should be altogether revised. We should not complacently affirm: *de gustibus non est disputandem*, which suggests that matters of taste and, by implication, that our preferences or dislikes with respect to artworks are purely subjective and, therefore, cannot be meaningfully debated. On the contrary, we should assume the maxim's very opposite: *de gustibus est disputandem*. For we can, and ought to, controvert "matters of taste." Perhaps it goes without saying that affirming this new maxim does not undercut my thesis concerning the possibility of an analogically universal significance in a (great) artwork, since the very activity of disputation logically and psychologically entails that the disputants have a common suppositional understanding, which includes the possible achievement of an agreement about the meaning and value of the artwork under investigation and, more generally, of there being in their eyes a universally significant aspect to it.

Referring to question (c), while there can be no perfectly effective defense against the corruptive potentialities of certain artworks or of the self-indulgent and narcissistic dispositions of us viewers, irrespective of the issue of an artwork's being "good" or "bad," this state of affairs should not lead us to censorship of the arts, à la Plato or Tolstoy, or make us feel obligated, before crediting our initial felt pleasure or dislike, to process it immediately according to some ideological program. Thus, although artistic experiences can doubtless be perilous for us, still if they can harm us, they can, I have insisted, also help us – and, occasionally, greatly so, if my argumentation has been correct, just as certain crucial experiences in our everyday lives can help us. What is needed in artistic viewing is neither censorship nor critical detachment, but openness and imaginative exertion if we are to be aided in fulfilling our deepest needs to ourselves and to others. Yet, as in our quotidian existence, even an imaginative engagement vis-à-vis a particular artwork guarantees nothing at all, I must admit once again. Our encounter may well issue in sentimentalism and a kind of sweet, unacknowledged self-absorption or preening, enabled by our own determination to focus on and isolate in those experiences we label aesthetic only those "lovely features" that are ordinate to our *Seinkönnen*, as Virginia Woolf's character, Clarissa Dalloway, does in indulging her love of white dresses or prettily arranged sweet peas. When we act in such a manner, we tacitly thrust aside or suppress those dark features – part and parcel of our facticity (and our world's evils) – that beg for acknowledgment. We see this kind of disposition explicitly, for example, when Clarissa fears that the mention by Dr. Bradshaw of Septimus's suicide that day will spoil the elegant party that she is hosting. Perhaps it is hardly necessary to remind ourselves that our self-aggrandizing proclivities are aided by a consumerist ethos that promises happiness in material, sensuous, and fundamentally unaffiliated pleasures. Or, on the contrary, our "aesthetic experiences" may issue in a personal and positive orientational transformation. Paul de Man is correct in his claim that there will always be an element of undecidability about the meaning and value of our artistic encounters. Yet, it seems to me that this element is not due primarily to the fundamental ambiguity of all terms in any language whatsoever, including (by implication) "the language" of painting itself, as de Man wrote in *Blindness and Insight*

and as Derrida stated in many of his writings.[31] It is due to a measure of ambiguity in and the unfinishedness of our very lives and our world for, I believe with Heidegger, our *Seinkönnen* always calls us to do more, so long as we are conscious beings, and always suggests that we could have done more. But to say that our lives and our world have been and are always in process, thus unfinished and never unequivocally determinate with respect to the quality of our being-in-the-world, that therefore we cannot ever know the true and final significance of what we have achieved or failed at or, correlatively, of the quality or the true value of the interpretations that we have given to our artistic experiences, is not to imply that we must be in these respects profoundly skeptical or even nihilistic. The broad and pervasive existential ambiguity in our lives may lead us, on the contrary, to an appreciation of the virtues presupposed by imaginative *disponibilité*: namely, faith, reflection, and choice, or, differently expressed, the need to make a commitment to ourselves (to our being-in-the-world, and thus a commitment to others) without ultimate assurance – and yet not with total blindness either, for it seems to me that we all, indeed, have some intimation of an (our) ownmost-potentiality-for-being, the *Seinkönnen* that Heidegger regards as definitive of our humanity, and we all experience benefit from ever-renewed rational consideration, and correspondingly appropriate behavior. Correlatively, I am suggesting that, in the long run, both our successful and unsuccessful inhabitations of the subworlds of artworks (as well as of "the world" itself) partially reveal themselves for what they were and are, if we are attentive and persistently determined to gain insight into them and to test their indications to us in and through decisive action.

Finally, I wish to underscore what was implied throughout these two last chapters; namely, that although "theory" is a crucial corrective to our naïve engagement with an artwork, an antidote to innumerable institutional and individual biases (especially, I have at times found, with respect to *parts* of a *great* work, but never to it as a whole, on account of its extraordinary surplus value), we should regard such interpretive models as enabling a more discriminating, not a transpenetrating, perception. For if our effort in viewing is always to "see through" our untutored apprehensions, we then suppress our very vitality. We may learn, for example, how to see through the

ostensible meanings of depicted figures and their subworlds to discover the "real motives" of the artist or of the culture of which the artist is an unconscious representative. Or, as a second type of example, we may attempt to discern, as Derrida and other deconstructionists do ad extremum, the painter's unconscious and subtly depicted opposition to what he or she seems to be thematically representing overtly.[32] But such interpretive activity on our part, carried out methodically and determinedly, will, I feel, fray our vivifying bonds to the depicted figures. If I am, in addition, correct in regarding depicted figures as not residing in a totally unreal realm, but instead in the domain of our "real life" and, therefore, as importantly linked to the so-called real people of our lives, then "seeing through" depicted people would be much like, and would have adverse consequences for, seeing through people whom we care about in a daily way, and, for that matter and to a degree, all people everywhere. Moreover, if you and I in our being are essentially (as opposed to contingently) related to and defined by the others, if in a fundamental sense we *are* the others (as I argued explicitly in Chapter 3), then theoretical analysis of artworks pursued incautiously and uncircumspectly risks in small but not insignificant ways our seeing through and thereby undermining our selves *as selves* – as, more accurately, in-the-world beings. Thus, by seeing through depicted figures and their worlds, we render them less opaque, but also less vital and significant to us. So, too, for everyday people to whom the depicted ones are existentially related. So, too, therefore and indeed for ourselves. In a specular and spectacular effort to see through depicted people, we therefore hazard seeing through ourselves. But such transparency does not lead us to something still more significant. It leads, on the contrary, to a world without any density, to an invisible world – in fact, to a *nonworld*, with not even ourselves to perceive it.[33]

<div align="center">NOTES</div>

1. Wittgenstein's aesthetic position, informed as it is by his linguistic conventionalism, may also be regarded as a variety of sociohistorical theory, although it must be quickly added that Wittgenstein does not posit, as do the Marxists, new historicists, and cultural critics, a deeper, darker, and hidden set of cultural principles that are the true and guiding basis of what ordinary people say about their aesthetic experiences. Thus, Wittgenstein doesn't wish

<div align="center">[243]</div>

to reduce one form of aesthetic discourse to a quite different, unseen, more basic logic of explanation. He wishes instead, as I first mentioned in my Introduction, to make explicit the principles (language games) to which tacit appeal is made in aesthetic discourse and to help those who philosophize about aesthetic matters to overcome their strong proclivity to allow misunderstandings about the linguistic forms of those principles, and related, nonaesthetic ones, to obscure their "grammar," their true (albeit convention-grounded) logic, thus further disposing such benighted philosophers to make all sorts of extraordinary and misleading claims about aesthetic phenomena, especially about their "meaning" and overall "value."

2. See, for example, Bleich's *Subjective Criticism* (Baltimore: The Johns Hopkins University Press, 1978) and Holland's *Readings and Feelings: An Introduction to Subjective Criticism* (Urbana, Illinois: National Council of Teachers of English, 1975).

3. Jacques Derrida, "Signature, Event, Context," trans. Samuel Weber and Jeffrey Mehlman, *Glyph* 1 (1977), p. 174. In this article he attempts "to demonstrate why a context [of a signifier] is never absolutely determinable." As another example of Derrida's position, in which he identifies Aristotle as the classic enemy of the polysemia of language, see *Margins of Philosophy*, trans. Alan Bass (Brighton: Harvester Press, 1982), especially pp. 247–8. See also *Limited Incorporated* (Evanston, Ill.: Northwestern University Press, 1988), pp. 89–90 and *Acts of Literature* (London and New York: Routledge, 1992), p. 65. I owe thanks to Simon Glendinning, *On Being with Others: Heidegger, Derrida, Wittgenstein* (London and New York: Routledge, 1998), for the three immediately prior references to Derrida's theory of linguistic indeterminability.

4. As indeed it will shortly be, for the frame of reference that most closely represents my own, and which is consistent with and supplements my phenomenological approach to the understanding of both the nature of artworks generally and of individual works themselves is reception theory, in the United States usually referred to (misleadingly, I believe) as reader response theory. Reception theory perhaps can most closely be related to my category of traditional theories of interpretation (a), although in calling for the respondent's grasp of an artwork's historical roots, and in rejecting the claim that there can be a final and thus definitive interpretation of it, the approach is nearer to my category (b), sociohistorical theories of interpretation.

5. The non-Marxist elements of this critique, the basic background information that I provide, owe much to four books: John Michael Montias, *Vermeer and his Milieu* (Princeton, N.J.: Princeton University Press, 1989); Svetlana Alpers, *The Art of Describing* (Chicago: The University of Chicago Press, 1983); Simon Schama, *The Embarrassment of Riches* (New York: Alfred A. Knopf, 1987); and Anthony Bailey, *Vermeer: A View of Delft* (New York: Henry Holt and Company, 2001). Little is known about Vermeer's life. Montias's biography, an incredible work of investigative effort and perseverance, provides a wealth of all sorts of details about Vermeer based primarily on legal documents of the period.

Bailey's recently published biography builds on Montias's work and thought-fully evokes the social world of seventeenth-century Delft (and Holland), including the world of its artists; he also provides information and widely accepted views in art history about the many ways in which Vermeer's and, more generally, seventeenth-century Dutch paintings may be interpreted. Yet there is still so much of importance that we don't know about Vermeer and are likely never to know. We can fairly readily see that the themes of Vermeer's paintings were influenced by some of his contemporaries in or near Delft; for example, Jan Steen, Pieter de Hooch, Gerard Ter Borch, Gerrit Dou, and Frans van Mieris. But was he acquainted with, and was his oeuvre strongly affected by, say, Rembrandt's work? Or Carravagio's? Where, if at all, did he travel, and did he, in marrying Catharina Bolnes, then or later convert to Catholicism? How did he regard his own work? What did he see himself as attempting to achieve? We have no sketches or drawings of his work, no personal letters or diaries. Thus, the profoundly personal life of Vermeer can only be speculated about by reflecting on his paintings (about thirty-five extant in all).

6. I am grateful to Anne Leblans of the Department of International Languages and Cultures at St. Mary's College of Maryland for her help with the Dutch terms that I have used in my deconstructionist pastiche of the Vermeer painting.

7. *Local Knowledge* (Boston: Basic Books, 1983), pp. 94–120. In this context, Geertz continues, "The capacity, variable among peoples as it is among individuals, to perceive meaning in pictures . . . is, like all other fully known capacities, a product of collective experience . . . as is the far rarer capacity to put it there in the first place. . . . A theory of art is at the same time a theory of culture" (pp. 108–9). Geertz, it should be mentioned, had a strong influence on both Foucault and Stephen Greenblatt, the new historicism's most famous practitioner and the person who named the movement. For a useful characterization of Greenblatt's modus operandi, see "Art Among the Ruins," by Frank Kermode, *The New York Review of Books* XLVIII, 11 (2001), pp. 59–63.

8. Geertz, *Local Knowledge*, p. 97.

9. Ibid., p. 105.

10. Position (e), cited previously.

11. This is school (f), the ethical – identified previously.

12. Geertz summarizes his position this way: " 'the sense of beauty'. . . is no less a cultural artifact than the objects and devices concocted to 'affect' it. The artist works with his audience's capacities – capacities to see, or hear, or touch, sometimes even to taste and smell, with understanding. And though elements of these capacities are indeed innate – it is really helpful not to be color-blind – they are brought into cultural existence by the experience of living in the midst of certain sorts of things to look at, listen to, handle, think about, cope with, and react to; particular varieties of cabbages, particular sorts of kings. Art and the equipment to grasp it are made in the same shop" (*Local Knowledge*, p. 118).

13. Ibid., p. 104.

14. Ludwig Wittgenstein, *Lectures and Conversations on Aesthetics, Psychology and Religious Belief*, ed. Cyril Barrett (Berkeley and Los Angeles: University of California Press, n.d.), p. 10.

15. Ibid., p. 9, footnote 1.

16. Geertz, *Local Knowledge*, p. 119.

17. Consider the summary remarks to be found in *A Companion to World Philosophies*, ed. Eliot Deutsch and Ron Bontekoe (Oxford: Blackwell Publishers, 1997). Compare: (a) Stephen J. Goldberg on Chinese aesthetics, Chapter 15; (b) Edwin Gerow on Indian aesthetics, Chapter 21; and (c) Seyyed Hossein Nasr on Islamic aesthetics, Chapter 33. At the deepest level, aren't the following generalizations – despite undeniable and important differences – in agreement with my claim that artistic expression aims at helping respondents to make sense of and come to terms with the "at-stakeness," the fundamental significance, of their lives?

(a) "In China creativity is construed as an ethico-aesthetic practice in which signifying acts of self-presentation (*yi*) are evaluated as to their efficacy in fostering harmonious relations of social exchange within specific historical occasions. . . . [T]he force of an expressive act . . . [should] produce effects that profoundly affect its recipients" (p. 225). In aesthetic acts of self-cultivation, one should "embody patterns of behavior deemed consonant with the immanent patterns perceived within the natural order of things" (p. 228).

(b) In India prior to the modern period, there is a developed set of speculations about artworks as providing "a transcendent solution [to] . . . human problems – most importantly, of course, the essentially religious problem of human suffering caused by the bondage of cyclic existence[;] [the fundamental question is . . .] 'how does the work of art . . . [help us to] accomplish human ends?' " (p. 304).

(c) "The most evident document of Islamic aesthetics is, of course, the eloquent but usually outwardly silent presence of Islamic art itself. . . . The products of Islamic art, whether visual or sonoral, themselves speak . . . of the philosophy upon which they are based. . . . These works reflect a philosophy of art that sees the origin of art forms in the imaginal and ultimately intelligible world beyond the whim and fancy of individual subjectivism, forms which, precisely because they descend from celestial archetypes, are able to carry us back to that realm. The function of Islamic art is therefore recollection in the Platonic sense – the recollection of spiritual realities which also reside at the center of our being. It is also a means of untying the psychological knots of the soul so as to enable the Spirit to breathe through the veils that stifle its presence within man. This art seeks to ennoble matter . . . by revealing it to be what it *really* is – namely, a mirror for the reflection of cosmic qualities which themselves reflect the Divine Qualities" (p. 458).

18. I am indebted to Wolfgang Iser for reminding me, and emphasizing the implications, of the explanatory incompleteness of all theoretical schools of interpretation.

19. Wittgenstein, *Lectures and Conversations on Aesthetics, Psychology and Religious Belief*, pp. 41–52.

20. When I assert that these "laws" are "strongly verifiable," I do not mean to imply that they are "absolute and objective truth." For although I believe that they are predictive on a macrolevel of events consequent upon the interaction of physical bodies, I at the same time think that the "truth" of these "laws" is relative to a frame of reference of certain needs and purposes, in some cases necessary and inescapable ones, of us human beings. As I see it, therefore, and in accordance with what I stated in endnote 30 of Chapter 4, it would be presumptuous to assert that in knowing the "laws," we thereby know the "being" of physical bodies as they exist independent of us as, so to speak perceivable by an Absolute Knower (God). If Newton's "laws" cannot be labeled "the Truth," then a fortiori we cannot say that any theory of interpretation of artworks is "the Truth" either. But, again, such a broad position does not preclude our presuming certain tenets as axiomatically necessary for the preservation of our living world or as pragmatically fructifying for explaining a whole range of existential phenomena that might otherwise be grasped simplistically or else rusticated to the limbo of the "to-be-dealt-with-later."

21. Cf. also in this context Foucault's interpretation of "*Las Meninas*" ("The Bride's Maids") by Velàzquez. Foucault argues that the "Classical" or modernist belief that there can be an objective and unbiased representation of an artwork is given the lie because both the creator of the work and its viewer are always tacitly present as observers; therefore, as interpreters who can never be assured that their perceptual dispositions are without bias: "it is not possible for the pure felicity of the image ever to present in a full light both the master who is representing [either the painter who creates the work or the spectator who views it] and the sovereign [the independent being] who is being represented" (*The Order of Things: An Archaeology of the Human Sciences* [New York: Vintage Books, 1973]). The translator of this work (in French, *Les Mots et les choses*) is, unfortunately, not cited in this edition.

22. My statement may suggest to the reader that a phenomenological approach itself is "immediate" and without theoretical suppositions. Such an inference would be too simple. Yet, as I have implied throughout this book, I do mean to distinguish the phenomenological approach from the more standard theories of interpretation cited earlier, for the former ordinarily gives greater weight than they do to the meaning, value, and overall significance derivable from confronting the depicted subworld of an artwork with a disposition of prereflective surrender.

23. See especially pp. 108–10.

24. Gadamer, who died on March 13, 2002, was Heidegger's most famous pupil. In *Truth and Method* (London: Sheed and Ward, 1979), he developed at length Heidegger's suggestive remarks on the hermeneutic circle found in *Being and Time*. Gadamer inspired the school of "reception theorists" at the University of Constance, and these thinkers, in turn, inspired many others internationally,

including the "reader response" theorists in the United States. The Constance school's founders and most prominent members were Wolfgang Iser and Hans Robert Jauss. Iser is still living, although his theoretical interests have moved somewhat away from reception theory in the direction of what he calls "literary anthropology."

25. Heidegger, *Being and Time*, p. 195.

26. Ibid., especially section 32, pp. 188–95, for a more detailed statement of what is meant by the "existential categories" or, better, "modes of being" (*Existentialia*) and by *Vorhabe* in particular.

27. Again, see Chapter 4, especially Part II.

28. Cf. the reference in Chapter 3, p. 143, to Schiller's claim that we must learn how to see others in ourselves.

29. Marx's phrase, coined for a very different purpose, but useful in a new setting; it was suggested to me by Professor Iser in conversation.

30. Thomas Aquinas, *Summa Theologica* II, Q. 94, Article 2.

31. According to Derrida, not just our language and its signifiers are open and indeterminable with respect to both connotative and denotative meaning, but our very "experience" itself is open and indeterminable as well: "This structural possibility of being weaned from the referent or from the signified (hence from communication and from its context) seems to me to make every mark [signifier], including those [marks] which are oral, a grapheme [a signifier that is *written*, as word or symbol or as something that is dependent on either for its essence or being] . . . which is to say . . . the non-present *remainder* [or residue, or unintended meaning, *restance*] of a differential mark cut from its putative "production" or origin [i.e., the communicator's consciousness in the act of speaking or writing]. *And I shall even extend this to all 'experience' in general* [my emphasis] if it is conceded that there is no experience consisting of *pure* presence [fully perspicuous consciousness of its own meanings and intentions] but only of chains of differential [or deferred] marks" ("Signature, Event, Context," p. 183). For Derrida, it is evident that the *restance*, the unspecifiable remainder or residue of "experience," is due to an ambiguity built into the very structure of language and its usage, whereas I maintain that it is the ambiguity and unfinishedness of our "experience" – more accurately, our lives which, while they are defined by the language we use, at the same time define it – that accounts for the final and definitive undecidability of artistic interpretation. This state of affairs does not, I believe, preclude a provisional decidability of artistic interpretation. Differently expressed, I would say that Derrida's entire skeptical stance reflects an unacknowledged rationalistic longing for a clarity and absoluteness that never has and never will exist.

32. Derrida's oeuvre, while undeniably revealing of problems that might otherwise have gone unnoticed and imaginative in reconceiving standard views of linguistic meaning and reference, is ultimately what Hegel would call a "negative moment" of historical and philosophical development, more destructive of

traditional forms of thinking, which is, of course, not without its value, than constructive, more motivated by antiauthoritarian animus (provocative, nuanced, and clever though it is) than authoritative anima. As an example of what I'm referring to, listen to the following statement from "Restitutions of the Truth in Pointing [*Pointure*]," in *The Truth in Painting* (trans. Geoffrey Bennington and Ian McLeod [Chicago and London: The University of Chicago Press, 1987]) in which Derrida derides those who believe, as I do, that it is necessary to believe in at least a qualified "beyond" of "textuality," something not wholly defined by the "mediation" of language and culture (e.g., the *Seinkönnen* of all human beings): "It [a suggested interpretation of a text or a painting] can always, more or less calmly, become police-like. It depends how, with a view to what, in what situation it operates. It can also arm you against that other (secret) police which, on the pretext of delivering you from the chains of writing and reading (chains which are always, illiterately, reduced to the alphabet), hastily lock you up in a supposed outside of the text: the pre-text of perception, of living speech, of bare hands, of living creation, of real history, etc. Pretext [by believers in some form of extratextuality] indeed to bash on [deconstructionists or, more generally, those who view all thought whatsoever as wholly mediated and relativized by cultural conventions] with the most hackneyed, crude, and tired of discourses. And it is also with supposed nontext, naked pre-text, the immediate, that they try to intimidate you, to subject you to the oldest, most dogmatic, most sinisterly authoritarian of programs, to the most massive mediatizing machines. But we can't here get into this debate about barbarities" (pp. 326–7). Note, too, how Derrida in this passage implicitly contradicts himself, since his own position on the essential intratextuality of every assertion, when applied to itself, cannot be seriously meant to be merely intratextual – thus part of a system of signifiers and signifieds with no authentic claim to any sort of objectivity or truth – for otherwise we would have no more reason to be deconstructionists than subjectivists, Marxists, or lotus eaters. I should also mention that John Caputo, in his biting, amusing, forceful work, *Deconstruction in a Nutshell* (New York: Fordham University Press, 1997), insists that Derrida's critics have horribly and perversely misinterpreted him and, in particular, that Derrida truly believes some things are *undeconstructible*. I was not able to ascertain from Derrida's explicit theory of language a vindication of Caputo's claim, even if, at some level, Derrida himself would like to believe in the possibility of undeconstructibility. In other words, whatever Derrida's wishes or offhand concessions may be, the principles that he has asserted or tacitly appealed to during the past forty years apparently outstrip and contradict such wishes or concessions.

33. I first developed this point in an article in *Man and World*, "Phenomenological Reflections on the Self and the Other – as Real, as Fictional" (27 [1994], pp. 318–23). See too, in a different but relevant context, C. S. Lewis, *The Abolition of Man* (New York: Macmillan, 1965), p. 91: "You cannot go on 'seeing

through' things for ever. The whole point of seeing through something is to see something through it. It is good that the window should be transparent, because the street or garden beyond it is opaque. How if you saw through the garden too? . . . If you see through everything, then everything is transparent. But a wholly transparent world is an invisible world. To 'see through' all things is the same as not to see."

Works Cited

Aldrich, Virgil. *Philosophy of Art*. Englewood Cliffs, N.J.: Prentice-Hall, 1963.

Alpers, Svetlana. *The Art of Describing*. Chicago: The University of Chicago Press, 1983.

Anscombe, G. E. M. "The Intentionality of Sensation: A Grammatical Feature." In *The Collected Papers of G. E. M. Anscombe: Volume II, Metaphysics and the Philosophy of Mind*. Minneapolis: University of Minnesota Press, 1981.

Aquinas, Thomas. *Summa Theologica*. Westminster, Md.: Christian Classics, 1981.

Aristotle. *De Anima*, Hugh Lawson-Trancred (translator). Princeton, N.J.: Princeton University Press, 1984.

Metaphysics, Hippocrates G. Apostle (translator). Princeton, N.J.: Princeton University Press, 1984.

Poetics, Richard Janko (translator). Indianapolis, Ind., and Cambridge: Hackett Publishing, 1987.

Bachelard, Gaston. *The Poetics of Space*, Maria Jolas (translator). Boston, Mass.: Beacon Press, 1969.

Bailey, Anthony. *Vermeer: A View of Delft*. New York: Henry Holt, 2001.

Barth, John. *The Floating Opera and The End of the Road*. New York: Anchor Press, 1988.

Beardsley, Monroe C. *Aesthetics: Problems in the Philosophy of Criticism*, 2nd ed. Indianapolis, Ind.: Hackett Publishing, 1981.

Berenson, Bernard. *The Florentine Painters of the Renaissance*. New York: G. P. Putnam's Sons, 1899.

Bleich, David. *Subjective Criticism*. Baltimore: The Johns Hopkins University Press, 1978.

Boruah, Bijoy H. *Fiction and Emotion: A Study in Aesthetics and the Philosophy of Mind*. Oxford: Clarendon Press, 1988.

Brough, John. "Cuts and Bonds: Husserl's Systematic Investigation of Representation." *Philosophy Today*, Suppl. 43 (1999).

"Depiction and Art." *American Catholic Philosophical Quarterly*, volume LXVI (1992).

Works Cited

Caputo, John. *Deconstruction in a Nutshell*. New York: Fordham University Press, 1997.

Carroll, Noël. "On Kendall Walton's *Mimesis as Make-Believe*," *Philosophy and Phenomenological Research*, volume 51 (1991).

 Philosophy of Horror or Paradoxes of the Heart. London: Routledge, 1990.

Chevalier, Tracy. *Girl with a Pearl Earring*. New York: Dutton, 1999.

Coleridge, Samuel Taylor. *Biographia Literaria*, Chapter 14. Cambridge: Cambridge University Press, 1920.

Crittenden, Charles. *Unreality: The Metaphysics of Fictional Objects*. Ithaca and London: Cornell University Press, 1991.

Danto, Arthur. "The Artworld," *The Journal of Philosophy*, volume 61 (1964).

Derrida, Jacques. *Acts of Literature*, Geoffrey Bennington and Rachel Bowlby (translators). London and New York: Routledge, 1992.

 Limited Incorporated. Samuel Weber (translator). Evanston, Ill.: Northwestern University Press, 1988.

 "Restitutions of the Truth in Pointing [*Pointure*]." In *The Truth in Painting*, Geoffrey Bennington and Ian McLeod (translators). Chicago and London: The University of Chicago Press, 1987.

 Margins of Philosophy, Alan Bass (translator). Brighton, England: Harvester Press, 1982.

 "Signature, Event, Context," Samuel Weber and Jeffrey Mehlman (translators). *Glyph* 1 (1977).

Descartes, René. *Discourse on Method*, Donald Cress (translator). Indianapolis, Ind.: Bobbs-Merrill, 1960.

 Meditations on First Philosophy, Donald Cress (translator). Indianapolis, Ind.: Bobbs-Merrill, 1951.

Deutsch, Eliot, and Ron Bontekoe (editors). *A Companion to World Philosophies*. Oxford: Blackwell Publishers, 1997. (Goldberg, Stephen J., "Chinese Aesthetics," chapter 15; Gerow, Edwin, "Indian Aesthetics," chapter 21; Nasr, Seyyed Hossein, "Islamic Aesthetics," Chapter 33.)

Dewey, John. *Art as Experience*. In Volume 10 of the *Late Works of John Dewey*. Carbondale: Southern Illinois University Press, 1987.

Dickie, George. *Art and the Aesthetic: An Institutional Analysis*. Ithaca, N.Y.: Cornell University Press, 1974.

Foucault, Michel. *The Order of Things: An Archaeology of the Human Sciences* (translator not cited; in French: *Les Mots et les choses*). New York: Vintage Books, 1973.

Freedberg, David. *The Power of Images: Studies in the History and Theory of Response*. Chicago and London: The University of Chicago Press, 1989.

Freud, Sigmund. *The Ego and the Id*, James Strachey (translator). New York: Norton, 1962 (originally published in 1923).

 On Metapsychology, James Strachey (translator). Harmondsworth: Penguin, 1984.

Gadamer, Hans-Georg. *Truth and Method*, 2nd ed., rev., William Glen-Doepel

Works Cited

(original translation revised by Joel Weinsheimer and Donald G. Marshall). New York: Continuum Publishing, 1994.

Geertz, Clifford. *Local Knowledge*. Boston: Basic Books, 1983.

Gibson, Michael. "Serenity and Ritual: [Giorgio] Morandi's Moral World." *International Herald Tribune*, 3–4 November 2001.

Glendinning, Simon. *On Being with Others: Heidegger, Derrida, Wittgenstein*. London and New York: Routledge, 1998.

Gombrich, Ernst. *Art and Illusion: A Study in the Psychology of Pictorial Representation*. Bollinger series 35, volume 5. Princeton, N.J.: Princeton University Press, 1960.

Goodman, Nelson. *Languages of Art: An Approach to a Theory of Symbols*, 2nd ed. Indianapolis, Ind.: Hackett Publishing, 1976.

Hacking, Ian. *The Social Construction of What?* Cambridge, Mass.: Harvard University Press, 1999.

Hegel, G. W. F. *The Phenomenology of Spirit*. A. V. Miller (translator). Oxford and New York: Oxford University Press, 1977.

Heidegger, Martin. "The Origin of the Work of Art." In *Poetry, Language, Thought*, Albert Hofstadter (translator). New York: Harper and Row, 1971.

Being and Time. John Macquarrie and Edward Robinson (translators). London and Southhampton: SMC Press, 1962.

Hjort, Mette, and Sue Laver (editors). *Emotion and the Arts*. Oxford and New York: Oxford University Press, 1997.

Holland, Norman. *Readings and Feelings: An Introduction to Subjective Criticism*. Urbana, Ill.: National Council of Teachers of English, 1975.

Hopkins, Rob. Review of *Mimesis as Make-Believe: On the Foundations of the Representational Arts* by Kendall Walton, *Philosophical Books*, volume XXXIII (April, 1992).

Hume, David. "Of the Standard of Taste," *Essays, Moral, Political, and Literary*, Part I. Indianapolis, Ind.: Liberty *Classics*, 1987 (originally published in 1742).

Husserl, Edmund, *Ideas Pertaining to a Pure Phenomenology and to a Phenomenological Philosophy*. Revised edition in two parts: Part 1 translated by F. Kersten, The Hague: M. Nijhoff, 1980; Part 2 translated by Richard Rojcewicz and Andre Schuwer, Dordrecht, the Netherlands: Kluwer, 1989.

Phantasie, Bildbewusstsein, Errinerung [*Fantasy, Depictive Consciousness, Memory*] (1885–1925), *Husserliana* XXIII, Edward Marbach (editor). The Hague: Martinus Nijhoff, 1980.

On the Phenomenology of the Consciousness of Internal Time, John Brough (translator). Dordrecht, The Netherlands: Kluwer, 1991.

Inwagen, Peter van. "Creatures of Fiction," *American Philosophical Quarterly*, volume 4 (1977).

James, William. *The Principles of Psychology*. Cambridge, Mass.: Harvard University Press, 1981.

Works Cited

Kant, Immanuel. *Critique of Judgment*, Werner S. Pluhar (translator). Indianapolis, Ind.: Hackett Publishing, 1987.

Kermode, Frank. "Art Among the Ruins," *The New York Review of Books*, volume XLVIII, no. 11.

Kinzer, Stephen. "Pride of Salinas: Steinbeck at 100," *International Herald Tribune*, 26 March 2002.

Lamarque, Peter. "Fiction and Reality." In *Philosophy and Fiction: Essays in Literary Aesthetics*. Aberdeen: Aberdeen University Press, 1983.

"How Can We Fear and Pity Fictions?" *British Journal of Aesthetics*, volume 21 (1981).

Fictional Points of View. Ithaca, N.Y.: Cornell University Press, 1996.

Levinson, Jerrold. "Emotion in Response to Art: A Survey of the Terrain." In *Emotion and the Arts*, Mette Hjort and Sue Laver (editors). Oxford and New York: Oxford University Press, 1997.

"Making Believe." In *The Pleasures of Aesthetics: Philosophical Essays*. Ithaca, N.Y.: Cornell University Press, 1996.

Lewis, C. S. *The Abolition of Man*. New York: Macmillan, 1965.

Lewis, David. "Truth in Fiction." Reprinted in *Philosophical Papers*, volume I. New York: Oxford University Press, 1983.

Man, Paul de. *Blindness and Insight*. Minneapolis: University of Minnesota Press, 1983.

Mann, Thomas. *The Magic Mountain*, John E. Woods (translator). New York: Knopf, 1995.

Margolis, Joseph. *Art and Philosophy*. Brighton, England: Harvester Press, 1980.

McCormick, Peter. "Feelings and Fictions." *Journal of Aesthetics and Art Criticism*, volume 43 (1985).

Meissner, W. W. "Notes on Identification." *Psychoanalytic Quarterly*, volume 41 (1972).

Melville, Herman. *Moby-Dick*. Chicago: Northwestern University Press, 1988.

Montias, John Michael. *Vermeer and His Milieu*. Princeton, N.J.: Princeton University Press, 1989.

Oatley, Keith, and Mitra Gholamain. "Emotions and Identifications: Connections between Readers and Fiction." In *Emotion and the Arts*, Mette Hjort and Sue Laver (editors). Oxford and New York: Oxford University Press, 1997.

Panofsky, Erwin. *Meaning in the Visual Arts*. Garden City, N.Y.: Doubleday Anchor Books, 1955.

Parsons, Terence. *Nonexistent Objects*. New Haven, Conn.: Yale University Press, 1980.

Paskins, Barrie. "On Being Moved by Anna Karenina and *Anna Karenina*." *Philosophy*, volume 52 (1997).

Paskow, Alan. "Phenomenological Reflections on the Self and the Other–as Real, as Fictional." *Man and World*, volume 27 (1994).

Works Cited

"What is Aesthetic Catharsis?" *The Journal of Aesthetics and Art Criticism*, volume 42 (1983).

Plants, Nicholas. "Therapeutic Interpretations: Rorty's Pragmatic Hopes and Fears." *Annual Catholic Philosophical Association Proceedings*, volume LXII (1999).

Plato. *Phaedrus*. Alexander Nehemas and Paul Woodruff (translators). Indianapolis, Ind., and Cambridge: Hackett Publishing, 1995.

The Republic of Plato. F. M. Cornford (translator). London and New York: Oxford University Press, 1945.

Symposium. Alexander Nehamas and Paul Woodruff (translators). Indianapolis, Ind., and Cambridge: Hackett Publishing, 1989.

Radford, Collin. "The Essential Anna." *Philosophy*, volume 54 (1979).

Radford, Collin, and Michael Weston. "How Can We Be Moved by the Fate of Anna Karenina?" *Proceedings of the Aristotelian Society*, suppl. volume 49 (1975).

Rauch, Leo, and David Sherman. *Hegel's Phenomenology of Self-Consciousness: Text and Commentary*. Albany: State University of New York Press, 1999.

Riegl, Aloïs. *Das holländische Gruppenporträt*. Wien WUV-Verlag, 1997 (originally published in 1902).

Rorty, Richard. "The Pragmatist's Progress." In *Interpretation and Overinterpretation*. Cambridge: Cambridge University Press, 1992.

Rosebury, B. J. "Fiction, Emotion, and 'Belief,' a Reply to Eva Schaper." *British Journal of Aesthetics*, volume 19 (1979).

Russell, Bertrand. "On Scientific Methods in Philosophy." In *Mysticism and Logic and Other Essays*, 2nd ed. New York: Barnes and Noble, 1971.

Sacks, Oliver. *The Man Who Mistook His Wife for a Hat and Other Clinical Tales*. New York: Summit Books, 1985.

Salomon, Nanette. "Vermeer and the Balance of Destiny." In *Essays in Northern European Art Presented to Egbert Haverkamp Begemann*. Doornspijk: Davaco Press, 1983.

Schama, Simon. *The Embarrassment of Riches*. New York: Alfred A. Knopf, 1987.

Schiller, Friedrich. *On the Aesthetic Education of Man*. Oxford: Charendon Press, 1982.

Shakespeare, William. *Hamlet*. New York: W. W. Norton and Company, 1996.

Macbeth. New York: Cambridge University Press, 1997.

Shustermann, Richard. *Pragmatist Aesthetics: Living Beauty, Rethinking Art*. Oxford, England, and Cambridge, Mass.: Blackwell Publishers, 1992.

Stolnitz, Jerome. *Aesthetics and the Philosophy of Art Criticism*. Boston: Houghton Mifflin Company, 1960.

Taub, Eric A. "Pets Are Robotic, but Pride Is Real." *International Herald Tribune*, 9 May 2002.

Walton, Kendall. "Depiction, Perception, and Imagination: Responses to Richard Wollheim." *The Journal of Aesethics and Art Criticisms*, volume 60 (2002).

Works Cited

"Spelunking, Simulation, and Slime: On Being Moved by Fiction." In *Emotion and the Arts*, Mette Hjort and Sue Laver (editors). Oxford and New York: Oxford University Press, 1997.

Mimesis as Make-Believe: On the Foundations of the Representational Arts. Cambridge, Mass., and London: Harvard University Press, 1990.

Weber, J. M. Gregor. "Vermeer's Use of the Picture within a Picture: A New Approach." *Vermeer Studies*, Ivan Gaskell and Michiel Jonker (editors). Washington, D.C.: The National Gallery of Art; distributed by Yale University Press, New Haven and London, 1998.

Weston, Michael. "How Can We Be Moved by the Fate of Anna Karenina?" *Proceedings of the Aristotelian Society*, suppl. volume 49 (1975).

White, Hayden. "Literary Theory and Historical Writing." In *Figural Realism: Studies in the Mimesis Effect*. Baltimore and London: The Johns Hopkins University Press, 1999.

Wittgenstein, Ludwig. *Lectures and Conversations on Aesthetics, Psychology and Religious Belief*, Cyril Barrett (editor). Berkeley and Los Angeles: University of California Press, n.d.

Philosophical Investigations, G. E. M Anscombe (translator). Oxford: Blackwell Publishers, 1958.

Wollheim, Richard. *Painting as an Art*. Princeton, N.J.: Princeton University Press, 1987.

Wolterstorff, Nicholas. *Works and Worlds of Art*. New York: Oxford University Press, 1980.

Woolf, Virginia. *Mrs. Dalloway*. San Diego, Calif.: Jovanovich, 1985.

Yanal, Robert J. *Paradoxes of Emotion and Fiction*. University Park: The Pennsylvania State University Press, 1999.

Young, Julian. *Heidegger's Philosophy of Art*. Cambridge: Cambridge University Press, 2001.

Zemach, Eddy M. "Emotion and Fictional Beings." *The Journal of Aesthetics and Art Criticism*, volume 54 (1996).

Index

Index

Index